IRISH WOMEN AT WORK, 1930–1960

IRISH WOMEN AT WORK, 1930–1960

An Oral History

Elizabeth Kiely and
Máire Leane

Foreword by Maria Luddy

IRISH ACADEMIC PRESS
DUBLIN • PORTLAND, OR

First published in 2012 by Irish Academic Press

8 Chapel Lane,
Sallins,
Co. Kildare, Ireland

920 NE 58th Avenue, Suite 300
Portland, Oregon,
97213-3786, USA

© Elizabeth Kiely and Máire Leane 2012

www.iap.ie

British Library Cataloguing in Publication Data

Kealy, Elizabeth.
 Irish women at work, 1930-1960 : an oral history.
 1. Women employees—Ireland—History—20th century.
 2. Women—Employment—Ireland—History—20th century.
 3. Women—Ireland—Social conditions—20th century.
 I. Title II. Leane, Maire.
 331.4'09415-dc23

ISBN 978 0 7165 3390 0 (cloth)
ISBN 978 0 7165 3391 7 (paper)
ISBN 978 0 7165 3189 0 (Ebook)

Library of Congress Cataloging-in-Publication Data
An entry can be found on request

Printed by SPRINT-print, Rathcoole, Co. Dublin

Contents

Acknowledgements

This book has been in production for a long time. It is one of the end products of an oral history project funded by the Higher Education Authority Programme for Research in Third Level Institutions. This was part of a broader Women in Irish Society research initiative. We would like to acknowledge our colleagues, who were part of this initiative: Linda Connolly, Pat Coughlan, Tina O'Toole and Eibhear Walshe. Those who worked on the oral history project made a very significant contribution. Marian Elders worked as a research officer and conducted interviews on the project, while Clodagh O'Driscoll worked as a research assistant and an interviewer. Margaret Kearns also conducted interviews for the oral history project. Sincere thanks go to our colleague Rosie Meade, who carefully read an earlier draft of this book and who asked incisive questions, gave excellent feedback and encouraged us along. We are grateful to Donal O'Drisceoil, who has also been very supportive. Our thanks also go to the anonymous reviewer who gave positive feedback and made very insightful comments, which we used to improve the work. We thank Jennifer K. DeWan for her very professional proofreading. Lisa Hyde at Irish Academic Press was patient and gave assistance at crucial times in the writing of this book. We would like to sincerely thank the College of Arts, Celtic Studies and Social Sciences in University College Cork for providing a very significant grant towards the publication of this book. We are forever indebted to the forty-two women who shared their lives, memorabilia and time with us. Without their participation, this book would not have been possible.

List of Plates

All photos and other items of memorabilia were reproduced courtesy of the women who were interviewed and who donated them to the oral history project on women's work.

List of Tables

Foreword

In spite of the advances made in Irish women's history over the last two decades we still have little insight into women's working lives and cultures. Concepts of gender, status and power shape our understanding of work generally, and in relation to women's work issues of economy, class, demography and family situation further determine how women involve themselves in the world of paid employment. Looking at the lives of working women in Cork, Kerry and Limerick from the 1930s to the 1960s and utilising oral history, this pioneering study by Elizabeth Kiely and Máire Leane offers real insight into the factors that shaped women's entry into the world of paid work, and what it meant to be a working woman in the south of Ireland in this period.

In this book we engage with women who tell their own histories of work. The range of work is fairly typical of what was available to women in the period and includes teachers, nurses, domestic and agricultural workers, factory workers and civil servants. There was a social and cultural status applied to different types of work, and the women themselves were very conscious of this status. The occupation most consistently identified with low status and poor pay and working conditions was domestic work, which remained a key source of women's employment until the 1950s. Generally women had a dislike for working in the households of others. The advance in technology has changed work practices enormously over the years and it is salutatory to be reminded that working for instance in a grocery shop, was really hard work where items such as sugar, and flour had to be measured and repackaged, and some of the domestic workers found themselves washing clothes without the use of washing machines.

The family appears to have been a significant mediating force in deciding who was to work, and what kind of work daughters could engage in. It is clear that the socialisation of girls in particular, through the family and through education, shaped women's views of the work that might engage them. Women were prepared for short-term working lives and the ideal was marriage and children, with women's labour confined to the domestic sphere. The impact of parents on the work choices of their daughters is evident and the

deference of young women to authority reveals a great deal about the nature of Irish society in this period. Personal desire was not the leading factor in determining a woman's choice of work. Women secured jobs through family connections, local politicians, community networks, and through friends and family, and many started work at fifteen years of age. Most women gave up their jobs on marriage. Gender ideology which cast men as breadwinners, tended to exclude married women from work and criticised single women who sought work if men were unemployed. Women were always paid less than men, and many women accepted this imposition unless they themselves were the family breadwinner, and it was then that the unfairness of their situation was most evident to them. It is from their own stories that we can begin to understand the constraints imposed by family and society on the 'opportunities made available to these women. Their stories also tease out the ways and means women devised to sustain themselves and their families in times of economic and familial difficulty.

The authors' interventions provide the contextual information that brings out the important details of the oral histories. Their subtle and nuanced interpretations of these women's working lives give primacy to the women's own experiences. The diversity of women's experiences as waged workers is complex and the authors' recognise that complexity. The detailed picture given of women's work, and women's understandings of their place in society and the identity that work provided for them, offers a major contribution to Irish social and economic history. This is a landmark study that urges the exploration of women's working lives and experiences in other regions of the country.

Maria Luddy
University of Warwick

Brief Biographical Details
of Oral History Interviewees

Alice was born in Cork City in 1937. She began work as an apprentice dressmaker in 1952 but left this position in 1953. In 1955 she took a post as a domestic worker in a household in Cork City and after a few months left to take a job as a presser in a dry cleaning company. She remained in this job until 1963, two years after she married. In the 1970s when her four children were of school age, Alice took up work as a presser in another dry cleaning company in Cork City.

Bridie was born in County Limerick in 1929. She worked on her parents' farm between 1940 and 1944 and then took a position as a domestic worker in County Limerick between 1944 and 1945. Subsequently she returned to work with her parents until her marriage in 1948. Following marriage she combined her motherhood role with home-based, income-generating work such as raising and selling animals and poultry.

Caitlín was born near Fermoy in Cork in 1912 and trained as a primary school teacher. She worked as an assistant teacher in Dublin between 1936 and 1941, after which she moved to Kilmurry National School in Kilworth, County Cork and took on the duties of Principal until 1945. She continued to teach in a number of schools in Cork until her retirement in 1978, as Vice-Principal of Ráth Dubh national school.

Catherine O'D. was born in 1915 in Cork City. Her first job as a dispatcher was in a small sweet manufacturers in Cork City and when this was closing, she found work in the Eclipse factory where she worked until she married in 1940. Catherine did not engage in paid work after marrying.

Catherine W. was born in 1926, grew up in Macroom in County Cork and qualified as a civil engineer in 1949. She worked in this capacity for different engineering contractors until she married in 1953. Widowed in 1961, when she was four months' pregnant with her fifth

child, Catherine subsequently resumed employment, working in different civil engineering positions. She held the post of Assistant County Engineer in Cork County Council when she retired in 1982.

Chris was born in 1918 in Cork City. She was employed as an office worker in Thompson's Bakery on MacCurtain Street in Cork between 1940 and 1949. She subsequently worked as an accounts machine operator and as an assistant manageress in hotels in Offaly and Kerry until she retired.

Clare was born in Dublin in 1928. She took her first job in 1945 as a telephonist in the central exchange in Dublin and after a few weeks she took a position in the Civil Service in the General Post Office. She held this post until she married in 1957 and relocated to Kerry with her husband where she became a full-time home-maker.

Doireann was born in Blackpool in Cork City in 1936. She began her training as a drapery assistant in Dunnes Stores in Cork City and worked there until her marriage in 1958, when she resigned. Doireann returned to work as a shop assistant in Dunnes Stores in a part-time capacity in 1972 and remained there for a further twenty-eight years.

Dympna was born in Bantry, West Cork, in 1931. She received a scholarship to complete her secondary school education and subsequently trained as a primary school teacher in Limerick. Dympna worked as a teacher in Cork City from 1950 until her marriage in 1955. She re-entered teaching in a substitute capacity in 1959 and returned to a full-time teaching post in 1963 and remained in it until her retirement.

Eileen C. was born in Midleton in East Cork in 1918. In 1936 she took a job as a shop assistant in the Savoy Cake Shop in Cork City and remained in that post until she married in 1941.

Eileen D. was born in Berrings in County Cork in 1914. She won a one-year scholarship to a domestic economy college in Dunmanway in Cork and did a further year of study in the Munster Institute in Cork. She subsequently took a position in Coachford Creamery as a trainee butter-maker and then moved to Newmarket Creamery to train as a cheese-maker. She continued to work as head cheese-maker in Ballygarvan, County Limerick until her marriage in 1952. She and her

husband subsequently moved to a cheese factory in Rathduff, County Cork and worked for a further short period before being dismissed for attempting to introduce the union into their workplace.

Elizabeth was born in 1925 and grew up in Clonmel, County Tipperary. She trained as a nurse in St. Andrew's Military Hospital, London, qualifying in 1947. She was employed in different hospitals in England and she subsequently took up a position as a nursing sister with the Irish Army and was stationed in Collins Barracks in Cork City. After marrying in 1955, she emigrated and lived in England with her husband. While there she took up part-time work, which included jobs in a bank and a music company. She returned to Cork in 1972, by which time her husband was incapacitated and Elizabeth resumed nursing in St. Finbarr's and other hospitals in the Cork City area and continued to work full-time until 1984.

Ena was born in West Cork circa 1935 but was raised in Cork City. Upon finishing her Intermediate Certificate she took a summer job as a sales assistant in the Moderne and was subsequently employed as an office worker by Browne and Nolan publishers in Cork City from 1952 until she married in 1958. After her marriage she owned and managed a fashion boutique in Cork until the late 1990s.

Helen was born in Limerick City in 1942. She left school in 1956 and completed commercial courses in a local technical college and in a private commercial college. Helen began working as an office junior in a hire purchase company in Limerick in 1958 and continued to work there until a few months after her marriage in 1965. During her time in the office, Helen was promoted initially to a clerk typist post and then to a post as a ledger clerk. She did not work outside the home after marrying.

Joan D. was born near Killarney in County Kerry. She began general nurse training in Whipps Cross London in the mid-1940s and qualified as an SRN. She continued to work in London for six months and then returned to nurse in Kerry until the early 1950s, when she took up nursing with the Irish Army. Joan was based in the Curragh Camp in Kildare and nursed there until her engagement in 1963, upon which she resigned. After marriage she did not work outside the home.

Joan F. was born in Cork City in 1932. She took her first job as a factory worker in 1946 at Mill Industries, where gloves were made. She then moved to Egan's Optical Company in Blackrock, Cork, where she cut and filed frames for glasses. She remained in that post until her marriage in 1956 and she did not work outside the home subsequently.

Joan G. was born in Tralee, Co. Kerry in 1932. She completed her leaving certificate in 1948 and did a one-year commercial course in Tralee. She subsequently took a job as an office clerk in a large shop in Tralee and resigned from this job in 1952 when she secured a job as a clerk typist in Kerry County Council. Joan remained in this post until she married in 1966 and moved to live in Cahersiveen, Co. Kerry. In 1972, Joan returned to work on an occasional, part-time basis, as a substitute national teacher for junior classes in local schools or as a substitute office worker. In 1979 she took a permanent, part-time post as a clerical worker in a local hospital and she held that post until she retired in 1999.

Joan H. was born in County Limerick in 1916. She was employed as a clerical worker in the Department of Industry and Commerce Office in County Limerick and in Limerick County Council between 1934 and 1946, when she left her post in order to marry. Joan returned to the workforce in the 1970s as a bar and shop worker.

Joan N. was born in 1923 in West Limerick. She worked as a domestic servant/farm labourer for different employers in County Limerick when single and for many years after she married in 1944.

Kathleen F. was born in Cork City in 1925 and took her first job as a machinist in the Sunbeam factory in Blackpool in 1939. She stayed in this post until her marriage in 1954. Kathleen didn't work outside the home after her marriage.

Kathleen O'R. was born in Cork City circa 1939. Her first job was in the Goodwear factory in Cork, where she was employed from 1953 until 1960 when she married. She returned to work in 1977 as a cleaner with the Cope Foundation, where she was still employed when interviewed in 2002.

Madge was born near Cork City in the early 1930s. After completing

one year of secondary schooling she did a one-year cookery and domestic economy course in the School of Commerce in Cork City. Madge then began to work in the family home and farm as her mother suffered a chronic illness, which made it difficult for her to work. Madge continued to work at home until 1962, when she emigrated to Boston to work as an au pair. After a year in that job she moved to New York and took a job as a telephonist and did occasional night work as a care assistant in a home for older people. Madge held her telephonist post for a year and then returned to Ireland following the death of her father. Madge subsequently married and did not work outside the home.

Margaret was born in Cork City in 1941 and grew up in the St. Luke's area. She completed her Group Certificate at the age of sixteen and took a job as a sales assistant in McCarthy's Paint and Decorator's shop in Castle Street, Cork. After a few months she moved to an office job in R&D Cleaners and Dryers in the Grand Parade and remained in that post for seven months until she was obliged to resign following the death of her mother. Between 1958 and 1963 Margaret ran her family home and cared for her father and younger siblings. During this time she took a part-time evening job as a cashier in a Pongo Saloon, and attended night classes in cookery and in typing and shorthand in the School of Commerce in the City. In 1963 she returned to work as a dental receptionist but left that post within a year to take up better paid factory work in the Dunlop rubber factory. Margaret resigned from the Dunlop factory when she married in 1965 and didn't work again until the mid-1970s, when she took a morning job picking mushrooms in Rathcooney Fruit Farms, Cork. She resigned from this work after a year when she became pregnant with her third child. Margaret returned to night-time, weekend work as a care assistant in a home for older people in 1980. After eight years in this post she resigned.

Mary F. was born in County Limerick in 1938 and she began work in 1953 as a ward's maid in a sanatorium in County Limerick. She remained in that position until her marriage in 1958 after which she worked for a year with her husband as a general operator in Birds Carnival Amusements.

Mary G. was born in South Kerry in 1914 and qualified as a secondary school teacher in 1939. She worked for a year in Dublin before

returning home to Kerry to provide care for her widowed father. Between 1940 and 1956, Mary combined substitute national school teaching with her role as carer for her father. In 1957 after her father's death, Mary took a post as a secondary school teacher in Kilkenny and later in a Christian Brothers School in Cahersiveen, Co. Kerry, where she stayed until she retired in 1980.

Mary K. was born in South Kerry in 1933. She completed her leaving certificate and in 1953 began working in a primary school as a Junior Assistant Mistress (JAM). In her early years as a JAM, Mary went to London to work during her summer holidays. Mary married in 1963 and continued to work as a JAM. In the late 1960s she undertook training which upgraded her teaching qualification and gave her parity of status and conditions with fully trained primary school teachers. Mary continued to teach in Kerry until she reached retirement age.

Mary O'D. was born in Schull in West Cork in 1924. In 1940 she cared for a relative for one year before taking up a position as a childminder and domestic until 1942. She subsequently worked as a waitress in two different restaurants in Cork City between 1942 and 1953, when she became ill and had to move back home. When she recovered, she managed a guesthouse in Cobh, County Cork from 1954 onwards.

Mary O'N. was born in 1920 near Bandon, County Cork. She worked as an assistant in a tobacconist/sweet shop in Cork City for one year before moving to work as a shop assistant and domestic helper in Inniscarra Stores in Turner's Cross, Cork in 1940. She left that job in 1950 and returned to work in her family home. In 1953 she married a farmer and from that time on, she reared her children and worked on the family farm.

Mary O'S. was born in Tower in County Cork. After completing her schooling and a secretarial course, she took up a post as an invoice clerk with a wholesale tea and wine merchants in Cork City in 1950. Two years later she moved to a position as a general office worker with a building firm in Cork City, where she worked until 1958 when she became pregnant with her first child. Mary subsequently became a full-time home-maker.

Mary T., who was born in County Tipperary, trained as a poultry

instructress in the Munster Institute in Cork, and qualified in 1945. She worked in this capacity in counties Limerick and Cavan throughout her single life until she married in 1953. After being widowed in the late 1950s, she resumed employment as a poultry instructress.

Maura C. was born in 1927. Her first job was as a cash girl in Roche's Stores, Cork in December 1944. She subsequently took a job as a wages clerk in an office on the South Mall in Cork and in 1946 secured a post as a telephonist in the Department of Posts and Telegraphs Telephone Exchange in Cork. Maura stayed in the post until she married in 1951. She returned to similar work in the telephone exchange in Cork in 1973 and remained there until 1985.

Maura D. was born in 1922 in Limerick City and began her working life in a Tait's clothing factory in Limerick City in 1934. She worked in the factory for ten years as a timehand and a brusher. Following her marriage in 1944 she combined motherhood with work in her husband's chip shop until 1961.

Maureen was born in Cork City in 1917. She was employed by Roche's Stores in Cork between 1934 and 1943 where she was responsible for stock control. After she married in 1943, she worked from home doing book-keeping and stock control for Dunnes Stores.

May was born in East Cork in 1925 and she worked in a variety of positions in different hotels in Cork County from 1940. In 1945 she commenced work as a cook in the Metropole Hotel in Cork City. She remained in this job until her marriage in 1965. She did not engage in paid work after she married.

Muriel was born in Cork City in the late 1920s. She took her first job in the office of Cork Ironworks in 1945 and remained in this position until her marriage in 1949. She subsequently returned to work as a sales assistant in a Cork City paint and decorating shop in 1975, and continued to work there until 1987.

Noreen was born in Cahersiveen, Co. Kerry in 1919. She completed her matriculation examination at the age of seventeen and spent a year learning shorthand and typing in the Presentation Convent in Cahersiveen. In 1939 she moved to Dublin to train as a nurse in the

Richmond Hospital. She finished her training in 1943 and married in April 1944. Following her marriage she returned to Cahersiveen where she worked in her husband's family drapery business until 1983 when the shop closed.

Pauline was born in 1917 in Cork City. She worked as a secretary from 1935 until 1941 in a painting and decorating firm in Cork City. In 1941 she married and emigrated to Wales with her husband in search of employment. Pauline worked as a secretary in the Civil Service (in the ministry of shipping) in Cardiff and subsequently moved to Manchester where she worked for a short period in a battery factory. She returned to Ireland in the mid-1940s when her husband's employers transferred him to a sister factory in Clonmel. Pauline's first child was born in 1945 and she was a home-maker until the early 1970s when she took up part-time work for a market research firm.

Rena was born in 1940 in the northside of Cork City. After a brief period training as a tailoress with her aunt, she took up employment in O'Gorman's hat factory in Cork City, where she worked for one year. She was employed in the Lee boot factory in Cork City until it closed. After a brief period of unemployment, she took up a job in the Sunbeam Wolsey factory, in Blackpool, Cork City, where she worked for a number of years as an overlocker, until she married in 1962. Rena did not work outside the home after marrying.

Rita, who was born in West Cork, was employed as a cook general/ domestic from 1940 onwards for different employers. In 1946, she emigrated to London where she took up a position as a cashier for Lyons Tea Company. She resigned from this job in 1952 when she returned to West Cork and married a farmer. After her husband died suddenly, she took up work as a paid housekeeper for some years after.

Rose was born circa 1933. In 1949 she completed six months of nurse training in Dublin before returning home to Cork, where she took up a job in the Dunlop rubber factory. She stayed there for a few years before moving to the Cork spinning factory where she worked until 1974. From 1974 until 1978, she worked part-time in a take away restaurant and provided care for an elderly friend. She was then employed for twenty years as an attendant in a public institution until her retirement in 1998.

Sheila was born near Cork City in the late 1920s. After completing one year of secondary education, she began a three-year apprenticeship with a dressmaker in the city. After qualifying Sheila remained working with the dressmaker for approximately 9 years, after which time she worked from her family home until she married in 1958. She continued to do dressmaking work for the first year after her marriage but following the birth of her first child she made clothing only for family members and friends.

Sr. Paul was born in Newmarket, County Cork in 1921. Having taken her final vows in 1947, she managed the farm in Drishane Convent until 1961. She then engaged in community work in Ireland and England until the 1980s.

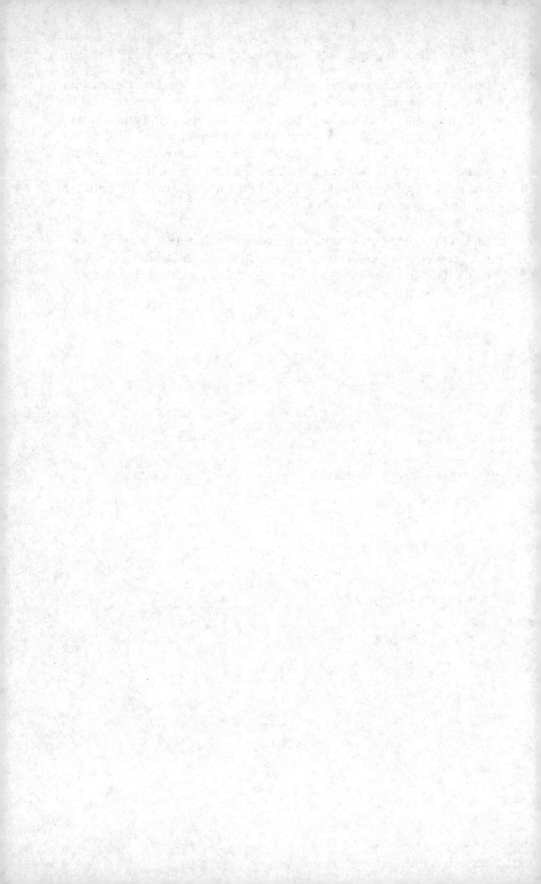

Introduction

The limited nature of academic study into women's experiences of waged work in the Southern Irish state from the 1930s to the 1960s provided the impetus for this book. It is based on a feminist analysis of forty-two oral histories collected from 'ordinary' women, who worked in Cork, Kerry or Limerick during this period.[1] In Irish historical work, the voices and experiences of 'ordinary' women have been marginal. Irish historiography in the post-war period has been predominantly focused on the political and public world, to the neglect of the social and economic sphere.[2] In the 1990s, historians noted that the recovery process in women's history was still at an early stage[3] but more recently historical work on women's lives has been on the increase and oral history has played a significant part.[4]

The research conducted for this book contributes to an area of Irish women's history which has been largely overlooked, namely women's involvement in paid work. The history of labour in the Irish context is largely a male history.[5] Notwithstanding some significant contributions[6] we still understand very little about the role paid work has played in women's lives and how this changed over time. In the independent Irish State which emerged in 1921, legislation and policies were introduced which limited women's rights both as citizens and as workers and idealised their role as carers and home-makers. However, the extent to which these measures constituted a totalising ideology of domesticity has been the subject of some discussion, as has the level and significance of women's economic activity during these decades.[7] Such discussion provided the starting point for our research. We wondered what a collection of women's life stories might reveal about women's aspirations regarding work, their entry routes into work and their subsequent employment trajectories; what would we find out about their conditions of work and the challenges they experienced as female workers? By collecting women's life stories could we generate some subtle and interesting understandings of the ways in which a group of women experienced their lives as

working daughters, as working women and in many instances as working wives and mothers during the 1930s, 1940s and 1950s? Could such personal narratives provide insight into women's subjective engagements with the main cultural representations and discourses of femininity in Ireland in the 1930s, 1940s and 1950s? Would they throw light on the meanings women attributed to work and the role work played in shaping their identities and their sense of who they were, both as workers and as women? The oral history methodology employed in this study did allow us to answer many of the questions outlined above and facilitated a very useful exploration of both the material and subjective aspects of women's working lives throughout the 1930s, 1940s and 1950s.

The focus on the working lives of women in the Munster counties of Cork, Kerry and Limerick is significant, as most existing historical accounts are based on the larger urban settings of Dublin and Belfast, to the neglect of regional and rural workplaces.[8] This focus, results in the production of a body of localised data, which can be used to facilitate regional comparative analysis by other scholars.[9] Although the study group is not designed to be a representative sample of women who worked in this period, the women who came forward for interview were reasonably diverse in terms of their age, social class, education level, geographical location, profession and length or continuity of their working careers. Analysis of census data for the period of the study confirmed that the main occupations in which women workers were concentrated were largely represented in the oral histories collected.[10] Of the forty-two women who told their stories, thirty-seven women were married, four were single and one woman was in religious life. The group studied included nurses, teachers, domestic and agricultural workers, factory workers, office workers, service sector workers and civil servants. In addition a poultry instructress, a civil engineer, a cheese-maker, a convent-based farm manager and a woman who generated a home-based income from rearing and selling farm animals were also interviewed.

Among the forty-two participants were eight women who worked mainly in the 1930s, twenty women who engaged in paid work predominantly in the 1940s and fourteen women who were in the paid labour market in the 1950s. As would be expected, of the thirty-seven married women, thirty-three resigned from work upon marriage or once pregnant. The women who married had truncated working lives of between three and twelve years service in the paid labour

market before marrying. Those women who remained single, took vows or combined marriage with employment, had long working lives of more than forty years. The married women's work histories show that more of them than might have been expected combined paid work with domestic and caring responsibilities. Only ten of the married women did not engage in any kind of paid work after marriage, whilst twenty-seven did. Of those who did engage in work, four women had continuous employment trajectories, largely unbroken by their marriages. Two of these women were teachers, one worked in a family business and another worked for farmers, in lieu of her family's accommodation on their land. The remaining twenty-three women generated earnings at some stage of their married lives.

Of the forty-two women interviewed, seven had periods of employment outside of Ireland. Six women worked in the United Kingdom and one worked in America. The nature of their engagements with these labour markets was varied. Some emigrated for nurse training opportunities, others for reasons relating to their husbands' employment and yet others for better work prospects. While these experiences of emigration and employment abroad feature in the stories gathered, they do not receive specific analysis as they are not the main focus of the study.

Our aim in the research was not only to uncover more historical details about women's work but also to do so in a way which was in accordance with feminist research principles.[11] In keeping with these principles, we took steps to redress some of the inequities which generally characterise the researcher–researched relationship and to do our utmost to ensure that it was a positive experience for the participants. Women were invited to participate in the study through a public call issued through the local media and organisations such as the Older Women's Network and the Irish Country Women's Association, in Cork, Limerick and Kerry. The only selection criteria employed were that the women had worked in one of these counties between the 1930s and the 1960s and were willing to have their stories recorded. In many instances women who expressed an interest in becoming involved in the research had to be assured that their experiences were relevant and worthy of our attention. This doubt in the value of their contribution was a recurring feature of the women's engagement in the research process.[12]

All the women who agreed to participate were interviewed in their own homes at a time of their choosing. They were given control over the duration and the pace of the interviews and were encouraged to

tell their stories in ways with which they were comfortable. Many prepared for the interview by jotting down dates, times and details of events and gathered materials relating to their working lives. Some requested or instructed us to ask them about specific events that they wished to talk about during the interview. In a few situations, the women closed the interviews themselves, suggesting that possibly enough had been discussed. We respected the wishes of participants who told us stories about aspects of their lives, past or present, which they did not wish to be used as research data. Furthermore, by returning transcripts or recordings of the interviews to all participants, we provided an opportunity for them to edit their narratives. Most availed of this opportunity but mainly to correct grammar, improve fluency or information incorrectly transcribed.[13] In a small number of instances, women asked us to delete what they perceived to be sensitive information relating to family, friends or employers and some elaborated on or clarified aspects of their stories. Furthermore, in a very small number of cases we suggested that some material might be judiciously edited. Our suggestions related to detailed personal information, sensitive comments pertaining to other people or some forms of expression which could cause offence. This was undertaken out of a duty of care to the interviewees.

The use of consent and copyright forms obliged participants to consciously consider their involvement at different stages of the project and they were advised that they were entitled to withdraw from the study at any time. Interviewees were given choices regarding the use of their stories and a small number decided not to have their interview deposited in the online archive of recorded interviews but permitted us to use the material on the condition we respected their anonymity. Three women opted for pseudonyms to protect their identities. Those women who chose to be named are identified on a first name only basis throughout this publication. After some deliberation, we made this decision in order to strike a balance between celebrating their lives and their contributions publicly while at the same time protecting their own and their family members' privacy.

Inspired by the feminist commitment to reflexivity in the research process, we interviewed the women about their experiences of being oral history participants and found that most of them viewed the telling of their story as a good experience. However, a small number of women did withdraw from the study after being interviewed and no pressure was exerted on these women to explain this decision. We

remained in contact with the women after the interviews to keep them informed about the progress of the project and we organised a multimedia exhibition, which showcased the material generated by the interviews. This exhibition, to which all the participants were invited, was designed to give them back their history, to value their contributions and to share our interpretations with them.

To elicit the empirical detail of women's experiences of work, the interviews were built around themes such as childhood and family life, schooling and vocational training, entry into employment, work practices and job descriptions. Questions pertaining to the connections between work, family, community and social life were also asked and participants' views of changes in women's lives over time were elicited. In addition to the collection of factual accounts, feminist oral history requires a probing of women's consciousness through the exploration of experiences, feelings, values and meanings.[14] We deliberately asked questions that would uncover the women's understandings of how various social forces impacted on their consciousness. The messy interplay between familial and working roles was teased out, as was the meaning that work had in women's lives. Women's emotional responses to positive and negative work experiences were at times revealed, as were their feelings about significant occurrences in their working lives. As it was our deliberate intention to use oral history in a feminist way, the focus on meaning very strongly characterises the work. The oral histories in this study were analysed in a way so that they might show how identity construction is an ongoing process and how much insight into consciousness can be lost when we do not investigate issues in the context of the interwoven experiences which occur throughout life's course.

The need to investigate silences in narratives and the significance attached to them has also been identified by oral historians.[15] Different levels of silences were evident in the narratives we collected. As interviewers, we did not set out to ask what we considered intimate questions pertaining to their personal lives; this was, after all, a study primarily focused on their working lives. For the most part the women interviewed did not raise intimate subjects such as fertility control or marital relations that might have been relevant to discussions about work and family life. Information about sensitive issues such as the failings of alcoholic or negligent husbands and the sexual exploitation of domestic servants was provided in a few instances but not always on the record. There was general acknowledgement of

the difficulties encountered by women married to mean or controlling men and the lack of support for such women, but no interviewee provided a detailed personal account of such issues.

Women rarely drew on temporal markers when telling their stories, despite the fact that the first question we most usually asked each woman was to recall her childhood years. Each woman's life story usually unfolded in a weave, rather than in a linear chronological form. At times it was only possible to establish the order of events by returning to the standardised profile forms that specifically asked each narrator to provide certain information in a structured and chronological fashion prior to the interview.

We sought to elicit from women what they perceived to be the dominant discursive constructions of women's lives that shaped women's identities and choices in the 1930s, 1940s and 1950s. The responses revealed discernible patterns: for example, the idealisation of the patriarchal family, which was hierarchically structured along gender and generation lines; prevailing understandings around what constituted appropriate work and behaviour for women, and the prioritisation of women's caring roles over their economic roles. In explaining the direction their lives took and the choices they made, many participants drew on generalised depictions of women from popular discourses. Oral histories allow for an exploration of the different engagements women have with dominant discourses and a consideration of the ways in which individual women accept, negotiate or rebel against them. We endeavoured to provide an enabling environment for women to speak outside the constraints of dominant narratives. Our attention to agency when exploring each woman's relationship with dominant discourses was central to our analysis.[16]

We actively sought individual stories of agency and resistance from the women we interviewed and we deliberately asked questions to educe the unhappy as well as the happy memories of their working lives.[17] For example, we drew out the stories of how women, as workers and mothers, sought the emotional and practical resources they needed to sustain themselves and their families. In so doing, we considered practices of resilience and resourcefulness as strategies developed and honed by women in their active engagements with their environments. In conceptualising and interpreting both agency and resistance, we made specific choices more conducive to a study of women in a society that was strongly patriarchal, class divided and

repressive in certain aspects. For instance, we aimed not only to interpret agency in terms of women's struggle against the norms, practices and institutions which oppressed them but we also recognised agency in women's adoption of norms or practices, which they knew constrained their choices.

A variety of experiences and views were gathered from the diverse group of women interviewed, highlighting the restrictiveness and the incompleteness of relying solely on dominant narratives to explain the past. The tenets of a post-structuralist analysis[18] proved useful in the exploration of the women's continued construction and reconstruction of their multiple, and sometimes contradictory, subject identities and in their negotiation of agency and autonomy in contexts of material and cultural constraints. We recognised the value of developing more sophisticated and nuanced accounts of power relations based on age, gender, class and culture with each close reading of the narratives. The emphasis placed on subjectivity in post-structuralist work alerted us to the subjectivity of memory as something valuable rather than problematic; precisely because it allows us to make inroads into what historical experiences mean for people.[19] While drawing on post-structuralist tenets to develop aspects of the analysis, we did not lose sight of social structures such as class and gender in terms of how they significantly shaped the life chances and opportunities of the women interviewed.

Just as it was evident in the narratives that the women constructed and reconstructed their views of themselves as they moved through life, while telling their stories they were also actively recomposing their pasts. For example, one interviewee, Joan N., commented that 'the memories are better than the life … 'Tis grand to turn back the clock, to turn back the clock and let everyone be happy like … and leave the last hour be the hardest'. A minority of women interviewed had pre-packaged or ready stories of their lives, which they had prepared in advance of us meeting and which they read out to us, but the usual dialogic interview always followed. Though the presentation of a pre-packaged account could suggest a firmer view of self, most of the women we interviewed seemed to use the occasion provided by the interview to 'bring the self into knowledge'[20] and were often tentative in their descriptions of themselves and their lives. This raises the important issue about the complicated relationship between past and present in the telling of a story. It has been noted that although interviewees can temporarily inhabit the past experience being recounted, most interviewees, when remembering, maintain

that conscious separation between past and present, using the benefit of hindsight to put perspective on the past.[21] This latter tendency was very apparent in the oral narratives we collected, in which there were many examples of retrospective commentary. Similarly, our own worldviews, shaped by the present which we inhabited, revealed themselves in the questions we asked and at times highlighted the age gap between us and our distance from the time period being studied.

As we shared pieces of information about our own lives, narrators gained greater knowledge about us and we are convinced that this knowledge shaped the interviews, particularly some women's selection of the stories they told. It is entirely in keeping with feminist research approaches to attend to the relationship between the researcher and the participant and to recognise the oral history interview as the product of a dialogue, a co-creation, made in the interaction between researcher and participant.[22]

As feminist oral historians, we exercised the responsibility and indeed the privilege to interpret the narratives in feminist ways for presentation to the public. The feminist frames of analysis we employed may set forth interpretations not shared by the narrators or may be perceived by them as distorting or undermining the accounts they gave during the course of the interviews. Furthermore, as our interpretations have taken precedence, our control over the finished products and our power and privilege as researchers in a university is manifest. This highlights the limitations of this feminist research project to totally equalise power relations between interviewers and interviewees. At the same time, a feminist approach requires that we attend to gendered experiences of oppression and exploitation when interpreting women's lives, while also paying due regard to women's agency and resistance.[23] To make the process of our feminist inter-pretation more transparent, we have made the narratives available in their raw form in an online archive. In this medium, the subjects of this study speak for themselves, unmediated by feminist ideology. The creation of a project website – www.ucc.ie/wisp/ohp – where there are details of publications and conference papers available to download, has meant that the end products, which emerged from our interpretive work, are more accessible to the women involved in the study than they would be if only published in academic books and journals. Furthermore, by creating the project archive we opened up the narratives to further analysis and interpretation.

Because we sought to produce rich and textured understandings

of women's working lives in Ireland, we also utilised other documentary sources. Our decision to triangulate the oral histories with secondary sources of information was not motivated by our desire to produce research that would fulfil the rules relating to validity set by positivist science, but for the reasons best explained by Turnbull. She suggested that when information from the oral history interview is triangulated 'a more complex, richer, understanding of human experiences' is the result.[24] Our use of secondary sources is designed to supplement and better contextualise the oral histories, which form the centrepiece of this book. The story we are telling is not concerned with presenting the 'facts' about women's work in this period of Irish history, rather it is a story drawn from our interpretation of the recollections of those we interviewed about their working lives. Data extracted from their accounts is presented from the first chapter onwards. Rather than being systematically reviewed, the secondary data is used to contextualise accounts provided by the women and to inform our discussion and understanding of their lives.

The book is divided into six chapters. In the next chapter our focus is on gaining a clearer understanding of how family, class, gender and geography shaped the contours of these women's working lives in the period being studied. What women said about their working-lives was recalled as part of a broader set of life experiences. Therefore, in Chapter One we locate women's working experiences in their early life stories, recognising the vital interconnections explaining women's socialisation into the world of work and their employment destinations. In the following two chapters we explore what the women had to say about working in their particular sectors of the labour market. We concentrate very specifically on women's work in factories and services in Chapter Two and on their work in small offices, in the civil service and in the professions in Chapter Three. What they told us about their experiences of the organisation and culture of very diverse Irish workplaces is the main focus of these two chapters. Women's experiences of both traditional and less traditional areas of work are revealed, as are their accounts of work in both sheltered and indeed less protected employment contexts. How social mores and gender relations permeated the various occupations are particularly illuminating. The focus on specific blue collar and white collar occupations allows us to look more closely at working conditions in the different sectors and the value women put on their own work relative to the work of other women of their generation.

In Chapter Four we explore how individual women experienced and engaged with prevailing cultural images and discourses of femininity, revealing the frameworks of understanding they drew on when constructing their identities as working wives, working mothers and single working women. A particular focus is put on women's experiences of leaving employment to become wives and mothers and their experiences of combining the roles of spouse, home-maker and paid worker. How women constructed their subjectivities as waged workers is at the heart of Chapter Five. The interconnections between their working lives, social lives and community participation are given greater consideration. This discussion leads into a more focused account of women's accommodation, agency and resistance in the context of their working experiences in Chapter Six. Their views of trade unions and their own experiences of trade union organisation and activism are elucidated. In addition, we take account of the women's engagement in practices of conformity and compliance as well as in their collective and individual struggles designed to improve their working and personal lives. An additional spin off of this chapter is the insight it provides into the character of employers, managers and work environments during the time period being investigated as recalled by the women interviewed. We hope that the analysis of the oral histories collected and presented as chapters in this book provides significant understanding into the nature of the work women were involved in, the role it played at different stages of their lives and the meanings they ascribed to it in the context of evolving social, economic and political conditions.

Aspirations and Realities:
Childhood and Entry into Work

The forty-two women whose stories inform this book were born between 1912 and 1942 and entered the workplace between 1934 and 1958. As Table 1.1 indicates, nineteen of the women finished their education around the school-leaving age of fourteen.[1] Nine of these women completed the Primary Certificate Examination, which was introduced in 1929 but not made compulsory until 1943.[2] The nineteen women who began their working lives between the ages of thirteen and fifteen were typical of many young Irish people. In 1953 80 per cent of Irish children were leaving school at the age of fourteen.[3] A further six of the women who participated in our research completed either a Group or Intermediate Certificate examination, while five more gained either a Leaving or Matriculation Certificate.[4] Again, these exam completions were not unusual, for although educational participation for the age group between fourteen and sixteen rose continuously during the period covered by this study, increasing from 38 per cent in 1929 to 42 per cent in 1944, just over half (51 per cent) of all young people in this age group were in full-time education in 1962 and in 1957 only 10,000 students sat the Leaving Certificate.[5] Another nine of the forty-two women we interviewed progressed to post-Leaving Certificate professional training, three qualified as nurses and three as national school teachers, while the remaining three women trained in the respective professions of secondary school teaching, civil engineering and poultry instructing. Three women in the study completed apprenticeships in cheese-making, dressmaking and drapery. Quite a few women also undertook commercial courses, which entailed the study of typing, book-keeping and, in some cases, shorthand. These courses were for the most part provided in private colleges or occasionally in local vocational schools, sometimes as night classes.

TABLE 1.1: EDUCATIONAL PROFILE OF RESEARCH PARTICIPANTS.

Highest Level of Education Undertaken/Achieved	Number of Sample per Category (N=42)	Type and Number of Professional Qualifications/ Apprenticeships Achieved (Where Applicable)	
School attendance until compulsory leaving age of 14	19	N/A	
Completion of Group or Intermediate Certificate	6	N/A	
Completion of Leaving Certificate or Matriculation	5	N/A	
Completion of Post-Leaving/ Matriculation Professional Qualification or Degree	9	National School Teacher	(3)
		Secondary School Teacher	(1)
		Nurse	(3)
		Poultry Instructress	(1)
		Civil Engineer	(1)
Completion of Apprenticeship	3	Dressmaker	(1)
		Cheese-maker	(1)
		Drapery Assistant	(1)

In this chapter we chart the women's childhood and educational experiences and their progression into employment. Particular attention is paid to how they decided when to begin work and what type of work to look for. This chapter also explores how structural factors, such as class, geographical location, place in family and the prevailing economic and political climate, impacted on the work aspirations and practices of the individual women and shaped the realities of their engagement with paid employment. Finally, the ways in which the women constructed and made sense of their identities as prospective or new workers is investigated against the backdrop of prevailing political, religious and social discourses of female roles.

IDEOLOGICAL AND MATERIAL CONTEXTS

Previous historical research has indicated that young women's ambitions and understandings in relation to employment were shaped by the combined forces of home, school, church and community and were 'gendered' well in advance of their actual involvement in paid work.[6] The stories we collected also reveal that, for most women, expectations and ambitions about employment were forged during childhood, and were fashioned in accordance

with class, gender and cultural expectations. A key factor which emerged in the life stories of the women was the central role family relationships and associated familial norms and obligations played in shaping both their experiences and identities as workers. Historian Joe Lee asserts that the vision of Irish society articulated by de Valera in the early 1940s promoted a model of intergenerational solidarity, where care for the young and old was seen as the responsibility of those of working age.[7] It cannot be assumed, however, that the vision and values articulated in political rhetoric were actually reflected in daily social life.[8] Memories such as those collected from the women whose stories inform this book are invaluable in providing insight into the norms that underpinned social and family life. The accounts provided by the women indicate that a strong familial ideology, similar to that aspired to by De Valera, did indeed permeate the society in which they grew up. This ideology – characterised by subordination of personal desire for the good of the wider family, acceptance of parental direction and assumption of familial care-taking roles – provided a shared normative context within which women made, or indeed, accepted decisions about their employment. Furthermore, women's responsibilities for care extended beyond the immediate nuclear family, with the women interviewed identifying situations where they provided care for the families of sisters, cousins, friends and even neighbours.

The women's stories yield insights into how their childhood experiences predisposed them to assume responsibilities toward the welfare of their families from an early age. The poor health of many mothers resulted in older female siblings being assigned responsibility for the care of younger siblings. Caitlín, who was born in 1912, was keenly aware from an early age that she had a role to play in contributing to the welfare of her family. As the eldest of eight children, with a mother who worked full-time as a teacher and a father who had 'a fair share of idleness' in his work as a carpenter, Caitlín undertook childcare and domestic work at home, before leaving at the age of fourteen for preparatory college.[9] Despite being very lonely in the preparatory college, she was conscious of the potential contribution she could make to the family as a teacher: 'I knew well that I had to put my shoulder to the wheel'. The women's stories clearly indicate that many girls were expected to contribute to the care and daily maintenance of the family home and also highlight the young age by which they had internalised an understanding of what was expected of them. Joan N., one of a family of twelve

children, was the daughter of a farm labourer. Work was a constant feature of her life, even before she left school in the late 1930s at the age of fourteen. Like Caitlín she noted with resignation and indeed without any form of resentment that 'we had to obey the parents'. Joan's experiences of engagement in physical labour as a child were reflected in the accounts of many women, particularly those from working class and farming families. Sr. Paul, born in 1921, remembered the contribution she and her five sisters made to farm chores such as milking, feeding calves and saving hay. Similarly, Joan D., who grew up near Killarney in Co. Kerry, recalled being taken to a bog along with her siblings in the late 1930s and being given an allocation of turf to foot before her father returned.

Young working-class women from urban backgrounds also undertook a range of domestic and external chores, including the gathering of sticks and other materials that could serve as fuel – a particularly common task during the war years when rationing made coal more unattainable. The involvement of some urban, working-class mothers in part-time employment outside of the home often obliged their daughters to undertake unsupervised domestic work. Kathleen O'R., who was born in a suburb of Cork City in 1938, acknowledged that when considered from the perspective of contemporary fears about childhood, the responsibilities she had as a child were both arduous and dangerous

> My mother would be late home from work … After coming back from school we might light the fire and I'd have to get the dinner on for my father and everything. And sure we were very young that time. I must have been only about twelve … We were kind of capable of doing things at a very young age because we had to do them, you know? I remember getting my father's dinner and things like that, and pots and pans and lighting fires. God, how we never set fire to ourselves like, because I'm sure we used to use paraffin oil and everything with the fire to try and light it.

The accounts of childhood provided by the women clearly indicate that expectations of children in relation to work in the home were highly gendered, with boys rarely being required to contribute to chores within the house.[10] Many women recalled the higher status accorded to boys within the family and the rigid division of labour that prevailed. Elizabeth, who was born in the mid-1920s to a middle-class family, noted

> In our house, it was nearly a question of getting up and let your brother sit down. The boys were so spoilt. Never cleaned their shoes, never did anything like that, you know … there were maids in the house but the girls were sent down to the kitchen to learn how to scrub.

For some of the women in our research familial expectations required not just participation in household chores but the leaving of school to undertake full-time domestic and care work within the family. For some of these women the transition from school to family work was fragmentary, characterised by periods of absence from school to supplement the work of a sick mother or to provide an extra pair of hands during busy times of the farming year. Bridie left school permanently in the early 1940s at the age of fourteen after a period of uneven attendance caused by her mother's frequent hospitalisation. As a surrogate mother to her eight younger siblings, Bridie assumed 'a lot of responsibility'. She explained her accept-ance of the caring role in the context of prevailing practice: 'When I was asked to stay at home, I did it. That was the custom that time I suppose'. In the absence of formalised systems of public welfare and support or commercial care enterprises, young women were relied on as free source of care labour.[11] Kathleen F. left school in Cork City in 1938 at the age of thirteen, when her widowed father remarried and her stepmother had a baby. Her stepmother worked in a local bacon factory and Kathleen assumed responsibility for the baby and the family home. The practice of children under the age of fourteen remaining at home to undertake work was not unusual, despite the requirement of compulsory school attendance between the ages of six and fourteen.[12] Furthermore, it was a practice that appeared to traverse class boundaries. Sr. Paul, whose father kept thirty-six cows and also farmed pigs and grew crops while her mother made butter and kept poultry, highlighted the volume of work involved in keeping the farm running in the mid-1930s. Despite the relative wealth of the family and the employment of a farm labourer and a female domestic worker, Paul's elder sister 'never got secondary education because she was needed at home'.[13]

The stories we collected consistently indicate that parental decision-making regarding the education of daughters was most significantly influenced by the economic and social status of the family, with the school having limited influence.[14] Mary G., an only child born in 1924 to professional parents (her mother a teacher and her father an

accountant) was primed from an early age for a career in teaching and her education trajectory was plotted accordingly. She was sent to the Gaeltacht as a child to improve her proficiency in Irish and following primary school she attended a boarding school with a strong academic record. In contrast, other women were conscious of both the limited interest their parents had in their education and their inability to pay for schooling. Kathleen F., who left school in 1938 at the age of thirteen, noted that her father 'couldn't care less' about education and that her stepmother had 'no interest' in it either.[15] However, the nuns in the local convent where she had completed a year of secondary education encouraged Kathleen to continue with her studies: 'Well they did advise you to go on, yes definitely but I mean it was up to the parents then like. That time you didn't have much say in it'. Maureen, who left school in 1934 at the age of sixteen-and-a-half to take an office job, also commented on the lack of parental encouragement for education. She expressed regret that she could not stay in education and noted that as a child she had been a voracious reader who had 'the makings of being very bright, you know if I got half a chance'. This chance was not possible because 'the money was needed at home and that was that'. Some women were cognisant of the divergent aspirations teachers and parents had in relation to education, with the former usually being more encouraging of women continuing with their studies. Receipt of encouragement from nuns to aspire to certain careers, in particular teaching and religious life, was identified by a number of women while others highlighted their gratitude for the extra tuition some teachers provided to prepare students for specific exams. Clare took a civil service exam at the age of sixteen, having been tutored by the teacher from her primary school who 'was very helpful, even taking me to her own home and loaning me her own children's books when my mother couldn't afford them'. The cost of second level education was a significant barrier for many women. The Vocational Education Act of 1930 established a nationwide system of vocational schools, which were significantly less expensive than secondary schools and provided a more technical, skills-based curriculum. However, the vocational curriculum was highly gendered and prioritised domestic and commercial subjects for girls.[16] This curriculum reflected widely held cultural belief that women's primary destiny was marriage and motherhood, and this belief continued to influence parental views regarding the value of

education for girls. Humphreys' study of family life in 1950s Dublin revealed that among families from the labouring class second level education was rare, with females receiving notably less of the limited educational opportunities provided.[17]

Similar accounts of the prioritisation of male education were provided by a number of working-class women we interviewed. Maura D., who left school in the mid-1930s, was keenly aware of the prioritisation of male education in her family: 'The boy in the family must be educated because he was going to be the breadwinner and ... I left school at twelve'. There were, however, exceptions to this experience and Mary O'S., who grew up with six siblings on what she described as 'an average' farm on the outskirts of Cork City, was conscious of the 'great struggle for people [at] that time to send their family to school'. Her parents ensured that she and her siblings remained in education up to Intermediate Certificate level. Mary, who did her Intermediate Certificate in the late 1940s, believed, however, that her parents' interest in educating their daughters was uncommon: 'A lot of people didn't send their daughters. They sent their sons. My father, both my parents, being of different thinking, they did the best for all of us, you know'. Stories provided by women who left school in the 1950s suggest that, even then, keeping children and particularly daughters in school beyond the permitted school-leaving age was not a priority or perhaps even a possibility for many working-class families. As a working-class adolescent in the North side of Cork City in the 1950s, Margaret was aware of a continued reluctance toward the education of women, while Mary F., who left school in rural Limerick in 1953, reported a similar awareness of the limited value placed on education by her working-class family and peers, 'there wasn't really any great ... onus on going to school, you know'.

Changing financial circumstances within families resulted in siblings receiving different educational opportunities. The death of Clare's father in the late 1930s, when she was only nine, had profound consequences for her educational prospects: 'My oldest sister was in secondary school when my father died, but in those days there was no free secondary education. The other three of us that came after her didn't have that chance'. Similarly Joan D., who completed her Leaving Certificate in the early 1940s, noted that of a family of five, only herself and one of her brothers completed second level education. Joan, whose father had steady employment as a foreman in a local factory, highlighted that staying on to

complete the second level was unusual and that most of her primary school classmates would not have done so. Birth position in the family also proved significant in relation to parental expectations about education and employment and indeed, parental ability to provide opportunities in this regard. Being the youngest child in the family of a skilled worker meant that Doireann, unlike her older siblings, was given the option of studying for her Leaving Certificate, while for Eileen C., the youngest child of successful grocers, it meant less parental pressure to pursue further training. Other research has suggested that families from artisan, small shopkeeper, clerical, managerial and prosperous farming backgrounds saw second level education for girls as a means of improving marriage prospects and of ensuring a secure income for those who did not marry.[18] Our findings certainly indicate that the more prosperous the woman's family of origin, the greater the aspirations her parents had for her in relation to education and employment. Elizabeth, who was born in the mid-1920s and whose father was a relatively successful businessman, was keenly aware of the expectation that she would complete secondary school: 'you just went to school, and you did your exams and you got them'. It is important to acknowledge that remaining in education was not always the preferred option of young women, even if this opportunity was available to them. Maura C., who was an only child from what she described as a 'comfortable' family refused to continue in education after completing her Matriculation examination in the early 1940s. She agreed to do a commercial course, which satisfied her parents as it provided her with the skills to enter the respectable sphere of secretarial and clerical work. Ena, also an only child of a middle-class family in Cork City, left school after her Intermediate Certificate in the late 1940s despite her parents' wish that she would continue and her own observation that, 'in general the people that I knew anyway, would all have kind of continued on'. Ena was conscious that in this regard she was 'a bit of a disappointment' to her parents, who had wished for her to become a teacher and only allowed her to leave school on the condition she undertook a commercial course. For those who did complete second level education, continuing on to university was uncommon.[19] Of the seven girls in Catherine W.'s Leaving Certificate class in 1945 only three went to university. The limited participation of women in university impacted on Mary G.'s experience as a student in UCD in the 1930s. Mary, who graduated

in 1939 with a BA and a Higher Diploma in Education, was the only woman in her first year history class, which consisted of 'mostly clerics, Jesuits and Christian Brothers'.

State-funded scholarships provided the opportunity for educational and career advancement for a minority of young women. Three of the forty-two women involved in our study received scholarships which provided them with the opportunity to secure a professional qualification. A County Council Scholarship, which Dympna won after completing her Primary Certificate in the mid-1940s allowed her to complete her Leaving Certificate and she subsequently qualified as a national school teacher in Mary Immaculate Training College in Limerick. Eileen D. and Mary T. secured Committee of Agriculture Scholarships in the 1930s and 1940s respectively, which allowed them to train in domestic economy in rural agricultural colleges.[20] Both subsequently acquired further training, with Eileen qualifying as a butter-maker and cheese-maker while Mary qualified as a poultry instructress.

For some working-class women participation in the educational system were alienating and discriminatory. Many recalled the class hierarchies that shaped their school lives. Chris described the nuns who ran the school she attended in Cork City in the 1930s as 'awful snobs', while Rena, who began her education in the mid-1940s, recalled that the nuns focused their attentions on pupils from wealthier backgrounds and on those who were particularly bright.[21] This differential treatment of students was mirrored in the spatial arrangement of the schoolroom with all the favoured pupils being 'pushed to the front of class' while everyone else was 'pushed down the back'. She also felt that these class divisions were perpetuated by the students themselves, and noted that the wealthier students whom she described as 'the grandees' shunned the 'ordinary working person'. The harsh regime of physical punishment which prevailed in some schools, combined with the limited encouragement given to pupils deemed less academically able, compounded the alienation felt by some women in the education system of the 1940s and 1950s. Doireann, who left school after her Intermediate Certificate in 1954, noted that she 'found school hard. I found learning hard' and believed that, 'with a bit more encouragement like they're getting now I would have made it [Leaving Certificate], you know'. She also expressed her resentment at the spatial division of the class into two distinct groups, on the basis of who had 'the brains'. Joan D., who

completed her Leaving Certificate in Kerry in the early 1940s, described the nuns in her school as 'very hard' and recalled that the pupils were 'abused right, left and centre, really and truly. Slaps and all the rest of it and the belt'.

CAREER ASPIRATIONS AND OPPORTUNITIES

The socio-economic context within which our cohort of women reached adolescence was characterised by economic stagnation and widespread unemployment and emigration.[22] Unsurprisingly the economic depression which prevailed between the 1920s and 1960s, was invoked by most of the women as a key explanatory paradigm in their accounts of their aspirations and decision-making around employment. Noreen, who grew up in south Kerry and qualified as a nurse in 1939, observed in relation to her contemporaries, that 'all they were anxious for was to earn a living and feed themselves ... it was tough going for people'. Kathleen F., who began factory work in Cork City in the same year, emphasised that she was grateful to have a job and observed that she thought little about what work she might like: 'I just didn't think about it ... going to work, get a job and that was it. The first job that came along, I suppose'.

Over ten years later in 1950, Mary O'S. completed a secretarial course and secured an office job. She emphasised, however, that most women still had limited career aspirations at that time: 'we didn't think enough about what we were doing that time. It was sort of automatic, you did, you know, secretarial course and you just went on'. Similarly, Rena, who left school in 1954 and worked in various factories until she married in 1962, noted how the combined impact of class and the poor economic climate curtailed employment aspirations for working-class women: 'In those years then it all was either the rich and then all the working-class ... most factory workers now, manual workers, their children ... it was a case of go to work ... it was just a matter of fact that we had to go out and work ... I mean jobs weren't there that time'. It is noteworthy that women from higher socio-economic backgrounds, who had superior educational opportunities, also constructed their career aspirations in relation to prevailing economic circumstances. Eileen C., who completed her Leaving Certificate in the mid-1930s, noted that 'the jobs weren't there that time', and recalled that she had no career ambitions other than to 'get a job and get married'. Chris, born in

Cork City in 1918, the third of nine children, also had the opportunity to gain her Leaving Certificate after which she did a commercial course. Despite these qualifications her career expectations were tempered by her perceptions of employment opportunities: 'The '30s, '40s and '50s were kind of bleak years ... you couldn't be too ambitious because the openings weren't really there ... I mean it was a relief in the first place to have a job'. Notwithstanding the shared recognition of limited employment opportunities, some women did express preferences for particular types of work but in the main the work they desired was consistent with their class and gender positions.

Mary G., who qualified as a secondary school teacher in 1939, highlighted how the occupational history of her family shaped her career: 'I took it for granted I'd teach! ... My mother was a teacher, primary teacher. My mother came from a teaching family ... there were six primary teachers in the family ... I had three uncles, three aunts, teaching. Two grandfathers. So, you know, I suppose I never decided on doing any other job'. Family background was equally significant in Kathleen O'R.'s explanation of how she became a factory worker in Cork City in 1953, when she was fourteen years old. She expressed a fatalistic acceptance of the employment opportunities open to her and her class contemporaries: 'everyone was in the same boat that time. There was no-one with big jobs. You were all kind of factory workers and that was that'. Indeed the women rarely identified career aspirations which challenged prevailing class and gender divides. Women from prosperous farming, business or professional families considered occupations such as teaching, nursing and office work as possible areas of employment while their working-class contemporaries aspired to skill-based occupations such as dressmaking, hairdressing and cooking, which often involved an apprenticeship.[23] For many however, the cost of an apprenticeship was prohibitive and the need to make an imme-diate contribution to family finances led them to take whatever unskilled employment was available. Joan N., who was born in Co. Limerick in 1923 and left school at the age of fourteen, recalled her lifelong desire to work as a cook in a hotel: 'I'd have loved to have gone into a hotel. Always and ever, oh, that was my ambition'. She explained, however, that being the child of a labourer and having eleven siblings, it was never an option for her, noting with resignation that there was no good 'looking in over another man's ditch' when

you had 'nothing'. Mary F., another Limerick woman born fifteen years later in 1938, expressed regret for her unfulfilled ambition to become a hairdresser. Her working-class parents, who had a family of eight, could not pay for a hairdressing apprenticeship and were anxious that she should secure employment as soon as possible.[24]

In the 1930s, 1940s and 1950s the range of occupations open to and considered suitable for women was quite limited.[25] Security of employment, compatibility with perceived feminine qualities such as caring and nurturance, and moral respectability in terms of the people and conditions to which one might be exposed, were defining factors in perceptions of what constituted a good job. In their assessment of the suitability of a job, individual women applied these criteria from the perspective of their unique class, educational, community and family backgrounds. The traditional 'girls' jobs' consistently identified by women were secretarial or office work, civil service positions, nursing, teaching, shop work and waitressing. Occupations relating to agriculture such as butter- or cheese-making featured in the potential occupational options identified by some women from rural backgrounds, whereas more commercial options such as training as a drapery assistant featured in the accounts of women who were based in a city.

Young women, from both urban and rural backgrounds, who were educated to Intermediate Certificate level, coveted posts in the Civil Service, as did their male counterparts.[26] Chris, who completed her Leaving Certificate in Cork City in the mid-1930s, recalled that despite the low pay associated with some grades, 'the favoured job … if you didn't want to work in an office would be the Civil Service … I was hoping that I would get a job in the Civil Service. When I didn't I did a commercial course'. Over a decade and a half later, the appeal of Civil Service posts for young women was still strong. In 1951 Joan G. declined the opportunity to train as a nurse and took a clerical post with Kerry County Council. She was very conscious of the value of job security and noted that her parents' aspiration had always been for her 'to get a permanent pensionable job. That was the way to live that time'.

Even without the job security offered by the Civil Service, a clerical or secretarial post was perceived to be highly respectable and conferred a certain status on the holder. As a sphere of work which was closely supervised, did not involve mixing with a large numbers of other employees and had good working conditions and regular

hours, office work met the demands of respectability and was acceptable to parents who were concerned for the moral and physical well-being of their daughters. Pauline, who stayed on in school until the age of seventeen and then completed a commercial course, had no 'serious ambitions' with regard to employment preference but was conscious that factory work would be unacceptable to her mother and hence she took a secretarial job in 1941. Other female-dominated spheres of employment associated with care and nurturance, such as nursing and teaching, were widely regarded as suitable for young women. However, despite its association with caring and its predominantly female membership, nursing was a profession about which some parents had reservations. Elizabeth recalled her mother's shock at her decision in the mid-1940s to become a nurse and believed that this was informed by her mother's correct perception of nursing as hard and difficult work.

The social or cultural status attached to certain types of work also proved influential in women's assessment of the suitability or desirability of particular jobs. Work was a key signifier of social status and Joan G. was very conscious of the status differentials that accompanied different jobs in early 1950s when she began work; 'in the jobs there was a kind of distinction'. She recalled hearing the comment, 'she only worked in the sausage house' at a dance made with reference to a woman who worked in Denny's bacon factory in Tralee.

The stories suggest that notwithstanding the limited employment opportunities they had, women made very conscious assessments about the relative merits of various jobs. In making these assessments, the occupations of women from their own class group were taken as the unit of comparison and decisions to take certain jobs were primarily determined by the pay, work conditions and status associated with the job.[27] Kathleen F., who began working in the Sunbeam factory in Cork in 1939 when she was fifteen, was mindful of the superiority of her working conditions relative to those of other factory workers: 'we had a doctor and a nurse and a dentist … that you could go down to anytime, which was the first in Ireland I think to have one'. A pragmatic assessment of pressing as 'a kind of a trade' influenced Alice's decision to leave a dressmaking apprenticeship and take a job in a dry cleaning company in 1955. In Alice's view, this made the heavy and uncomfortable work conditions associated with the job more acceptable.

The occupation most consistently identified with low status and poor pay and work conditions was domestic work, which was one of the key areas of employment for women during the 1930s, 1940s and 1950s.[28] Rita, who worked as a live-in domestic servant throughout the early 1940s was acutely aware of her lowly status: 'They'd have no respect for you. That's true for people who did housework.' The narratives of other women also provided evidence of the low status attributed to domestic service. Caitlín, a national school teacher, recalled an acquaintance of hers being threatened that if she failed her exams she could 'go out and be a servant girl'.

The highly gendered division of occupations further limited the employment opportunities open to women. Muriel, who was born in 1928, developed a great interest in woodwork as her father was a foreman of works at a large institution in Cork City and she would spend many happy hours in his workplace as a child. She recalled, however, that she never considered it a viable career option because 'in those days, women didn't do that type of work'. However, twenty years later, in the late 1940s, Catherine W. did pursue a non-traditional career choice when she undertook a degree in Civil Engineering at UCC. Catherine's father always aspired for her to become an engineer and her parents argued throughout her childhood about the suitability of engineering as an occupation for a woman. Catherine perceived her mother's opposition to engineering to be based on assumptions about the moral unsuitability of the work: 'looking back now she probably looked at it on a par with prostitution ... To be with men, you know'. Her story was the exception to the largely gender-bound employment in which women participated.

Notwithstanding the limited nature of the work options available to them, women often made job decisions based on subjective assessments of their skills and aptitudes. Despite positive accounts of her progress as a trainee nurse, Rose decided herself that a career in nursing was not for her. After doing a typing course, she decided that 'she wasn't interested in pounding a typewriter' and that office work would make her restless. Rose settled on factory work, despite being very conscious that it was of much lower status than office work and that it was not what her guardian considered appropriate for her.

SECURING JOBS AND BECOMING WORKERS

The stories provided by the women suggest that while jobs were secured through a range of strategies, the practice of accessing jobs through family, neighbourhood and friendship networks was common in both urban and rural contexts and transcended class and occupational boundaries. Ties of kinship and affinity facilitated recruitment through the provision of information about vacancies and frequently an established worker who had a good relationship with a superior would 'put in a word' for someone they knew. Larger places of employment, such as factories, hospitals and big shops, were frequently staffed by members of the same family.[29] Rena got a job in the Lee boot factory in Cork in the mid-1950s because her mother and other siblings were already employed there. Jobs in the public sector were not immune from such family influence. Caitlín secured her first job as a substitute teacher in 1934 because her mother, who was also a teacher, knew the husband of a teacher going on maternity leave. Chris recalled that her friend secured a job as a telephonist in the 1930s through her father, who worked in the GPO. In the 1950s Mary F. secured a domestic post in a Limerick hospital when her sister left to marry: 'You put in your name, that's all you did, for a vacancy when it came up ... 'twas automatically given to me then like'.

Community networks, in both urban and rural contexts, also provided key sources of information about local job opportunities. Alice sourced her first job as a dressmaking apprentice in Cork City in 1953 through a conversation she overheard in her local shop, while her second job in a dry cleaning company was offered to her by the man who collected insurance from her mother. The influence of community networks transcended local geographical boundaries. Noreen, who worked in her husband's family drapery business in Kerry after her marriage in 1944, explained how she and her husband were used as a resource by local people seeking to access employment opportunities for their children: 'And you see you'd have contacts with people and you could always get something for them'. Noreen's brother, who worked with the ESB in Dublin, was a useful connection in this regard.

Local politicians were another source of assistance in acquiring employment in the public sector. Mary T. secured her first temporary job as a Poultry Instructress in 1945 through direct canvassing of members of Limerick County Committee of Agriculture,[30] while Joan

D. acquired a job as a nurse in the Irish Army in 1953 with the assistance of a local TD: 'You just applied and if the truth be told, you were pulled in by a TD. That's how you got it'.

Community networks also impacted on young women's decisions about migration and emigration. Noreen and her friend decided to apply for nurse training in the Richmond Hospital in Dublin in 1939 because they knew of a girl from Waterville who had trained there. Joan D. and her sister chose to train in Whipps Cross in London because they had a friend there and it was a common destination for Irish trainees.[31]

The women's accounts suggest that newspaper advertisements were used less frequently as a source of information about employment opportunities. However, a number of women from rural areas secured positions in towns or cities by this means. Women seeking work in England also noted that they availed of advertisements in newspapers and periodicals and used employment agencies. The use of family or community networks to source employment meant that in many cases young women's transitions to employment were mediated by existing relationships, which potentially provided both support and surveillance for the young employee, something which was valued by parents. Employment secured outside kinship or communal networks was sometimes viewed suspiciously or rejected outright. Upon graduating with a degree in engineering in 1949, Catherine W. replied to an advertisement in an English engineering journal and secured a post in a concrete factory in England. She didn't take the, job, however because when her father heard about it he 'exploded' and subsequently used a work contact to find her a job as a site engineer with a local Cork company.

Despite being wage earners and holding down full-time jobs, many workers were still very young and were subject to close supervision by both parents and employers.[32] For young women such as Joan N., who took a live-in domestic post at the age of fifteen, employers acted in loco parentis. Similarly, in hospitals and other residential training settings, young workers, students and trainees were subjected to continuous surveillance. Mary F., who at the age of fifteen, began working as a live-in wardsmaid in a hospital in Foynes, found that the night nurse on duty closely monitored the time at which she returned from dances. Returning back to the hospital later than the other revellers would result in a report being made to the Matron and the possibility of a ban on dance attendance

in the following week. Mary's duties were also monitored to ensure that they were age appropriate and she was not allowed to work on the male ward until she was older, as the Matron considered it an unsuitable place for a fifteen-year-old girl. Sheila, who began a dressmaking apprenticeship in the 1940s at the age of fifteen, recalled the kindness of her older colleagues and suggested that young women, despite their employee status, were frequently treated as children by employers and older colleagues.

The experiences recounted by women who began employment at a young age suggest that for some time their status as children and employees overlapped and that it took a while for them to assume a stronger worker identity. Kathleen F., who began work as a sweeper in a factory in 1939 when she was fifteen, remembered her lack of focus on what her employment status actually meant. She noted that she 'hadn't a tack of mind for work' and that she found her first days 'terrible frightening' but after seeing 'one or two [people] that were familiar' she settled in. The restrictive and regulatory atmosphere of the workplace was keenly felt by Kathleen, who resented 'being confined all day ... and you had to conform out there like. You had to obey things'. Mary F., who also started work at fifteen, remembered that during the first 'horrendous' days in her job as a wardsmaid, she doubted her ability to continue. However, after a while she adjusted to the lack of freedom occasioned by long days and a busy routine and identified the establishment of friend-ships with her colleagues as the key factor in her settling into the job. For Maureen, who began working in the office of Roche's Stores in 1934 when she was sixteen, it was not the work, but the fact of being obliged to interact with male colleagues which marked the transition from childhood to employment in a very stark way. Maureen, who had been allowed no contact with boys, found herself 'covered in confusion' and 'one blush from nine in the morning 'til six in the evening', despite finding that the men she dealt with were 'never anything but respectful'.

Some women from more privileged backgrounds, who enjoyed more extended periods of secondary education and entered the workplace in their late teens or early twenties, also experienced the transition to employment as challenging. Noreen from Valentia Island described with feeling the sense of confinement she felt in the 'airless wards' of the Dublin hospital where she began nurse training in 1939. The strict regime, which governed the work practices of

probationer nurses made life less than enjoyable but she persevered. In explaining this perseverance she noted that she came from a family which was 'Spartan' and had instilled in her a belief that 'I've started the thing so I must finish it'.

Noreen's account highlights yet again the significance of childhood familial socialisation in shaping young women's subjectivities as workers. Furthermore, her account of her early experiences of nurse training reveals that, for her, the transition to adulthood was marked by the development of a less naïve and more cynical worldview and a consequent development of her own ability to assert her rights. In contrast, Muriel, who began employment in the office of friends of her father when she was seventeen, found the transition to work to be a positive experience as her employers were 'very thoughtful. Everything would be done for my comfort'.

Another change, which the transition to employment brought for many women, was the emergent awareness of their role as economic actors and in many cases financial contributors to their families. Caitlín, who began her teaching career in 1934, noted that the sense of independence she gained from employment was closely entwined with the ability it gave her to help her parents financially. Chris also appreciated the sense of financial power which employment gave her, despite having to give most of her wages to her mother. For Mary T., employment meant that she gained a certain social status, as she needed a car for her work as a poultry instructress and at that time only the teacher, the doctor and herself had a car in the village where she grew up.

For others, assuming work was significant in its conferral of opportunities to take on the trappings of adult femininity. Ena's desire to take a summer job in 1949 at the age of sixteen was motivated by her wish to move on from her childhood, schoolgirl status. Clothes were employed as a metaphor for this transition to adulthood and she recalled her aspiration 'to be very grown-up looking' and to have 'heels on my shoes'.

CONCLUSION

Class and gender proved the most significant factors in understanding the relationship between history and biography as revealed in the women's accounts of childhood and their transitions to employment in the Ireland of the 1930s, 1940s and 1950s. The

dismal state of the Irish economy, the material resources of individual households, the strict division of labour both in the home and work-place, the harsh reality of class divisions, and the culture of deference to parental and other authority structures, all featured in women's explanations of their employment aspirations. They fit with Connolly's claim that the gender regime of the Irish State in the 1950s was characterised by a 'strong emphasis on gender difference; the hierarchical ranking of male and female; a clear division between the public sphere and the private/domestic sphere; and the subju-gation of individual rights within the family'.[33] The dominance of a familial as distinct from an individualistic ideology was a continuous theme in the women's accounts, and, as we shall see in future chapters, tensions did sometimes arise as women strived to reconcile family obligations with personal desires.[34]

While it was clear that economic hardship rendered the pursuit of individual desires less important than the overall survival of the family entity,[35] it was also evident that the work aspirations and activities of young Irish women in the 1930s, 1940s and 1950s could not be understood solely by reference to economics; the micro-politics of the family, and the agency of individual women, limited though it may have been, were also significant. The women's accounts highlighted the significance of childhood experience and of their place and position in the family, for shaping their opportunities, values and identities as future workers.[36] Furthermore, their stories underlined the power differentials between individual members of households, differentials which were frequently gendered, reflective of legal and cultural sanctions which limited many young women's opportunities and resources to make decisions about work. The gendered exchanges of labour and money within families, which were revealed in the narratives, support the call made by feminist critics to avoid family histories which reflect an unquestioning conflation of the various interests within households.[37]

Attention to age is also highly significant in considering the character displayed by the women interviewed and it provides a vital context for understanding issues around agency and decision-making in relation to work. Almost half of the women we interviewed were in the workplace by the age of fifteen. Against a cultural backdrop where defiance of parental wishes was unusual, it is unsurprising to find that parents played a key role in choice of occupation for their daughters and that their daughters were largely accepting of

these decisions. Analysis of the women's transitions to work high-lights the blurred and permeable nature of the boundaries between worker and child roles and underlines the significance of social class in shaping the duration and the nature of childhood. Women who began work at an early age inhabited a position between childhood and adulthood, and it is important to keep this in mind when considering the women's accounts of their work conditions and experiences in the following chapters.

CHAPTER TWO

Factory and Service Sector Workers

This chapter and the next address a core aim of the book, which is to provide a detailed account of the women's experiences of particular sectors of employment between 1930 and 1960. Drawing on the oral histories of the forty-two women involved in the research, these two chapters explore the women's impressions of their working conditions and of the work cultures and environments which characterised their workplaces. In the interests of clarity and to facilitate comparison, a sectoral approach informs the content of the two chapters. The focus in this chapter is on women who worked in factories and in the general services sector, including women who were engaged in domestic and agricultural work as well as retail and catering. Of the forty-two women interviewed, those who worked predominantly in the services and factory sector were drawn from a cohort of young working-class girls with limited educational opportunities.[1] The experiences of the three women in the study who began dressmaking apprenticeships are considered alongside those of service sector workers as their educational backgrounds were similar. Women's experiences of clerical jobs, office work and professional occupations are considered in Chapter Three.

FACTORY WORK

In 1951, 35 per cent of women in employment were located in the manufacturing sector, a proportion which had grown from approximately 33 per cent in 1936 and just over 25 per cent in 1926.[2] We interviewed nine women who had experience of factory work and their stories indicate that factory workers generally negotiated their employment through localised family and community affiliations.[3] Urban working-class communities had reservoirs of knowledge about the conditions that prevailed in various factories and the opportunities for employment they presented. Rose, who began a twenty-four year career in factory work in 1950, described how

parents and siblings often worked in the same factories. Rena, who secured a job in the Lee boot factory in 1956, was a member of such a family. She left school at fourteen to work alongside her mother and sisters. Joan F.'s father worked in the Dunlop factory in Blackrock in Cork, as did two of her sisters and her brother.[4] Her father wanted her to work there also but she was only too familiar with her older sister's complaints of the physical demands of her job. Instead, she took up a job in the Irish Optical Company in the 1940s, having been recommended by her brother's girlfriend, who also worked there. The Dunlop factory also loomed large in Kathleen O'R.'s memory, because she grew up in Blackrock and from a young age she witnessed the droves of bicycles going down the Marina towards the factory. She had a clear recollection of the familial networks that were used to enter into factory work. However, when Kathleen left school in 1953 at the age of fourteen, she made a conscious decision not to go into the Dunlop rubber factory because although it paid well, she believed that work in the Goodwear factory was less physically demanding and more suited to women. In Rena's estimation, Sunbeam, Ford and Dunlop were 'all considered good factories' in Cork City[5] while the Lee boot factory[6] or the Hanover Company's shoe factory[7] were not accorded the same status. Rena had experience of working in both the Sunbeam and Lee factories and she was cognisant of the disparity in working conditions between them.

The work trajectories of many of the factory workers indicated a high rate of transfer between factories. These transfers were motivated by a variety of factors, including redundancy, better pay and improved working conditions. It is significant, however, that in the main, women who began their working lives as factory workers remained working within this sector. Their limited educational qualifications and the relatively good pay women received in some factories, discouraged them from seeking out other occupations.

However, not all factory employers paid a good wage and Joan G., who worked in an office in the 1950s, was conscious of the poor pay and the low status of her contemporaries working in the Denny's bacon factory in Tralee. She noted that, 'women went in with overalls and did honest work ... and got a pittance'. Unsurprisingly, women who began their working careers in areas of employment with more status and better conditions did not aspire to factory work and, notwithstanding the possibility of better wages,

the stories we collected indicated that there was very limited transfer into the sector by women who had begun their working lives in higher status occupations. Pauline, who began her career as a secretary in 1935, was however obliged, when she emigrated to England in 1941, to take a job for a short period in a battery factory in Manchester. She strongly disliked both the work and the working environment and very quickly sought another office job.

Some women we interviewed were, however, prepared to trade job status for increased wages or other perks. Alice recalled that her sisters resigned from the dry cleaning company where they worked in the mid-1950s to take jobs in Goodbody's sack factory in Cork because the wages were so much better. She noted, however, that the work was physically demanding and the conditions were poor. Her sisters had to 'clean out the bags ... brush them and clean them out – oh you'd be stinking'. In 1964, Margaret resigned from her job as a dental receptionist to take employment inspecting wellington boots at Dunlop. Though very conscious of the loss of status involved, she reasoned that her boss in the dental practice was very difficult and that the factory job was significantly better paid at the time. As she was engaged and due to be married the following year, Margaret was keen to take any work opportunity which paid more. Rose fancied the idea of being a shop assistant rather than a factory worker and a friend said to her one day 'in the name of goodness, what are you doing out in a factory?' She promised her 'to get her into a shop in town'. However, when Rose went into the particular shop and witnessed the queue of customers waiting for assistance, she rejected the opportunity to move jobs, fearing that it would be much too demanding. She also recalled that her sister resigned from her job as a shop assistant and took on factory work precisely because she would have Saturday as well as Sunday free to visit her relatives in West Cork, which she liked to do frequently.

WORK CONDITIONS IN FACTORIES

Harsh working conditions prevailed in some factories between the 1930s and 1950s. The pressure created by the production line was etched in the memory of some workers. Kathleen O'R. had a clear recollection of her place and function on the assembly line in the Goodwear factory, where she worked as an over-locker between 1953 and 1960:

... you had the cutters before us like. There was all the benches for the cutters ... they cut them [garments] up and then we sewed them up like and the overlocker at the ordinary machine ... they made the button holes and the buttoners were behind us next then. You had the examiner after that and then you had the packers ... at the bench, I always remember you had to keep going the whole time, there was no relaxation, keep going with the work to try and get it done.

Some narrators provided detailed descriptions of the discrete tasks they undertook in the production process. In the Irish Optical Company, where Joan F. worked from 1946 to 1956, her job involved filing spectacles after they had been crudely cut in the previous production phase and then passing them on to other workers for polishing. Rena's function at the Lee factory in the mid-1950s was to stamp the company name between the heel and sole of the boots that were produced. She subsequently moved to Sunbeam, where her work included over-locking, button-holing and over-lapping sewing on the garments being produced. Rose was involved in banding and packing balls of wool at the Cork Spinning Company, where she worked from 1960 to 1974.

Piecework, the practice of paying workers extra if they exceeded a set production target, was a common feature of many factories. However, some women exercised choice and control over the extent of their involvement with the practice. Kathleen F., who worked in the Sunbeam factory between 1939 and 1954, recalled the introduction of piecework but claimed that she never felt any obligation to do more than her quota, preferring instead to take a cigarette break. In Pauline's experience piecework gave rise to frustration on the production line in the English battery factory where she worked in 1941. She acknowledged that when she started working there she was 'slow', and the woman next to her on the line 'got mad because she was losing money'. The pace of work required was pressurised, but piecework provided opportunities for increased earnings and in Kathleen O'R.'s recollection this was particularly welcomed by women saving to get married. This potential to earn more was an advantage of factory work, which was not readily available to women in other areas of employment. Rose remembered one occasion when piecework allowed her to earn 'a bonus of up to three pound'.

Margaret had similar memories of her earnings from overtime in the early 1960s:

> I worked one week-end in Dunlops, one long week-end … and I'll always remember the following week, I came up St Luke's Hill with nearly £12 in my pocket and that was a hell of a lot of money, and I thought I was a millionaire. That was great. That was way more than a man's wages at that time.

However, some of the women drew attention to the vulnerability of factory employees to slumps in production and their lack of control over their employment status. During slack periods in factories, workers were frequently laid off. Kathleen O'R. dreaded telling such news to her mother: 'you were told you won't be wanted until such a time. They'll tell you again when they need you. You go home and tell your mother … And you'd swear it was your fault, like. You couldn't do a bit about it'. The challenges of the production line were compounded in some factories by the unpleasant and in some cases dangerous work conditions generated by the machinery and the assembly line production process. Factory work could be deleterious to employees' health. Rena recounted situations where some male Sunbeam workers had accidents with the garment cutters, while women workers whose concentration lapsed, ran the risk of piercing their fingernails with the needles of sewing machines. Rose also recalled that the 'cranking' of the machines at Sunbeam was so loud that employees suffered from laryngitis and hearing problems. She suffered from sinusitis and chest-related conditions that she believed were attributable to working with wool. Kathleen O'R., who worked in the Goodwear factory in the 1950s, actively chose not to work for Dunlop, despite the better pay, because of what she perceived to be a harsh working environment for women: 'Dunlops was a hard job that time for women. Some girls … fine girls … when they came out they'd be so thin. Where as ours was more of a woman's job d'you know'. Margaret, who worked briefly for Dunlop in the early 1960s, had similar views about some of the jobs held by women in the factory. Margaret felt that her job, which involved inspecting plastic boots was 'hard on the eyes', but it was better than working in the 'bowels of the factory' where tyres were being produced.

There was a shared perception among most of the women involved in the research that factory work, despite its low status,

TABLE 2.1: FACTORY WAGES, AS REPORTED BY RESEARCH PARTICIPANTS.

Factory	Details	Respondent	Weekly Wages	Time Period
Tait's Clothing Factory, Limerick	Founded by Sir Peter Tait, later known as Limerick Clothing Factory. It was located in Edward Street, Limerick. It produced and supplied uniforms to armies. It finally closed in the 1970s.	Maura D.	7/6	1934
Sunbeam Wolsey Factory, Cork	The Sunbeam factory, (1928–1990) established by William Dwyer was amalgamated with British Firm Wolsey and it relocated from Shandon to Blackpool, Cork City. It produced hosiery.	Kathleen F.	7/6 increased to 12/6	1939–1940
Irish Optical Company, Cork	Based in Blackrock, Cork, this family-run business produced spectacles.	Joan F.	12s increased to £3-2-6	1946–1956
Cork Spinning Company	Set up in 1938, Cork Spinning Company was a subsidiary factory of the Sunbeam factory and it produced woollen yarn.	Rose	£3	1950s
Goodwear Factory	The Goodwear factory was established in 1935 by Messrs T. Lyons & Company Cork in association with Samuel Davis & Son Leicestershire. It was based in the Marina, Cork and it produced knitwear and hosiery etc.	Kathleen O'R.	£1-7s	1953
Dunlop Factory, Cork	The Irish Dunlop factory, was established in 1935 and it closed in 1983. It was based in the Marina Cork. It produced rubber goods; footwear, industrial hoses, tyres etc.	Margaret	£8	1964

Note: There were 20 shillings in one pound (£) and 12 pence (d.) in one shilling (s. or /-). 7/6 means 7s. 6d.

paid well relative to other jobs open to workers with a basic education. As noted by the women interviewed, piecework – and the need for overtime during periods of increased production in factories – presented women with opportunities to earn more than they could in other spheres of employment of similar or higher status. Table 2.1 provides an overview of the rates of pay earned by some of the women in this study, who were involved in factory work. These rates may not be entirely accurate, based as they are on women's memories of their earnings after a considerable period of time.

THE FACTORY WORKING ENVIRONMENT

A restrictive feature of factory work was the close monitoring of the production process. The strictness of the supervisory regime varied a little between establishments but punctuality was rigorously enforced in factories with clocking-in systems being used to monitor timekeeping. Rose remembered that when she worked in the Dunlop factory, a failure to clock-in on time every morning led to pay deductions, while Rena recalled that at Sunbeam if you were 'two or three mornings late getting in, you were dismissed'. Rena identified the other transgressions, which resulted in employees' dismissal, and these included doing damage to a garment by not taking due care or attention or smoking in the toilets of the factory building. In Tait's factory in Limerick[8], where Maura D. worked in the early 1940s, the management threatened to dismiss any employees who were found to be clocking in for each other. Dismissal was also the penalty for an employee caught stealing goods from Sunbeam. However Kathleen O'R. recalled that some employees frequently took this risk despite the high penalty and the 50 per cent discount on the purchase of products in the factory shop, which was available to all staff: 'I know for a fact the stuff that walked out of the factory then ... the stuff that walked out them doors was no-one's business; clothes, jumpers, underwear, more out of the underwear department. I mean the beautiful panties and the bras you know, the strapped vests ... they used to sail out the doors'.

On the production line at the Lee boot factory in Cork in the mid-1950s talking was strictly prohibited, and any workers caught breaching this rule were summoned to the office for what Rena described as 'a dressing down'. She noted however that singing was permitted and 'somewhere up or down the line there was always

singing'. In contrast, singing was strictly prohibited at the Irish Optical Company in the mid-1940s, but Joan F. had fond memories of the singing, which started as soon as the manager left the production floor:

> ... we used to love to sing all the songs while we were working the machines. It was a fierce popular thing. There was a girl, Margaret, and she had a lovely voice. She was singing all the old songs, but then she couldn't do that if he was down there, like. But it was lovely to be listening to it.

Singing also made the production line more bearable for Kathleen O'R., who worked for Goodwear in the 1950s.

Notwithstanding their critical assessment of aspects of the production process and of the conditions that prevailed in some workplaces, the factory workers' accounts of the atmosphere in their workplaces were predominantly positive. Very often a culture of support and solidarity amongst workers served as a counterpoint to the negative material and regulatory aspects of the factory floor. Joan F. mentioned that there was 'a small community' of workers in the Irish Optical Company and that the atmosphere was 'easygoing'. Rose, who was highly critical of the de-humanising nature of the production line in the Dunlop rubber factory, acknowledged that 'there was a good atmosphere at the same time, you know. There was a good camaraderie with the crowd, like, you know'. Rena also mentioned the 'good atmosphere' in the Lee boot factory, despite the 'shocking' working conditions. Workers always felt the cold in the factory, regardless of whether it was winter or summer. Though both factories were owned by members of the Dwyer family, her memory of Sunbeam was very different because 'the food was lovely' in the subsidised canteen and she was 'glad to get into work for a bit of heat'.

A paternalistic attitude to employee welfare prevailed in the Sunbeam factory and staff there enjoyed significantly better working conditions and supports.[9] The management introduced a range of initiatives to improve employee health and morale, reduce absenteeism and maximise production. These included free employee access to the services of a doctor, nurse and dentist located in a fully equipped surgery and dispensary within the factory. The Sunbeam Social Service Society which was chaired by the factory owner, William Dwyer, administered payment clearance for marriage

grants, prescriptions for glasses and sickness benefit for workers who were certified by the company doctor as unfit for work for more than three days. The provision of these services was identified by management as highly successful in terms of reducing staff absenteeism due to illness.[10] A subsidised canteen sold a range of hot meals, while cigarettes and chocolate were also on offer with a view to enhancing the morale of the workforce. It was mentioned in a Sunbeam promotional booklet that 'gay check cloths on the tables give a cheerful continental air to the canteen'.[11] The Social Service Society also organised a holiday savings club and oversaw the installation of baths and showers in the factory. Institutionalised religious observance was integrated into the work schedule in Sunbeam, with employees reciting the rosary before commencing work each morning and interrupting production at midday and at six o'clock to say the Angelus. Kathleen O'R., who worked in the Goodwear factory between 1953 and 1960, recalled rushing her lunch so that she would be back in the factory in time to recite the rosary.

While most other factories did not attend to employee welfare in the way the Sunbeam management did, the narratives do provide evidence of incidences where factory employers and managers reacted in humane ways to difficulties experienced by employees.[12] Kathleen O'R. recounted a kindness shown to her by the office staff and a boss at Goodwear in the early 1950s when she lost £10 she had been given to carry out an errand. Kathleen was only thirteen at the time and was not in a position to replace the lost money: 'I was in an awful state. … So didn't they collect for me, to give it back, and I always remember that … but the boss wouldn't take the money afterwards, so they bought a statue of our Lady and that was put up in the shelf in the factory'. Similarly Rose recalled that when her father died in 1969, she and her sister were responsible for the expense of the funeral. The management of the Spinning and Weaving factory (a subsidiary of Sunbeam) where both she and her sister worked offered them a loan to pay for the funeral.

The working environment in factories appeared to be conducive to the establishment of good relationships and friendships women made in factories continued long after they finished their employment. Similarly, much of their social lives were spent with co-workers. In factories, the large number of employees and the close working relationships facilitated the development of informal saving

schemes, such as the Christmas club or what was called the 'diddlum' or the 'manage'. Rose explained how the diddlum/manage operated in the Sunbeam factory in Cork:

> A manage is where you, you save so much and there would be some one of your colleagues minding it or putting it in the bank. And you'd have to pick a number say one to twelve then and every month then like, someone of the twelve would get the money ... you might get your money, it might be twelve pound at the end of the year, ... if I picked number one then, might pick in February, I'd have only just started. I'd have a pound paid in. ... I'd love if 'twas number, say ten. 'T would be two weeks before Christmas.

When she received her money, one Christmas, Rose went shopping and bought 'snow boots ... the laced up white ones' and 'a green full-length leather coat'. The 'manage' enabled Joan F. to have her hair styled, when she worked at the Irish Optical Company in the 1940s:

> ... and we had a 'manage' we used to call it. We'd pay a shilling every week in and they'd pick out your number then and you might be number seven. Well after the seventh week, you'd get the seven shillings to get your hair done and you'd keep paying it then until the twelve had their hair done.

Social events organised by the factories included Christmas parties, annual day trips and regular social nights in local dance halls. Engagements and marriages were causes for celebration as they connected women's personal and working lives and sustained the atmosphere of camaraderie which factory women valued so much. Despite the atmosphere of solidarity most factory employees described, their narratives also highlighted tensions, sometimes in the relationships amongst workers but more often between workers and supervisors. Kathleen F., whose fifteen-year factory career began at Sunbeam in 1939, noted that: 'The foreladies, they were alright. You get on with some of them, you don't with others'. According to Rena, the forelady in her section of the Lee boot factory 'wasn't too bad' to her but as she acknowledged, this was because her mother was there to keep a watchful eye over herself, her two sisters and her brother, all of whom worked in the same part of the factory. Rose was promoted to the position of 'inspector', examining the

rubber shoes and boots being produced by Dunlop. However, she found the animosity she encountered from some women on the line to be very stressful:

> The lady who was out-soling ... I had to go down and tell her one time, that something was wrong and that I couldn't pass it out. She lifted the boot on the lathe and whether she would have hit me or not, I don't know. She threatened to let me have it ... I was taken off the inspecting then ... I couldn't cope with people giving out to me ... I'd prefer to do my job and get on with it.

Alice's account provided a significant insight into how foreladies or foremen could potentially become hate figures in their workplaces and beyond. In her view, to become a forelady,

> you had to be a kind of a snakey person I think, because you had to keep the workers down and they were down enough already ... you had to be a bit bitchy to be in control of other women like, you know. They were the most hated person. 'See her I know her, she's a forelady in such a place!'

Aside from being unpopular with the workers, forepersons had employers and bosses bearing down on them, a fact which Alice believed made some workers very reluctant to take on the job, despite the extra pay.

SERVICE SECTOR EMPLOYMENT

Women have always been well represented as workers in the service industries such as shops, restaurants, and hotels and this sector of the economy provided employment for many women in Ireland from the 1930s to the 1950s. Statistical data from the Irish census indicates that domestic service was one of the key areas of employment for women during the 1940s and 1950s. The 1936 census recorded 86,102 women who were domestic servants.[13] This figure had fallen to 78,522 by 1946 and the 1951 and 1961 census recorded even lower numbers of 57,589 and 39,971 respectively.[14] The national trends were reflected in the census returns for the Munster counties included in this study. For example, in Kerry County in 1936, 3,705 women aged fourteen and over, were recorded as domestic servants, while thirty women were recorded as agricultural labourers.

Corresponding figures for domestic servants in Kerry County for 1946 and 1951 were 3,141 and 1,997 respectively, also reflecting the regional decline in this sector of employment.[15] In 1946 female domestic workers still accounted for 23.4 per cent of the national female workforce, but by 1961 there was almost 50 per cent fewer women working as 'domestics'. In contrast, participation rates for women engaged in shop work increased steadily between 1926 and 1961. In 1946, 21,450 women worked in shop service a figure, which represented 6.4 per cent of all gainfully employed women.[16]

Service sector work, and in particular domestic work or shop work, that had a residential requirement, was quite unregulated. Domestic work was an indistinct category of employment and domestic workers undertook a range of tasks in a variety of public and private establishments in both urban and rural settings. The lack of a defined job description, the young age at which women entered the sector, the residential requirement of many posts and the frequent isolation of the domestic worker from other workers of a similar category rendered it a largely undesirable sphere of employment. These characteristics also made it an accessible and flexible form of employment, particularly for young working-class girls from rural communities who lacked the financial resources to acquire educational qualifications and the opportunities for employment mobility. However, those who entered domestic work felt that they had no other choice.

Domestic posts appeared to be relatively easily sourced through local community and family networks. In 1940, at the age of sixteen, Rita secured her first job as a domestic worker after inquiring in a local shop in Skibbereen about the availability of any jobs in the area. The shopkeeper knew of a family looking for a live-in domestic and she secured the job a few days later without having to do an interview. Recruitment into retail and catering jobs appeared to be less informal and while family or community contacts still proved significant in identifying potential positions, interviews were commonplace. Eileen acquired her job as a cashier in the shop in the Savoy Cinema in Cork in the late 1920s through the influence of a family friend, while in 1950, Joan G.'s mother secured a job for her in a local wholesale shop in Tralee, but both were required to attend for interview.

The dearth of job opportunities combined with very limited means of transport, meant that a live-in job was the only viable work

option for many women in rural areas. The live-in option may have been attractive to poorer parents who were spared the financial burden of providing for daughters in service. Indeed, as acutely observed by Feeley, 'for the large families of the poor it was hire out or starve'.[17] Furthermore, it seemed parents perceived the live-in requirement as providing a degree of supervision over their offspring, who were often very young when first entering service.[18] The constant, direct engagement between the employer and the live-in worker facilitated considerable employer regulation of both the employee's working and non-working life and rendered employees very vulnerable to the character of employers. In some instances domestic work was combined with additional responsibilities, including outdoor agricultural work or shop work. Young women employed as live-in shop-workers in small family-run establishments were frequently assigned domestic chores, while domestic workers in farming households often undertook both indoor and outdoor work.

The relatively widespread availability of employment in the services sector meant that many young women engaged in domestic, retail or catering work for a short period at the beginning of their working lives or at times when they were moving between jobs. Domestic work in particular was a transitional occupation for a small number of women in this study, who subsequently moved into other more lucrative and higher status sectors of employment, most usually within the services sector. Mary O'D. took a live-in child-minding/domestic position in 1941, but within a year had moved on to a much better paid waitressing position in Cork City. Following a similar trajectory, May moved from her first job as a general domestic worker in a hotel in Garretstown in Cork in 1940 to pursue a twenty-four year career in hotel cooking. The flexible nature of domestic work also made it accessible to women at various stages of their working lives as they could combine it with other paid employment or with caring responsibilities in the home. For Alice, a weekly house-cleaning job, which she did on her half day off from her dressmaking apprenticeship, provided a temporary means of supplementing her meagre wages. For a short period in 1955 when she left her dressmaking apprenticeship, she took a full-time domestic job, which she viewed as a temporary measure until she secured other work.

Shop work also provided women with a range of flexible

employment opportunities at various stages of their working lives. Some of the women interviewed held short-term holiday posts in shops, or combined part-time shop or domestic work with their responsibilities as wives and mothers. Indeed family shops were common in Irish towns and villages during the period covered by this research and four of the forty-two respondents in the study came from families who were retailers. Catherine W. commented that when she was growing up in the 1930s, it was not uncommon for some married women to set up small shops or restaurants in their own homes.[19] Noreen recounted that her mother who was widowed in 1918, was sufficiently enterprising to set up a sweet shop in her home to service the nearby cinema in Cahersiveen. Noreen married in 1944, having just completed her nurse training, and immediately began to work in her husband's family drapery shop, also in Cahersiveen. As the female spouse in a family business, Noreen would not have been categorised as economically active in census returns yet she enjoyed a career of thirty-nine years in the shop.[20] Maura D. and her husband opened a chip shop in rural County Limerick in 1945, which provided her with a useful source of income for many years when her children were young. Indeed, the potential for combining service sector work with home-making and child-rearing was exploited by a number of respondents at various stages of the life cycle. Four women engaged in part-time shop work when their children were older, while others used it as transitory form of employment.

WORK CONDITIONS IN THE SERVICE SECTOR

Employment in the service sector was characterised by long hours, low pay and hard work. Women employed as domestic and farm labourers in private homes endured the worst conditions, usually working very long hours with only a half day off each week. Domestic work was very demanding in the period before electrification and the widespread availability of labour-saving domestic equipment. Young women employed by farming families were frequently obliged to undertake some of the agricultural work considered appropriate for women in addition to other duties.[21] Joan N. recounted her daily routine with the farming family she began working with in 1938 when she was only fifteen years of age:

> We'd start in the morning, you'd be up, you'd have your alarm

at five o' clock. I'd make a cup of tea for myself and I'd go out then and drive in the cows and milk them. And there was about forty pigs there. You'd have to feed them and clean out their house and that was that. ... Come in then and take off your old clothes ... and you'd do the vegetables, scrub the potatoes and scrape the carrots and slice them and then the vegetables would go into water up on the cold stove and the potatoes would go into the dry saucepan, do you see. It was all hygiene with her ... Oh my God, it was all hygiene everything had to be just so, everything. ... do your rooms and hoover them, they'd a hoover that time, like, I mean they were in America you see. And my God, the washing used to kill me because it was all snow white you know. ... You had no washing machines or anything, that time you see. ... it was all white sheets and 'twas all white shirts and collars ... and ties the men used to wear. There couldn't be a black spot or you'd have to go back again and do it.

Rita's first job in Skibbereen town in 1940 only involved indoor work. She too had an arduous and lengthy working day but she thought her employer to be a nice person:

Well I worked from eight o'clock until, mind you, eight in the evening. 'Twas long enough. ... I'd get up in the morning and 'twas only a range we had, light the fire and make the porridge and then I'd go upstairs and do over the place upstairs you know, the floors. The floors out in the landing ... I'd do them with a cloth, kneel down on my knees and scrub them all, and down the stairs and then get the brush and brush the carpet, the stairs and get the duster and dust around the carpet and do the hall then. And she'd be down then and we'd have the breakfast ... After that I'd, you know, I'd wash up and Monday I'd do the washing. Do it inside in a big tub. Sheets and everything that was going. It wasn't easy, no, it wasn't easy. ... It was a very big house and when you wouldn't have electricity or anything it wasn't easy but she was a nice woman, she was.

Mary O'D., who was hired in 1941 to look after the child of a professional couple in Cork, was treated very disrespectfully by her employer. Domestic staff received food allocations on the basis of their status and Mary found that she was often hungry and expected to do a lot more work than what was originally agreed:

The young one was a grand child. She was a lovely child and I
went there to give her first lessons and to make her clothes. But
before long I was introduced to a good bit of housework. A
good bit of other things to do too. Sewing in the house and,
you know, that sort of thing. And cleaning. But she [employee]
… she cribbed that time about bread being used and potatoes
being used … there was never any meat bought for the cook
general or the nursemaid … and I used to bring bread … and
potatoes … and cake from home and things like that.

Families who treated the domestic or agricultural workers with some
affection were often remembered by the women interviewed
precisely because they viewed them to be exceptional in this regard.
Domestic work in institutional settings, while still being physically
demanding and poorly paid, did release employees from the intense
and often lonely work environment that characterised domestic
work in private homes. Mary F. began working as a wards maid in
St. Senan's Hospital in Foynes, Co. Limerick in 1953. As Mary
recalled, the position involved hard physical labour, long hours and
an unflattering uniform, but the camaraderie, fun and social life
made up for the drudgery of the job.

The conditions associated with shop work, and the status
attached to it, depended on the type and size of retail establishment.
Respondents from Cork recalled that a Group or Intermediate
Certificate was frequently required for shop work and that positions
in the large, independent drapery stores in Cork City were consid-
ered to have a relatively high status. Doireann, who began a four-year
apprenticeship as a drapery assistant in Dunnes Stores in 1954,
noted that Dunnes would have ranked low in the hierarchy of retail
establishments in Cork, with Dowdens' Drapery representing the
pinnacle of retail excellence.[22] Woolworths was also identified by
Doireann as a desirable workplace in the 1950s as 'they paid very
well and they also had a pension scheme, which was a marvellous
thing in those days, particularly for women'.[23]

In family-owned shops, often located in the family home, there
was frequently only one employee, who was often required to
live-in. After completing her Intermediate Certificate in 1938, Mary
O'N. acquired a live-in post in a tobacco and confectionery shop in
Cork City. The shop owner was a widow and Mary, who was obliged
to do both house and shop work, recalled that the practice of shop
workers living-in was quite common, particularly if the employee

was from the country.[24] Mary left her job after twelve months to assist with family duties and in 1940 she resumed paid work, taking a live-in position in a very well stocked grocery shop in Turner's Cross, a suburb of Cork City. Grocery shops were labour intensive as many products such as sugar, butter and flour came in big bags and boxes, which then had to be weighed and packaged in smaller quantities for purchase in the shop. When interviewed, Mary recalled the war rationing of basic foodstuffs sold in the shop where she worked for the ten years before she married.

The disparity in conditions, which prevailed in shop work, is highlighted when Mary's working conditions are compared with Eileen C.'s. In 1936, at the age of eighteen and having completed her Leaving Certificate, Eileen began work as a shop assistant in the cake and sweet shop in the Savoy Cinema in Cork City. Her hours of work and her pay were significantly better than those experienced by Mary. The job was based around two shifts, an early shift from nine to five and a late shift from five in the evening until ten at night, and Eileen worked five days a week, including Saturday and an occasional Sunday for which she received extra pay. Eileen considered her working conditions to be quite good for the time as she received a free lunch and tea in the Savoy Restaurant and was provided with a nice uniform of green linen 'with a little mandarin collar'. The work in the sweet shop was not arduous or mentally taxing as there was a cash register which was 'easy enough to manage'. Noreen, who began work in 1944 in the drapery shop owned by her husband's family, also enjoyed pleasant working conditions and cordial relations in what was a female-dominated family enterprise.

Noreen never drew a formal wage but 'for tax reasons ... was allowed forty-five pounds a year' and had access to the 'safe in the shop' and within reason she could take what she needed for herself. In contrast, Doireann found the early days of her apprenticeship as a drapery assistant in Dunnes Stores in 1954 to be 'nerve-wracking' and she had a clear memory of the status differences which existed between the qualified drapery assistants and the apprentices. Female apprentices had the job of collecting purchase dockets and cash from the various busy counters on the floor and taking them to a central office in the shop and returning with the change. The work was fast paced and the working day extended from nine to six with an hour for lunch and a short morning tea break in a tiny and poorly

equipped cloakroom. Alice, a contemporary of Doireann, who began working as a presser in a dry cleaning company in Cork in 1955, also commented on the demanding pace of her work, which was compounded by the harsh physical conditions in the dry cleaners and the anti-social hours: 'It was roasting! And they had a glass roof. And the glass roof was whitewashed to keep the sun from coming in on them. The smell of the stuff! The perklone [chemical for cleaning] stinking you'd be of it some nights, desperate altogether, stupefied from it'.

May started work in the hotel business in 1940 at the age of fifteen. Her first job in a hotel in Garretstown in Cork involved general domestic work for the busy season. After this she worked for four years as assistant to the chef in Eccles Hotel in Glengarriffe. In 1945 she moved to a similar post in the Metropole Hotel in Cork, where she worked six days a week with every second Sunday off, and along with the other twenty-three kitchen staff, she was obliged to work until eleven o clock a couple of nights a week. Mary O'D., who took a job as a waitress in a restaurant in Cork City in 1942, was positive about her experience. She believed the job to be a significant improvement on her previous post as a live-in childcare and domestic worker and she remained for over three years before moving to another restaurant where she worked for a further eight years. Mary found this latter job interesting and appreciated the diversity of tasks involved:

> We'd have to go behind the counter, then to the grill and do the grilling. We'd have to go behind the bar and pass out all milk, ice-cream, teas, coffee, drinks of all descriptions. We'd have to go to the coffee-bar where they'd have special coffee. We'd have to go up to the still room for a fortnight, only washing ware and dishing out puddings and sweets. We had to do everything except the kitchen.

A particularly interesting aspect of Mary's work was her experience of waitressing at the Freemason suppers in the Masonic Hall in Tuckey Street in Cork City. A Freemason owned the restaurant where Mary worked and he had the contract for supplying the suppers for meetings. The grandeur of the hall and the mystery of the proceedings were etched in Mary's memory:

> … the Masonic Hall was a very secret kind of place. We had special uniforms for that place. Blue and silver and … they had

everything. They had chocolates when we hadn't seen them for two years and their sign was a column with a globe on top of it and the secret room – I looked into the secret room, peeped into the secret room – and all of them had their mottos and their house flags hanging out over their special seats.

Mary's job was structured into alternating weeks of shift work with shifts running from 7.30 in the morning to 3.30 in the afternoon and from 3.30 in the afternoon to 11.30 at night. Earnings were supplemented to some extent by tips from customers, which were pooled. Mary acknowledged the generosity of customers at Christmas, when she frequently received 'pound notes' or 'ten shilling notes' and on one occasion a pair of earrings from a male customer. Chris was in her early forties when she moved into the hotel sector in the early 1960s and she continued to work in management positions until her retirement in 1984. She identified independence at work, nice food, accommodation and access to leisure facilities such as beautiful scenery and golf clubs, as compensatory aspects of working in the hotel sector, which tended to be low paid and non-unionised.

Low wages, frugal practices and demanding work schedules characterised dressmaking apprenticeships. Apprentices were obliged to pay a fee to their employer and entered into a contract to work under their direction for a training period of three to four years. Three of the women who participated in the research took up apprenticeships in dressmaking. Sheila, who began her training with a dressmaker in Cork City in 1943, highlighted the financial disincentive involved: 'We paid a fee; we had to pay a fee at that time to start ... Yeah, pay the teachers, the lady that I would have worked with, £30. And I had five shillings a week and my bus fare at that time was five and six. £30 was the fee for ... a three year apprenticeship'. In the third year of her apprenticeship her wages increased to seven and six a week and on completion of her training she also received a payment for each garment she completed. As an apprentice, Sheila worked six days a week and was frequently required to work her half-day off on Wednesdays. Lack of electricity and the hand sewing required on delicate materials made her work more laborious: 'The old foot machine was used a lot. Nothing electric, just the old foot machine and again an iron used to sit on the gas. You know, one of those solid irons that you sit on the gas stove. And was heated up and that kind of thing.' The frugality and scarcity of

the 1940s and 1950s impacted on the work practices of dressmakers as used clothes were continuously remodelled into more fashionable styles or remade into garments for children. The scarcity of fabric during the war years saw every scrap of material being utilised and Sheila, who specialised in evening wear and wedding dresses, recalled making a wedding dress out of silk from a parachute found in the Wicklow mountains.

Sheila's account of her employment highlighted the kindness of her employer and her satisfaction with her work. In contrast, Alice, who began a dressmaking apprenticeship almost a decade later in 1952, did not complete it due to her dissatisfaction with the poor treatment she received. Initially, she was apprentice to a dressmaker who paid her twelve shillings a week and provided her with very satisfactory skills-based training:

> She let me do a lot. She let me on the sewing machine. She let me tack up hems, rip out tacking. She showed me how to cut out patterns ... She wouldn't let me do it all but she let me at the sewing machine, which I thought was brilliant. She used to let me do little bits of hand sewing for her, hems and things.

However, the lure of higher wages enticed Alice to transfer her apprenticeship to a tailor. Limited opportunities for skill development combined with an oppressive working atmosphere resulted in her leaving the apprenticeship after two years to take a more lucrative job in R and D Cleaners on North Main Street in Cork City. Rena followed a very similar trajectory when she left school in 1954 at the age of fourteen. After six months of her tailoring apprenticeship, meagre earnings and long working hours prompted her to forego her ambition to be a tailoress and to take up higher paying employment in O'Gorman's hat factory in Cork City.[25] She continued to work in different factories in Cork until she married in 1962. Because of the emphasis on earning as much as possible in the intervening period between school and marriage, apprenticeships had few attractions for women, whose working lives were very likely to end upon marriage or pregnancy.[26]

Recollections of pay among the service sector workers in our research reveal the low rate of earnings in the sector (see Table 2.2). Rita's payment for her live-in domestic post in 1940 was a very modest five shillings a week and she recalled sending some of it home to her mother. When she left the job three years later her

TABLE 2.2: WAGES IN THE SERVICE SECTOR, AS REPORTED BY RESEARCH PARTICIPANTS

Position	Respondent	Weekly Wages	Time Period
Live-in Domestic Servant	Rita	5 shillings, increased to 7 shillings	1940–1943
Live-in Grocery Assistant	Mary O'N.	9 shillings	1940
Dressmaker	Sheila	7s-6d	1946
Hospital Wards Maid	Mary F.	£7, increased to £11 (a month)	1953–1958
Drapery Assistant	Doireann	19 shillings	1954
Presser in a Dry Cleaners	Alice D.	£5	1963
Hotel Cook	May	£10	1965

Note: There were 20 shillings in one pound (£) and 12 pence (d.) in one shilling (s. or /-). 7/6 means 7s. 6d.

wages had risen to seven shillings a week. Rita noted that on such wages, she even found it very difficult to clothe herself. Joan N. worked as a domestic servant/farm labourer throughout her life, but she received no income after she married as she was remunerated in the form of the very poor lodgings provided for herself and her family on the farms of her employers. Mary O'N.'s position, as a live-in shop/domestic worker in Cork City in 1940, obliged her to work from eight in the morning until eight thirty at night for the low wage of nine shillings a week. Mary O'D.'s first job as a live-in domestic in east Cork in 1941 also paid very little. Her wages as a waitress in 1945 were higher than those earned by women employed in live-in domestic positions but in her view the wages were still very meagre. Mary F.'s pay as a wards maid in St. Senan's Hospital in Foynes, Co. Limerick in 1953 was seven pounds a month and this had only risen to eleven pounds when she left in 1958. Generally, most factory jobs had the potential to provide a very similar group of women with a much higher earning potential than those in the lower echelons of the service sector.

WORKING ENVIRONMENT IN THE SERVICE SECTOR

Close surveillance of employee work practices appears to have been common in various workplaces within the services sector. The integrated parental and employer control, which could be experienced by young women in service, was evident in Joan N.'s recollections of her first job. She was unfamiliar with what she earned as her wages were paid directly to her father at Christmas time. As noted in Chapter One, many working-class women who started work at a very young age were in the anomalous positions of being both children and wage earners. The restaurants where Mary O'D. worked in the 1940s and 50s were strictly supervised and the use of war-rationed foodstuffs was closely monitored. Ena remembered that the elderly owner of the drapery shop where she held a holiday job in 1949 closely monitored employees' work and appearance. Employees were expected to be 'neatly dressed' and were censured for such practices as using too much twine when wrapping parcels. Doireann had similar recollections of being under scrutiny at the start of her drapery assistant apprenticeship in Dunnes Stores in 1954: 'You were on trial for four weeks and they watched you like a hawk'. She also recalled the owner Ben Dunne, standing on the stairs and watching employees' interactions with customers and if the customer left without a purchase 'he'd shout from the stairs down to come up to him. And he'd ask you "Why did that customer walk out? What did she want? And did you do enough?"'. This scrutiny also extended to the managers, all male, who would be 'shaking' in his presence. A mistake involving an undercharge was punished by deducting the said amount from the wages of the employee concerned. A particularly oppressive regime prevailed in one dry cleaning company where Alice was employed. A clocking-in system was imposed and wages were docked if an employee was more than three minutes late. Work was closely supervised, talking was prohibited and the managers adopted a very distant and haughty yet watchful approach to staff.

Good working relationships made many highly-regulated work environments more tolerable. Doireann recalled that in the drapery department of Dunnes Stores in the mid-1950s, more experienced workers provided support to junior staff members, particularly in the context of informing them of entitlements and accompanying them to any meetings with management over disciplinary issues. Individual collegial relationships also mediated the harshness of the

workplace and Doireann found that her immediate supervisor, despite being a tough taskmaster, was a supportive mentor. Camaraderie with colleagues and the shared social life they enjoyed were mentioned by a number of service sector workers as significant factors in making the workplace more bearable. May recalled that staff in the hotel where she worked from the mid-1940s through to the mid-1960s, counteracted their antisocial hours by socialising together during their afternoon break. Chris commented on her good working relationship with the manager in the hotel where she was assistant manager, 'we got on very well together and for that reason of course it was quite comfortable'. Similarly one of Eileen C.'s most positive recollections from her working days in the shop in the Savoy Cinema in the late 1930s was the opportunity it provided her to mix with other workers her own age.

CONCLUSION

Women who took employment in factories were predominantly working-class women residing in urban settings, whose families had too few resources to enable them to obtain educational qualifications. Factory jobs were sourced through family and community networks and different generations of families frequently worked in the same place. Women who took up factory work were conscious of its low social status, but they emphasised the earning opportunities factories provided for less educated women. Factory conditions varied, with some being viewed as cleaner, more modern and indeed more feminine than others. A paternalistic and gendered style of management characterised some factory settings, however, in all of them control over workers tended to be quite overt and punishment oriented. Factory work was regarded as monotonous and the working day was considered long, but recollections of the chat and singing on the line as well as the friendships formed punctuated factory workers' accounts of their workplaces.

The women who worked in the services sector, also experienced physically demanding, closely regulated working conditions but had generally supportive relationships with co-workers. As might be expected, many of these service sector jobs were poorly paid. Given their family circumstances, many of the women who worked in the lower paid services, were also inclined to have limited expectations of their own employment opportunities and earning capacities.

They accommodated regimes of surveillance and discipline, charac-
terised by structured requirements around neat dress and punctuality
and hierarchical and formal management styles. Promotion oppor-
tunities were limited in most jobs and while a minority of women
displayed ambition and agency in securing higher status and better
paid employment, the majority remained for significant periods in
the same jobs. The exceptions were a few of the women employed
as domestic workers in private houses. The low status of this work
and its poor remuneration and conditions, prompted them to
seek more satisfying employment, or, at the very least, to seek out
employers who paid more and offered better conditions. The
private and unregulated nature of some work in the service sector
undoubtedly gave rise to harsh conditions and exploitative relations,
with those involved in household or agricultural labour being most
susceptible to exploitation. Work in hotels, restaurants, dry cleaners or
in shops provided preferred forms of employment for working-class
women and afforded somewhat more status than domestic service.

Women in Professions, Clerical and Office Work

This chapter explores the stories of women who worked in clerical and office positions or in professions. As in the previous chapter, we consider their working conditions and their impressions of the work cultures and environments they experienced. As workers in the professions, the public service and company offices – spheres of work that were also populated by men – the experiences of this constituency of women provide some significant insights into the differential treatment of male and female workers. They also reveal the impact of gendered assumptions and practices in shaping career trajectories for women in the 1930s, 1940s and 1950s.

CLERICAL AND OFFICE WORK

White-collar office and secretarial work was the sector of employment for women, which showed the greatest increase between 1936 and 1961; 25,425 women or 7.2 per cent of all gainfully employed women in 1936 worked in the sector. The corresponding figure for 1961 was 48,442 women or 16.9 per cent of gainfully employed women.[1] A study of the post-school history of children who completed secondary education from the rural areas of Limerick during 1959 revealed that the Civil Service was a key employment destination for women, followed by nursing and clerical work.[2] Office or clerical work was considered eminently suitable for young women, as it was perceived to provide a regulated and somewhat protective work environment. Secretarial positions in the private sector were frequently acquired through family connections or contacts with the employer or with other employees, and these relationships sometimes made for more protected working environments. The popularity of office work was further increased by its relatively short hours, good conditions of employment and the physically undemanding nature of the work.

The oral histories reveal that young women who became office workers frequently had aspirations toward work in the Civil Service. Security of tenure was a criteria consistently used by the women we interviewed to categorise a 'good' job. The permanent and pension-able nature of a public service job, the conditions of the work and the status associated with it were all factors which made it a very attractive employment destination for young middle-class women. In 1911, 30 per cent of clerks in the Civil Service were female. In the first decade after independence, the number of established female civil servants increased from 940 to 2,260 due to the introduction of low paid positions, such as 'typist' and 'writing assistant', which were only open to women.[3] Despite the low pay, deemed by some commentators to be inadequate to maintain a single person, competition for the women-only positions was stiff and those who were successful frequently had significantly better educational qualifications than the required primary education.[4] Two of the four civil servants who participated in our study, held the female-only posts of clerk typist and writing assistant, while the remaining two worked as a telephonist and a clerical officer respectively. Entry into these posts was through a competitive public examination and three of the four civil servants we interviewed had completed their Leaving Certificates and approximately one and a half years of training in private commercial colleges before they took the civil service examinations. Office jobs in the private sector were sourced through family or community contacts or through newspaper advertisements and usually involved an interview and frequently a test to check the candidate's suitability for the post.

WORK CONDITIONS IN CLERICAL AND OFFICE SETTINGS

The working hours of office staff were quite good, with most working from nine to six, with an hour-long lunch break and a morning tea break of ten to fifteen minutes. At the time when the women we interviewed were employed, office work was a labour intensive endeavour dominated by the manual keeping of records and accounts and requiring proficiency in handwriting and arithmetic. In the 1930s, Maureen kept account of the sales dockets in Roche's Stores for the purpose of auditing levels of stock in the shop. She described the mentally arduous but somewhat monotonous nature of such work:

Totting, totting, totting … There were sheets of data … You got your data in bundles. It came from the floor where it was sold. There at that time there was an assistant … sold somebody a pair of stockings for two and eleven pence … they wrote on a duplicate docket – hose two and eleven – rayon or cotton or wool. … well that double docket would go up to a little office in the centre of the floor and the lady cashier there – she stamped it and she gave the top bit with the change … and stuck the duplicate on a file. … And I received a huge bundle of those dockets … and I had to go through every single one of those … And believe me it was monotonous. You waded through thousands and at the end of each department and each column you totted up. I mean I could tot in my sleep backwards.

The first job held by Chris in 1940 involved keeping ledgers of the sales made by each van driver at Thompson's Bakery in Cork City. Other aspects of office work at the time included working on telephone switches, doing wages or writing invoices. The mechanical devices which make contemporary office work less time consuming and tedious were largely absent, a point made by Mary O'S., who began work in 1950:

> While I was there, they got an adding machine. That was the very first automation, apart from a typewriter of course, but everything else was done manually. All the ledgers were, but that was the way we were trained, too. You posted everything to the ledger and everything went through manual books and your writing was very important. You had to be a good writer.

Ena, who totted up prices on invoices for orders of books in Brown and Nolan's in Cork in the 1950s, recalled that her good handwriting and neat appearance endeared her to her boss. The tedium of manual record-keeping was highlighted by Helen, employed in the 1950s as a ledger clerk for a hire purchase company in Limerick. The ledger clerks were crammed into an office and each of them had six ledgers to go through weekly, in addition to dealing with customers who called to the office. When Helen left work in 1966, everything was still being done manually and the only machine they used was a franking machine.

Some office jobs, such as that held by Maura C. in a printing company in the mid-1940s, involved a diverse and more enjoyable variety of tasks. Maura was responsible for the post, filing, wages and

checking time cards. Muriel also enjoyed her job in an ironworks in the 1940s, as she had a great interest in the creative aspect of the work. She particularly enjoyed copying and filing the designs used in the ironwork and appreciated the opportunity to visit sites where the gates and railings produced by the company were installed. The variety of tasks that comprised her job in a builders' suppliers company in Cork City in the early 1950s was also offered by Mary O'S. as the key reason for her enjoyment of work.

The oral histories of the women who worked in the Civil and Public Service revealed a range of jobs and working environments. They also point to the poor physical infrastructure which characterised many Public Service workplaces, particularly in the 1930s. Joan H.'s first workplace in 1934 was the labour exchange in Newcastlewest, County Limerick and this was part of the new nationwide administrative system established as a consequence of the introduction of the 1933 Unemployment Assistance Act.[5] There was significant dissatisfaction among the unemployed about the administration of the 1933 Act and Joan recalled local TDs coming into the office to make representations on behalf of their constituents to speed up their unemployment payment. The exchange was located in a very cold, private house, heated by turf fires. During the Emergency when there was not enough work in the exchange, Joan was temporarily re-deployed to Limerick County Council. She worked for four months of the summer as a timekeeper, supervising the men, women and children, who were hired to cut turf in the bogs to counteract the fuel shortages created by the war.[6]

Clare, who began her Civil Service career as a telephonist in the central telephone exchange in Exchequer Street in Dublin in 1945, also noted the impact of the war on her work. Old equipment was not replaced and many tasks were still being undertaken manually. Similar conditions in the telephone exchange in Cork City in 1946 were recalled by Maura. She also recounted the fast pace of work demanded and the impatience of callers using the exchange:

> ... We had a small little room ... and you got a relief [break] in the morning and you got relief in the evening and all you got was ten minutes and it was ten minutes, it wasn't eleven, it was ten. ... And a couple of the subscribers [customers] were desperate like ... if they weren't answered immediately, they'd want to know were we having coffee.

In 1945, within weeks of beginning a job as telephonist, Clare moved to a writing assistant post in the General Post Office where her work involved making out telephone bills. In the early months of the year she was frequently re-deployed to the Savings Bank, which was under the auspices of the General Post Office, to make up the interest accruing on the saving accounts from the previous year. Joan G.'s fourteen-year career as a clerk typist with Kerry County Council, which began in 1952, also provided her with the opportunity to apply for transfers and she worked in five different offices spanning the three administrative departments within the County Council.

From what the women told us, the culture in their offices varied. The power imbalances, between new and inexperienced workers and their superiors, and the general acquiescence of young workers with demands made on them by employers, were clearly evident. Junior office workers were frequently obliged to undertake a range of non-secretarial duties in their workplaces, which let them know their place in the hierarchy. As junior workers in the mid-1940s and 1950s respectively, Maura C. and Margaret were assigned tea-making responsibilities, while Joan G. was obliged to dust the desk, the ledger and the phone before she commenced work in her office job in a large shop in 1950.

The non-delineated nature of their jobs was also highlighted by a number of women, who felt obliged to assist in other areas of the business in which their office was located. Maura C., who was employed in Eagle Printing Works on South Mall in Cork City, had to work in the shop attached to the business on Saturday mornings. At busy times, such as Christmas and Easter, Joan G. was expected to help out in the shop of the business where she worked. Maureen was frequently re-deployed from the office in Roche's Stores in Cork in the 1930s to serve on the shop floor. This often created a backlog in her own work, which she had to take home and finish in her own time and for no extra remuneration. Joan G. highlighted that a person's area of work was not always so clearly delineated in the past and that helping out other workers or employers when it was required was not unusual. When she worked in a hospital setting where there was a clearer delineation of responsibilities, she thought this cultivated a more negative working culture. Acquiescence to do work beyond the call of duty was also explained by the junior status of new employees, their relative youth, the prevailing culture of deference to authority and their tendency not to be unionised.

The lack of any formal training or induction in many workplaces also meant that entry into office work could be quite intimidating. Maura C. acknowledged that she was 'petrified' during her early working days in Roche's Stores in 1944. She was employed as a cash girl for the Christmas rush and she explained the demanding and stressful nature of the job:

> Now there was a lady in a central station, like a pay station and there were cables overhead and you put the customer's bill and money into this thing, stuck it up on one of these little holders and pulled a thing and it went up to the cash desk and you had to wait then until it came back. You couldn't leave the floor and in the meantime you were seeing to the ones [customers] this side and the other side.

During the course of her career, Helen, who worked for a hire purchase company, was promoted from the position of junior clerk to typist and finally to ledger clerk. However, she recalled that when she entered the job at seventeen she felt overwhelmed by the office environment but, following encouragement by the manager, she gained greater confidence in her abilities:

> In the beginning I was very unhappy as I said, because I didn't think I had the ability. ... I just didn't have the confidence. ... it might sound kind of naïve now like, but even to answer the telephone ... I wasn't trained for nothing. You just were thrown in the deep end and you learned as you went along.

In contrast, Pauline's first day on the job in 1935 was much more positive due to the fact that she had a friend already working in the office and she helped Pauline settle in.

The management cultures in offices varied significantly. Some offices were very formal, hierarchical and disciplined workplaces. Punctuality was expected and monitored closely. In some situations talking was not permitted between employees unless it related directly to business. Neat dress or the wearing of a uniform was required in most offices and women's appearances and conduct provided key sites of surveillance and regulation. Female office workers were expected to be respectable and to display their respectability through both their dress and demeanour. Attention to appearance was expected but too much attention and the wrong kind of attention could be punished, as recalled by Maureen, who started work in 1934:

> You had to be very punctual, and there was a uniform ... And
> I mean they were very strict about punctuality ... Now you
> couldn't wear nail varnish. And I remember one time I had been
> staying in Crosshaven with my parents ... we were going to a
> dance there and a friend of mine had rather posh nail varnish
> and she shared it out to us ... and we thought we were the cat's
> pyjamas like! And I came up the next day anyway and back to
> work and the manager happened to come down and he said
> 'Ms. Collins, we don't allow nail varnish here at all'. And I was
> terrified so I went down to ... there was a man, he was a sign
> writer, he used to do all the signs for the store and he had methy-
> lated spirits and I took off the nail varnish with that.

Maureen also noted that it would not be permitted for any friends or
family members to come and talk to the shop workers on the floor.
Helen, who began office work over twenty years later in 1958, gave
the following account of the stuffy atmosphere, which prevailed in
her workplace:

> We had a clerk and she was sitting at the top of the office. We
> could not talk; pass any conversation at all, unless it concerned
> our work. So when the tea break in the morning would come,
> she'd leave the office to go down three flights of stairs to the loo
> and we used to create havoc. We'd be talking at a mile a minute
> and we'd have someone outside the door watching for her.

Maura C. highlighted the pecking order, which prevailed in her office
in the mid-1940s and noted that she 'kowtowed' to the other more
senior office workers and was intimidated by the boss, whom she
described as quite 'frosty'. When interviewed for the job she recalled
that 'he had a fearsome kind of face' and that she 'cowered in front
of him'. In contrast, Muriel, who worked in the same period for a
company where the owners were friends of her father, recalled her
work place as very relaxed and friendly:

> My four bosses, like, I did get on great with them. I was
> extremely fond of them. ... they were very thoughtful and
> everything would be done for my comfort. If I wanted extra time
> off, I had extra time off. No questions asked, and they were just
> lovely people.

Similarly Catherine O'D., who began work in 1931 as a dispatcher in
a sweet factory, believed that her employers, the Collins brothers,

looked on her as a sister and she commented on the pleasant atmosphere in her workplace and on the kindness she experienced. Catherine also enjoyed a pleasant working environment in a subsequent office job and recalled that her colleagues presented her with a mahogany clock when she resigned to get married in 1940.

Formal rules operated in the Civil Service and tardy timekeeping and absenteeism were monitored systematically. Clare was obliged to sign-in each morning in a book, which was monitored by a staff officer, who drew a red line in the book at three minutes after starting time and anyone who signed in after that was recorded as late. Accruing more than twelve 'lates' resulted in a formal warning and the possibility that a pay increment could be withheld. Absenteeism was also a significant transgression and typically prompted a written warning as Clare explained 'you'd get a paper. It was a written reprimand and you had to reply in writing and make your excuses, you know'. However in Clare's experience, there was usually some leniency in the application of the rules.

Working in the Civil and Public service had its advantages, such as the opportunity of taking days in lieu instead of extra pay for overtime, and Joan G. remarked that staff in Kerry County Council were 'the envy of the place' because they were not required to work on holy days. When first appointed to Kerry County Council in 1951, Joan was assigned to the roads department and she commented that in comparison to the private sector office where she had previously worked, the staff in the roads department were all very 'staid office people'. A gender hierarchy prevailed in the department, mirrored in the spatial organisation of the offices. Three male higher-ranking officers worked in an outer office while Joan was based in a small, stuffy, inner office with two other typists. Joan had very little work to do and recalled with humour, that her male superiors spent much of their time studying the form of horses while one of them advised her that

> 'The most important thing' he said 'when you join Kerry County Council is to look busy even though you are not'. And he said 'always keep books on the table and you can be opening them and closing them and have your pens and pencils' … I became adept at this, you know! To look busy when I wasn't, like … On my probationary period I learned how to back horses and to look busy.

However, following the completion of her six-month probationary period, Joan was made permanent and assigned to a section of the health department where a very different work culture prevailed:

> I was under two women at this stage ... that had gone up through the ranks, you know and I was warned about them, that you know, do what they tell you and no more about it. So, I did ...

Joan's narrative clearly highlights the way in which workers within larger institutions gathered and shared information about the working ethos of various work sections and the staff members responsible for these sections. It also emphasises the occupational hierarchy that prevailed in organisations, where different categories of workers were employed. At another stage of her career Joan was assigned to a tuberculosis clinic where she worked directly with, and was answerable to, medical as distinct from administrative staff. She found this position very isolating, as it provided no opportunity for the development of workplace friendships:

> I worked there for a few years under two doctors and two nurses and it was very nice. I did all my work, you know, and I was very subservient to the doctors, like you know, 'yes, doctor; no, doctor' and the rest of it, like. You'd adapt that time. But they knew nothing more about me, other than that I did my work and I'd know nothing more about them ... You wouldn't be comfortable with them, you know.

The work culture in the clinic prompted Joan to apply for a transfer and she was assigned to an x-ray department in the local county hospital, where she subsequently became secretary to a doctor, who had been recently recruited from Britain. Her relationship with this man was much more egalitarian and she noted that she 'had a great time' working with him. Joan subsequently sought another transfer as she was hoping to be relocated to a section near where her friend worked and she finished her career in a typing pool: 'there were six of us in a room. In a back room, a big room, like. There were six of us. It was stuffy alright but I loved it. I loved the company'.

Despite the potential for a variety of work locations the transfer option provided, promotional opportunities were quite limited, particularly for women who entered the Civil Service at female-only grades. Joan G. and Clare were very conscious that being in

female-only grades, they could not get promotion based on perform-
ance, as Civil Servants in other grades could. Women in the writing
assistant and clerk typist posts did, however, have an option of taking
an examination for a clerical officer position. The marriage bar, which
applied to female workers in the public sector was another major
barrier to progression to higher ranking positions, a situation with
which the women interviewed were very familiar.[7] Joan H. recalled

> I never heard of anyone in my time, a woman reaching
> manager level, never … there'd be no such thing as staying on
> after getting married. … Men got priority. There was no such
> thing as going to work after getting married that time.

Joan believed that her female contemporaries in the Civil Service in
the 1930s and 1940s did not consider or expect promotion. She
recalled that other local women employed in the Board of Health
found they lost their jobs to men who returned from the war to
recommence their employment. These men frequently received
promotion for their war effort.

Maura C.'s account of her career as a telephonist also highlighted
the gender restrictions that prevailed in telephone exchanges. When
Maura began work in the telephone exchange in Cork City in 1946,
female telephonists were not allowed to work after 10pm at night and
their working hours were organised in shifts to facilitate female cover
of the exchange until 10pm, after which time male operators took
over. Clare acknowledged that during her career from the mid-1940s
to the late 1950s, the higher echelons of the Civil Service were almost
exclusively male dominated. Significantly, she described the positive
reaction of her female colleagues to the appointment of the first
female secretary of a Civil Service department in 1959: 'I remember her
well. And there was great support from women in the Civil Service,
saying "about time, about time".'[8]

WOMEN IN THE PROFESSIONS

The 1946 census indicated that 36,806 women were gainfully
employed in a profession, with over 30,000 of those being concen-
trated in the three occupations of nursing, teaching and religious life.[9]
However, the number of women recorded as working in the profes-
sions had increased to 41,176 in the 1961 census. Diarmaid Ferriter
has noted that by the 1950s, women were making small inroads into

the higher professions with female doctors representing 17 per cent of all doctors in 1951 compared to 10 per cent in 1926, while the percentage of female legal professionals increased from 1 per cent in 1926 to 4 per cent in the same period.[10] Women dominated, however, in the lower professions. Nurses were almost exclusively female and 60 per cent of the membership of the Irish National Teachers' Organisation was female in 1919, while in 1949 women accounted for 53.5 per cent of secondary school teachers.[11]

Entry into religious life provided women with opportunities for careers in teaching, nursing and domestic economy and indeed the high number of religious persons in the former two professions significantly reduced opportunities for lay-women.[12] Female religious congregations had a monopoly over most of the traditional areas of women's paid employment in Ireland, running schools, hospitals and other institutions.[13] Cunningham has documented that up to the mid-1960s in the post-primary school system, the majority of both male and female full-time teachers were religious, with lay teachers being marginalised in the Catholic second-level system and rarely entrusted with any significant responsibility.[14] Furthermore, lay secondary school teachers had few opportunities for promotion, as senior posts were routinely filled by members of the religious orders.[15]

The agriculture and dairying sector also provided opportunities for professional training for a relatively small number of women in poultry instructing, cheese-making and butter-making. Only two of the women we interviewed had non-stereotypical careers for the time; one woman was a civil engineer and the other, a farm manager, on the farm owned by the community of nuns she entered. This is unsurprising given that the secondary school curriculum was strongly gendered and steered young women towards a narrow range of careers.[16] It is interesting to take note of the occupations preferred by farming parents for their daughters as identified in the Limerick Rural Survey (1958–64). They included careers in the area of domestic science, teaching, nursing, the Civil Service, the bank and clerical and office work. The farmer's daughters interviewed for the Limerick survey, tended to view marriage rather than a career as their destination in life and were favourably disposed toward these areas of work, believing that they would provide opportunities for meeting men of the same social standing as themselves.[17]

While the range of professions seen as suitable for women was narrow, they did provide some limited opportunity for career mobility

and promotion, and the professional women interviewed for our study certainly had more varied career trajectories than their non-professional counterparts. They also experienced greater career satisfaction and were very conscious of the status and respectability associated with their areas of work. These points will be discussed in greater detail in Chapter Five, which examines women's identities as workers and the meaning of work in their lives.

<div align="center">NURSING</div>

Nursing, characterised by almost exclusive female membership and calling on the supposedly innate feminine caring instinct, was considered a respectable and highly suitable profession for women. By the late 1920s, the demand for places in training hospitals exceeded the available opportunities.[18] Training as a nurse in Ireland in the period covered by this study was a career option available only to those from relatively wealthy backgrounds. A substantial annual training fee of between £50 and 200 guineas was charged by hospitals and students were also required to purchase specific uniforms, shoes and coats and to supply blankets, books and other ancillary items as directed by the hospital.[19] Of the three nurses we interviewed for this study, one trained in Ireland and the other two emigrated to England to undertake their training. This was common practice and Irish women tended to select hospitals which had a tradition of training Irish nurses.[20] Training for general nursing, which was similar in both countries, was predominantly ward-based and consisted of three years of initial training followed by compulsory post-qualification work in the training hospital for a further six months to one year.

On the first of January 1959, there were 8,525 registered general nurses in the country and all but twenty-two of these were female.[21] In the same year, thirty Irish hospitals provided general nurse training. Entry into training usually involved a written exam and an interview, designed to ensure that potential students not only had the academic ability for nursing but also the appropriate attitude, personality and indeed family background. Nursing was perceived as a vocation that was perfectly attuned to the female disposition.[22] Noreen's recollection of her interview for nurse training in the Richmond Hospital in Dublin in 1940 reflected this concentration on the vocational aspect of the job. She recalled that her interview consisted of questions such as 'why do you want to be a nurse?' and 'do you like helping people?'

The nurses interviewed commented on the severity of the nurse training regime and the conditions of pay and work, which prevailed in the 1940s and 1950s. These features also caught the attention of politicians interested in health service reform at the time.[23] Probationer nurses lived-in and Noreen, who trained in the Richmond Hospital in Dublin between 1940 and 1943, remembered the military-like discipline and inspection which characterised her training:

> You'd be called at half past six and then you'd have breakfast at seven. You'd get your breakfast, bacon and sausage and a bit of bread, margarine I suppose, tea. You'd be ready to go on duty at twenty to eight and you'd go along the wards. ... The poor old probationer got the brunt of everything. She was put running here and running there, and snapped at if the nurses were in bad humour. And you were terrified when the matron would come around at twelve o'clock. Your cap would be on our head, and your uniform would be straight and your apron would be clean.

Nurses in the Richmond were also considered responsible for ensuring that all tableware and cutlery for the ward was accounted for and a missing item would result in a search of lockers and a veto on anyone leaving the ward. Probationer nurses bore the brunt of the status hierarchy, which was observed in all aspects of nursing, including the dining experience, as recalled by Elizabeth:

> When you started, you were sort of the dregs, you know. And you had big long tables and you sat at the last seat. And then as you were there three months and six months, you gradually moved up. And at a round table at the top of the dining room were all the registered nurses, the staff nurses. And oh the joy of getting up to that seat! And of course, the sisters ate in a completely separate dining room, you didn't mix at all.

Though nurses commanded much lower status than doctors, Joan D. recalled that the status differential varied in the different locations where she worked. It was particularly pronounced in the large London hospital where she trained. However in the fever hospital in Killarney where she nursed in the early 1950s, relations between doctors and nurses were cordial and friendly. High standards of morality and discipline were also expected of nurses whose social and personal lives were regulated through disciplinary techniques, such

as limited provision of late passes and frequent room inspections. Joan D. remembered the strict regime, which applied in Whipps Cross in the 1940s. She mentioned the window on the ground floor which they kept open to go out again after the ten thirty curfew.

The disciplinary regime in nurse training was accompanied by working conditions characterised by long hours and low pay. The accounts of training in the 1940s provided by interviewees who trained in Ireland and England suggest that very similar practices prevailed. Long periods of night-duty were common and no provision was made for exams or for cover for sick colleagues. Noreen recalled that during her training in the early 1940s in Dublin, 'you'd be on night-duty that time for three months at a time and all you'd get off is one night in the month … you know it was really very tough'. Joan D.'s experience in Whipps Cross in the late 1940s was similar: 'terrible hard work. Do you know what we got per month? Two pounds seven and sixpence for a whole month's work. And we did three months [of] night-duty. Three months [of] night-duty on a run and we had to do it'.

The impact of the Second World War on nurse training in London was recalled by Elizabeth. She recounted how she and other nurses raided the hospital stores to find what they could eat when they were on night-duty because they were always hungry. Nursing prisoners of war on their return to England impacted profoundly on Elizabeth, who recalled an incident with one particular patient:

> I remember when prisoners of war came back from the Japanese war camps. I remember I was a night-duty. I wasn't qualified. The war finished in 1945, it would have been 1947 when I was qualified and I remember they had beriberi and everything. And I remember one man, he was English obviously, they were sent to the hospitals near their home and it was snowing in winter and he went out and he was in a wheel chair because of his disease, he couldn't walk … and picking up the snow, and in my arrogance of youth I said, 'You must come back to bed' and all this old rubbish. And he had been in the Japanese death camp, you know, where they built a railway and I don't know how many thousands died in the building of it. … All he remembered was stifling heat so the joy of seeing snow … but I hadn't enough understanding, you know.

Elizabeth had positive memories of meeting members of the American

Air Force stationed in London during the war. One of the men was a relation of her American pen friend and a group of them frequently visited the hospital to meet up with off-duty nurses, who could accompany them to the cinema or to the dance hall.

Working conditions for trained nurses were only a limited improvement on those experienced by probationers. The long hours, the range of nursing and domestic duties expected of them and the danger of contracting illness – which was particularly acute among nurses who attended fever patients – rendered the work challenging. Noreen contracted diphtheria while pursuing an extra year of training as a fever nurse in the Richmond Hospital in Dublin in the 1940s and highlighted how conscious nurses were of trying to avoid infection, particularly tuberculosis. Joan D., who worked as a nurse from the late 1950s until the early 1970s, acknowledged that nurses were never paid well and that women in the job 'were doing it because they loved it'. In 1943 a Dáil deputy drew attention to the nurse wages and argued that some nurses were paid as little as £40 a year.[24] Nurses employed by the local authorities in 1944 earned between £75 and £90 a year while those working in voluntary hospitals frequently earned less. Only a third of nurses were in pensionable positions at that time and a standard pension scheme was not introduced until 1968.[25]

Despite the challenges of the job, a nursing qualification provided women with the opportunity to secure employment in a range of geographical and medical settings. Elizabeth was keenly aware of this and her career highlighted how a nursing qualification could provide women with continued access to the labour market through-out their lives. Having finished her training in St. Andrew's Military Hospital London in the late 1940s, Elizabeth moved to the private London Clinic because it paid better than public hospitals. In response to the high incidence of TB at the time, she undertook a further year of training in chest surgery and medicine in Dublin, and in 1952 moved to a chest surgical unit in the Isle of Wight. Encouraged by her father to return home, she took a post as a nursing sister in the Irish Army in 1953 and was stationed in Collins' Barracks in Cork until she married in 1955. Elizabeth returned to nursing in the early 1970s when she undertook further training in gastroenterology and fibre-optic investigation and continued to nurse until the late 1980s.

Nursing in the Irish Army also appealed to Joan D., who enrolled the same year as Elizabeth and was dispatched to the Curragh in

Kildare. Army nursing conferred more status but less pay than hospital-based nursing and army nurses escaped the more arduous, hierarchical work practices of hospitals. Joan D. explained that the attractions for her, were the stylish uniform and the great social life:

> we'd a great life of course because, just imagine there were seven or eight officer's messes ... there was one in Kildare and there was one in Naas and we used to be going to all them dances and everything. The social life was great.

Elizabeth also enjoyed being part of the army sports club where she played tennis and badminton but observed wryly that 'it was quite a social sort of cachet to be a sister in the Irish army but for some reason or other because of that you were paid less'.

TEACHING

Of the four teachers involved in the study, there were three national school teachers and one post-primary teacher. Two of the women, Mary G. and Caitlín, grew up in families steeped in teaching and were groomed by their parents for a teaching career. Caitlín's preparation for teaching began when she passed a preparatory college examination at the age of fourteen. She moved from her home near Fermoy to Talbot House in Dublin where she remained for two and half years before being sent to Tourmakeady, where a new Preparatory College had been built.[26] Following her Leaving Certificate in 1932 Caitlín began a two-year national teacher training course in Blackrock in Dublin, graduating in 1934. Entry into teacher training required a Leaving Certificate and successful performance in a very competitive interview process where applicants far outstripped available places.[27] These entry criteria rendered the profession inaccessible to many young women; however, possession of a Leaving Certificate qualification did allow employment as a Junior Assistant Mistress (JAM). JAMs were employable in schools of two teachers or less and were restricted to teaching junior classes. Mary K., who began work as a JAM in a rural part of Co. Kerry in 1952, availed of this option because her parents could not afford the fee for teacher training. The significantly lower payment earned by JAMs and a sense of having low status relative to trained teachers, resulted in their organising a campaign through the Irish National Teacher's Organisation for training, which would earn them parity with fully trained teachers.

This training, introduced in 1968, was provided by the teacher training colleges during the summer holiday period and it enabled Mary to eventually acquire a Bachelor of Education qualification.

The intensity and the expense of the two-year training programme provided by the teacher training colleges was recalled by Dympna, who graduated from Mary Immaculate Training College in Limerick in 1950:

> you had lecturers every single day until ten past seven at night and on Saturday you had them. You were only free from two to four on a Saturday and in that much time like, we used go down town. Might be lucky if you got as far as Woolworths and got an ice-cream. … You were free to go down that far, or you'd always nearly have to get a book. And there was one book, we were warned the very first week we came there – Needlework for Student Teachers – that if we didn't have it we'd nearly be expelled out of the college. And like it was five pounds some-thing at the time, and five pounds was an awful lot. … We never saw [anyone] on a Sunday because Sunday we saw Bishop Murphy when he was only a priest. … he used to come into us for religion every Sunday morning… and then we got so many hours to write letters. … Then after we had our lunch … we had games and in the evening our study again.

A strict disciplinary regime operated in the training colleges and Dympna recalled that each month conduct marks were received from lecturers and instructors, with each student being obliged to achieve a minimum of 60 per cent to be deemed as making satisfactory progress. Fluency in both written and oral Irish was highly prized and Irish was the most rigorously examined aspect of the curriculum.[28] All teachers had to pass an oral examination to achieve their Teastas Dhá-theangach (bi-lingual certificate) which was required for teaching.

Training for second-level teachers consisted of a three-year BA degree followed by a one-year Higher Diploma in Education. Mary G. from Cahersiveen, graduated from UCD in 1939 with a first-class honours BA Degree in English and History and a Higher Diploma in Education.[29] University education provided a somewhat less regulated educational environment than that experienced by nurses or national teachers. Mary enjoyed her time in university and despite being resident in a Dominican Hall, she enjoyed quite a bit of freedom:

> girls in first [year] had to be in at ten, at ten o'clock, yes. And then in … third and fourth year we had a night porter, a nun of

course, and she'd let you out till twelve or one. You were treated more as an adult.

The primary teachers who participated in this research had little difficulty finding work; however, they were all employed in a temporary capacity in the initial stages of their careers, often to cover for other female teachers who were having babies. All of them held a number of different posts before securing permanent employment. Pregnant teachers were allowed to employ a substitute to perform their teaching duties for two months.[30] Temporary jobs were typically sourced through information from family or community contacts or the teacher training colleges and advertisements in newspapers and professional publications such as the Irish School Weekly, which had a nationwide distribution. Caitlín acquired her first job informally in 1934 when she provided two-months cover for a woman in a one-teacher school in West Cork who was due to give birth. Dympna got her first three-week temporary job in her home town of Bantry in 1950 just days after finishing her training. Upon graduation in 1939, Mary G. was offered a post in the secondary school in Eccles Street in Dublin where she had undertaken her teaching practice.

Teaching posts required young women to assume a high degree of responsibility and this was particularly true in one-teacher schools or in schools with high student numbers.[31] As an inexperienced teacher, Dympna found her post in a Limerick City boys' school in 1950 to be quite challenging:

> Sixty senior infants, boys. There were no desks. They were in what you'd call a gallery. Ten on each step up along and you just had space down the bottom for your table and chair that you couldn't sit on because you had to be watching the whole time, like. And they were real toughies. And then if you wanted to do drawing or writing or anything with them, you had to nearly go on your knees to the teacher, who had desks.

After two months in Limerick, Dympna replied to a newspaper advertisement and to the dismay of the principal, she immediately secured a temporary post in the North Presentation Convent in Cork. While there she taught fifty-four fifth-class girls, who were all assigned to her classroom, based on their seemingly limited academic ability. Dympna recalled that 'they were very nice children, from the back streets of Cork, they were all living in tenement houses' and that the principal was supportive and very kind toward them.

While large class sizes were a disadvantage of bigger city schools, the larger staff complement meant that there were enough senior staff members to provide young teachers with support and advice. In her first permanent post in the Sisters of Charity School in Marino in Dublin in 1936, Caitlín was required to submit her weekly lesson plans and syllabus to be reviewed and signed by the principal each Monday morning. It was a practice she found reassuring, as was the support of other, more experienced teachers. In contrast, Mary K., who began her career in a one-teacher school in the early 1950s, experienced the challenges posed by smaller rural schools. In addition to her teaching she was responsible for the school and the administrative work required for the school inspection process. As noted by both Mary and Caitlín, securing teacher replacements to cover sick leave in more remote schools was challenging. When teaching with her husband in the two teacher primary school in Rathduff in Cork in the 1950s, Caitlín was obliged to teach the 100 pupils and manage the school on her own for the few weeks it took to secure a substitute teacher for her husband, when he became ill.

Teachers working in rural communities were public figures whose professional standing garnered status and respect within the locality. As discussed in Chapter One, teaching was perceived to be a high-status career particularly suited to women. Noreen, who was herself a nurse, noted that women teachers were 'a class apart', and Mary K., who worked in rural schools from the early 1950s, was acutely aware of social expectations relating to acceptable behaviour and lifestyle for a teacher. The involvement of priests and nuns in teaching appointments undoubtedly influenced expectations regarding appropriate behaviour for teachers and the interview data suggests that priests in rural parishes took an active role in the recruitment of teachers. In the period being researched the vast majority of primary and secondary schools were owned and managed by the Catholic Church.[32] Dympna's reply to a newspaper advertisement for a teaching post in the Bandon area in 1951, solicited a response from the parish priest who sent the curate to Cork to interview her. Similarly in the early 1960s, Mary K. was invited by her local parish priest in Co. Kerry to apply for a post in one of the parish schools. As well as managing schools, religious orders provided a plentiful cohort of teachers, thus limiting job opportunities for lay-women, particularly at school management level.[33] Mary G. recalled the composition of staff in one single sex girls' secondary school in Cahersiveen: 'I

remember when there were twenty-six nuns there. In the convent, you know. … No lay teacher, not one. … But you see, anyone could come in, a little postulant and if she had a Leaving Cert, she was put out teaching.'[34] The practice of employing unqualified teachers also impacted more on the female lay teachers than on male lay teachers, because schools controlled by nuns tended to employ more unqualified teachers than those controlled by Christian Brothers.[35]

The work trajectory of the four teachers involved in this research was significantly different to other women interviewed in that all of them, including the three who were married with children, had long careers spanning most of their working lives. Dympna, who married in 1955, had to resign her post, as the marriage bar introduced in 1933 obliged female primary teachers who qualified after October 1st 1933, to resign on marriage.[36] However, she recommenced work in 1959; a year after the removal of the bar. The other two national school teachers interviewed were not subject to the bar. Caitlín qualified as a teacher just before the marriage bar was introduced and was exempt from it, while Mary K. married after the bar was lifted. The removal of the bar was due to a shortage of teachers, a sustained Irish National Teachers' Organisation campaign against the bar and a belief that teaching more so than other occupations could be successfully combined with the duties of motherhood.[37] Interestingly, in the same year as the bar on married teachers was lifted, the Garda Act (1958) which provided for the introduction of female members of the force, provided for a marriage bar for female Gardai. This suggests that teaching was perceived as an occupation more suited to mothers than other careers were.[38] The strong career orientation of married female teachers in the 1930s and 1940s was evidenced in the sustained campaign they waged against the bar within the INTO.[39] Mary K.'s recollections reveal how she and her contemporaries felt about the marriage bar:

> The issue at that stage was the ban. I know it is called the bar in a lot of things but we always referred to it as the marriage ban … it affected us in every way. A lot of us who may have had boyfriends, thinking of getting married, it restricted us. Should we get married? Should we not get married?

Teachers' shorter working hours and their relatively lucrative salaries rendered reconciliation of employment and mothering responsibilities more straightforward than for women in other occupations. Teaching also provided women with very modest promotional opportunities,

particularly if they were willing to work in small remote schools, where principalships were more easily secured. Dympna, who had thirteen children and worked in the family-owned bar at night, secured a vice-principal post in the latter stages of her career. Caitlín managed her employment with being a wife and mother by refusing promotion opportunities which would require her to bring home more work, and by curtailing her engagement in extracurricular activities which would oblige her to leave home in the evenings or during summer holidays.

All of the teachers emphasised the enjoyment and satisfaction they gleaned from teaching. Good relationships with colleagues and the children they taught and a sense of achievement at having helped particular children who might have required extra support, were identified as positive aspects of their work. Teaching also provided continued opportunities for professional and career development and teachers interviewed recalled participating in summer courses and other in-service training opportunities.

AGRICULTURAL SECTOR EMPLOYMENT

Three of the women in this research began careers in the agricultural sector in the 1940s. This sector provided women with opportunities for skilled employment as cheese-makers, butter-makers and poultry instructresses.[40] Eileen D. commenced training as a butter-maker in 1940, and in 1945 Mary T. completed her training in poultry instructing. Following her profession in 1942, Sr. Paul taught summer courses in domestic and farm management in Drishane Convent and subsequently took responsibility for management of the convent farm. Entry into training courses for poultry instructing and butter- and cheese-making was usually preceded by generic one-year residential courses in domestic economy provided in colleges run by various orders of nuns.[41] Demand for such courses was in part fuelled by concern about the limited domestic economy skills of working-class Irish housewives. This concern was frequently expressed between the early 1920s and the early 1940s, with politicians, churchmen, members of the health professionals and at least one feminist campaigner drawing attention to the need for greater training in this area.[42] Domestic economy and commercial skills were the key areas of instruction provided for girls in the technical schools established under the Vocational Education Act of 1930 and although Domestic

Science was an exam subject available to girls in the Leaving Certificate, the low rates of attendance at second level meant only limited exposure to formal education in the area.[43] The expectation that young women on farms would engage in farm work generated demand for specialised domestic economy courses.[44]

In the late 1930s, Eileen D. won one of the ten Committee of Agricultural scholarships to St. Mary's College in Dunmanway, Co. Cork, which was run by the Sisters of Charity. She completed a one-year course in domestic economy and subsequently progressed to the Department of Agriculture administered Munster Institute in Cork where she completed a further eighteen-month higher level course in domestic economy. Mary T. followed a similar educational trajectory, winning a Committee of Agriculture scholarship in 1942 and attending the Presentation-run Dundrum Rural College in Tipperary, where she joined a class of fifty young women. On completion of her year's training she secured a scholarship to the Munster Institute, which she described as 'quite selective ... there were only two taken from each rural school into the Munster Institute'.[45] In addition to the Munster Institute, Sion Hill and St. Mary's, both colleges in Dublin, provided places for young women who wished to build on the training they acquired in the domestic economy colleges.[46]

The curriculum in the Munster Institute included instruction in cookery, laundry and needlework, dairying, poultry-keeping and household management. Students were involved in every aspect of the domestic and farm work and were obliged to undertake tasks ranging from washing the floors to feeding the animals. The training regime was rigorous and was embedded in a strict disciplinary and regulatory framework. Eileen D. explained that in Dunmanway College even a slight infringement of a rule would be sanctioned "Twas strict. We used go out every evening for a walk and if we looked left or right you've had it'. Despite the harsh discipline, Mary T. was positive about the education she received in Dundrum College: 'it was hard, but it was fairly educational. You learned an awful lot in a short time. You learned particularly how to use your hands, you learned how to think for yourself about what to do'. In contrast, Mary was very critical of the harsh regime in the very selective Munster Institute, where she trained as a poultry instructress between 1943 and 1945:

> It was run day-to-day by a very, very tough woman who had very, very little tolerance of children. Well, we weren't children then, but young people. Dreadful individual, put us through

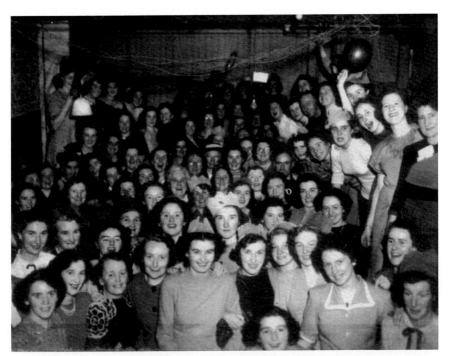

1 . Telephonists in the Department of Posts and Telegraphs at a social gathering in Cork City, circa 1940s (courtesy of Maura. C.).

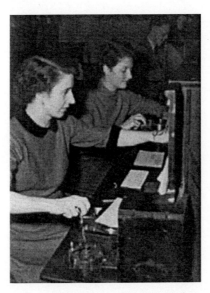

2. Telephonists at work in the Department of Posts and Telegraphs Telephone Exchange Cork City, circa mid-1940s (courtesy of Maura C.).

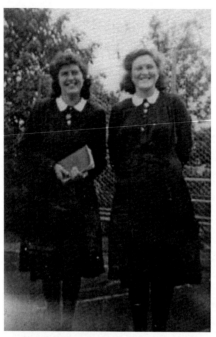

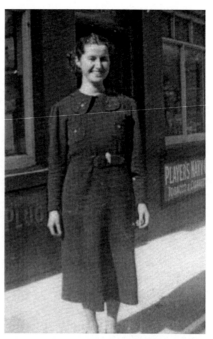

3. Dympna, on the right, with her friend Mary H. on the grounds of Mary Immaculate College Limerick, where they trained as teachers, circa late 1940s.

4. Noreen, photographed outside her mother's shop, Cahersiveen, Co. Kerry, circa 1930s.

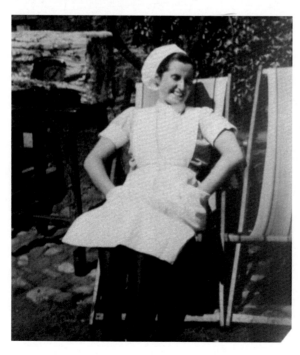

5. Noreen, training as a nurse in Richmond Hospital, Dublin, circa early 1940s.

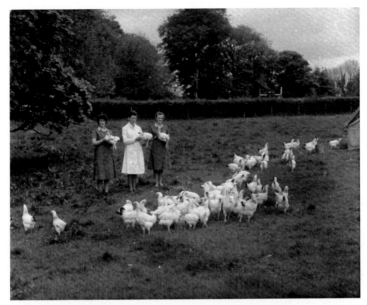

6. Poultry Instructress and Domestic Science students at Drishane Convent, Millstreet, Co. Cork, circa 1950s (courtesy of Sr. Paul).

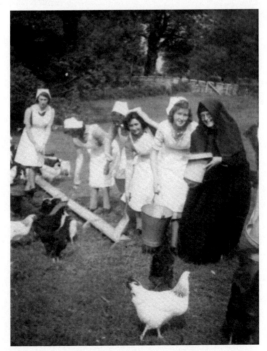

7. Sr. Paul and Domestic Science students at Drishane Convent, Millstreet, Co. Cork, circa late 1950s.

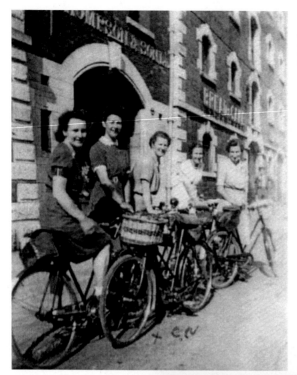

8. Chris (second from left) and co-workers outside Thompson's Bakery, MacCurtain Street, Cork City, circa early 1940s.

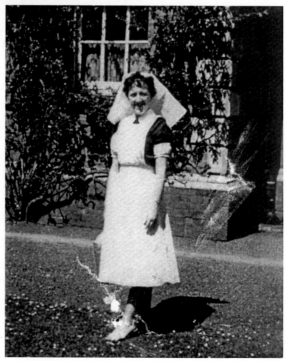

9. Joan D., training as a nurse in Whipps Cross Hospital, London, circa late 1940s.

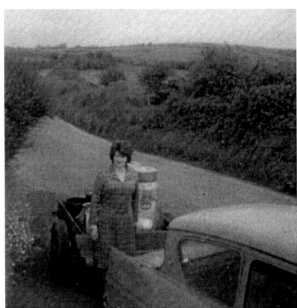

10. Bridie, going to the creamery, circa 1970s.

11. Joan G., office worker, circa 1950s.

12. Catherine W. graduating with a Bachelor of Civil Engineering in 1949.

13. Joan F. (second from left) and co-workers outside Irish Optical Company, Blackrock Road, Cork, circa late 1940s/early 1950s.

(2238) C7667. W.13425. D11. 500. 11-45. F.P.—G24.

C.S.257/5

Ġuṫán 73108.

Ein-ḟreaġra ar an liṫir seo, is
mar seo ba ċóir é sċiúraḋ :

An Rúnaí,

ḟé'n uiṁir seo—

Coimisiún na Sċáṫ-Ṡeirḃíse,

45, Sráṫo Uaċ. Ó Conaill,

Baile Áṫa Cliaṫ.

28·11·45·

Comórtas :— *Cúntóirí Áerbhreóireaċta áibrea* 45.

A Cara,

Tá orm le h-órdú Coimisinéirí na Sċáṫ-Ṡeirḃíse cur in-iúl duit gur dáilíoḋ
ċun fónaiṁ tú, ḟé mar a luaiṫear ṫíos. Má's ruḋ é, naċ féidir leat beiṫ i láṫair
ar an dáṫa san, ba ċeart duit é sin do ċur in-iúl láiṫreaċ don Roinn in ar dáilíoḋ
tú, ag cur síos an cúis, agus an dáṫa is luaiṫe gur féidir leat beiṫ i láṫair ċun fónaiṁ.

Mise, le meas,

Míċeál Ó Caṫáin,

Rúnaí.

Clár Mic Ṫiomubhaisa.

Dáilíoḋ ċun fónaiṁ.	Beiṫ i láṫair ċun fónaiṁ.	
sa Roinn.	Dáṫa	Uair
Poist agus Tilegrafa.		
Report to :-	*Saturday,*	*9·30a.m.*
The Establishment Officer,	*1·12·1945*	
Secretary's Office		
General Post Office		
Prince's St. Dublin.		

14. Letter to Clare, informing her of her appointment to a position in the Civil Service on 28
November 1945.

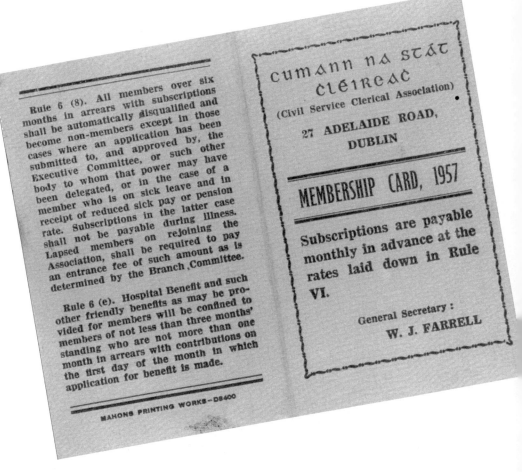

Rule 6 (8). All members over six months in arrears with subscriptions shall be automatically disqualified and become non-members except in those cases where an application has been submitted to, and approved by, the Executive Committee, or such other body to whom that power may have been delegated, or in the case of a member who is on sick leave and in receipt of reduced sick pay or pension rate. Subscriptions in the latter case shall not be payable during illness. Lapsed members on rejoining the Association, shall be required to pay an entrance fee of such amount as is determined by the Branch Committee.

Rule 6 (e). Hospital Benefit and such other friendly benefits as may be provided for members will be confined to members of not less than three months' standing who are not more than one month in arrears with contributions on the first day of the month in which application for benefit is made.

MAHONS PRINTING WORKS—DS400

cumann na stát cléireac
(Civil Service Clerical Association)
27 ADELAIDE ROAD,
DUBLIN

MEMBERSHIP CARD, 1957

Subscriptions are payable monthly in advance at the rates laid down in Rule VI.

General Secretary :
W. J. FARRELL

15. Civil Service Association Membership Card, 1957 (courtesy of Clare).

out paces all right. But you came out of the place with very, very little confidence in yourself in doing your duties. And it was a dreadful way to throw us out into a job. It was tough going.

The Munster Institute was under the control of the Department of Agriculture and was managed by lay staff consisting of poultry instructors and domestic economy instructors. The course was residential and consisted of 'a week in the kitchen, a week in the dairy, a week in laundry and a week in poultry keeping'. Student perform- ance and behaviour was monitored continuously and students who did not meet the required standard were eliminated from the course. A student hierarchy similar to that which operated in nurse training also applied, whereby students who had completed a year of their eighteen-month course were in charge of a couple of new students and as Mary T. noted, 'they were very much your junior'. Despite the challenge of the training provided in the Munster Institute, Eileen D. and Mary T. both successfully completed their training in 1940 and 1945 respectively. Their subsequent career choices provide some interesting insights into the rural agricultural economy of the 1940s and 1950s and the specific roles female workers played within it.

Training in butter- and cheese-making was under the control of the Department of Agriculture and graduates of the thirty-week training received departmental certificates following an oral examination by the Inspector of Creameries.[47] Trainees were assigned to various creameries throughout the country and received a small allowance. This was described by Eileen D., who began her butter-maker training in Coachford Creamery in 1940, as 'a pittance'.[48] Trainees worked under the supervision of the butter- or cheese-maker in the creamery. On completion of the thirty-week course, the trainee became an assistant and following a period in this capacity, was eligible to apply for a position as a cheese- or butter-maker.

Butter- and cheese-making jobs were undertaken by both men and women and in Coachford Creamery in 1940, the butter-maker was a woman and the assistant butter-maker was a man. Eileen's hours of work extended from eight in the morning until five in the evening, six days a week and she recalled the training as relatively easy: 'I had no responsibilities, and after that then I got the form from the depart- ment [of agriculture] to go cheese-making and I went cheese-making to Newmarket creamery'. The cheese-maker in Newmarket Creamery was a single woman in her fifties from Donegal, who lived locally

with her unmarried sister, who also worked as cheese-maker in another creamery in the locality. Cheese-making also involved a thirty-week training programme, however Eileen found it to be a much more responsible job than butter-making: 'You'd be in for all the mistakes then or if anything went wrong'. According to Eileen, cheese-making was very suited to women because it had to 'be handled like a baby from start to finish or else the fat would be knocked out of it. And women, mostly put care into it'. She viewed it as being very skilled work and she was a member of the Cheese-Makers' Association. After her training she secured an assistant cheese-maker post in Freemount Creamery and in 1943 she took up a cheese-maker position in Ballyagran Creamery where she was in charge of an assistant, a trainee and four other male workers involved in the cheese production process. Eileen was keenly aware of the responsibility of her position and her role:

> We'd four vats of cheese. Four vats, about four hundred gallons in each vat … I used to go to the pictures of a Sunday night … and I thought at the pictures that I'd never see the time when I didn't worry about cheese! It was on my mind, always on my mind.

Being a woman in charge of men was not an issue for Eileen, who noted that the cheese-maker before her was female and 'bossy', while Eileen indicated that she saw herself more on a par with the other workers. Indeed Eileen married the assistant cheese-maker in 1952 and left employment until the early 1960s when, as a mother of three children, she answered an advertisement for cheese-makers in a new factory opening in Rathduff, owned by a company from the Isle of Man. Eileen and her husband were both offered positions there but ironically, Eileen, who was the more experienced worker of the two, was paid a woman's wage of £8 in comparison to the £12 paid to her husband. However, their tenure in the company was short-lived as their attempt to introduce a union was punished by dismissal and this marked the end of Eileen's working career outside the home.

Poultry instructing, unlike butter- and cheese-making, was an entirely female occupation and while it provided similar opportunities for satisfying, autonomous and responsible work, it lacked the training structure and collegial support the creamery setting provided. Mary T.'s first poultry instructress job in 1945 was a temporary position with Limerick County Committee of Agriculture. In contrast to most of the workers interviewed, Mary found herself largely unsupervised and

undirected in relation to her roles or responsibilities and recalled that on her first day she met 'this terribly formidable gentleman who gave me very, very little information. He gave me my diaries and a bundle of envelopes and said to go out to start in Kilmallock'. This 'terribly formidable gentleman' was the local Agricultural Officer responsible for the male agricultural and horticultural advisers. Though it was also part of his responsibility he was decidedly 'disinterested' in poultry instruction, which was an occupation that entirely involved women. However, Mary got support from one of the Agricultural Officers in the area who introduced her to some local people and taught her how to keep her weekly working diary. The existing cohort of poultry instructresses in the area also helped to initiate her into the profession through the provision of support and advice. Mary's observations about one such woman highlights the potential poultry instructing had to provide single women with a relatively well-paid, professional lifestyle:

> there was a formidable body of women, there, just when we qualified. ... they ruled the area supreme. There was one of them in Limerick ... and she lived a different lifestyle. She had a flat in Limerick and a maid. And she served beautiful after-noon tea and she had what appeared to me, who came from a very simple background, she had this magnificent drawing room full of all kinds of antiques and what have you ...

Poultry instructresses were autonomous workers and had control over the organisation of their working day. Much of Mary's work involved responding to written enquiries from farming women about aspects of poultry-keeping and visiting them on their farms to proffer advice on their facilities and the condition of their stock. The need for assistance was particularly acute when poultry showed signs of being sick or diseased. She also organised and gave poultry-keeping classes, often in conjunction with the Irish Countrywomen's Association (ICA) and local Vocational Schools, which dealt with topics such as managing incubators, providing correct poultry housing and sourcing reliable stock.[49] The introduction of the Poultry Hatcheries Act in 1947, which provided for the licensing, regulation and inspection of hatcheries, saw poultry instructresses assuming an inspecting function and significantly increased their workload.

Growing confidence in her ability is a key theme in Mary's narrative and she attributed her increasing self-assurance to her recognition

that she was able to meet the requirements of the role: 'I was a problem solver, you know, and I did find myself able to do it, and found that there was quite a bit of job satisfaction in that'. The poultry instructress occupied a very public role in localised rural communities and Mary was conscious of the status associated with the role. Mary enjoyed a good social life and considerable popularity in her hometown as a result of being one of the few car owners at that time.[50] Attendance at events such as the annual Spring Show in Dublin, professional conferences and social outings such as the agricultural officers' dance also enhanced Mary's sense of professional identity and her connections with other similar occupational groups.

Sr. Paul, who was professed in 1942, went to the Sisters of the Infant Jesus Convent in Drishane, Co. Cork in 1939 to do a domestic economy course. The course involved poultry management, needlework, dairying and cooking and Paul subsequently taught on the course in the 1940s. She recalled that most of the students were farmer's daughters who were eager to learn. Farming in the 1940s and 1950s was still a very labour-intensive practice, in which all members of the household usually had a role. As discussed in Chapter One, the practice of one daughter staying at home to help was commonplace and domestic economy courses provided opportunities for the acquisition of new skills, and for exposure to emerging appliances and equipment which were transforming some farming and domestic practices. Sr. Paul provided interesting insights into the increasing mechanisation of farming and she explained that convent-run farms were often at the cutting edge of technological advancement, keen as they were to do things more effectively and more efficiently. The contribution of convents to local rural economies was significant and Sr. Paul described Drishane convent as a 'hive of industry' in the 1940s and 1950s because in addition to the farm, the order also managed a knitting factory, which supplied school uniforms to the local technical school and this provided a source of employment for fifteen young women from the locality.

As a member of a religious community Sr. Paul's employee status was somewhat different to that of the other women in the study, in that she was limited to work available within the order and any decision about change of employment was made in consultation with her superiors. However, the international reach of her order provided her with a variety of employment experiences, both in Ireland and in the UK, and of all of the women interviewed her career trajectory

was the most varied. Sr. Paul's working life after her profession in 1942 spanned fifty-seven years, included seven different work roles in the areas of agriculture, domestic management and parish and community work, with each of these positions being in a different geographical location. Her working life was structured by the strict time schedules of institutional living and by the demands of religious life, but her narrative suggests that she had a high degree of autonomy in her day-to-day work. In recalling her working life she concentrated mainly on her position as farm manager between 1947 and 1961. She emphasised the collaborative style of management she practiced:

> I got up in the morning at half past six ... And before I went to the chapel, I had one little round up in the yard to see would I hear any men around and if I heard them in the distance, that was enough; they were there. And I went down and I said my prayers and I had mass. And at eight o'clock I came out and came up to the farmyard and met the men who had come in to start their day's work and we discussed what was going to happen during the day. ... They'd say, 'well the turnips need to be thinned' or ''tis getting fine now, we might start to cut the hay'. I left it to them ... I would be actively involved in that I would know exactly where everything was and what everyone was doing. ... if there were repairs to be done, I would look after the repairs you know, slates or gutters or anything.

The above extract and Sr. Paul's story in general, suggests that the work and spiritual aspects of her life were well integrated on a day-to-day basis.

CIVIL ENGINEERING

Catherine W., who graduated as a Civil Engineer from University College Cork in 1949, had the most atypical occupation of the women involved in our research. As explained in Chapter One, it was her father's strong intention that she should be an engineer that predicated her entry into this male dominated profession. It was a move that Catherine's mother strongly opposed, because she thought her daughter's morality would be jeopardised by her employment in a sphere where there was a concentration of men. She wanted Catherine to pursue a permanent and pensionable career in the Civil Service

while the nuns and teachers in Catherine's convent school encouraged her to become a nun and to pursue a teaching career.

After her graduation, Catherine's father secured a job for her with a local firm of engineers and she began work as a site engineer on a hospital building project in Waterford.[51] The physical conditions on the site were challenging but Catherine emphasised the good work spirit and support and camaraderie she experienced with all grades of workers:

> I was the lowest form of animal really ... I didn't have an office to myself ... I was in the hut with the general foreman ... I started on the 5th of January ... and I used to do a lot of setting out with a steel tape, and my fingers were frozen off me ... And there was great camaraderie there, fantastic. Remember this was after the war. Things were just beginning to open up. And you know, there was a great friendship ...

Catherine was emphatic that she did not feel intimidated by the prospect of starting her first job on site. She explained that she had been accustomed to male company in college, as there had been no other female students in her class. Furthermore, Catherine was employed on the hospital project from the very beginning when only a very small number of men had been hired. She explained that by the time the 300-strong male staff was on site, she had gained confidence and was well established in her post. Significantly she also remarked that she had been conditioned by her father to be comfortable in male company and to expect similar treatment to men, an observation which highlights the key significance of childhood socialisation for women's expectations as adult workers. Catherine's hours of work extended from nine to five with one hour for lunch, and after being reprimanded by the General Foreman for turning up late on a few mornings, she subsequently attended work very punctually.

In 1961, Catherine's husband's untimely death obliged her to return to full-time employment despite having four children and being pregnant with her fifth child. She acknowledged the support of her former college friends, who tutored her and gave her the confidence to successfully apply for a job with the Office of Public Works. However, she found this job, which was office-based, to be extremely boring and unchallenging in comparison to her earlier work on the building site. Earning only 80 per cent of what her male colleagues

were earning and being acutely aware that she had no prospect of promotion, she was spurred on to apply for work to the County Council, where a gender pay differential did not apply. Catherine subsequently got a job in Dublin County Council, and recalled that it was in that post that she first began to view her work as a career as distinct from a job, inspired as she was by a boss, who was 'totally devoted to roads'. Her work involved concrete road design and Catherine also had responsibility for preparing the documentation for contractors tendering to build sections of the Naas dual carriage-way, which she worked on at the time. The job was predominantly office-based and involved working on road drawings at long desks with drawers equipped with the maps and other materials she needed. However, Catherine also had opportunities to go out on site when she replaced engineers on holiday leave and this gave her great insight into the practicalities of road building and the challenges involved in progressing a project from the design stage onwards. It was this extensive background in concrete road design and building, which she believed enabled her to eventually secure a permanent job in Cork County Council as an Assistant County Engineer, a post she held until her retirement in 1982. Catherine's story, while representing the potential for women to enter and succeed in non-traditional spheres of work, also highlights the significant barriers that had to be overcome to pursue such a career. These challenges are discussed in more detail in forthcoming chapters.

PERCEPTIONS OF PAY AND STATUS AMONGST PROFESSIONAL, OFFICE AND CLERICAL WORKERS

Most of the professional workers in the study acknowledged that they felt very fortunate relative to other workers at the time, because they had earned reasonably good salaries, (see Table 3.1).[52] Mary T. recalled that her wage as a poultry instructress in the 1940s was considered very good, while Catherine W. also reported that she was earning a very good income in the 1950s when employed as a civil engineer on a building site. Teaching was also considered to be a well-paid occupation of some status and Noreen remarked that teachers were 'very looked up to' because of their salary. However, as discussed earlier in the chapter, nurses received a relatively low rate of pay, a fact which all of the nurses involved in this research drew attention to, noting that they found it particularly difficult to survive

TABLE 3.1: STARTING SALARIES AND SALARY SCALES IN PROFESSIONAL JOBS

Profession	Yearly Starting Salary and Salary Scale	Year
Poultry Instructresses and Butter-makers	£280 rising to £470 with annual increments	1949
National School Female Teachers	£210 (18 increments - £386)	1949
Junior Assistant Mistresses (JAMS)	£160 (8 increments - £226)	1949
Secondary School Teacher	£209 (average school salary)	1955
Office of Public Works Junior Engineer	£200-£350, commensurate with qualifications and experience	1936
Just Qualified State Registered Nurse	£70	1949

Note: There were 20 shillings in one pound (£) and 12 pence (d.) in one shilling (s. or /-). 7/6 means 7s. 6d.

Sources: *Irish Press*, 'Any Jobs Going? Nurse', *Irish Press* (24 October 1949), p.2; 'Any Jobs Going? National Teacher', *Irish Press* (8 November 1949), p.2; 'Any Jobs Going? Poultry Instructress', *Irish Press* (16 December 1949), p.2. The secondary teacher's salary was sourced from Cunningham, *Unlikely Radicals*, p.127. The Junior Engineer's salary was sourced from an Irish Press advertisement entitled 'Positions Vacant – Civil Engineers', *Irish Press* (7 October 1936), p.8.

on their wages when training. Elizabeth commented that nurses in training spent their wages so quickly, that it was 'penury' for the rest of the time. Joan G. remembered how shocked her nursing friends were to discover that she was paid much more than them as an office worker in the 1950s and she believed this to be unfair, as her experience of working in hospital administration had made her keenly aware of the fact 'that nurses worked so hard' in comparison to office staff. Maura C.'s experience also highlighted how some Civil Service jobs held by women paid well relative to some male Public Service posts. When they married in 1951, Maura's job as a telephonist paid slightly more than her husband's job as a local authority fire officer. Some private sector office jobs also paid well (see Table 3.2) and Ena recalled that when she decided to marry in 1958, her mother had reservations about her resigning from a job which was paying her £9 a week. A few years later in 1966 when Helen resigned from her office job, she was earning a little over £9 a week, which according to her, was considered a good wage at that time. Despite having relatively good earnings, the professional and clerical/office workers we interviewed appeared to be financially prudent and stories about spending earnings foolishly or exercising little control over spending were rare. Only three women represented themselves as being poor

financial managers and significantly they were women whose families did not depend on their earnings to bolster family finances.

TABLE 3.2: SALARIES OF OFFICE WORKERS AND CIVIL SERVANTS, AS REPORTED
BY RESEARCH PARTICIPANTS

Position	Respondent	Weekly Salary	Time Period
Factory-based office job (dispatcher)	Catherine O'D.	10 shillings	1931
Secretary	Pauline	12/6	1935
Accounting Machine Operator	Chris	15 shillings, increased to 25 shillings	1939–1940
Shop Cashier	Eileen C.	25 shillings	1940
Shop-based office worker	Maureen	15 shillings	1943
Telephonist	Clare	29/11	1945
Writing Assistant	Clare	£2-2	1946
Telephonist	Maura C.	33 shillings increased to £3-6	1946–1951
Shop-based office worker	Joan G.	£1-4	1950
Invoice Clerk	Mary O'S.	25 shillings, increased to 30 shillings	1950–1952
Office worker at Builder Providers	Mary O'S.	£2	1952
Shop-based office worker	Ena	£9	1958
Ledger Clerk	Helen	£9	1966

Note: There were 20 shillings in one pound (£) and 12 pence (d.) in one shilling (s. or /-). 7/6 means 7s. 6d.

CONCLUSION

Of the professional women we interviewed, all but two were engaged in gender stereotypical careers. One woman accessed farm management but only because she had entered religious life and another worked as a civil engineer at a time when this was virtually unheard of. The concentration of women in professions and jobs considered suitable for women succeeded in keeping them off a career track and facilitated wage and other kinds of gender discrimination. It

is hardly surprising that nursing, which had the highest concentration of women, was very much viewed in vocational terms and both the pay and conditions were perceived as being much poorer relative to other professions.

The residential training for professions in agriculture, nursing and teaching instilled values of discipline, deference to authority, punctuality and responsibility. In their training women were socialised into being dutiful workers, who could survive in workplaces which were strongly hierarchical, authoritarian and bound by rules. In offices women were also confined to female-only enclaves, where they often started at a junior level and were very much subjected to the authority of others. Office work was sometimes considered a better employment destination for women than nursing on the grounds that it was less labour intensive, well remunerated and required less training. Posts in the small number of professions open to women, along with clerical and office jobs, were coveted by both middle-class daughters and parents as they were seen to provide protected, regulated and pleasant working environments. The promise of a paid pensionable position in the Civil Service also proved very attractive at a time when middle-class women's opportunities were limited and accessing further education was the preserve of a minority. The potential to travel, to earn a relatively decent wage, to wear a uniform that conferred status, to discriminate and make choices between job offers were aspects of professional careers that were less common in non-professional occupations.

Most of the women who returned to full-time employment in the area of work they were in prior to marriage worked in professions, which indicated the advantage of having a dedicated training in a specialised field. The professions, and to a lesser extent the Civil Service, provided women with the opportunity to exercise a degree of autonomy in their work, to seek and gain advancement, to exercise employment mobility, to pursue their career interests and, on a few occasions, to upset the gendered order of things.

Constructing and Reconstructing Working Identities: Wives, Mothers and Single Women

In this chapter we put the spotlight on how individual women experienced and engaged with prevailing cultural images and discourses of femininity, and we consider what frameworks of understanding they drew on when constructing their identities as working wives, working mothers and single working women. A particular focus is put on women's experiences of leaving employment to become wives and mothers and their experiences of combining the roles of home-maker and paid worker. This chapter also seeks to explore the power relations which existed between married couples within households and in particular considers how access to an independent income or the generation of independent earnings impacted on these relations.[1]

Of the forty-two women interviewed, four remained single, one entered religious life and thirty-seven married. Thirty-six of these married women subsequently became mothers, and the majority of the married women resigned from their employment upon marriage or their first pregnancy. Significantly, however, twenty-eight of these women undertook some form of paid employment or income-generating work at some stage of their married lives. Women's transitions from the role of paid worker to unpaid domestic worker and mother are considered first, and attention is then focused on ways in which women remembered and explained the loss or re-adjustment of their worker identities following marriage and motherhood. Specific attention is also given to the work trajectories and identities of the four women who remained single throughout their lives.

Academic analysis of women's experiences of Irish society in the first four decades of Independence has, for the most part, emphasised

the legislative, religious and socio-cultural factors that promoted motherhood as the appropriate role for married women and discouraged their participation in paid employment and in public life in general.[2] Some commentators have however posited more nuanced readings of this period arguing that while there were serious restrictions to married women's rights as workers and citizens, these restrictions were not consistent enough to constitute a totalising ideology of female domesticity, and that economic factors were as significant as ideological ones in shaping women's employment trajectories.[3] For instance, Clear points out that a marriage bar was in operation, but married women were not prohibited from engaging in factory or service work, from professions, farming or labouring. She acknowledges that the attacks on women's rights were substantial, but at the same time too piecemeal to constitute an ideology.[4]

Undoubtedly, legislative and policy initiatives in the new Irish State significantly hindered women's equal participation in the labour force. Married women confronted particular barriers to equal partici-pation; the prohibition of contraception being the most obvious and pertinent example.[5] The legal and social endorsement of motherhood in the 1937 constitution reflected contemporaneous beliefs which were widespread in Western society and supported by both religious teaching and popular culture and by the employment and welfare contracts which emerged in many post-Second World War European states.[6] The legal barriers to women's participation in the labour force were compounded by the discriminatory conditions of work they experienced. The practice of paying women lower wages for work similar to that being carried out by men continued until the enact-ment of the Anti-Discrimination (Pay) Act in 1974. Pregnant workers were not accorded any specific rights until the passing of the Maternity Protection of Employees Act in 1981. Furthermore, the tax and welfare system was based on a male breadwinner model and was intrinsi-cally biased against female employees and, in particular, married female workers. In 1926, 90.3 per cent of all married women described themselves as being engaged in home duties; this figure had risen to 93.7 per cent by 1961.[7] Married women's participation in the formal labour market remained static at around 5 per cent from the 1920s to the 1960s. Those recorded as working were, for the most part, employers, self-employed or assisting relatives, with only 8,000 being classified as employees in the 1926 census.[8]

Irrespective of whether the legislative and policy measures which

framed women's engagement with the workplace represent a 'domestic ideology',[9] there is a compelling body of evidence that highlights the way in which an ideal of maternal domesticity was strongly promoted. Catholic clerical commentators both eulogised and castigated Irish married women in relation to their role as mothers, while Irish women's magazines of the 1930s also promoted an ideal of domesticity characterised by marriage, motherhood and full-time home-making.[10] The female ideal codified in cultural images was undoubtedly one which emphasised a domestic, nurturing and dependant role for women. This view was mirrored in the rudimentary Irish welfare system, which further institutionalised the male bread-winner/female home-maker model. The universal children's allowance payment introduced in 1944 for third and subsequent children was, after some debate, paid to the father in recognition of his role as the primary family breadwinner.[11] It was within this cultural and legislative milieu that women made decisions about marriage, motherhood and paid work.

MARRIAGE DISCOURSES: BECOMING WIVES AND MOTHERS

The women's accounts of decision-making around marriage indicate that a range of factors (aside from romantic considerations) impacted on their decisions in this regard. Mary K. ended a relationship with a public servant in Dublin in the 1950s because she could not get employment as a JAM in the city and she was unwilling to give up a job she dearly loved. Mary T., who held a well-paid job as a poultry instructress, shied away from marriage and motherhood for a period, considering that it was not what she wanted at a time in her life when she had many friends and was part of a busy social scene. Similarly, Joan D. recognised the appeal of being married but was not willing to settle for a marriage that was not meaningful to her. Despite having a gynaecological problem, which she believed rendered her a less desirable marriage partner from the perspective of suitors, Joan rejected an offer of marriage from someone whom she did not love.[12] Significantly, she acknowledged that having a nursing career – which afforded her opportunities to travel and socialise – was a significant consideration. After fifteen years of a nursing career Joan married a widower to whom she had always been attracted and happily embraced both marriage and motherhood.

Despite the fact that some women gave considerable thought to

the desirability or otherwise of marriage, all of their accounts revealed
a keen awareness of the cultural prescription of marriage as the most
appropriate role for women. The life trajectory, which women
expected to follow, was succinctly described by Rose, who left school
in 1954: 'meet somebody and get married and that was it, you didn't
work anymore then usually'. Expectations of marriage caused
women to limit their aspirations around employment and their
narratives consistently construct marriage and employment as dual-
istic opposites. Muriel, who resigned from her office job when she
married in 1950, emphasised the self-regulating nature of married
women's resignation from employment and her retrospective regret
about her compliance: 'Well, everyone did it, so, I suppose you just
took it for granted … you just did what everybody else did at that
stage, but if I had my life over again, I wouldn't do that. I would be
more independent. I would not give up…'. Clare believed that
acceptance of the male breadwinner ideal was at the core of this
'taken for granted' attitude among and toward married women
workers:

> I think that the attitude then was – don't forget that this was a
> time of severe unemployment – and the attitude was, and it was
> certainly my attitude, and I'd say it was generally held, that it
> would be unfair to have one household with two people working
> and another household with neither working, that it was fairer
> all round to have one breadwinner.

As a civil servant, Clare was obliged to resign when she married in
1957. Unlike Muriel, she had no sense of grievance about this, being
firmly of the opinion that for her motherhood would take priority
over employment. The expectation, and in most cases the reality, of
pregnancy early in marriage framed women's explanations of why
they left work. However, it is significant that quite a number of
women continued to work in the private sector for the period imme-
diately following marriage and before their first pregnancy. It was
pregnancy, and not marriage, which precipitated Joan F. to leave her
factory job four months after her marriage in 1956. Similarly, Helen,
an office worker, continued in her job for some months after her
marriage in 1965 and resigned only when she became pregnant. Alice
also framed her exit from employment in the early 1960s as an issue
of childcare responsibility: 'When I had my first child, I had to leave. I
had to mind him. There was no one to mind him'. Elizabeth's husband's

career required frequent relocations. Elizabeth, who acknowledged her unquestioning acceptance that she would resign her nursing job upon marriage, did engage in part-time work in the early years of her marriage but she viewed this employment as insignificant: 'It was convenient and I only worked part-time anyway, pin money'. The use of the term 'pin money' suggests that Elizabeth's participation in employment was not motivated by what she earned. However, it also reveals how women's economic contribution might have been diminished by themselves and others.

Doireann, who married in 1958, also recalled how unquestioning she was of the practice of married women leaving their jobs and her account, like those of many others, highlighted the absence of an alternative discourse on married women's roles: 'Sure we didn't know any better. That's the way it was. You sort of got on with it then. The man was coming in and he was the breadwinner'. Almost a decade later, Joan G., who was obliged to leave her Public Service job as a typist in Kerry County Council recalled a similar sense of acceptance: 'I didn't think anymore about it because we were conditioned into that. ... When you married, you gave it up. ... And of course you'd get money. You'd get a gratuity, like, for every year that you worked'.

The marriage gratuity was mentioned by many women, and as Kathleen F., a factory worker who received £10 when she left work in the mid-1950s, noted, '£10 was a lot then'. Dympna, who was legally obliged to resign her teaching job in 1955 due to the marriage bar, also highlighted how significant the marriage gratuity could be to the finances of newly married couples: 'I got a gratuity of £120 when I got married ... I owed it all!'[13] The gratuity symbolised women's shift from being independent workers with an associated insurance relationship with the State, to being financial dependents on their husbands with no separate insurance entitlements. Margaret's concern about the dependency which giving up work would provoke was a source of some debate in her marriage in the mid-1960s:

> I would have thought of working but there was no way my husband was going to hear of me working. That was another thing that was taboo at that time ... I think their (women's husbands') idea in some senses was that it was their job to provide for you and your job was in the home. ... Now I was bursting to go out to work because I liked the thought that I could earn money and provide for myself if it came to it. And no way would he hear about it.

The cultural imperative for men to be breadwinners, the threat to patriarchal power and husbands' earnings that women's employment generated, was at the core of Margaret's husband's opposition to her working:

> ... your tax was effecting his then, they don't like that ... I suppose he was reduced money then and he just didn't seem to like that. Like, it was a thorny issue for a number of years, but then after two and a half years, when we had our first child, that kind of put working on the back burner anyway ...

TRANSITIONS TO DOMESTIC ROLES

The women's accounts of the domestic situations in which they found themselves emphasised the potential for marriage to be both a source of satisfaction and fulfilment, and a site of dependency and confinement. The narratives suggest that while some women entered marriage with a very romantic understanding of what it would mean in terms of a transition from the routine drudgery of employment, a minority were wary of the potential limitations marriage, and particularly motherhood, might generate. Catherine W., who left her job as a civil engineer when she married in 1953, never entertained the prospect of continuing her career after her marriage and she enthusiastically embraced the prospect of becoming a home-maker and mother:

> I was delighted. ... Oh God, I remember walking up the aisle ... babies, I was going to have loads of them and of course they didn't need any work. I knew nothing about anything and I floated up the church. That I'd be with him for the rest of my life and no going back to work ... I never have to go to work again, isn't that marvellous!

In contrast, Mary T., a poultry instructress who also married in 1953, foresaw the potential disadvantages of marriage and homemaking for women: 'I mean I was looking for a man alright but not to marry ... I thought God how can they do that, they (women) give their whole time talking about feeding babies and changing them and that sort of thing. I thought dear God, protect me from that'.

Despite these reservations and Mary's admission that she found it 'difficult enough to adjust' to leaving work and beginning married life, she also employed a discourse of romantic love to explain how

her relationship with her husband compensated for what she stood to lose by marrying:

> I was very much in love with my husband. I mean he was the only thing that mattered. Do you know that sort of thing? ... Real romantic sort of stuff ... He certainly replaced everything there was, you know. ... The peripheral losses were there all right, but I don't know how aware of them I was. I was a little, of course I was ... but they didn't cause me a lot of concern.

Some young women, who had always lived at home under parental surveillance, thought at the time that married life promised liberation. Maura C., a telephonist who married in 1951 at the age of 24, was 'thrilled' about the independence and freedom which she perceived marriage would bring: 'I was going to a new life altogether and I could stay up as late as I liked'. Mary O'S. also recalled her optimism about marriage as a young bride of 23, 'you looked through, at that time, rose-coloured spectacles and sure I was very happy'.

The social isolation occasioned by leaving work and assuming a full-time domestic role was commented on by a minority of women. Joan G. resigned from her position as a typist with Kerry County Council when she married in 1966 and moved from Tralee to Cahersiveen where her husband worked:

> Like, the house, the four walls closed in on me, because I was, what will you say, when you worked with people and you have company and you're out and about ... isolation ... I couldn't have stayed living here if I hadn't been out and doing something.

Joan's account of motherhood and married life clearly highlighted what Summerfield refers to as the 'emotional discomfort of changing roles'.[14] The limitations, which maternal responsibilities put on opportunities for further training or employment, were emphasised by Mary F., who married in 1958 at the age of 20. Mary regretted her lack of training for any specific occupation: 'after getting married and everything, you know, I wished I had gone and done things, like ... but it was too late then because the children were all small so you had to ... you had to stay'.

In the main, however, women's accounts of their domestic roles drew on essentialist discourses about women's capacity for nurturing and caring and cultural constructions of motherhood as the primary

vocation of women. This image of maternal nurturance clearly influenced the framework of understanding most women employed to explain their decision-making about employment. Roberts's oral history studies of working-class communities in the North of England in the periods from 1890 to 1940 and 1940 to 1970 also indicate support for the ideal of married women being home-based carers, even in families where mothers were forced through financial need to work outside the home.[15] Catherine O'D., a dispatcher in a sweet factory, gave up her job when she got married in 1940. She was acutely aware that the prevailing expectation of married women was motherhood and child-rearing: 'I mean when you married you married for good. ... And you married for ... if you were blessed with children well you were to stay at home and mind them till they were, you know, adults. ... It was an unheard [of] thing, women going back to work in those days'.

Many of the women interviewed reiterated the prevailing view that mothers were at the heart of the home and the family, and that they had special qualities for this role which men did not possess. Kathleen F. made this point: 'Women have the children and the women are geared for children, I think. ... But in family life, I think, the mother has a more important role than the man'. Maureen, who married in 1942, voiced a similar opinion: 'and a mother had something. She mightn't have thought so herself but I mean she was the focus, the pivot of the home really'. Maureen's description of a typical Sunday in her home highlighted the pride and satisfaction associated with her role and included an implicit challenge to constructions of full-time home-making as drudgery: 'But in my day, it was Mass and then you got the dinner and you baked and you kind of ... and they all trouped in and there was a high tea then. You maybe baked again in the afternoon. It sounds like drudgery but it wasn't. It was home'.

The belief that maternal care was vital to the wellbeing of children was widespread. Joan F., who resigned from her factory job when she got pregnant in 1956, emphasised that as a mother her primary responsibility was to be present in the home and available to her children.[16] Assessing her life as a home-maker during the interview, she described how she felt personally fulfilled by what she recognised as the role prescribed for her: 'But the women stayed at home. I did anyway and my children were my life. I was quite happy actually'. Mary M. expressed concern that women working outside the home in contemporary society have less time and energy for the emotional

labour associated with motherhood. She elevated the significance of her own role as home-maker when she positively contrasted the way her family spent their Sunday at home with how young couples spend their Sundays now:

> But in my day it was ... home, it was family, it was love ... now where is that? ... They are trouping off to lunch someplace, like the mother is tired after the week and the man has been working too and all the kids are hawked along and there is pandemonium. Sure more often or not then children are brought into pubs ... Where are we going?

Like Mary, Clare believed that contemporary women who combined careers with motherhood were 'marvellous' but she also thought women were 'stretching themselves' and that there may be negative implications for children. The interview data reveals that many women still held on to traditional views of men and women's separate roles in society as best for society and best for children.

POWER RELATIONS WITHIN MARRIAGE

For women who were dependent on spouses who did not or could not provide adequate finances for the family, or who were patriarchal, home-making was an onerous task. Mary O'S., while positive about her role as a full-time home-maker, was keenly aware that some of her contemporaries had less favourable domestic situations: 'My husband was very good to me always and I always had plenty ... but as I said ... for women who didn't ... life was extremely hard ... particularly if you have children and if you couldn't go out to work'. Kathleen F.'s marriage in 1954 heralded difficult times in terms of financial need, poor housing, frequent childbirth, hard physical work and the burden of managing the household income. Not surprisingly she viewed being a wife and mother as important roles but also as demanding and limiting for women: 'All life stopped when I got married. I had eight children in twelve years so that put a stop to my gallop'. After spending the first five years of married life living with her father and subsequently in rented flats, Kathleen got a corporation house some distance from her native part of Cork City. She found the five months she spent in it to be 'the most miserable five months of my life ... I saw no hope whatsoever up there'.

The support that women in difficult situations could draw from

the informal networks which existed in close-knit communities was highlighted by Kathleen, and she recalled with feeling how significant it was for her to return to a two-bedroom corporation bungalow in the neighbourhood where she grew up.[17] The support network and sense of belonging which relocating to her own community provided made her cramped conditions bearable:

> They were all small. Michael (son) was in a single bed, with the baby at the time. And the five of them were in a double bed … And Paddy and I had the double bed in the small box room. … It was like heaven, I cheered up again then. Life wasn't too bad at all then again back in the old place.

Kathleen believed that her family's experience of struggling to survive on the finances her husband provided were not unusual: "twas a man's world that time. It definitely was, like. The husband handed up a certain amount and he could go off, pinting and you know … All the men I knew at that time, they all did it, like. You very seldom got a husband that put his wife first'. Kathleen acknowledged the isolation and the lack of independence women could feel within marriage, and the demoralisation associated with the lack of any personal income. The solidarity and material support she received from her sisters in England was significant for Kathleen, and she vividly recalled the pleasure of a holiday with them for which they provided the ticket and the clothes to wear: 'It was heaven, heaven. The first time in twelve years being out'.

Mary T., who in her capacity as a poultry instructress visited farming women in rural Ireland during the 1940s, noted the poor conditions in many households.[18] Furthermore, she was acutely aware of how women could experience home as a place of confinement and control, particularly if husbands assumed very patriarchal roles:

> You had many instances in Ireland of course where men were notoriously mean … There are many women, who never saw any money. … That was the only money they had (poultry money). Most of them educated their children with their poultry money. … They would have improved things in their houses, you know. This was during the time when rural electrification came in. … They (farming men) resented any kind of intrusion in their lives … the fact that you (a poultry instructress) were going in there and helping her, perhaps to become more independent.

Bridie made similar observations about the dominance of men in some homes and their perceived status:

> Oh, men were the bosses. And they were looked up to. Women didn't have much of a say at all like now. ... They weren't treated as the head of the household, we'll say. It was the man, whether he was wrong or right, or whether he drank, or what he done, he was still head of the house and his say went.

Significantly, women who referred to power differentials and difficult experiences within marriage did so generally and did not provide direct commentary on their own relationships with their husbands. While three women did identify that their husbands did not prioritise the family in terms of financial provision, they did so in short oblique comments, which indicated that while they were acknowledging the fact, they were reluctant to discuss it further. One woman noted that her husband 'was a bookies clerk and he liked betting too much', while another remarked that when her husband died he was missed most by the pubs in town but that she 'wouldn't say no more about that'. A third woman commented that her husband 'didn't hold down many jobs at all, temporary work here and there'. Only one woman provided a detailed account of discord with her husband and offered a coherent critique of the powerlessness of women within marriage. She argued with her husband over his insistence that she give up work when they married in the 1960s. Her continuous efforts to generate an independent income during her marriage, whether through paid employment or through home-based work, was motivated by her desire to avoid complete financial dependence. She recounted how an argument with her husband once caused her 'to ... think deeply about one's situation as a female, that really, if things weren't working out for you, you're entrapped, if you don't have financial means. So then I looked for this job ... like, having my own money was to me very important as a security for myself'.

The theme of having to accept one's lot as a married woman was indeed evident in a number of interviews. Noreen, who married in 1944 and worked until retirement in her husband's family drapery shop in Cahersiveen, described her marriage as 'very happy'. She was conscious, however, of the difficult situations other women were obliged to endure: 'women had nothing in the 1940s. If they wanted, they couldn't leave their husbands because they had no other security. ... Women put up with a lot. An awful lot. There's no doubt about it'.

Doireann, who married over a decade later in 1958, expressed a similar sentiment about the cultural and religious construction of the marital unit as indissoluble and remarked that women's own families were frequently unwilling or unable to provide an escape route in the context of a difficult marriage: 'Whether you had it hard or soft, you never came back and cribbed'.

WORK AFTER MARRIAGE

A significant number of women engaged in income-generating activity after marriage, despite their apparent adherence to the prevailing domestic and maternalist discourses and practices. Thirty-seven of the forty-two women who took part in the research, were married and twenty-eight of these women engaged in some form of income-generating activity at some stage of their married lives. However, only four of these had continuous work trajectories that were not disrupted by marriage. Two primary school teachers, one of whom was in employment before the introduction of the marriage bar in 1933, and the other, who did not marry until after it had been removed in 1958, continued in their careers and combined teaching with motherhood. Noreen, who joined her husband's family drapery business when she married, had no children and continued to work in the family business until retirement. Joan N. worked throughout much of her married life as a farm labourer alongside her husband while also raising fourteen children.

The majority of the women who combined income-generating activities with their domestic roles did so to supplement or replace a husband's earnings. The exception in this regard included teachers for whom financial need was not the motivating factor in their continued employment. The three primary school teachers in this research all had husbands who were in employment. Married women's continuation in teaching was in part due to their desire to continue working. Mary K., a teacher who herself was not affected by the ban, recalled the reaction of many married teachers to the lifting of the marriage bar in 1958, noting that they were 'absolutely delighted that the opportunity had come for them'. Even afterwards, Mary noted that her desire to keep teaching influenced her decision about whom to marry. As a Junior Assistant Mistress, Mary was only eligible to teach in small country schools and she consequently restricted her consideration of potential marriage partners to

individuals who lived in locations where she could find employment. In contrast to many other women in this study, none of the three married primary school teachers saw their employment as undermining their mothering capacities, or identified childcare as a barrier to employment. This may be a reflection of the fact that their employment was with children and hence was culturally acceptable, while their hours and conditions of work were such that reconciling employment and motherhood was financially and logistically easier for them than it was for women in other forms of employment.

Apart from the teachers, most of the other married women who took employment or engaged in money-generating activities did so for financial reasons and worked primarily on a part-time basis. Some of these women reconciled the physical division of workplace and home by developing enterprises which could be undertaken within the confines of the home. Joan N.'s work as a farm labourer was a contractual obligation of her husband's employment as a labourer on various farms through the 1940s and 1950s, and Joan and her family usually had accommodation on the farm.[19] In the mid-1940s, when her eldest child was only eighteen months old, Maureen accepted the offer of a home-based book-keeping job from her former employer. The job involved the calculation of sales dockets from a drapery store to track stock levels. Although the payment she received was very low and her husband was obliged to assist her by collecting the dockets from the shop and by taking two-days' holidays from his own job to do an annual stock-take with her, Maureen continued the job for many years as it fitted in well with her domestic circumstances. Alice knitted and sold Aran jumpers to add to the family's finances, while Bridie reared and sold cows, pigs and poultry on her smallholding in Co. Limerick, using the money for Communion and Confirmation outfits and for other family expenses.[20] Maura D. and her husband, who married in 1944, also worked together, running a chip shop in the evenings. When they closed this business in 1960, Maura prioritised the need to find another source of income:

> But when I gave up the chipper in 1960, I had only 6 girls and 2 boys. We had time on our hands. ... I couldn't stay idle. So I made him (her husband) get enough together to get a chicken hatch and I bought chickens. I sold eggs ... I baked, I did a lot of things and reared two pigs.

The income-generating activity of women in the home during these

decades complicates any stereotypical notion of women as completely financially dependent and draws attention to the ways in which some women added a public dimension, albeit a modest one, to their private lives. It is significant, however, that when recounting stories of their engagement in employment or income-generating work, most of the married women keenly emphasised that their motivation was to meet the needs of their families rather than to acquire funds for their own personal use. Doireann's return to part-time employment as a drapery assistant in Dunnes Stores in 1972 was motivated by her desire to purchase her corporation house and she justified her decision to work as a selfless one informed by her commitment to the welfare of her family: 'I didn't do it for pin-money. I didn't do it for cigarettes and drink'. To minimise disruption to her domestic role, Doireann negotiated evening hours on Thursdays and Fridays and a full day on Saturday. Financial need also prompted Alice's return to work. She recalled the limited resources she had when she married in 1961:

> Jimmy's (her husband) wages were £6, mine were £5. I mean loving God. You'd pay 13s. rent for a little cottage down in Blackrock that had no water only a pump and a Nissan toilet. Dry chemical toilet we had, out the back ... We had to pay our light bill and our gas bill. The two of us used to smoke. ... We had to have our coal ... When I was having Mary I was saying, 'Jesus, how will I manage?'

These financial constraints spurred Alice to return to work as a presser in a dry cleaners in the mid-1970s when her youngest child was five. Their husbands' ill health prompted Maura C. and Elizabeth to return to their former jobs following some years of home-making. Maura resumed work as a telephonist in the early 1970s and Elizabeth returned to nursing in the same period. Three of the women interviewed were widowed at a young age and all returned to paid employment; two on a full-time basis and one in a part-time capacity.

Only a minority of the women who returned to work did so for reasons other than to increase the financial resources of the family. However, as mothers of older children, a number of women sought out work as a way of remaking or extending their sense of self. When Muriel resigned her secretarial post after her marriage in 1950, she found full-time home-making to be isolating and she yearned for the camaraderie of the workplace: 'I felt I had missed out on life and I

felt I had missed out on the company of other people and I said, you know, am I going to spend the rest of my life just at home?' The part-time job Muriel took as a shop assistant in 1969, when her youngest child was seven, provided her with a source of companionship and fulfilment: 'My youngest was at school and I took up a job again ... I was meeting people all the time ... and I was working with other women, which was great ... and that was a whole new life to me'. The majority of Muriel's colleagues were other married women, which created a supportive work culture for reconciling home and work responsibilities: 'we were all married, we all had children and we would swap around with one another'. Like Muriel, Joan G. sought part-time office employment as a means of counteracting the isolation of home-based mothering and a way of increasing her confidence: 'women going back to work, like, you know, after marrying. It gave them a great, how will I say, a great confidence, where as when you married, you went into four walls you know'. Joan H. took up part-time bar and shop work in the 1970s as an opportunity to meet people and, while her earnings helped with the rearing of her children, she acknowledged that money was not her primary motivation as her husband always threw 'his pay packet up on the table'.

Children getting older or reaching adulthood prompted other women to seek out work. In the 1970s Pauline engaged in part-time work with a market research firm, Ena found an outlet for her love of fashion and meeting people by opening a boutique, and Kathleen O'R. took a cleaning job. This group of women sought out work opportunities to add another public dimension to life, usually at a time when their children were older and required less of their time. They displayed different constructions of self at different stages in their lives and experienced different engagements with the labour market and with the dominant constructions of wife and mother at various stages of the life course.

COMBINING EMPLOYMENT AND MOTHERHOOD

Married women who combined motherhood and home-making with paid work traversed the boundaries of family and workplace and forged identities which held in tension their dual roles as paid and unpaid workers. For most women who combined employment with motherhood, their identities as home-makers remained dominant

and shaped and curtailed their engagement with the public sphere of work. The tension between their identities as worker and as carer was particularly pronounced for women who had taken up full-time work in professional positions after widowhood.[21] Mary T., a poultry instructress, was widowed in 1959 after six years of marriage, when the youngest of three sons was only ten weeks old. Obliged to become the family breadwinner, she secured a temporary post as a poultry technician and moved her family from Dublin to rented accommodation in Limerick. However, she was shortly moved to Donegal and was forced to give the care of her children to various family members. When she subsequently got a permanent job managing a hatchery in Kanturk in 1962, she was reunited with her children. Determined to secure work as a poultry instructress, Mary continued to apply for permanent posts and eventually secured a position in Cavan, a post which required yet another relocation of her family. Mary's experience shows how enforced employment mobility potentially presented significant problems for women workers parenting alone.

> I moved around so often and most places I went to I had to move twice because I used to pick the first housing I got. You know, when men are transferred they generally go someplace and the wife stays put until they've got a house. This wasn't so in my case … So … we were in various houses. … It was fairly rough all right, but what could you do?

When her sons were young Mary employed 'some great women who worked temporary [sic] with me' and she subsequently decided to send her children to boarding school because 'it was easier on them I think'.

Catherine W., widowed in 1961, felt that her return to work within weeks of her husband's death represented a double loss for her children and she poignantly recalled the distress she and her children experienced at the time:

> And then I went back to work and I will never forget it, because getting the bus every morning, but walking down the road to the bus stop, and Richard standing at the door screaming 'you will come back mummy' and he screaming and roaring and I'd be in tears walking down that road. I had to go in. I had to work. That was heartbreaking especially with him. It was with all of them.

Rita's husband died suddenly when her youngest daughter was only two weeks old and Rita moved from her rural surroundings to a nearby village, where she could survive without a car and could more easily secure employment: 'I couldn't live alone there. I felt I couldn't. We had a car but I couldn't keep the car going. The wages was gone. It was really terrible. I went out to work, to housework, and I took the baby with me'. Rita's situation as a working-class woman with limited earning power compounded the difficulties she faced as a widow and she had to shoulder the burden of work and caring without the paid help widows with better paid jobs could afford. The women's narratives, while highlighting their resilience and agency in assuming the breadwinner role and providing for their families, also reveal their lack of choice about having to take on this role and their concern about its implications for their children. The resumption of their careers arose out of financial necessity rather than an unprompted choice.

For most women, combining their home-based role with paid employment was demanding and often required both resourcefulness and selflessness on their part. This was particularly true for working-class women whose work, which was frequently part-time and lowly paid, could not support the hiring of any help. Joan N., who worked as a farm labourer throughout her married life, displayed extraordinary resilience, attending to her responsibilities on her employer's farm, while also rearing fourteen children:

> I'd have to be up at five o'clock in the morning and I'd run in to look at times ... and you'd get up and milk your cows and feed the calves, come in home then and look after the children and put them out to school and get a barrel of beet and pulp it ... You had everything to do. ... Not one hour could I sit down ... Joan was born a Monday night, I came home a Tuesday night and I was above milking my cows a Wednesday morning, but I milked the cows that evening after Connie being born. And that was our life that time.

Rita, who took a domestic post when widowed and combined her job with her own domestic responsibilities felt like she had 'two full-time jobs. It's true. I'd be up from half past seven in the morning till one o'clock the next morning. That was my day'. Despite having the support of her husband, Doireann also found managing household responsibilities and her part-time job in Dunnes Stores in the 1970s to

be very demanding: 'Boy, was it tough going for a couple of years. ...
It was really, like, with your job here at home and your job then
inside [the workplace]'. Husbands' support of women's work outside
the home usually required negotiation, and women's decisions to
enter the workplace generated conflict amongst some couples. A
minority of the women who returned to part-time work in the early
1970s emphasised that they worked for the welfare of their families,
but also constructed themselves as somewhat radical, using words
such as 'liberated' and 'militant' to describe themselves. While not
directly attributing their views to the influence of feminism, their
accounts of their return to work suggest a subjective if not a
consciously political critique of the male breadwinner model. Joan G.
recalled her husband's initial response to her plans to return to work
in 1972:

> Oh, they didn't want married women working. No man wanted
> it, no. You see, they had the power, like ... and this man (her
> husband) didn't believe, you know, that I could be liberated. I
> wanted some liberation, you know ... I had my own, what
> would I say, my own union here! So that I had to stand up for
> myself.

Doireann had a similar experience when she made the decision to
return to part-time work in the same year: '[My husband] didn't
accept it at all. He thought 'twas unbelievable. I said "I'm doing it". ...
I was probably one of the militant women, I really was'. Alice, who
returned to part-time work in the mid-1970s, also viewed her actions
as challenging gendered norms and understood that the distribution
of domestic labour within her marriage was significantly better than
that which prevailed in most marriages at the time. She noted that
her husband was a 'very good father' and that within the home 'I
had my jobs and he had his jobs'. Muriel had no reservations about
her decision to return to part-time work in the late 1960s, when her
youngest child was seven years old, and recalled that her 'husband
was extremely helpful, I couldn't do it without him'. She did,
however, encounter some disapproval from friends and acquain-
tances, who questioned how appropriate it was for her to be at work
when she had a young child.

Bridie's combining of farm work with child-rearing during the
1950s and early 1960s, also caused her to traverse gender roles and
undertake activities normally considered to be the preserve of men.

However, she did not explain what she did as any form of militancy nor did she interpret her actions as a challenge to gendered power relations. Rather she acknowledged that she didn't enjoy some aspects of the work, such as the selling and buying of animals at fairs, which was a very male affair, but she legitimated the work as a necessary extension of her maternal duty to provide for her children in the absence of an adequate family income: 'Well I had to take them to survive. And I didn't see any shame in it. I was doing no harm'. Bridie supplemented her farm work with occasional paid employment as a domestic and care worker. All of this work was undertaken alongside her childcare and domestic duties and Bridie's recollection of her child-rearing practices highlighted the compromises working women sometimes had to make to accommodate their work responsibilities:

> That time there was no expensive cots or prams. There was a tea chest to put them standing into ... I used to have to leave them alone. ... Another evening I came back from the cows they had the glass in the front door broken ... and another evening I couldn't find one of them and a neighbour said to me 'have you tried the barrel?' I was to try the barrel of water, rain water ... and she was inside under the bed having a joke on me.

The narratives of most of the working mothers indicate their sensitivity to prevailing discourses of good mothering and suitable childcare practices and highlight a keen awareness of their failure to meet some of these standards. Bridie, while acknowledging that she was not always present to supervise her children, emphasised that she always kept them 'spick and span' and justified her work practices by frequent references to the imperative to improve her children's welfare and future prospects: 'It was to make ends meet. And to keep your children going to school and some of them on to secondary school'. Alice, who returned to work when the youngest of her four children was five years old, was also conscious of her partial absence from the home and her lack of availability, in particular to her youngest child:

> I rejoined the workforce when James was five and poor James, I feel had no mother. I used to say to the other four, when they came in, they'd be arguing ... I used say 'c'mon c'mon c'mon'. When ye came home from school with a runny nose I was there to wipe it. When he came home from school he had to look after himself.

Alice also felt that her housekeeping standards were compromised by her involvement in full-time employment: 'There was never a cupboard cleaned or a wardrobe in my house. You'd be stuffing things back in saying you must get around to that, but you couldn't...' .

SINGLE WOMEN WORKERS

The four single women we interviewed had long and continuous working lives and in this regard they differed from the other women interviewed. They experienced greater employment mobility and longer engagements in the paid labour market. In every other respect, however, there was little to set them apart from the other women interviewed. The accounts of these four women do not indicate that single women could aspire to higher wages, alternative careers or ambitious promotional opportunities. Low pay, occupational segregation and perceptions of gendered abilities continued to limit their work opportunities. The focus on the family wage provided a justification for paying low wages to all women irrespective of their marital status, and single working women were also negatively affected by the marriage bar because the perception that women would only give short service in employment created a culture in which women were rarely considered for promotion or advanced training. Speaking of female civil servants who were single, Daly has highlighted the likelihood that they would not have achieved their potential and would have been passed over for promotion, being seen, in the words of Mary Kettle, a feminist activist, as 'loitering with intent to commit a felony', the felony being marriage.[22]

Chris, who was well educated, having completed both a Leaving Certificate and a commercial course, had a working life in the clerical/managerial sphere which extended from 1939 until 1984. As a young woman she aspired to a career in the Civil Service, but when she wasn't called she took an office job in Thompson's Bakery in Cork City in 1939. In 1949 she moved to Dublin to be closer to her siblings and to extend her social life and worked as an accounts machine operator until 1976, when she became an assistant hotel manager in Tullamore. She ended her career as an assistant hotel manager in Waterville, retiring in 1984. The mobility Chris experienced in her working life was undoubtedly facilitated by her single status and despite acknowledging that none of her jobs paid well she emphasised that she enjoyed all of them. Chris believed, however, that up until

the 1960s women had limited opportunity for labour market mobility, regardless of their marital status. As an older, single, female worker in the 1970s, she welcomed what she perceived to be a relaxation of attitudes between different generations. She remarked that in the hotel industry at that time, she was viewed as just another worker by her co-workers rather than as an older woman worker who could have become very isolated. The fact that accommodation and food were provided was a key factor in Chris's decision to move into hotel management when she was in her mid-forties. Her experience of living in digs had highlighted the poor standard of accommodation available to her as a single woman. Chris's choice of work at this stage of her life indicates how single women's experiences of home and domestic living were indeed very marginal, and stories of domesticity and home life, which were frequently recalled by married women, were not a feature of single women's accounts.

Mary G.'s career as a secondary school teacher followed a similar timeline to that of Chris's. Mary also began work in 1939 but a year later she resigned in order to care for her sick father, a role she held until 1957, and which as an only child she did not feel she could refuse. Although she secured occasional temporary work in local primary schools, this period of her career was marked by low earnings and a subsequent reduction in her pension entitlements. Following her father's death, Mary spent twenty-three years teaching in a boarding school in Kilkenny and ended her career back in her native Cahersiveen, where she retired in the early 1980s. While Mary's single status facilitated job mobility, the independence and potential to earn typically associated with single living was not experienced by Mary until her long-term caring obligation to her father ended. Furthermore, she experienced the difficulties encountered by all female lay teachers in the secondary school sector, where there was an abundance of religious personnel available to teach and to take the promotional opportunities that arose. Mary was highly critical of this state of affairs and throughout her account she also referred to the negative treatment of women in the world of work relative to men, and indeed to what she believed was women's own lack of confidence and drive to get what they wanted out of life.

The accounts provided by Mary O'D. and Rose, whose working life is discussed below, highlight how a lack of educational opportunities impacted on the work trajectories of women who were single and obliged to provide for themselves throughout their lives. Mary,

who left school without any qualifications, began her working life in 1940, when she provided unpaid care for a sick family member and their child for a period of eight months. She subsequently took a post as a domestic servant but poor treatment and her unhappiness in the job prompted her to take a waitressing job in Cork City. She held that job for eight years until she became ill. Despite sending doctors' certificates to her employers, she received a letter one morning informing her that she was dismissed from her employment. A challenge to her employers proved unsuccessful, and she noted that employers 'could do things like that in those days'. The good fortune of inheriting her family residence provided an economic lifeline for Mary and she opened up her home as a guest house in 1954, a business she enjoyed and continued to operate until she retired thirty years later.

Rose, another young woman who left school without qualifications, was not as fortunate as Mary and her account of her long working life was defined by expressions of regret, limited opportunity and a lack of personal fulfilment and achievement in her work. Her working life, which was 'meandering'[23] extended from 1950 until the late 1990s, when she retired from her job as an attendant in a large public institution. Rose began her working life at sixteen, when she completed six months of unpaid work in a Dublin hospital designed to prepare young women for entry into nurse training. However, homesickness for her native Cork and a realisation that she was unsuited to nursing and in particular the strict and hierarchical nature of the nurse-training regime, prompted her to return to Cork. She drifted into factory work, which her aunt, who was her guardian, deemed highly unsuitable and on her aunt's insistence she began a night course at Skerry's Secretarial College. However, Rose decided after a short period that 'pounding a typewriter' made her feel as restless and unfulfilled as her day job in the factory. With the passing of time she did wonder whether she should have endured the secretarial training because she might have secured a 'nice, decent job, a respectable job, as they would say in those days'. Rose did look at other career options, including emigration to New Zealand with a friend, but after some deliberation that was decided to be too big a step. She also considered shop work but when presented with such an opportunity she decided that the particular shop was too busy and opted to continue in the factory. Rose acknowledged that working on a factory conveyer belt was mind-numbing, repetitive and generally

unsatisfying and while noting that women did become foreladies, she remarked that in her experience they did not hold, or aspire to hold, managerial positions. In her view, women, regardless of their marital status, were not regarded suitable candidates for significant promotions at work and she believed that there were few interesting work opportunities open to women such as her who had no professional training. In the early 1970s Rose left factory work and moved into a service sector job in a local public institution.

Of the four single women we interviewed only Mary O'D., who jokingly referred to herself as 'a spinster', commented on how she felt about her single status. She portrayed herself as a strong woman in charge of her life, who did not have marriage as a goal and who did not regret her marital status.[24] She remarked that she had 'a lot of other interests in life' and that 'you could have a very full life and not be married'. Furthermore, Mary mentioned that at various points in her life, some married women told her they envied her single status, which she interpreted at the time as their attempt to console her for being on her own.[25] However, she revised this interpretation over time because as she explained she had begun 'to realise that they were in earnest, that a lot of these women had hard lives as married women but they didn't talk about it, nobody talked about the real situation'. Mary's comment indicates the persistent ideation of marriage as the expected role for women throughout the time period, despite the fact that the number of women marrying was in decline up until the 1960s.[26] Furthermore, her observations again highlight the culture of silence, which discouraged women in unhappy marriages from revealing too much of their disenchantment.

CONCLUSION

This chapter has highlighted that women in the period under study in this book were keenly aware and largely accepting of the prevailing social and cultural norms which deemed the home as the appropriate sphere within which they would fulfil the prescribed roles of wife and mother. The majority of women expressed little regret at the termination of their employment upon marriage or pregnancy, a fact which is unsurprising given the prevailing cultural support of marriage and the reality that the jobs held by many women were dictated by class and economic restrictions rather than reflecting individual employment aspirations. Many women drew on

maternalist discourses and invoked the male breadwinner/female home-maker model when explaining their attitudes and feelings about employment after marriage. The practical structural disincentives to married women's participation in paid work, such as marriage bars, lower pay, lack of fertility control and lack of childcare options also featured in women's explanations of their work trajectories after marriage.

Yet while drawing on these common discursive and material frames of reference when explaining their work histories, women's engagements with and negotiation of both the ideological and structural milieu were individual and unique. Some women highlighted the physical drudgery or the social isolation associated with aspects of their domestic role, others identified instances of the unequal distribution of household power and resources, and yet others emphasised the pleasure and satisfaction they gained from motherhood and home-making. In various ways women's actions, whether politically informed or demanded by economic necessity, resulted in different levels of engagement with and acceptance of domesticity and employment.

Undoubtedly women's close identification with the home-based mothering role impacted negatively on what they could achieve (or expected to achieve) in the formal labour market. However, material circumstances obliged many married women to challenge gendered norms in relation to working and caring practices and to seek out and avail of opportunities for employment and the generation of additional income. Significantly, many of the married women who did return to work did so following offers of employment from former employers. Many also noted that they were not obliged to resign from their posts upon marriage. This would suggest that for some employers the contribution good workers could make was more significant than their marital status. It also challenges the view that there was a complete cultural and societal consensus about the undesirability of married women's engagement in the paid labour market. Married women who were employed outside the home for the most part justified their employment as a financial necessity. They framed it as an extension of their maternal responsibility to provide for their children, most often in situations where husbands' earnings were unavailable or inadequate for the needs of the family. Significantly for some women, earning extra money from employment was a strategy not for material survival but for the material advancement

of children through the provision of extended educational opportuni-
ties. For a minority of women, seeking employment was a deliberate
strategy to expand the limitations of the maternal home-maker role
and to carve out an additional public identity. Despite their different
motivations for entering employment or taking on income-generating
work when married and the undoubted demands such endeavours
put on women, most expressed a sense of accomplishment in their
ability to provide for their families. For some work was liberating and
affirming; for others it was a burden to endure. While some of the
younger women in this study, who took the decision to return to the
workplace in the early 1970s, presented themselves as challenging
the prevailing cultural and social dictates regarding women's roles,
most of the women who were combining work and care judged their
mothering practices in relation to established discourses of maternal
care, which stressed the superiority of the ever-present mother who
turned out clean children and kept a tidy house. Furthermore, while
many commented on the existence of serious power differentials in
many marriages and a minority provided oblique accounts of the
difficulties they experienced in their own marriages, few articulated
a systematic critique of patriarchal family practices. Many did,
however, devise strategies in their daily lives that enabled them to
fulfil their mothering role even in the face of material and cultural
challenges, while a minority achieved a more equitable distribution of
household tasks and caring roles within the family.

The impact of class on married women's opportunities for and
experiences of employment and motherhood is significant. For
professional women, workplace participation was usually on a full-time
basis and was facilitated by paid help with childcare and housekeeping.
For working-class women, it meant the assumption of the double
burden of employment and unpaid care. The stories told highlight
the difficult financial and emotional situations some women experi-
enced and emphasised how structural and cultural factors limited the
support and options available to them. The solidarity of other
women, sisters, other female relatives and neighbours provided the
main sources of support for women in these situations.

Marriage and motherhood may have been the paths prescribed
and indeed pursued by most women during these decades, but the
accounts reveal that women actively engaged with diverse models of
womanhood, which also included permanent singleness and
religious life. The women we interviewed assigned themselves

significant personal agency when accounting for the paths they took in life. They rejected and accepted marriage proposals, delayed marrying to continue working, entered marriage to escape the drudgery of paid work or parental authority and they chose to form new identities as wives and mothers. As evident in the data presented in this chapter, the choices they made brought opportunities and challenges, which women negotiated in their own particular and individual ways throughout their lives.

CHAPTER FIVE

Family and Community Connections

In previous chapters we explored women's memories of their workplaces and considered how being married or single shaped the course of their working lives. In this chapter we turn our attention to the relationship between dominant cultural constructions or discourses and individual consciousness or subjectivity. Feminist theorists have argued that in forming their identities or subjectivities, women draw on numerous and at times contradictory ideologies.[1] As discussed in the introduction, we subscribe to the view that there is no one story or historical narrative that tells the truth of women's experiences of work. We are cognisant of post-structuralist critiques of generalised assumptions about gendered experiences and of the need to acknowledge the multiple, shifting and contradictory nature of identities. We are also sensitive to the interplay between material and ideological factors in shaping the experiences and identities of the women we interviewed and recognise that the stories provided by the women were influenced by many factors, including what they remembered, what they decided to share with us, what they felt comfortable telling us and what image of themselves and their lives they wanted to publicly portray.[2]

We begin this chapter by analysing how the women's positions within families and the dynamics of their family milieu impacted on their work trajectories and featured in their accounts and explanations. We then turn our attention to a consideration of the ways in which women's working lives shaped and were shaped by the communities in which they lived and socialised and the relationships, practices and discourses through which this cultural milieu was embodied.

WORKER IDENTITIES: FAMILY RELATIONSHIPS AND DYNAMICS

Acceptance of parental authority and the prioritisation of family need rather than personal desires were consistent themes in the women's stories of becoming workers. This is unsurprising for a

period during which prevailing religious, educational and indeed cultural discourses emphasised parental rule. Muriel, who was born in 1928, vividly described how the interplay of parental and religious control shaped her early life: 'It was a straight and narrow line. You were either obeying your mother or father, or obeying the church. Catholicism had a huge effect on our lives then. You just did what you were told'.

Young women in particular were expected to be subservient to parents, a cultural message, which Mary K. clearly remembered from her childhood in the late 1930s: 'I can remember back my mother saying to me that you should be seen and not heard. That type of training that went on. ... She would always say that girls should be seen and not heard'.[3] This childhood socialisation of young women to be deferential to parents and cognisant of family need meant that they generally accepted parental decisions about employment with resignation.[4] Joan, who began work as a live-in domestic with a farming family in 1937 when she was fifteen years old, clearly conveyed the acceptance of family responsibility:

> I felt I had to do it like, do you know. I had no other choice because it was, you know now, a father would be earning maybe five shillings a week, do you know and trying to feed us all and work hard by day and by night and all this. Like you had to live by that then, you had to do what you're told, like.

It would, however, be incorrect to assume that young women were always reluctant to take on a breadwinning role, or indeed to assume that the desires of individual women in relation to employment were always in conflict with the needs of their families. Rather it must be acknowledged that most women had strong emotional attachments to their parents and siblings and this provided another dimension to their understanding of their responsibilities toward their families. Some women emphasised how concern for their parents, and in particular their mothers, made them eager to earn an income. Alice, for example, presented her decision to begin working at the age of fifteen as a conscious strategy to provide support to her mother, whom she greatly admired. She took pride in her ability to earn and was motivated by a wish to relieve her mother of some of the breadwinning responsibility she had assumed when her husband, Alice's father, emigrated to England in 1940 and sent scant remittance for the family's survival.

This model of compassionate and hardworking motherhood identified by Alice featured in many stories, where daughters emphasised their mothers' skills as home-makers, their gentleness, their ladylike qualities and their loving natures. Maureen, who was born in 1917, noted that she and her siblings 'saw a lot of love' in their home and described her mother as a 'wonderful person' who played a central emotional role in the family. However, a close connection between a mother and daughter could on occasion thwart the latter's career aspirations. Catherine, who was the youngest of seven children, believed that her mother's attachment to her foiled her plans to pursue nurse training in England: 'Mummy wouldn't let me go because I was the youngest. She was probably too nervous or something. My one ambition in life was to be a nurse'.

It is important to also acknowledge the positive emotional relationships that some women had with their fathers and the significant role played in relation to their daughter's working lives. When Sr. Paul expressed her wish to become a nun, she was advised by her father to take her time and think very seriously about the decision but was assured that 'if you want to go, we'll allow you to go'. Paul presented her parents as being very united and their marriage as egalitarian and companionate. Parental accord was also revealed in Joan's account of choosing her career. Confronted in 1950 with a choice between nurse training in Dublin and an office job in Kerry County Council, she recalled that her parents, who had objected to nurse training in England on the grounds that at seventeen she was too young, did not subsequently try to influence her career choice. They advised her that 'it's your life. You do what you want with it. You decide what you want to do. Make up your own mind and don't ever blame us after'. However, as discussed in Chapter One, Catherine W.'s account of how she became a civil engineer suggests that parents did not always share similar aspirations for their daughters. Catherine's father decided as soon as she was born that she would be an engineer and this caused great friction between her parents. Catherine did not, however, perceive her father's determination of her career path – or his dismissal of her mother's concerns – as authoritarian. Rather, she saw her mother as a distant, independent woman, who was overly concerned with social propriety, while her father and his relatives were very warm and attentive:

> I was his pet and he always brought me out with him on Sunday
> afternoons and away walking every night and funerals … Now
> at that time nobody hugged you or anything and people never
> kissed you. But you still knew who loved you and I knew … I
> was for my father's side of the family and there was fantastic
> affection there.

Significantly, the women's stories revealed no clear division between
fathers and mothers in relation to who took responsibility for deci-
sion-making about when a young woman would start work or what
work she would undertake.[5] Kathleen O'R.'s description of seeking
her mother's permission before accepting an offer of work in a local
factory in Cork in the early 1950s, highlights that in some cases
decision-making about when a daughter would enter employment
was more opportunistic than planned: 'Eily (older neighbour) met
me one day and she said would you like to go to work and I said
"I'll ask my mam". So she said "you can", so I went off and I started
at about fourteen'.

However, Sheila, who grew up on a farm of seventy acres of good
land had a very different experience; her father planned out her
work trajectory and that of her sisters in the early 1940s. Sheila
employed a discourse of family need to explain her father's sugges-
tion that she should become a dressmaker rather than a teacher as
she wished. Her account was highly ambivalent, revealing the
tensions between her acceptance of filial responsibility and her
frustration with it. She constructed a picture of a sensitive father,
who was cognisant of her sewing talent and hence suggested
a dressmaking apprenticeship, but also noted her own sense of
unexpressed disappointment at this arrangement:

> I was disappointed, because I couldn't be a teacher. I was very
> disappointed I couldn't keep on at school. I was very disap-
> pointed but I don't think I voiced it. I don't think I said a word
> to my mother. I just went and did what I was told like, and you
> know, I was happy enough about it then, once I started, like.

Sheila's sister, Madge, was required to take on a domestic role within
the family home and she explained this as a matter of family necessity
given her mother's ill health: 'somebody had to stay so I was the
choice'. Madge worked at home without a wage for almost twelve
years, until her brother married and with his wife took responsibility
for the running of the household. While Madge expressed her

dissatisfaction with the arrangement during her interview, her narrative indicates that, like her sister Sheila, she didn't challenge her father's decision. Again she framed her acceptance of the situation with reference to cultural expectations of filial compliance: 'I didn't like having to stay at home. I used to envy Lil and Mary (her sisters) when they were going off in the mornings, you know. They were the days when you just did what you were told, and you had to stay at home and that was that'.

Other narratives indicate, however, that some young women did successfully challenge parental wishes in relation to employment and negotiated an outcome more favourable to their own aspirations. It is significant that these women were from families for whom an extra income was not essential and thus, greater choice in relation to career was a possibility. Joan D., who completed her Leaving Certificate in the early 1940s, described her tenacity in challenging her father's authority to decide her career orientation. Joan initially wanted to train in hotel management, however her father considered it to be an occupation unsuited to a woman and 'wouldn't have anything to do with it'. Joan's subsequent suggestion that she train as a nurse met with the approval of both her parents, however her father resisted her plan to train in England. Joan, who believed that the training in England was superior, persevered with her request to be allowed to train there and eventually her father relented and both Joan and her younger sister began training in Whipps Cross Hospital in London in 1945. The significance of securing her father's compliance was emphasised by Joan, who viewed her father as the key arbiter of power within the family and described him as: 'A hard task master ... a tough man. I mean he was nice and all the rest of it. Mother was totally different then, of course. We used to blackguard mother'.

Ena's career trajectory reflected a similar accommodation of personal aspiration and parental control and she was conscious that in refusing to continue in education after her Intermediate Certificate she was 'a bit of a disappointment' to her parents, who had aspired for her to become a teacher. Ena wanted to work in fashion and succeeded in persuading her mother to allow her to take a summer job in a drapery shop in the late 1940s. However, her parents would not acquiesce to her wish to become an air-hostess, a plan which they deemed to be 'out of the question' as it would involve leaving home. Ena, who had no siblings, did not perceive

her parents to be authoritarian or oppressive, but rather acknowledged that their concerns were genuinely well meaning. At her parents' behest, she completed a commercial course and she subsequently took an office job which she enjoyed. However, in the early 1950s when the first modelling agency opened in Cork, Ena fulfilled her ambition to work in fashion by combining modelling assignments with her office job.

When a daughter's work aspirations went beyond what her parents considered possible or appropriate, a sense of distance or disjoint between daughters and parents sometimes emerged. Mary K., who was born in 1933, always had a burning ambition to be a teacher, however she noted that her parents 'didn't really have those kinds of aspirations. They would have preferred if I had worked in a shop in Kenmare'. Despite being very conscious that her parents could ill afford the £10 secondary school fee, Mary successfully campaigned to be allowed to continue her schooling until Leaving Certificate. Margaret also highlighted the tension which could be created by a personal ambition to progress beyond the class or occupational status of one's family. Margaret wanted to work in an office when she left school in the late 1950s, an aspiration which her working-class father could not understand. She noted the lack of support she received in pursuing this trajectory and the impact this had on her confidence: 'I was ambitious within myself but yet I lacked confidence. But of course that comes from your background as well, you know, if you're not encouraged'.

The impact of family dynamics on female work trajectories and on women's identities as workers and daughters was keenly highlighted in the narratives of two women who were obliged to resign from permanent jobs to provide care for family members. Their accounts of these events highlight the significance of employment to their identities and indicate how acutely they both felt the subjective and material implications of withdrawing from the workplace. Mary G., who qualified as a secondary school teacher in 1939, worked for one year in Dublin before returning home to Cahersiveen to spend seventeen years caring for her widowed father. Mary's mother had died when Mary was four and she understood her obligation to her father in terms of a reciprocal care arrangement: 'I was an only child and then my poor Dad practically reared me. He had to, the poor man. It was tough on him too, you know, but I made it up to him when I came home'.

Despite her sense of loyalty to her father, Mary described herself as broken-hearted at leaving her job and the tension she felt between her identity as a dutiful daughter and an independent worker was clearly evident in her conflicted account of how she felt about the situation: 'I mean, no, I didn't regret it. Of course, I did when I was young. It was very tough, you know, when you're young and you know tied down like. I took seventeen years like that. 'Twasn't easy'.[6]

Mary was unequivocal however about how 'bitter' she was about the financial implications of taking substitute work while caring for her father and she experienced her return to teaching in 1957 as liberating and satisfying. Indeed, her narrative clearly revealed how closely her sense of self was bound up with her occupation: 'it was a lovely break of course going back and starting up after seventeen years ... I was in my element'.

Margaret was urged by her father to give up her office job following her mother's death in 1958. However, unlike Mary G.'s ambivalent account, which highlighted the tension about her wish to care for her father and her dismay at leaving teaching, Margaret emphasised her resentment at being the subject of paternal control and noted how unwillingly she gave up her job:

> I was sixteen, going on seventeen and the youngest member of our family was eight years of age. But like I wasn't given a choice. It wasn't 'would you like to?' Or 'do you want to?' It was you give up your job. And I think I've always resented that bit, that you didn't have the choice ... There was no thought given to your life or what you wanted.

Margaret felt her domestic role to be a significant diminution in her status and a challenge to the adult worker identity she had assumed. She was also conscious of how domestic work was undervalued in comparison to participation in the formal workplace and despite being paid by her father for her work in the home, what she received was significantly less than what she had earned in her office job:

> it was a major backward step for me ... I felt I was working harder and I felt like the work wasn't valued. Work in the home is never valued I believe. ... And I suppose I had this great sense of independence and adulthood and I just wanted to be paid for my work and that was it.

During the five years she spent in this domestic role, Margaret strove to maintain some semblance of a worker identity and she supplemented the payment she received from her father with part-time night work as a cashier in a bingo hall, and she took night classes in shorthand and typing with a view to enhancing her future employment skills. Her father's decision that her younger sister was ready for work provided her with the opportunity to relinquish her domestic role 'my father was talking about my sister going out to work ... and, like, when my father mentioned this, I said "no, I'm going back out to work"'. Margaret also missed the social aspect of the workplace and the opportunity to mix with persons her own age. She found being at home like being 'in isolation because the people you were friends with now were in their forties and fifties and sixties ... you know, you missed out the camaraderie of people of your own age'.

The significance of family relationships and responsibilities in shaping work trajectories was evident even in cases where there was no acute family need as experienced by Mary and Margaret. In 1941, Caitlín left a permanent teaching job in Dublin to take a post in Kilmurry, which was near her family home. A key factor influencing this move was her parents' wish for her to return home, a wish made more poignant by the death of her brother a year previously. Marriage, in 1945, required another move to Cork City where Caitlín's husband, also a teacher, was employed. This move resulted in Caitlín leaving a principalship and subsequently, when she and her husband moved to a two-teacher country school to work together, it was her husband who applied for the principalship. A desire not to add to her workload and in particular to avoid having to bring work home, prompted Caitlín to refuse the opportunity to take a more senior class in the school: 'I'd get nothing extra for it ... I felt it was enough to have Michael coming home with a bundle of essays and so on'. The prioritisation of husbands' career needs was also evident in the accounts of leaving work provided by some married women. Catherine W. would not have been legally obliged to resign from her civil engineering job when she married in 1953 but she was happy to do so to move to Northern Ireland with her husband, who had been transferred there. Similarly, Pauline left her job in Cork and subsequently found employment in England when she married her English-based husband and emigrated to be with him in 1941.

WORKER IDENTITIES: OCCUPATION AND STATUS DIFFERENTIALS

The earlier discussion of Mary G.'s and Margaret's reactions to being obliged to leave the workplace to care for family members draws attention not only to the impact of family dynamics on work trajectories but also to the role which work played in providing women with both an economic and social identity. Most women commented on the status associated with their jobs and on the implications of their occupations for the way they were perceived in their communities.[7] The social and cultural scripts which delineated the occupations that were respectable and appropriate for women continuously featured in the women's stories of why they entered particular spheres of work. Concerns about respectability were expressed by women from all class groups and proved to be a significant factor in decision-making about employment. Parental worries about less than respectable or desirable aspects of particular jobs resulted in some women eschewing certain types of employment. Muriel's decision to apply for nursing in 1945 was vetoed by her mother who perceived that the 'scrubbing and washing' and other physical care tasks involved in nursing to be beneath the dignity of her daughter. Pauline, who remained in school until the age of seventeen and then completed a commercial course, was conscious that factory work would be unacceptable to her mother and hence she took a secretarial job in 1935.[8]

Working-class parents and their daughters did not have the luxury of vetoing the domestic and factory jobs which were objectionable to more financially privileged families, however concerns about respectability and status were not only the preserve of the affluent. Indeed the oral histories collected in this research clearly indicate that women who worked in factories paid most attention to the issue of respectability.[9] Awareness of the implications of respectability was evident in Catherine O'D.'s description of relationships in the factory where she worked in the 1930s. Her account highlighted how class and gender combined to determine the status accorded to particular workers in the factory. Catherine asserted the respectability of her colleagues, noting that 'the girls in the factory, they came from nice backgrounds', but observed that they were looked down on by two male workers who 'always thought they were superior to the girls. They wouldn't talk to them. They were always very sarcastic, you know, they were only factory girls'.

Working-class women frequently emphasised their respectability with reference to their compliance with the rules and norms of the workplace and their honesty and diligence as workers. Rena identified how strictly she adhered to norms of punctuality and obedience in the factory where she worked and invoked her exemplary behaviour as proof of her respectability: 'I believed then like I do today that punctuality is important. We were very quiet people and we never gave any bother. We did what we were told'.[10] Quietness, discipline and deference to older employees and supervisors were key characteristics of the practice of respectability in the workplace and a means by which a working-class young woman could assert her good standing. While engaging with cultural and ideological markers of respectability when assessing the status of her job, Rena also employed the pragmatic criteria of wages and conditions of work, criteria which, as a working-class woman, she could not ignore. Using these criteria she perceived her job as an overlocker for Sunbeam to be very good. She was keenly aware, however, that when assessed from the perspective of respectability or status, factory workers were 'looked down on. … Oh definitely, there were snobs girl and they looked down their nose at you if you worked in a factory. There was … discrimination kind of, in a sense'.

The pervasiveness of this cultural image of factory girls as immodest or immoral was evidenced in the recollections of women who themselves were not working in the sector. Alice, a working-class woman who worked in a dry cleaners, recalled that the words of a popular Cork song were modified in the 1950s to comment on the respectability of girls working for Sunbeam: 'there was a song out when I was younger. You know "The boys from Fairhill", that song. "Sunbeam girls are very rude, they go swimming in the nude"! But the Sunbeam was a great job too'. Margaret, who worked for Dunlop, felt that there was a perception that factory work might make one work in close proximity to less respectable members of the working class. Margaret struggled to reconcile the public construct of the less than respectable factory girl with her own perceptions and experiences of her co-workers:

> you had what you called rough diamonds working in factories, that you wouldn't get say in an office maybe and that's not quite correct to say, maybe now either you know. You had … all I can say is you had all classes of people working in the factory. You had a wide mix.

Margaret's employment path also reveals the women sometimes made strategic trade-offs between the remuneration and status afforded by particular jobs. Margaret left an office job to take up her job at the Dunlop factory because the higher wages helped her save for her forthcoming wedding. In contrast, Elizabeth and Joan D., both nurses, left hospital posts in the early 1950s to take up lower paid nursing positions in the Irish Army because such posts had a greater social cachet and provided more opportunities for socialising. In these accounts, work was not solely a means to earn a living and decisions about work were entwined with socially constructed perceptions of the status of various occupations and the non-monetary opportunities they provided.

The narratives of the few women whose occupations caused them to traverse or strain class, race or occupational boundaries highlighted the ways in which some workers constructed their identities by reference to their sense of displacement in their workplace or their difference from their colleagues. Helen was determined to expand her employment horizons beyond those of her older sisters, who all worked in a local clothing factory. However, when she secured a job as a junior office clerk in 1958 at the age of sixteen, she recalled that she entered the job 'completely without confidence' and was 'very unhappy' in the position. She explained these feelings with reference to the rigid class boundaries which governed occupational destiny and the cultural dissonance she experienced in a job which was outside the realm of women from her family and neighbourhood: 'It was unknown at that time for anyone say from my background to get a job in an office. At the time that was classed as one step above'.

Mary K. experienced a similar sense of displacement when she travelled to England during her summer holidays from her teaching job in the 1950s to take a job as a coding clerk in British Distillers. Despite acknowledging that she needed summer work to supplement the limited wages she earned as a JAM, her description of the summer job and of her colleagues, conveys her sense of the occupational superiority and respectability of teaching. Mary found the job to be

> very contained and very ordinary. There was nothing exciting about it and the women that worked there, you know, they obviously went on nights out and had a few gins and you know and I did a lot of laughing about it at the time. Of course me, I didn't drink at that time.

Like Mary, Pauline, who was from a shop-owning family, which she described as not being 'badly off', highlighted her sense of difference from her English co-workers. Well educated and used to office work in Ireland, when Pauline emigrated to England in 1941 to be with her husband, a condition of her entry into the country was that she would take a factory job.[11] However, she perceived her co-workers to be antagonistic towards her, due to the fact that she was from Ireland, a country whose neutrality they perceived as a shirking of responsibility in the war effort. Pauline's discomfort with assuming the identity of a factory worker was fuelled by a keen awareness of her mother's conviction that a woman from her class should not engage in factory work and she saw her English co-workers as women who were 'uneducated, uncouth and hated the Irish'. Pauline portrayed herself as a youthful victim of racial taunting by women whom she considered to be fundamentally different to herself: 'well 'twas educated women … they were walked on. The others, you see, are tough. They were reared in tough schools, I'd say and they were, you know, didn't take any nonsense from anyone'.

In other cases women's sense of who they were as workers impacted on the way they interacted with and, indeed, were treated by the wider community. Mary K., who began her career as a JAM in a rural part of Co. Kerry in 1952, was keenly influenced by the social expectations which she believed to be associated with her profession, expectations which led her to self consciously monitor her behaviour outside of her work place and to be careful in her choice of social activities and social contacts: 'You also had a sense, you know, teaching was a strange career in that it kept you apart from others in one way, sort of isolated. You had to keep up certain standards and be correct at all times'.

A perception of teaching as a high status occupation, one which differentiated teachers from other workers, was also expressed by Noreen, who herself trained as a nurse. She observed that women teachers would be 'a class apart' and that 'they'd be very looked up to because they had the minding of children and they had a salary'.[12] Two of the nurses interviewed also drew attention to the way in which societal expectations of nurses – who were seen as particularly capable and responsible women – influenced how they were perceived in their wider familial and community contexts. Elizabeth and Joan D. acknowledged that their training prepared them to accept responsibility and to take charge of situations, and

that they found themselves drawing on these skills throughout their lives when called upon by their families and neighbours in times of crisis. The need to maintain a distance from the farm women she visited was impressed on Mary T., a poultry instructress, by one of her senior colleagues when she began working in the mid-1940s. This professional distance was to be achieved through dress and demeanour and Mary was advised to never enter a farm without wearing a hat and to avoid getting on first-name terms with the women she met. Mary rejected this advice, however, and became good friends with some of the farming women she visited.

The implications of occupation for community standing and social status were most keenly felt by women whose jobs were considered menial in nature. The narratives of women employed as domestic workers in private houses were dominated by accounts of the attitudes of employers and in particular the degree of respect, which they showed to the women in their employment. Joan N., speaking of her working life as a domestic and agricultural worker in the late 1930s, noted her appreciation for the respect shown to her in a particular house: 'There were three of them ... but very respectful children though. And do you know, the parents had great respect for me, like'. Joan married a farm labourer in 1944 and combined agricultural work on whatever farm her husband was working on with the rearing of her fourteen children. She expressed bitterness at her servility in some work situations and noted her lasting resentment towards some employers: 'But the more you'd do that time, oh certain farmers, they'd walk down on you ... they'd no respect, no respect'.

Disrespect and humiliating treatment also featured in Rita's account of her work as a domestic in Cork in the 1940s:

> There was not much respect for me at all. I don't think the man used say 'hello' or 'good morning' to me. No. And you would often find that dear. They'd have no respect for you. That's true. For people who did housework. That's true, they wouldn't have much respect for you. No.

Rita subsequently emigrated to London and secured a job as a cashier in a Lyon's teashop in Oxford Street. In this post she experienced far better working conditions, pay and social status and her narrative emphasises how significantly this enhanced her self-esteem:

> Oh, I felt it was great; you'd be looked up to. They used to call

me 'cash'. ... I suppose I got four or five pounds a week that time. 'Twas very good beside what I was getting [as a domestic]. I mean you could buy a bit of clothes or something for yourself and send a few pounds home to my mother.

The above quote from Rita calls attention to another key dimension of women's working lives, namely their roles and identities as earners and consumers. Being in the workplace and earning a wage, however small, was significant for women's sense of self, for their role and standing within the family and for their ability to negotiate and fund an independent social life.

WORKER IDENTITIES: CONSUMPTION AND LEISURE PRACTICES

A common theme, which emerged in some women's accounts of their transition to employment, was their pride in becoming economic actors and financial contributors to their families. Work, however menial it might be, was significant to many women because it helped to alleviate some of the financial pressure on the family. Caitlín, who began her teaching career in 1934, noted that the sense of independence she gained from employment was closely entwined with the ability it gave her to help her parents financially. As unmarried young women, almost all of the respondents made financial contributions to their families and in most cases had limited access to the money they earned. Joan N. did not even know how much she earned in her first live-in domestic post in 1937. Her earnings were paid directly to her father, who came to collect them at Christmas time: 'If you were under age, like, if you were young, your father would collect it. They wouldn't give it to you for fear you'd spend it'. In many instances women gave their entire wage to their mothers, who then granted them pocket money.

Women's expectations around their earnings were clearly shaped by a familial rather than an individualistic ideology and their stories contain no discernible sense of resentment about parental appropriation of earnings. Even women who began work in clerical positions usually at the somewhat older age of sixteen, or those who had professional qualifications and were out of their teenage years when commencing employment, appeared to share the view that their income was a family resource. Chris, who commenced work in 1939 when she was twenty-one, employed a philosophy of reciprocity to explain parental appropriation of single women's wages:

> When you left school to get a job, you got a job so you could contribute at home. Give so much, pay so much at home, you know. There was no such a thing as you kind of getting your salary and putting it in your pocket. ... It happened a lot that you handed over your salary and you got back pocket money. ... It would be more or less that kind of thinking in my day. They (her parents) supported me and fed me and educated me so now what I must do is pay them back.

The practice of parental control of wages was not only confined to families who were in financial need. In the early 1950s, Catherine Walshe, whose parents owned a small business, earned a very substantial salary of £8.10 a week in her civil engineering job. She was encouraged, however, to send three pounds of this home every week to contribute to her brother's boarding school fees.

The amount of pocket money received by the women varied between families. Catherine O'D., who worked as a dispatcher in a sweet factory in 1931, earned 10 shillings a week but she received so little in pocket money that buying a pair of stockings required saving. In contrast, Margaret, recalling her earnings from her office job in the late 1950s, commented on her good fortune in comparison to others:

> My mother handed me back fifteen shillings, which was half, which was very good at that point in time. I had heard of people maybe only getting five shillings, you know ... that they'd have got less than that, you know? Whereas I thought that was kind of a fair return, more than fair.

Increasing age or changing family or personal circumstances, such as getting engaged, frequently resulted in daughters being granted more control over their own earnings. Referring to her wage from her first job as an office clerk in 1950, Mary O'S. explained that she

> handed it up at home and my mother gave me back my bus fare and whatever other expenses I would have and then if I wanted something she gave me money to buy it. As time went on then and other members of the family moved out and got married or were in a different position, I kept my money myself then.

According to Mary, being able to manage her own money as she got older was considered to be 'a good preparation for life'. Saving for

married life features in many women's accounts and single women's obligation to contribute significantly to their family of origin dissolved somewhat at this juncture. Maura C., who described her family as financially comfortable relative to others, recounted that: 'up to the day I left the telephone exchange, my wage packet was handed up. To my mother. The controller of programmes. ... Oh I gave it as I got it, up to the time I got married'.

It is noteworthy, however, that while Maura's mother retained control over her earnings, they were not used to bolster the family finances, rather Maura believed that her mother saved most of the money and used it to provide her with the deposit for a house when she married in 1951.

Young women who were compelled to leave home for employment or those receiving very low wages or training allowances, often struggled to make ends meet. Noreen recalled visiting friends in Dublin who worked in the Civil Service and finding them sitting in the dark because they couldn't afford the electricity.[13] For some women, commencement of employment or training provided very limited access to disposable income and some continued to rely financially on their families. When Sheila started her dressmaking apprenticeship in the early 1940s, her earnings of five shillings a week were not enough to cover her weekly bus fare to work. Similarly, nurse training, while providing board and lodging, was poorly paid and Noreen recalled that the 15 shillings a month she received as a first-year probationer nurse in the Richmond Hospital in 1939 was never adequate for her impetuous spending. She relied on the good nature and generosity of her brother and sister, who were also working in Dublin at the time, to supplement her income. Mary T., a poultry instructress who described herself as 'a pretty bad manager' also recalled her struggle to manage her finances despite her quite lucrative salary in the 1940s. While Noreen and Mary constructed themselves as poor financial managers during the course of their professional training, other women, particularly those engaged in factory work, highlighted their thrift and the measures they took to prudently manage their money by organising work-based saving clubs and engaging in practices such as making their own clothes.

The women's accounts of the significance of income in their early working lives indicate that earnings, while a source of pride and a marker of adult status, were not the only factor in women's

construction of their identities as workers. Women did move jobs to secure better wages as discussed in previous chapters, and they were cognisant of the relative pay rates associated with different occupations, but for the most part they displayed limited interest in material acquisition. As young workers, their aspirations rarely went beyond having the money to socialise and to acquire the clothes and hairstyles required for such activities. In the following section we explore how the women's social lives were intertwined with their working lives.

WORK AND LEISURE

The women's descriptions of the leisure practices they engaged in as young workers highlight the extent to which these were framed by prevailing expectations regarding respectability and moral propriety among young, unmarried women.[14] The parental control, which was commonplace in the regulation of young women's work trajectories and the appropriation of their earnings, was also evident in the sphere of leisure. Strict curfews were enforced by most parents and many young women were allowed to attend events that involved mixed company only if they were chaperoned by brothers or other male relatives. Young men were allowed significantly greater freedom around socialising, a fact resented by some women.[15]

Dances appeared to be the highlight of the women's social lives and provided one of the key places for meeting and mixing with young men.[16] Ballroom dancing, dancing to brass bands and traditional Irish ceilis were most common in the 1940s and '50s.[17] Mary O'D., whose career as a waitress in Cork City spanned the '40s and '50s, had a clear recollection of the dance schedule in the city

> The City Hall of a Sunday night always was ceili … 'Twas supposed to be ceili but no one knew how to do the ceili, we used all come home with sore toes. But the Gresham Rooms on a Tuesday night was ballroom dancing and on Wednesday night was the nurses' dance … and on Friday or Saturday night was the Arcadia. Sunday night in the Arcadia was also ceili.

The enjoyment and freedom of dancing was contrasted by many women with the drudgery of their working lives and their stories highlighted how it provided an escape from the world of work. Kathleen F., who started work in 1939 and worked for fifteen years

in the same factory job, acknowledged that she 'lived for dancing, you know, the foxtrot, the tango, the rhumbas'. Mary F., whose job as a wardsmaid in the mid-1950s was physically demanding, felt energised by dancing:

> you has a very, very hard day down on your knees, scrubbing and polishing and you went out then and you danced your heart out … Modern dancing. Rock 'n' roll, everything, jiving, you name it. It was brilliant because it gave you a great boost up for the morning … We might come home at two o'clock and be up at the wards at quarter to eight.

The type of music provided was not the only criteria that differentiated dances. They were also organised along a gradient of surveillance ranging from highly supervised dances organised under the auspices and in some cases direct supervision of nuns or priests, to the public 'ten to four' dances which were cheaper to attend but were frowned on by some parents. Maureen went to a regular Thursday night dance in the Arcadia Ballroom in Cork in the mid-1930s when she was in her late teens. The dance started at eight and finished at eleven and Maureen noted that 'there was never any drink whenever we went to any of those little dance places'. Her attendance at such events was strictly regulated by her mother, who always ensured that she was chaperoned by a male relative. In her retrospective appraisal of the situation, Maureen considered herself too submissive to take advantage of the opportunities that came her way; 'I never did anything wrong. I wouldn't say boo to a goose' and recalled with some regret 'the lost chances' she experienced as a result of having to refuse invitations to dances.

Ena's account of a Sunday-night dance organised by a nun in the oratory of the North Presentation Convent in Cork, indicates that concerns about female respectability and moral propriety were very much to the fore in the 1950s. One had to be a cardholding member of the oratory club to gain entry to the dance and a strict dress code, including the requirement of stockings and the prohibition of make-up, was enforced: 'I remember a very attractive friend that I had, a very pretty girl, she defied one day and went in with her lipstick and the sister got newspaper and literally almost tore it off her lips'. Modest dress requirements precluded the wearing of trousers, skirts above the knee, sleeveless garments or anything low-cut and the dance was supervised by a nun who measured the distance between

dancers with a ruler to ensure that a six-inch gap was maintained. Those attending the oratory dance were also required to observe the religious custom of refraining from dancing for a year following the death of a close relative: 'You see in those days you wouldn't go dancing for a year and you'd have to wear the black band, the mourning band, on your sleeve ... you know, it was extraordinary and we were so accepting of all this'.

Public dances such as the 'four penny hops' that Kathleen F. loved attending in Cork City during the 1940s and early 1950s, were subject to less moral surveillance but the presence of many acquaintances at such local events ensured a high degree of self-regulation. For the fortunate minority of women who had access to transport, attending dances some distance from home provided greater anonymity and the freedom to be less disciplined in their behaviour. Joan G., who lived in Tralee, recalled that in the mid-1940s the Saturday-night summertime dance in Ballybunion was a place where 'you could leave your hair down. You wouldn't be yourself at all because it would be a different side of the country ... and they'd be coming from different places'.[18] Joan attended the 'eight to twelve' dance at a cost of two and six because her parents forbade her to attend the later 'ten to four' dance which only cost five bob.

Joan D.'s first job as bartender in her uncle's pub in Tralee in the early 1940s made it clear to her that certain leisure practices, such as frequenting public houses, were highly gendered. She noted that the women could drink in the snugs but 'they daren't stand up at the pub' and recalled that the women who usually came into the pub did so in the company of their husbands or boyfriends, and were frequently countrywomen who would be in town with their husbands at a fair.[19] The women's descriptions of leisure activities continuously emphasised the gendered nature of women's participation in the public sphere and highlighted their keen awareness of the greater liberty which their brothers and male peers enjoyed.

Women's enjoyment of going dancing was closely associated with the rituals of dressing up which accompanied it and under-scores the prevalence of a discourse of femininity which emphasised the social expectation that women should look well.[20] The disposable income employment provided to young women was usually spent on clothes and for many young women having a wage resulted in their gaining greater control over what they would wear. Clothes

shopping was a novelty for Catherine W., when she began working in 1949: 'in college, you had clothes but … you certainly had no selection and all my clothes were made by dressmakers … clothes were the big thing to buy'. Similarly, when Madge emigrated to New York in the early 1960s after fifteen years of unwaged work on the family farm, she vividly remembered the clothes she could afford to buy with relative ease: 'I remember, you know, I bought a coat and a suit, going home from work one evening. … I got this lovely kind of biscuit coloured coat, a beautiful coat for twenty dollars and the suit I think, for fifteen. … It was marvellous'. While wardrobes were limited and many costumes were homemade, women undoubtedly aspired to look their best. Rose, a factory worker, recalled the limited nature of her wardrobe: 'You had two sets of clothes, for the dancing like, or for going out at night. I remember having two A-line skirts, one was a green and the other was a kind of a tan, and you'd mix and match them then … a white blouse with one and a pink with the other and that's all you had'. Alice and her friend both had sewing machines, which allowed them to keep up with the latest 1950s fashions:

> we'd see something out in Bennett's (a clothes shop in Cork) window and we'd copy that … I'd have to have a pattern but she could cut out, out of her head. She'd cut out mine and we'd have beautiful skirts going out to the Arcadia (a local dance hall). A couple of weeks more and we'd have another new one, but we'd be doing it cheap because we'd buy the material.

Shopping for clothes in the 1940s and 1950s was a very class-based practice. The lay out of drapery shops prohibited browsing and one only entered shops when intent on purchase. Alice recalled that during the 1950s, Dowden's in Cork City was the preserve of the middle classes:[21] 'There was a big shop in Patrick Street – Dowden's – you'd never go into that. That was for the big shots. … Haberdashery. Buttons and everything, but the working class never went in there'. The purchase of clothes often involved paying over a long period of time and many women provided precise descriptions of outfits purchased and the prices paid for them. Joan D., who trained as a nurse in England between 1945 and 1948, recalled how she and her sister, also a trainee nurse, ensured that they would have a new outfit to wear to the Killarney races, during their summer holiday home: 'When we would go over [to London]

having been at home in July for the Killarney races, we would go into Layton and there was one shop there that we used to go into and we'd put two and six on a frock, that we'd bring home the next time with us, and then would be a year ahead'. The work-based saving schemes, the 'diddlum' or the 'manage' described in Chapter Two, provided a strategy to maximise the purchasing potential of young female factory workers and help them pay for hairdressing and clothes.

Dinner dances were the epitome of glamour and required the acquisition of more ornate clothing. Attendance at such events also mirrored occupational divisions and they tended to be the preserve of particular categories of worker.[22] Sheila, who worked as a dress-maker near the South Mall in Cork City from the mid-1940s to the late 1950s, recalled that a lot of her work involved the making of evening wear for young women who worked in the banks and offices in the city: 'We used to have a lot of girls coming into us before they'd go to their dinner dance ... they'd dress where their frock was made ... before they'd dress up, they'd go into the Imperial Hotel, and they could have a bath there for a shilling ... people didn't have baths at home you see'. Ena, an office worker who lived close to University College Cork and socialised with male students, found college dress dances during the 1950s to be both thrilling and glamorous events:

> ...so exciting and you know the long dresses, I remember my first one was pink and there were layers and layers of tulle, you know very fine lacing, anyway, under the first skirt of it the underskirt was all done with sequins, so the net underneath was covered with sequins, so that when you danced they all sparkled and it really was very pretty.

However, the practice of handing over much of their earnings to their mothers left many young women only a small amount of money with which to socialise. Pauline, who was from a relatively comfortable family in Cork City, was conscious of how fortunate she was to be allowed to keep most of her wages and noted that '12 and 6' went a long way in the mid-1930s: 'it would well last you for the week. You'd have entertainment, dancing, films, the odd meal out ... You'd get a high tea for five pence, a shilling'.

The opportunities for socialising described by Pauline contrasted sharply with the more limited opportunities available to young

women in rural areas, particularly if their working life revolved around the family household. Bridie recalled the lack of leisure activities available to young people in rural Limerick in the early 1940s: 'There wasn't much socialising that time. But I remember the crossroad dancing and people playing the music on the stage, the platform. We danced on that a few times'. Rural social life often revolved around local households and the work practices associated with a farming community. Bridie fondly recalled this kind of neighbourly interaction:

> We had a very welcoming household where a lot of neighbours came in and we'd play cards and give cups of tea and we didn't sort of miss the time going. And we used to have to bring the sow into the kitchen to have her baby ones. And we used to stay up all night with them and there might be a few of our own age in and we used to have a good laugh and good jokes and we were happy.

Mary O'S. recalled that much of her leisure time in rural Cork in the late 1940s was spent doing handicrafts in the family home.

> We didn't have television, so we did lots of arts and crafts by night. Embroidering and my mother was always knitting, she used knit socks for everybody and painting ... us girls sat around the table and did that and just chatted away all night.

Young women exploited the social potential of all public outings, including highly structured and regulated encounters such as those provided by religious ceremonies and meetings. Religious events such as novenas, retreats and pattern days and membership of organisations such as the Legion of Mary, were an important aspect of their social lives.[23] Speaking of her involvement in the Children of Mary and the Legion of Mary in a parish outside Cork City during the 1940s, Sheila observed, 'I suppose those were our social outings really'. However, even these virtuous activities were subject to parental monitoring. Sheila's sister, Madge, recalled that their father used to comment on the fact that attendance at religious events included 'prayers and devotions and notions besides' and noted that 'you couldn't chat with anyone for too long afterwards because you'd be timed'.

Women who grew up in country towns appeared to engage in class-segregated leisure pursuits. Mary G., who was born in Cahersiveen in

1914, identified swimming, boating, tennis, amateur drama, cinema and the library as the leisure activities which she and her friends enjoyed. Eileen C., whose parents were shop-owners in Midleton, played hockey and followed the local rugby club in Midleton town in the 1930s, activities which in her own words were 'great fun'. These accounts suggest that patterns of class-based socialising were frequently established before women took up employment, however the commencement of work or training provided some young women with increased opportunities for socialising. What is clear, however, is that leisure practices among young female workers frequently mirrored and indeed reinforced occupational and class cleavages.

Mary G. recalled having a very good social life when she took up her first teaching position in Dublin in 1939. She went to the cinema regularly, visited sites around Dublin and spent so much of her money socialising that she was often desperately waiting for her next month's salary. In 1934 at the age of sixteen, Maureen's job in the office in Roche's Stores provided her first opportunity to socialise in mixed company at a work dance. At her mother's insistence, she was accompanied by her three male cousins and recalled, 'I don't think anybody else danced with me for the night or got within a mile of me, like they mightn't have wanted to either!' Attending a dance with colleagues two weeks after starting a job in 1950, initiated a lot of new experiences for Catherine W. She had her first drink and met the man who was to become her husband: 'they made me take my first gin and orange and I just wanted to go to sleep and this fellow was annoying me to dance with him, that was Nicky'.

Christmas parties, annual staff outings to local seaside resorts or beauty spots and occasional staff dances were recalled by many women. Popular day trip destinations included Killarney, Tramore and Sherkin Island. The Sunbeam factory in Cork was notable for its efforts to provide social activities for staff, which provided them with much pleasure and rare opportunities for travel. In the mid-1940s the management recruited a Choral Master to oversee the establishment of a choir, which subsequently competed in and won the annual Oireachtas choral competition in Dublin.[24] Kathleen F., who was a member of the Sunbeam choir, observed that their participation in the competition was something unusual: 'there were choirs from all over Ireland ... and they were all in evening frocks,

... we were from Sunbeam, these were all say the middle class and they used to have beautiful evening frocks and dress suits and all that'. The Sunbeam management also organised a chartered flight to take their staff on a pilgrimage to Rome for the 1950 Holy Year. Those who wished to participate had the price of their ticket docked from their wages each week.[25]

Socialising with co-workers was remembered fondly by many women and leisure practices frequently reinforced both worker identities and occupational differences. Camaraderie was common among women who worked in female-dominated workplaces, and friendships made at work continued throughout women's lives. Rena, who worked for Sunbeam for eight years until her marriage in 1962, emphasised the longevity of workplace friendships in her life: 'They were very good days. I mean you made loads of friends, and we're still friends up to this day'. The kind of job a woman had was significant in determining the range and nature of the social activities available to her, with particular occupations giving rise to specific leisure practices. May, who worked as a chef's assistant in the Metropole Hotel in Cork from the mid-1940s to the mid-1960s, emphasised the good relations which existed between service sector workers, and recalled how the chef at the Metropole provided the porter in the Palace Cinema with sandwiches in exchange for entry to the matinee, with cinemagoing being a regular pastime among the hotel workers: 'We'd all go out there at three o'clock in the evening when all hotel workers would be off from three to half-five. ... Our chef ... he used say to me, "Hennessy, I'll see you out in the Palace. Bring your own crunchy but you can have a look at my Echo"!'

Young domestic workers who lived with their employers also adapted their leisure activities to suit their unsociable hours. Rita recalled socialising with two other domestic workers when she worked in Blackrock in Cork during the mid-1940s: 'we used to walk around a lot really. We'd go to an odd dance and all that, you know, but there wasn't a lot done at the time'. Mary O'N., who worked in a live-in capacity in a grocery shop in Cork City in the 1940s, also identified the very limited opportunities available to the isolated domestic worker and recalled knitting in her room at night as her key pastime.

Attendance at night classes in cooking and needlework was popular among women who were involved in domestic work.

Madge, who was working on the family farm in the late '40s, recalled that the introduction of rural electrification was accompanied by demonstrations and classes organised by the Vocational Education Committee, which instructed homemakers how to use electricity to best advantage.[26] The classes were provided locally during the working day: 'they sent out an instructress and we had cookery classes and crafts ... and there would be other girls now like me, that were at home farming and we would go in the afternoon'.

While domestic work provided limited opportunities for socialising, occupations such as nursing afforded women particularly good social lives. For Elizabeth, the excitement of occasional outings to 'dancing and to the pictures' with a group of American officers, provided some welcome entertainment during her nurse training in wartime London. She described herself and her fellow nursing students as 'quite wild' but qualified this by stating that they only engaged in 'harmless fun ... utterly innocent really'. When she returned to Dublin in the early '50s her social life was rich and varied: 'I was at every change of theatre in the Abbey and the Gate and I was playing senior league badminton and inter-hospital tennis, and all that kind of craic'. Noreen joined the tennis club in the Richmond Hospital Dublin when she began her nurse training in 1939 and noted that being a good tennis player raised her social standing with the city girls who usually looked down on their country colleagues: 'they kind of looked up to you if you were a good tennis player. You were kind of in a different social circle'.

Leisure pursuits frequently reinforced class and occupational divisions and in the 1950s it was common for certain ballrooms in Cork to organise dances for nurses only, and to preclude the attendance of women who were not nurses. Alice, who worked for a dry cleaning company, keenly resented this occupational segregation: 'Thursday night was nurse's night. I mean, wasn't that discrimination? A nurse, like had a better education ... That was discrimination against, ordinary other people, factory workers, like'.

Accounts of leisure activities often revealed awareness of class differences and in some cases expressions of class antagonism. Doireann, who worked as a drapery assistant in Dunnes Stores in the early 1950s, was conscious of status and class discrepancies in the social activities organised in her workplace, where the social club was only open to management. In contrast, Joan D.'s job as a nurse in the Irish Army in the 1950s provided her with access to all of the

social functions organised for the officers in the Curragh camp and consequently she enjoyed a great social life. Being a car owner, between the mid 1940s and 1950s allowed Mary T., a poultry instructress, to have a 'fantastic' social life and made her very popular with friends. Moving to a job in Cavan in 1949 where there were a few other poultry instructresses of a similar age was 'a big plus because socially we all got together ... we loved life and we loved the freedom of it'. Marquee dances, badminton and golf were some of the activities Mary and her colleagues enjoyed. Clare's job as a writing assistant in the Civil Service in Dublin between 1945 and 1957 also provided opportunities for work-based sporting activities including camogie and tennis, which she played with a Civil Service team.

The connections between women's work and personal lives were also fostered by the workplace customs around the celebration of engagements and marriages.[27] Catherine O'D., who left her job as a dispatcher in a factory in 1940, recalled 'they gave me a beautiful send-off. They presented me with a beautiful clock, a mahogany clock with my name on it'. Maura C., a telephonist in Cork, who married in 1951, described how her marriage was celebrated by her colleagues: 'When I got married all my pals came up. There was no drink in it, 'twas only tea and cakes and sandwiches and that sort of thing'. In contrast, Rena remembered engagements being celebrated by the workers in Sunbeam in the early '60s in a less abstemious way: 'Well, if somebody got engaged, like, we'd all trot off to her house for the night and have a booze-up. Even if you didn't drink, well, there was 7-Up for you. But otherwise, you'd have great nights and you'd go to work then in the morning with a sicky. Nobody had pity for you!' Such customs demonstrate how female workers bridged the gap between the occupational and the personal dimensions of their lives and again highlight how the meaning of work for women was rarely confined to the financial remuneration it provided.

CONCLUSION

An expectation of daughterly obedience and, where necessary, the sublimation of individual desire to family need, undoubtedly provided the cultural context within which young women between the 1930s and 1960s negotiated their identities as workers. The women interviewed continuously referred to the constraints of class

and parental authority and highlighted the hierarchical nature of the family system. However, they also revealed the diversity of parental and filial interactions and the range of subject positions which young women assumed in their relationship with parents. Some unquestioningly accepted parental dictates regarding employment while others negotiated with or challenged parents in an effort to realise their own aspirations regarding work. Tensions between the aspirations of daughters and the wishes or needs of parents or the wider family were also revealed in a number of interviews and reconciling societal obligations as dutiful daughters with personal aspirations resulted in feelings of resentment and disappointment for some women. However, for the most part, the narratives suggest that women did conform to parental expectations, that parental control was common in all class groups and that decision-making about filial employment was not the preserve of either parent. Gendered expectations regarding the differentiated role of husband and wife clearly impacted on women's sense of their identities as workers, and the women we interviewed who combined employment with marriage and motherhood gave frequent accounts of their prioritisation of their familial rather than their worker roles.

This chapter also highlights that young women workers had a shared awareness of prevailing public rhetorics which categorised the respectability and status associated with various types of work. Factory work in particular was associated with low moral standards. However, a number of women involved in factory work challenged these categorisations asserting their respectability and that of many of their co-workers, and highlighting their exemplary workplace records in relation to obedience and punctuality. The moralising discourse of respectability was also counterbalanced by women employing a more material discourse that emphasised the practical benefits associated with some factory jobs, such as good earnings and conditions of work. Workplace camaraderie shaped and strengthened worker identities but also highlighted differences both between and within workplaces. While gender was a significant source of worker identity and camaraderie in many workplaces, rank was more significant in others. Identities within the workplace were in some cases forged in relation to constructions of 'different others', who were perceived as superior or inferior.

Worker identities spilled over into social and community life and

were a significant factor in dictating the social standing of women and in some cases the nature of their interactions in local social networks. Most women exhibited a keen awareness of class and status differentials and highlighted how occupational and class alliances, and related subjectivities, were continuously reinforced in leisure and consumption practices. Similarly, occupational and class segregation in leisure pursuits underlined the role the wider social and community environment played in reinforcing worker identities and in maintaining gender, class and occupational divides. Workplace practices around the celebration of events in women's personal lives, such as engagements and marriages, also served to consolidate worker solidarity and identity and demonstrate the interconnections which existed between women's personal and working lives.

CHAPTER SIX

Accommodating and Challenging Constraints: Women Workers' Agency and Resistance

How women experienced, interpreted and re-interpreted the society in which they lived is a pervasive theme in this book and therefore much attention has been given to women's agency throughout the different chapters. In this chapter we tease out for more detailed discussion the complicated relationships between subjectivities, power, agency and resistance by focusing very closely on the thoughts, actions, feelings and retrospections of the women, as revealed in our close reading of their stories.

In the first part of this chapter, we attend to the women's views of the society at that time and to the workings of power in that society in which their agency and resistance occurred. We describe briefly the societal relations and practices, which conspired to engender women workers' compliance. In our view, the strategies of agency and resistance that were employed by the women can be more fully understood in the context of the character of the society and the defining features of the labour market at the time. This discussion also highlights how agency, resistance and external power tend to mutually shape and change each other in ongoing dialectical relationships.

In this chapter we have also turned our attention to women's own involvement in attempts to collectively organise as workers, their engagement in trade unions, their strike actions and the other formal means they utilised to make gains in the labour market. The women we interviewed were not exceptionally charismatic individuals motivated by their political ideals to become the instigators of major revolutionary movements. Indeed, some of the women did not belong to trade unions or to other organisations or movements that existed in Irish society at the time. Much of what characterised the agency of the women interviewed would have

remained undocumented if we limited the scope of the chapter to only those acts which were public and which involved the collective formal organisation of workers. We analysed the women's accounts to identify what we have interpreted as everyday individual or collective acts of agency and resistance, which they employed in their workplaces. Therefore our intention in this chapter is to capture as completely as possible accounts of agency and resistance in the narratives.[1] To confine our account to the study of formal collective labour organisation would have excluded the women who were not part of such groups. The gains and losses the women made through informal and individual worker struggles as well as their often brave and more ordinary strategies of defiance or survival would have remained undocumented.

In adopting a more multifarious conceptualisation of agency and resistance, we searched for agency and resistance not only in actions, but also in subjectivities, meanings, feelings, wishes and fantasies.[2] For example, a few women related fantasies of vengeance, which might have provided the stimulus for action when they were workers if they had not so deliberately restrained their feelings at the time. The women we interviewed might have been reluctant to acknowledge any part they played in actions, which might be considered quite subversive (such as stealing from an employer), as they may have feared how they might be seen by others then and possibly even at the time of telling their stories. For this reason we paid attention to the routine resistant actions over which they were prepared to take ownership. How the women as workers defended positions or values important to them, pursued their own individual self-interests or acted on their desires for self-preservation, are given attention. The forms of 'escape' they recalled, which enabled them to resist the colonisation of their selves by work or which helped them to cope or to detach themselves from tiring or monotonous work and oppressive work relations are also documented.[3] We also took note of whether they got involved in any organisations in an effort to improve their lives generally or as wives or mothers in the home. We sought to interpret agency and resistance in these very broad terms in order to examine meanings, subjectivities and complicated imbrications in power relations that might otherwise be neglected.[4]

THE WOMEN'S PERCEPTIONS OF IRISH SOCIETY AT THAT TIME

Broad brush accounts of women's lives in this period, which tend to concentrate overwhelmingly on the limited rights they had as citizens and as workers, as well as the dependence and the drudgery that permeated their domestic lives, have been challenged.[5] In the narratives we collected, women did explain how repressive aspects of the climate of the time were experienced by them in their lives and when they did invoke the pronoun 'we', it was to capture a sense of shared oppression as women or as a group of working-class women. However, we have to be mindful that stereotypical assumptions about this generation of Irish women as subservient and downtrodden in what was undoubtedly a repressive Irish state for women are fairly ubiquitous in public discourse.[6] When these women recounted stories of their pasts, they did so through the lens of the present and after the emergence of the second wave of the women's movement and other social movements from the 1970s onwards. When a sense of shared oppression was recounted, it tended to be called up sporadically and retrospectively rather than sustained throughout a narrative.

Among the women interviewed, collective worker subjectivity was little in evidence. A unified, collectively held standpoint framed along class, generational or gender lines did not seem to us to exercise a defining impact on women's ways of thinking and being at the time. This possibly reflects the reality that the majority of the women we interviewed did not have strong links throughout their lives with consciously political organisations, trade unions or movements built around a commonly shared identity or experience. However, it also highlights that the narratives of the women we interviewed revealed all different kinds of complicated relations with collective organisations, trade unions and social movements, ranging from extremely positive to downright oppositional and all shades in between. This is a theme that is given greater consideration later in this chapter. Furthermore, in stories told, some women saw themselves as obedient and dutiful, others as defiant and daring, but there were also others who drew attention to their obedience and defiance at the same and different points in their lives.

Evoking a shared sense of oppression, Maureen commented in her narrative that, 'I suppose looking back we were a very quiescent generation'. She thought that the newness of the Irish Free State and limited access to education might have been important factors

in creating the strong culture of compliance. The role exercised by the Catholic Church in relation to women's lives in the period[7] was a theme threaded throughout many interviews. In the following extract, Catherine W. describes how the power exercised by the Catholic Church in the study period was experienced by her in her own life:

> The awful fear of the Church and the fear of the laws of God, I mean that permeated us, the fear in us going to confession. When we got married I remember saying, 'oh it will be marvellous now, we won't be telling about immodest touches or anything'. ... And then you got married but if you didn't have children, if you were doing the safe period, you nearly had to confess that. ... as far back as I can remember, you were told don't ask questions...

Madge expressed the view that even when women had grievances, they felt silenced in a public sphere, which did not encourage them to speak and where there was little interest in what they had to say:

> A lot of things made a lot of women angry that they couldn't do anything about. You see even if they were angry, you didn't know it. That kind of a silence. you see they wouldn't be listened to anyway. ... they might probably between themselves ... say, 'that's dreadful what's happening' but they had no voice. Even if you wrote to your local T.D., I don't think he would even acknowledge it, would he? Not for a woman no, I don't think so.

Mary K. also remarked that women might have exercised their voices in the privacy of their homes but that 'they certainly wouldn't have been vocal in public. I never remember women in my era being vocal about anything'. Joan H., while not settling for a self-representation or a representation of women in general as mute and submissive, was mindful of how the climate of the time set restrictions on what was possible for them. Joan's hidden transcript, revealed in this instance, was at odds with her public transcript of quiet obedience:[8]

> You took what you got and said nothing. Oh I'd be able to fight my battle alright if anything went wrong, but you couldn't. Women couldn't that time. And they kept going as they were like. Not that we (women) were browbeaten in any way into doing anything but it just wasn't in the times.

Similarly, Mary G. commented that women did not take on issues at the time and that she

> ...never heard of any rumpus. You were inclined to obey; we were brought up to obey, you see. It took a long time to realise you weren't getting your just dues, shall we say. ... and women were very slow at anything to speak up, to say something, or to try to improve their lot.

Trying to recollect if women at the time were involved in any significant protests to address particular issues or concerns, Mary's answer emphasised the triviality, rather than the significance of women's activism: 'Any of the protests were harmless little things ... a bundle of mamas might get together about the schools and say they didn't want such a thing, but they were harmless ones'. Doireann's comment that at the time women tended to 'box clever' suggested that their open or direct confrontation might have been eschewed in favour of low-key strategic action designed to bring about the desired change. However, Doireann's own story revealed that she did rebel against what was a normative cultural practice of the time. When she was churched after having her first child, she decided that she would never put herself through such a degrading experience again and she refused to be churched after her other children were born.[9]

Most of the women interviewed did overwhelmingly draw on constructions of themselves, which highlighted their conformity to social and cultural norms of the time. Looking back over their lives, it was their acceptance of social mores as they were and their 'consent' to their oppression, which overwhelmingly defined their agency in the contours of their accounts. However, a small number of women were keen to come across as spirited, feisty and militant. They readily recalled events in their personal and working lives when they reacted against authority or refused to blindly conform to expectations of them. As revealed in Chapter Four, Joan G. and Doireann both organised their return to work after marriage despite their husbands' determined opposition.

Differences in how women saw and represented themselves are important in terms of appreciating the variation in how women related to the social, material and cultural conditions of their lives. They reveal important insights into the opportunities for action and resistance but also the subjective and social limitations. As documented

in the following section, certain features of the society in which they lived did conspire to exercise limiting effects on what women thought was possible to achieve in their working lives.

ATTITUDES AND PRACTICES OF CONFORMITY REVEALED IN
WOMEN'S ACCOUNTS OF WORK

The limited employment opportunities at the time, as noted in other chapters, seemed to influence women's consciousness and to educe practices of conformity among women who felt fortunate to be employed in periods of high unemployment and emigration. Joan G. recalled that 'it was a great honour to get a job that time', and Sheila explained: 'You see at that time, if you had your job, you had to mind it, because if you lost your job you mightn't get another one, so you kept your mouth shut, I'd say'.

In Chapter One, the huge influence of the kin network in the recruitment process for many jobs during these decades was noted. To 'put in a word for someone' would have necessitated a very good and close relationship with a boss or an employer and a solid personal reputation as a hard worker. This kind of informal recruitment process would have served to build up worker compliance at a time of significant unemployment, when many workers were trying to help other family members and friends gain a foothold in the labour market. Through job training, which seemed at times to be as focused on respectability as much as skills, many workers were being socialised to be deferential in their attitude to authority, as well as dutiful and stoic in their demeanour as workers.

As noted in earlier chapters, strict gender segregation practices were common in some workplaces and served to perpetuate notions of women and men's work as different and thus deserving of different levels of remuneration. There tended to be a concentration of men in the key positions in most workplaces and where employees were promoted into more senior positions they were often in separate spheres, due to the gender segregated nature of most workplaces. Muriel worked alongside men and women in a painting and decorating shop in Cork, but as she noted, 'the bosses were men, there was one or two accountants with secretaries. The secretaries were women; the accountants were men. My overall boss was a man'. In Thompson's Bakery, where Chris worked, male and female employees worked physically apart from each other. As she

observed: 'All the men were downstairs. All the directors were on the first floor and all the women were on the next floor'. She also observed that all the Directors were men. In Dunnes retailers, women worked on the shop floor and were paid less than the men, who were assigned to counter duties in the different sections. As Doireann observed it was the female assistants, who were expected to dress the shop window because, as the bosses explained, the male shop workers 'wouldn't have the taste for it'. Helen noted that in the hire purchase company where she worked, the male employees' tasks 'would have been completely different to what we would have been doing. They were sales men, you know on the floors, selling the furniture so I wouldn't be familiar with what they were paid'. All the debt collectors and sales representatives were male and the ledger clerks were female.

The distance between male and female employees meant that women did not always know what male employees in the same workplace were paid, though some women believed that they were not being paid the same as men even when they had the same job description. In many work environments there was no career track for women and no expectation of it because women resigned from work upon marriage. Joan H. remarked that she never knew how the promotional scheme operated in the employment exchange where she worked in the 1930s and 1940s, but that the managers were 'always men ... I never heard of anyone in my time, a woman reaching manager level like, never'. Noreen felt quite strongly when interviewed that in her generation, working women 'tended to be treated as a kind of apprentice half the time, as if they (women) didn't have any mind. I certainly think they were discriminated against'.

Significantly, however, other women whose work histories included experiences of differential treatment in terms of access to employment and payment for work similar to that done by male colleagues did not name their experiences as discriminatory at the time. Acceptance of the inequality in pay between male and female workers was identified by a small number of women, who believed that as breadwinners men's work was more important and that they should be paid more for it. Mary K. noted that at the time it was accepted as it was the 'normal state of affairs'. This is in keeping with Mary Daly's observation that general public opinion was not in favour of equal pay during these decades and that the Irish Women

Workers' Union's (IWWU) position on this issue was ambivalent even into the 1950s.[10] According to Mary Muldowney, there was no agitation for pay reform among women workers in the North or South of the country in the 1940s and it was generally expected in both of these contexts that male workers would be paid more than their female counterparts.[11]

The Association of Secondary Teachers of Ireland (ASTI) had adopted a policy of equal pay for women as early as 1914, but as John Cunningham noted, it was not adopted for egalitarian reasons. It was a policy position motivated by the fear that lower-paid women teachers might replace men in boys' schools.[12] After 1922, despite some small advances towards equal pay for female teachers, the policy itself was not progressed. Cunningham also wrote that the infrequency of pay negotiations during the decades after Independence worked against active pursuit of the policy.[13] Articles submitted to the *Cork University Record*, and assumed by Cunningham to have been written by a young female secondary school teacher, drew attention to the issues that concerned women teachers in secondary education in the 1940s. On the pay issue, she only went as far as arguing that women teachers should be paid the same as single male teachers, accepting that married men should continue to be paid more.[14] It is important to point out that of the women interviewed only a small number mentioned that they were in favour of equal pay in their early working lives, thus highlighting the potential limits on solidarity amongst women as workers.[15]

The paternalistic relationships some employers cultivated with employees also seemed to limit the collectivisation of workers and their militancy.[16] Some women recounted the larger-than-life personalities of key employers in their local areas and the esteem they held. Alice mentioned 'Willie Dwyer', who started the Sunbeam factory in Cork, and how 'it was great to work for him. He was a good employer'. She recalled when she was very young, she heard it was said that 'when they built Blackpool Church ... Willie Dwyer's wife gave the jewellery for the tabernacle'.[17] Women also recalled shows of paternalism they experienced or witnessed from employers or bosses and some volunteered their interpretations of the motivations underlying such shows of behaviour. In 1961, Catherine W., who had four children and was pregnant with her fifth child was obliged to return to work as an engineer following the sudden death of her husband. During a number of interviews

for temporary posts, the interviewers alluded to the fact that she was a widow with children and expressed their concerns about her suitability for the jobs. Catherine did not, however, believe that the attitude of the male interviewers was discriminatory in any way: 'I knew it was because they thought I wasn't doing the right thing. You know the horror of a woman, a widow with five children and how could she cope. It was no discrimination. It would have been purely concern'.

At a time when employer–employee relations were generally characterised by strong paternalism and chivalry, it is understandable that Catherine might not have taken objection to the way she was treated. Paternalistic gestures extended the control some employers exercised over the non-work related dimensions of employees' lives. For example, it was the creamery manager who found accommodation for Eileen D. when she took up her post as a cheese-maker in Newmarket Creamery. Caitlín cycled home from her teaching job daily in the 1930s until the Bishop of Cloyne ordered the parish priest to find her lodgings in the locality. What were viewed as genuine kindnesses shown to employees by bosses or employers at times of trouble or loss were recalled by the women interviewed. However, some of these recollections reveal that women were very grateful to supervisors or employers for what might be considered very minor concessions. Maureen remembered, when working in Roche's in the 1940s, that 'one time when my brother was very ill and my mother was in hospital and I took a week off and they didn't deduct it from my wages'. Clare told us that instead of being disciplined for being absent from her job for a day without notifying her supervisor, he ignored this particular transgression, which was usually punished by issuing a written reprimand. After making a mistake as a result of a misunderstanding when working as an office worker in a retail outlet, Joan G. remembered the kindness shown to her by '... poor Mr. Healy, he said he wouldn't say anything to Maureen (her immediate supervisor) about it and he never did, the poor man. He saved me, like, you know'. Instances of supervisor worker collusion were recalled which highlight the capacity of resistant acts to be concurrently ambivalent and complicit.

Being part of a union was not seen as being necessary by some women in office jobs, who reported having a reasonably close, personal relationship with their bosses or employers. Indeed, the

ways in which such relationships, when fostered, were conducive to winning worker compliance were also exposed. Muriel described her first office job with Buckley Brothers, ironworkers in Cork in the 1940s, as a 'pampered job' because as she explained, 'my four bosses, like, I did get on great with them. I was extremely fond of them'. This respect for her bosses made her reluctant to take any liberties at work: 'I had to be in for ten o'clock ... but if it was after that, well he didn't really mind. But being such a generous boss, I didn't take him for granted: I'd be in for ten o'clock'. Pauline was first employed in a painting and decorating firm in Cork and she told us that the office environment she worked in was very relaxed and convivial. As a result she 'wouldn't take advantage because I worked for a very good firm'. Catherine O'D. stated that she was treated like a sister in the sweet manufacturers where she worked, because the youngest owner had a crush on her. When it was closing, she was forewarned and in her own words: 'He was advising me, like, to go for a job in a nice way'.

Small bonuses were not uncommon and some women recalled receiving them from employers. Alice worked for two dry cleaning companies where the treatment of workers was very different. She recalled that in the better one of these companies, workers received a cash bonus at Christmas time, and at other times, to show appreciation, her employer gave the women workers perfume and the men aftershave. Maureen recalled the significance at the time of receiving a pound bonus if the accounts were in order where she worked in Roche's in the 1940s: 'And you came out then of course on top of the world. That went up a bit over the years, now not a king's ransom worth anyway, that I can tell you'.

Employers or bosses with good leadership qualities or other skills had charismatic power and commanded much respect from workers. Ena had great admiration for Mrs. Dowling, her boss in the shop where she worked because 'she had a wonderful gift for buying etc. and she was really the doyen of everything that was there and I learned an awful lot from her'. Catherine W. remarked that her job as an engineer only became a job she valued for more than the money she earned when she worked for a man who truly inspired her: '...it was a turning point for me in that it became a career then. It was a career before that because it had to be, for the money and then all of a sudden John Crowe, he imbued me with his dedication and love, a real love of roads'. The women's stories reveal how

worker compliance could be successfully engendered when bosses or supervisors were tacitly admired by workers, enjoyed good reputations and were known for little acts of kindness. Paternalism had the potential to be an effective management strategy and based on the interviews we conducted it seemed to be used by employers frequently during this period. Women, who were not prepared to accede to poor working conditions, made what could be considered prudent and tactical choices and these are discussed in the following section.

ROUTINE AND UNOFFICIAL FORMS OF WORKPLACE AGENCY AND RESISTANCE

Women were not long-suffering, rather they engaged in an array of informal strategies to actively change their working lives or to make them more tolerable. As already highlighted in earlier chapters, some women moved jobs to escape difficult employers or harsh working conditions. It represented an important step in some women's path toward exercising greater self-determination and control over their lives. However, for reasons mentioned previously, mobility was more likely for some women than for others and sometimes long-term aspirations were sacrificed for what were short-term gains. Alice's decision to leave her tailoring apprenticeship in the early 1950s was prompted by the limited opportunities the tailor gave her to develop her skills. As soon as another employment opportunity became available, Alice gave her notice. Mary O'S. exchanged office jobs for better remuneration and she claimed that if she felt unhappy in a job she preferred to resign and seek employment elsewhere rather than seek union membership. However, not all women could imagine alternative or significantly better working lives. The lack of education and employment opportunities, the prospect of marriage, the structure and culture of the labour market and the gendered ceiling on promotion undoubtedly served to resign many women to accept whatever jobs they had and to quell their ambitions accordingly.

Many women were acutely aware of how their vulnerability as workers did not permit them the luxury of open and direct confrontation with their employers. However, women did recollect accounts of interactions with employers and others in powerful positions when they acted very assertively or even daringly. When

her son, who worked long hours after school to help sustain the family, was being insulted and humiliated by the local priest and the farmer, who was her employer, Joan N., a farm labourer at the time, recalled how she stood up for herself and her son:

> A priest ... he was a big man's man ... and he said 'I don't think your son ... will get his confirmation'. 'Oh, he will not' says such a person, my boss. 'He will not be able to learn fast enough', he says. 'He will' says I. 'I don't mind what the two of ye says, he will get it, his confirmation sir, I have friends too, you know ... there's no collars on them, but I have friends in big places' I said. He started giving out anyway ... well honest it was the first time I ever got into a temper or the first time I ever insulted my employer. I told the two of them up to their face 'if you don't get outside that door ... I'll give you this block in between the two eyes'. And the two of them made for the door and out they went and J. (her son) got his confirmation. But you see this man now was full of bitterness ... our employer.

Feeley notes that servant girls often felt the brunt of snobbery and class distinction more than servant boys because they were around the house all day and got constant reminders of 'their place'.[18] The priest's behaviour towards Joan could also be considered in the context of Feeley's observation that, as the century progressed, there seemed to be less sympathy or concern shown by the Catholic clergy to the plight of farm labourers.[19] The clergy were increasingly drawn from the farming classes and had inherited the same prejudices and interest in sustaining paternalistic and unequal class relations. Joan's action could be perceived as being very brave in view of McNabb's comment that at this time people heeded the priest's advice and wishes and that it was very exceptional for them to oppose him openly.[20] In this instance Joan spoke her mind, blurting out her hidden transcript when she felt deeply affronted by the comments of her employer and she engaged in what could be considered a significant act of resistance with potentially very costly consequences.

Like some other women, Rose acknowledged the anxiety she experienced at the prospect of strongly asserting herself and her rights at that time in the workplace or in other areas of her life: 'I found it very stressful to have to fight for your rights, well most people do, I'd say, you know'. However, she managed to overcome

this anxiety when she took the very brave step of informing the Matron that she did not wish to continue her training as a nurse, because as she explained, she was homesick and wanted to leave Dublin to return home to Cork. The matron informed her that she would write to her guardian, who was Rose's aunt. When her aunt responded that Rose was only homesick and would get over this, it made Rose all the more determined to do as she wished. As she explained: 'I can be very stubborn then. I said, "my father wouldn't have me unhappy anyway" so I said I was leaving, so I left'. Definitive action was also taken by Eileen D., a young apprentice cheese-maker, when she put her qualification in jeopardy by confidently rebuffing the lecherous advance of a much older creamery inspector. She was also prepared to take further action, but only if she perceived that her refusal was used to further punish her:

> And he must be about sixty years and we were about eighteen. So he came along ... and when it was my turn to do the exam, he asked me the usual questions. I forget what they were now and he said: 'What would it be worth? Would it be worth a kiss?' To which I replied 'No'. I thought I wouldn't get my certificate but I did. I passed. I would have report him if I didn't get the certificate but you should see him, you wouldn't take him with a tongs as I said before.

Margaret, who worked as a dental receptionist in the 1960s, found her employer to be a very difficult man. She voted with her feet, deciding to leave a workplace where there was no union or formal channels open to her to address her grievances. She acted decisively when the dentist belittled her after she sought a pay increase due to her:

> I found him too hard and difficult and I was conscientious about the job but to the point where I started losing weight worrying. after twelve months I asked him for the rise that I was supposed to get six months earlier and he only laughed at me and I kind of said to myself 'well, you won't be laughing again, like' and I gave a week's notice ... and I applied to Dunlops to go into the factory.

What women did on such occasions reveals how they refused to be cowed by the potential negative repercussions of their actions. Some women reported situations where they took action with their

co-workers to ensure they were treated with respect by line managers or to force concessions from supervisors in order to redress gender discriminatory practices in their workplaces. Catherine O'D. stated in her narrative that one particular manager in the factory was abusive: '...he might catch a girl now talking and he'd blow the ears off of her and she might make a mistake in like labelling a tin, then he'd take it out on her and then there was constant ill-will against him, you know, a very nasty type of man'. This manager's abusive conduct was reported by the factory workers and it resulted in his dismissal. The workers informally organised to change poor working conditions and to challenge clear manifestations of gender discrimination in the Telephone Exchange and in the General Post Office in Dublin where Clare worked. Aggrieved that the women workers in the telephone exchange only had a small shabby locker room, they agitated for a decent restroom and they put this request in writing to Erskine Childers when he was made Minister for Post and Telegraphs in the late 1940s. Erskine Childers acceded to their request for a new restroom, which in Clare's own words was a 'most beautiful room'. He also granted the operators additional breaks, which were very welcome at the time because, as Clare pointed out, the work could be very stressful and demanding. On another occasion, Clare and her co-workers chose a strategy of collective open defiance as the most appropriate vehicle to challenge a covert form of gender discrimination when she worked in the GPO:

> There was one bit of discrimination, which existed and which I resented deeply ... I had started to smoke at the time and there was kind of an unwritten rule than men could smoke at their desks and that women couldn't. It was never said to us but it was the accepted thing. If a woman, if I wanted to smoke, which I did a couple of times during the day, I had to go out to the cloakroom. And I didn't see why that should apply to women only. So there were a couple of other female smokers in the section I was working in and I got to them and said, 'This isn't on! Light up. If we all light up together and see what happens. Bring it to a head. See is it a rule, an enforceable rule or is it not?' So that's what we did. Five or six of us, we all lit up together. And the boss at that time, she was a tall very slim woman, with very round glasses ... but she suddenly saw all these spirals of smoke down the room and she shot up to her

feet and she stood there looking at us. Absolutely agog. And we pretended not to notice her and got on with our work and she stood there for quite a while and then she sat down and there was never anymore about it.

In contrast, a collective action was unsuccessfully taken by Chris and her co-workers at Thompson's Bakery in Cork. Not being unionised, they collectively approached their bosses seeking a pay increase but as she told us, 'it didn't do a bit of good. They could be very independent in those days. You needed the job more than they needed you really ... they wouldn't even stoop to discuss it with you'. In a period of high unemployment, the threat of their expendability was routinely felt by many workers and used very effectively by bosses. However, as evidenced in these stories, efforts were made by workers to test and stretch the limits of compliance and non-compliance in their workplaces and on occasion in ways which were daring and risky.

Women employees also engaged in horseplay in the workplace, in work avoidance strategies that were part of the culture of the workplace, bent the rules and tested the boundaries of what was permissible at the time. Playing pranks on the salesmen was one of the ways Catherine O'D. and another worker brought fun and amusement into their working lives. Elizabeth, a nurse, remembered having a lot of fun at work and this included locking another nurse in a laundry basket and sending the basket down the chute. Catherine O'D. and another employee were reprimanded by the boss for making personal telephone calls during office hours. Catherine had been reported by another co-worker: 'we never sort of trusted the other one that was there ... Years and years older than we were and if you like, the manager's pet ... She'd tell everything to him ... we'd be afraid to open our mouths if ... she was there. She used to tell everything'.

Other narratives also highlighted that not all relations between co-workers were positive. Maura D. recalled how she was set up to be sacked by a few of her older co-workers, when she commenced working in the Limerick Clothing Factory at a very young age. They felt threatened by the quality and the speed of her sewing and so they placed a box of poorly sewn garments under her name in the storeroom for inspection. Fortunately for her, another woman had warned her to put her own secret code in addition to her name on the boxes of garments she completed. She understood that this act

of deception could happen in a climate of unemployment and hard-ship, where older workers had significant concerns about being replaced by younger workers who could produce at a faster pace: 'They were trying to get me the sack. They didn't want me there, you see'.

Other infringements of workplace rules were consequences of the youth and sociability of the women. Mary F. reported that she and other wardsmaids would 'find ourselves in the matron's office a few times. Over the time we came in. ... you'd get reprimanded and you wouldn't be let out the next night then. You kinda had to watch yourself, like'. When working in Kerry County Council, Joan G. used trips to the lavatory to take time from work to chat with employees in other departments of the council and she succeeded in escaping the watchful eye of her supervisors:

> ...and you'd have to get this key to go to the ladies and of course you'd have to go round and around the corridors and I'd be passing the roads department and I'd be going and I'd call in d'ye se, see what was going on you know, that was a world of my own you know, the ladies downstairs didn't know anything about that.

Joan N. punctured the tyre of her bike to cover up for the fact that she had been chatting and lost track of time when delivering news-papers for her employer while working in service. Women reported that they used the workplace and employer resources for their own purposes. Alice and her other married co-workers used the machines at the dry cleaners where she was employed to do her family's laundry:

> And there was a big hot-press upstairs, a kind of spinner. I used to bring in my washing and all. But you'd have to do it when [the foreman] wouldn't be there, when he wouldn't be looking. He'd go way for his lunch and we'd try to get the stuff ... that time you'd be up to ten o'clock at night and trying to do your washing for our children, desperate.

This example of furtive resistance was very much bound up with these women's practical need to reconcile the demands of long working hours with their household chores.

Stories of fun, camaraderie and close relations with other workers were also very plentiful. Rena recalled the banter at break time when

she worked for Sunbeam in Cork City, and her memories indicated how workers were prepared to help each other: 'Oh, "where are you going tonight?" and which fella you fancied inside in the other room and, you know, "have you your work finished and if you haven't ... I'll give you a hand"'. Maura D. and Kathleen O' R. were sent in search of glass hammers when they were first employed in factories at a very young age. Catherine W. was impressed by the solidarity shown to her by other temporary male workers who were also competing with her for permanent engineering jobs. They gave her extra tuition to help her prepare for an interview for a job in Wicklow County Council and they all shared information on the questions they were asked during the interview:

> And the lads came out again and there were grinds because I hadn't a clue about roads and waterworks or anything like that ... because we all applied for the same jobs and if I was in first, I'd come home and I'd make a note of all the questions and I'd ring each of them and tell them and if they were in before me, they'd ring me and they'd give me a list of their questions. So we all co-operated.

Neighbours and friends also provided networks of solidarity for many of the women we interviewed. They seemed to help make intolerable work situations more bearable for women and they provided the necessary buttresses to enable women to survive very oppressive and demeaning work relations and conditions. Joan N., who worked in service, explained it in the following way: 'No matter what slavery you do, forget the pig you're working for, but the neighbours were so nice and kind, do you know, at least you had something to fall back on, when you'd meet them and have a good old chat and a thing like that'. Alice was invited back to work at the dry cleaners after she was married and pregnant. Her mother encouraged her to take the job and she had offered to mind her other two children. However, she remarked that, 'It gave me the greatest satisfaction to tell them "Go to hell!" Well, I didn't exactly say it in those words but to tell them I wouldn't come in'. Eileen D. recalled her anger at her boss, a creamery manager, who refused her a slight increase in wages in the 1940s, and noted that at the time she swore that she'd never say 'the Lord have mercy on him'.

These feelings, which in times past had been sublimated so that they might not lose their jobs, became unsettled during interview

and revealed the ways some women had formed a bridge between the poor conditions of their employment and their consciousness of these conditions. The focus on women's informal strategies of agency, resistance and survival in the labour market at that time is very important when we appreciate how many women worked in situations and conditions, which were not always amenable to formal labour organisation. In the following section we turn our attention to women's formal activism.

COLLECTIVE AND FORMAL MODES OF AGENCY AND RESISTANCE

Trade union activism was not the only bearer of worker agency and resistance but it did feature in the array of formal and informal strategies women workers used at this time to improve their working lives. Of the forty-two women we interviewed, twenty were unionised and twenty-two were not. Of the twenty-two women who were not, two of them did make efforts to become unionised but were unsuccessful. One of these two women was actually dismissed for attempting to initiate union membership in her workplace. The majority of women, who were unionised (eleven), were members of the Irish Transport and General Workers Union, the most populous union in the country at that time. The other women unionised were in the Irish Nurses' Union (three), the Irish National Teachers' Organisation (two), the Civil Service Union (two), the Irish Post Office Workers' Union (one) and the Engineering Union (one). Women generally experienced difficulty recalling the name of the union to which they were affiliated and this is understandable given the passing of time and because some unions had ceased to exist or had been amalgamated and subsequently renamed.

During the 1940s and 1950s trade union membership increased substantially, yet there was a less remarkable increase in the number of women trade unionists during the 1950s. There were approximately 55,000 women unionised in 1950 compared to 60,000 in 1960. By 1970, the number had increased to 100,000.[21] The more significant increase in the 1960s is explained by the effect of the removal of the marriage bar and the retention of more women in the workforce after marriage. There was also expansion in sectors of the labour market where women were more likely to be concentrated. By the end of the 1970s women workers were equally as likely to be members of trade unions as men, marking a significant change from earlier decades.[22]

Some of the characteristics of women's work in the 1940s and 1950s particularly militated against formal organisation. Women, who worked as farm labourers/domestic servants, or in some small service providers, tended not to be unionised and the same applied to women who worked in offices of small businesses, in small retail outlets and in hotels.[23] By the time Chris retired, she had worked as an assistant manager in many hotels and she commented that, 'there were no unions in the hotels then' and that with the exception of the chef, other categories of workers were poorly paid. Some of the women acknowledged that they were unaware of the existence of a union in the workplace or indeed, had no consciousness of the need for the workers to organise. Pauline, a general office worker, quipped, 'we didn't know what the meaning of the word [union] was in those days. A union in those days was husband and wife'. Mary O'S. remarked that as an office worker she was never unionised and that she perceived that her working conditions were such that 'there was no need for me to go looking'. Women who worked in small offices and in other settings where there was no critical mass of unionised workers, had little opportunity to develop a collective worker identity conducive to unionisation and their day-to-day work was generally socially isolated and closely supervised, as Joan F., who worked in an optical factory in Cork recalled: 'I don't think we had any union. I don't think we did but it never worried us'.

In a few instances women were aware that unionisation was strictly forbidden in their workplaces and that attempts to unionise were likely to be punished by dismissal. Catherine O'D. reported that at the paint factory where she worked one male employee tried to 'organise a union but he was threatened that he'd be sacked'. Eileen D., a cheese-maker, recalled how in the early 1960s she was dismissed, in addition to her husband and a small number of co-workers, for attempting to introduce the Irish Transport and General Workers Union to the cheese factory where she worked in Rathduff. Ironically, they took this step in the first place to try and put an end to the practice of workers being fired 'at the drop of a hat'. Eileen was very conscious of practices in her workplace, which were in place to undermine workers. She told us that after she was overheard talking about having a certified qualification in cheese-making, her boss told her 'we don't count certificates as any good, we train our own cheese-makers'. As she explained: 'They'd bring

anyone in from the side of the road and train them. That would mean you could be doing any job in the factory and your qualifications weren't recognised'.

Women believed that union activity in this period was limited in comparison to later decades and that the right of workers to collectively organise and struggle for better working conditions was not so strongly countenanced in the culture of the time.[24] The perception that women who were nurses were demeaning themselves and their professional status by becoming involved in union activity was evident in both Ireland and England in the 1950s.[25] Joan D. and the other nurses were reprimanded by the matron in the English hospital where she worked in the 1940s for 'bringing yourselves down to the common or garden worker' when they attended a union meeting. She was a representative at the time but she recalled having to raise the ten pence among the nurses in the wards to cover her travel to London and back in order to attend a meeting with union officials campaigning for better pay for nurses. When she became a member of the Irish Nurses' Organisation, she noted 'it wasn't a union. The union had a negative image. We were then supposed to be professional people and you did not join unions as a professional person'. She also became a representative when working as an army nurse in the Curragh in the 1950s and she was involved in campaigning for parity of pay with hospital-based nurses, reduced working hours and a better holiday entitlement, but she recalled that they only had limited success up to the time she resigned from work to marry in 1963. They were awarded additional holidays and a small pay increase. That Joan was not derailed in her struggle on behalf of nurses may be explained by her own independence of mind or as she put it 'If you had any bit of spunk at all ... you spoke up'. Joan believed that women pursued nursing because of the nature of the work, as in her view it wasn't well paid at the time. However, she did not accept the premise that caring work and unionisation were incompatible. In contrast, Margaret took a different view when she was employed as a care assistant as late as the 1980s. When some of the younger care workers were unhappy with their conditions and sought to introduce a union to the nursing home, she said she 'chose not to join the union. I didn't see that a place like that was a place for unions, where you were caring for people'. Margaret's objection was motivated by her concern that in the event of any action, the patients would suffer most, but she did

fight for an increase in wages to gain parity with care assistants on day duty in the interests of 'fair play'.

In some workplaces or professions where trade unions were already well embedded, recruitment was well organised and almost automatic. Ena joined Brown and Nolans' school book suppliers in Cork and commented that 'it was automatic to my recall that when you went there that it was understood that we were in a union and you paid your six pence or whatever it was every week to this union and they were there to protect us, I suppose from all adversity or whatever'. Caitlín revealed 'I joined the INTO from the word go, from the word go ... I think you were supposed to become a member. I remember before we left the training college, somebody from the INTO came in and spoke to us'. In contrast, the ASTI seemed to be less organised in recruiting secondary school teachers and Mary G., a secondary school teacher with a truncated career due to caring for her father, revealed little awareness of its activity.[26] Joan G. remembered the beginning of unionisation of workers in Kerry County Council. She remarked that employees were 'kind of coerced into it' by other employees who suggested that they would not get their increments and they would acquire a reputation of being 'blacklegs' if they did not join. She joined and she recalled that there 'used to be meetings on arbitration and [that] this was a whole new ball game' to her and she had no real interest beyond paying her union subscription. She did recall that the issue of unequal pay between male and female clerical officers rankled some of her female co-workers in the early 1960s and generated heated debate at union meetings. However, being employed in a position open only to women, i.e., clerk/typist, she was often given the impression that she and her peers were in a hopeless position to fight for better pay.

An approach from a co-worker or a shop steward resulted in some women joining unions. Doireann had been working at Dunnes for six months when she was approached by a shop steward who told her 'sign this form and get into the union'. Alice took the step of soliciting union membership after some time working in the dry cleaning business. She was surprised to find out that many of her co-workers were already members. Acknowledging that there was a 'lot of rebel' in her, Maura D. also sought unionisation, when she found that the workers in her part of the Limerick Clothing Factory (Tait's), which was English-owned, were not unionised and that they were paid less than workers in another part of the factory, which

was Irish-owned and unionised. She thought she was risking her livelihood when she complained about the pay differential and when she joined a union. She said, 'I thought I would get sacked but I trusted in God and I prayed that I wouldn't get sacked and I didn't'.

Many women who were unionised reported that at the time they viewed the union as little more than an insurance policy to fall back on if they encountered personal difficulties with managers in the workplace. Rena explained her reason for paying her union dues, which at the time were approximately fifty pence a week: 'If you weren't in the union, if something happened on the job, you were out'. Helen paid her union contribution and remarked that the union might take action if there was any suggestion that a pay increase might not be honoured but that rarely happened because the company she worked for was reputable in this regard.

For some women the inevitability of resigning from work upon marriage made them less willing to expend their energies on union activity or on improving their working conditions. As Chris explained, 'I suppose the fact that once you got married anyway you had to leave your job, if 'twas like now, I suppose you would have been more conscious and you would have been kind of griping more as well you know, if you felt you weren't being treated properly'. Clare, a civil servant working in Dublin, shared this view:

> I was always at the women because we were in a majority in the GPO, to be more active and take office ... Women very rarely did. A lot of women weren't interested one way or the other. I suppose most women had the idea that they'd be leaving in a couple of years anyway [to marry] and they weren't going to involve themselves.

Clare could remember only one woman very involved in union politics, who held radical views on worker rights and was a very committed communist. Clare thought she was remarkable because there were few women so politically aware and active at the time. The implications of the marriage bar were such that the majority of women workers would have been young and single and possibly less confident about engaging in trade union activism or in office-holding. This ensured that the key roles in trade unions were left to the men.[27] Some women who were combining work and mother-hood acknowledged that they were much less committed to union

activism. Significantly however, Doireann's position as a part-time married worker prompted her to become a shop steward, when she returned to work for Dunnes in the 1970s. She was motivated by the desire to better represent the demands of part-time workers, who were typically married women. They experienced very exploitative work conditions as they had no holiday pay, no sick pay or any of the concessions afforded to the full-time workers. Confronted with a triple burden of family responsibilities, paid work and union duties, she took exception to the passive card-carrying membership who benefited from the struggle of a small number of workers active in the union: 'You'll always have these people that just meet on the stairs, passing out and they let you do all the work, you know'.

Indeed many women, who were more than dues-paying members, viewed themselves as reluctant union activists. Clare was very modest about her own involvement in the Civil Service Union, stating that she was only active on 'a minor scale'. She remembered that key issues discussed at meetings were pay-related as civil servants did not have the right to strike. Again like Doireann, she felt that employees had 'no right griping about their conditions … if they didn't do something about it'. A very small number of women interviewed did become shop stewards, albeit in female-dominated areas of employment or took more active roles in trade unions. Kathleen F., who worked in the Sunbeam factory in Cork City for sixteen years in the 1940s and 1950s, felt that both male and female workers at Sunbeam complained about the union doing nothing for them but rarely took much interest in union affairs unless they had a grievance of some kind. She explained that she 'only became a shop steward because no one else would take it'.

Some women were put off by the very formal proceedings and the masculinist culture of union meetings. The fact that meetings often involved very large gatherings in inappropriate physical surroundings did not help matters as far as some women were concerned. Mary O'D. noted that the rank and file was mainly comprised of women at the Irish General Transport Workers' Union meeting she attended, but that 'there'd be these big fat men talking and they'd be talking in such language you just simply couldn't understand what they'd be saying, and … like, there'd be no results'. Mary also remarked that she experienced difficulty following the discussion because of the poor acoustics and because she would be sitting at the back of a hall filled with two or three hundred people.

Dympna remembered that she attended meetings of the Irish National Teachers' Organisation a couple of times but she also acknowledged 'you wouldn't know what they were talking about. Arbitration, conciliation – they were the two big words. They came through every sentence. You wouldn't know what they'd be talking about'. Clare identified that for her, lack of confidence was a key barrier to greater union activity: 'I attended meetings and when I got the courage to do so, I spoke at meetings'. However, she felt intimidated by this experience and she admitted that she often feared that she might 'sound stupid'.

Undoubtedly, the socialisation of young women for employment and the organisation of their paid work did not give women a sense that they were on a level playing field with male workers and they did not have opportunity to hone their public speaking skills, which would have been beneficial for their active trade union participation. May remembered summoning the courage to challenge the defeatist attitude of a male union representative at a union meeting in Connolly Hall in Cork:

> There was a hotel meeting because there was a tipping zone and a non-tipping zone, you know, and of course I was in the non-tipping zone … and there was a waiter from the Victoria Hotel … they were discussing this wage thing and he says 'We'll look for a substantial rise for the non-tipping zone but we know we won't get it but we'll try for it anyway'. So I stood up and I said 'May I quote you? You know you won't get it so you're wasting our time down here'.

She knew subsequently that this union representative expressed his indignation to another that she should dare question him when she was merely a hotel kitchen worker. However, in answer to this, the person replied that her position did not 'stop her from having a brain'.

Mary K. identified herself as an active member of the INTO and in her view it was quite a female friendly union, which encouraged women to be active, however the key roles on the executive and the committees were still overwhelmingly filled by men. She also commented that the organisation of the INTO made her very aware 'how powerful men were and we (women) just went along and were there'. Mary Daly has noted that despite the fact that the INTO represented a significant number of women workers, the union

accepted the marriage bar and also failed to prevent the compulsory retirement of women teachers at the age of sixty.[28] Connolly has highlighted an incident where the INTO opposed the appointment of a woman principal to a Protestant primary school in 1958 on the grounds that such positions were scarce and that a man, who may have family responsibilities, should have been appointed rather than a single woman.[29]

Rarely could women remember what kinds of issues were discussed at union meetings, but many women expressed doubt that women's employment issues were ever really on the agenda. Daly and Connolly have noted that at this time of job shortages in Ireland, there was hostility to women working, amongst trade unionists, and in Irish societal opinion generally. Furthermore, hostility to women working was evident and embedded right across post-war Europe.[30] Women's employment was seen to jeopardize men's jobs and to threaten the family wage traditionally earned by male breadwinners.[31] Even Louie Bennett, the General Secretary of the Irish Women's Workers' Union was not entirely convinced of the value of married women working as she viewed it as a menace to family life and in her estimation certain jobs were just not suited to women.[32] As Kennedy has noted, early trade unionists idealised the family wage which would enable men to earn enough to support their wives and children, so that women and children would not have to engage in the workforce.[33] The priority was put on men's jobs, particularly when work was scarce. Kennedy has documented accounts of some trade union opposition to married women working which were evident as late as the 1960s and 1970s and which related to unionised husbands' opposition to their wives working and the fear that women would take 'breadwinner' jobs.[34]

Kathleen O'R., an ITGWU member, remembered attending the large gatherings of workers in the factory canteen but she also acknowledged that 'what rights they were fighting now, I don't know. Maybe it was bigger money or something, you know, or maybe the older men had something, you know'. Muriel thought, based on her experience of attending union meetings, that the mixed ITGWU definitely prioritised men's employment issues: 'I felt that men got a better hearing than women did at these union meetings'. Rose claimed that she often felt at the time 'that they (the ITGWU) weren't doing enough for the women'. However, she also identified her own lack of confidence in making her views known: 'I didn't

feel qualified to argue … in case I'd make a fool of myself I suppose, you know'. She mentioned that when she did complain about the union's lack of interest in women workers' issues, she was often told by other trade unionists 'you are the union, the members are the union'. Rose remembered having a discussion with a male friend, an active trade unionist, over a cup of tea one night. Her story of what happened is interesting in the context of how male trade unionists at that time might have perceived women's work and their work-related concerns:

> … and I said to him one time about the women in my place were getting a lot less than the men for doing the same work. And he said 'How would you like to go down the quay' he said 'shoveling coal?' I said 'I wouldn't be able for it'. I said 'It would be too heavy for me'. 'Well', he said 'there you are'. But I said 'I'm talking about like work, doing the same work … How would you like to be in the Victoria hotel' I said '… as a chambermaid?' So he walked out and he didn't come in for weeks … he was a man's man like, you know, like women were inferior beings in those days. I knew it talking to him and I said it.

As evident in Rose's story, prevailing views of women workers as competitors or inferior workers possibly served to limit the support women workers could muster from male co-workers and trade unionists. The comments of women in this regard support the argument put forward by Daly that while mixed unions sought improvements in women's pay and working conditions, until the second half of the twentieth century, 'they rarely articulated the point of view of women workers, nor did they do anything to redress inequalities in pay and career prospects for women'.[35] It was not until 1959 that the Irish Congress of Trade Unions appointed a women's advisory committee and, according to Daly, it took a few years for the committee to exercise an impact.[36]

The existence of widowed women in the workforce did pose a very direct challenge to the view that women should work for less than men because they had no choice but to take on the bread winning role in their families. When single male engineers put their lower pay than married men on the agenda at a meeting of the Board of Works Engineers, Catherine W. recalled how this concern was sidelined when a male co-worker highlighted her much lower pay as a widow rearing children:

> I remember there was a meeting, it was the first meeting I ever went to of engineers in Clyde road, of the Board of Works Engineers. And the next thing they were all there and Jimmy Shine stood up ... and he stood up and he lit into them all and he said 'how can you ... there's a woman here and she's a widow with five children ... and she's only getting 80 per cent of what we're getting. It's more in your line fight for her'. And when the vote came there was nobody for the motion that they came into vote for. Nobody put up their hands.

During decades when there was no significant campaign for equal pay for women, a small number of women in this study reported having a keen awareness of the unfairness of the pay disparity between men and women.[37] Mary T. recollected the struggle women poultry instructresses engaged in to achieve parity of pay with male horticultural and agricultural advisors. The agricultural advisors were paid more than the horticultural advisors and the poultry instructresses because they were educated to degree level and the latter two professions graduated with diplomas. The horticultural advisers' claim for equal pay with the agricultural advisers was accepted, but, according to Mary, it proved a lot less contentious because both professions were male-dominated. She revealed that the ITGWU supported the poultry instructresses' demand for the same pay as the other two professions, but that the poultry instructresses' demand was deeply resented by the horticultural and agricultural advisors she encountered who were members of the same union:

> We had one dreadful fight to give us equal pay ... for years and years and years ... while we were doing work of equal value ... they resisted that very much. You see they weren't with us, they were against us ... the agricultural advisors were against us. They would have felt that we were bringing them down in status, because that would mean that there were non-graduates coming into their service.

According to Mary, no progress was made in their pay claim over the years until the introduction of the European Community's anti-discrimination and equality legislation, principally the Equal Pay Directive implemented by the Anti-Discrimination (Pay) Act in 1974. According to Connolly, what little justification did exist for equal pay in Ireland at the time tended to be confined to situations

where men and women were doing exactly the same job. This was because of the fear that cheaper female labour might be used to replace male workers.[38]

In addition to the stories recollecting cross-gender antagonisms are the other stories women recollected which highlight support women garnered from male co-workers and union leaders. Stories about how unions effected local change or did bring about improved working conditions were recalled by some women interviewed. Doireann commented that in Dunnes the bosses were wary of the unions and on one occasion a supervisor, disliked by the workers, was removed as a result of union representation. Union action brought about a shorter working day for women pressers in a dry cleaning business where Alice worked in the 1950s:

> We had to work every night till ten o'clock especially when we were busy, coming up to Christmas. And a lot of people had families. We were moaning and groaning about it one day. I said 'I'd see what I could do now' but I had it in mind. I said to them, 'Now if I got eight o'clock for ye, would ye work every night till eight o'clock?' That'd be great, there'd be two hours off, like. So we send for yer man (the ITGWU official) anyway. Of course that time the union man, I don't know about now, went straight into the boss. He didn't even talk to you like, but of course he didn't know that I was the new representative, like. I said, 'Excuse me'. I knew bloody well that when he came in he'd go straight to the boss, so says I, 'Can I speak to you?' 'Yes', he says, 'I'll be out to you in a second'. I said, 'You'll be out to me now'. I said, 'We're paying your money'. Said I, 'It's we have the grievance, not him. You'll talk to me, I'll tell you our side of the story and then you can go into him then'. I told him that we'd work every night until eight o'clock. Ten o'clock was too much and we were tired and sick of it. So he said, 'That'd be alright, so'. I said, 'There's three men there, three pressers – men, and they can stay on till ten o'clock, like'. They stayed on till ten ... and the women were left home at eight o'clock and 'twas grand ... They were happy. It pleased us, just little things.

Alice's story highlights how little engagement this particular union official was prepared to have with her, the shop steward who contacted him and how his actions in this regard failed to surprise Alice, who asserted herself accordingly. It also demonstrates how

the women used patriarchal notions about women's roles as home-makers very successfully on this occasion to advance their own parochial interests. Undoubtedly the existence of shop stewards, who were often women in feminised sectors of the labour market, meant that the opportunities for local bargaining in the interests of women workers were enhanced.

Mary K. highlighted the apparent lack of interest shown by the INTO in the Junior Assistant Mistresses' (JAM) struggle for the same pay as teachers with a qualification.[39] To protect their own members, the teachers' unions were opposed to the recruitment of unqualified teachers in schools:

> They would have preferred if we'd disappear and stay quiet about it and we didn't. We almost set up an organisation, which of course the INTO probably got afraid of ... but it didn't come to that. We travelled the length and breadth of Ireland ... You see it was a certain group of junior assistant teachers who fought this virtually on their own by bringing it up meeting after meeting after meeting.

After protracted negotiations between the different interest groups, a settlement was reached which required the Junior Assistant Mistresses to attend a teacher training college during the summer months and they were then placed on a certain point on the pay scale. Mary commented on the fact that they were always paid less than their trained counterparts and that the stigma of being a JAM remained in the teaching profession for some time.

There was also evidence of sceptical attitudes towards union officials, who were perceived to be too close to bosses and too distant from the stewards or the union members to effectively represent workers. Doireann thought it inappropriate that union representatives dined with the bosses in Dunnes. Alice's story about the union official intervening to negotiate a shorter working day for women pressers also provided an indication that union officials did not always command the respect of the rank and file.

Despite their increasing female membership, trade unions were weak during the decades featured in this study, mired as they were by infighting and splits.[40] The movement was even divided into two congresses, a division that had negative implications for the movement and was not healed until 1959.[41] According to Ferriter, the establishment of the Labour Court as a result of the Industrial

Relations Act of 1946 brought the unions closer to the political establishment and quelled their militancy.[42] Despite women's growing involvement as lower ranking members in unions during the 1940s and 1950s, they did not permeate the senior levels of union management nor did they significantly influence the agenda to incorporate their concerns during these decades.

<div align="center">STRIKE ACTION</div>

According to the women interviewed, collective strike action was only memorable because it was so rare during the 1940s and 1950s. This is supported by the empirical evidence, which indicates a low average annual number of days lost due to industrial disputes in the 1940s and 1950s.[43] In some women's retrospections, they viewed the 1930s, 1940s and 1950s as gloomy decades, defined as they were by unemployment and emigration; whereas the 1960s were by comparison full of promise and rising expectations. Because strike action tends to be episodic and short lived, it is understandable that the details may have been forgotten, particularly by workers who were not central to the strike but there in support of other workers' demands. The women interviewed, who had participated in strike action, were often not quite sure what it was all about and at times they presumed it was action taken to support other workers, to improve their pay and conditions rather than their own. Ena had just commenced working in Brown and Nolans when she joined the workers who went on strike to effect a pay increase. The strike action only lasted one day as the employers acceded to the workers demand:

> I was only a week in Brown and Nolans and the only strike that was ever on happened and it was something like the commercial union or something. It was like 'em, the union that we were members of ... and I remember one of the senior ladies in the office saying 'Some people, they're only in the job a week and they're on strike'.

Doireann remembered participating in an extended pay-related strike action while working for Dunnes in Cork City in the 1950s. Eventually the workers returned to work defeated. They obtained a nominal pay increase, which fell short of what they demanded and it did little to compensate for the earnings they lost while on strike:

All Patrick Street closed down because they did not want to give us the rate, from Easter 1955 to September, but we went back for nothing. They blazed us out of it you know, which they always do and did over the years. We went back for nothing. I can't remember because you see I was so young, but my father, I remember was so disgusted. We had to because we'd no money, you know.

According to Doireann, there were many more strikes in the 1970s because in her own words, they 'nearly had to strike for every increase'. She recalled standing in front of the delivery trucks, which nearly knocked them over as they picketed by night. She recalled the support they received from other workers but also the 'black-legs' who were rewarded by the employers for their loyalty. Rose, who worked in many factory jobs, could only remember one strike action, the detail of which she could not recall, except it was taken to support a group of shift workers; it had nothing to do with the women workers but 'we were all brought out'.

Some workers who chose to continue working were dubbed 'blacklegs' and their lack of solidarity resulted in 'a lot of bad feeling', which lingered long after they returned to work a few weeks later. Chris remembered a bakers' strike when she worked in Thompson's in Cork but that she and all other employees continued working because they were fearful of the Directors and because they were not union members. Kathleen F. recalled one work stoppage in the Sunbeam factory, which she claimed was trivial because it was so short-lived. She recalled that in her capacity as shop steward she went to inform the manager that the machinists had stopped work and were refusing to take orders from one examiner, who was inclined to be officious and offhand. After the manager ordered the machinists to resume their work, they did so dutifully in a matter of minutes. Kathleen felt the strike action was taken to alleviate the boredom of the factory routine rather than to establish any important point of principle.[44] Generally, she felt that in the Sunbeam factory there were few grievances or issues in comparison to other work-places, which could be more turbulent and where employers might be attempting to deny workers pay increases due to them.

Overall, strike action features rarely in women's accounts and this is hardly unusual considering that during these decades workers generally were found to be apathetic about union membership and showed few signs of militancy. The 1960s is perceived as the decade

of upheaval as it featured a number of high-profile industrial disputes.[45] This is also borne out by Maura C.'s comment that she knew little of the union in the 1940s other than she paid her union dues. However, she mentioned that by the 1960s and 1970s, 'trade unions at that stage were becoming more militant, you know, and they were able to articulate the causes better'. In the 1970s, she went on strike with her co-workers for a pay rise and she was, in her own words, as ' militant as the next one'. The formal labour movement was not the only bearer of women's activism at a time when women's attachment to paid work was much more tenuous than their male counterparts. The day-to-day struggles that many women encountered in their domestic lives resulted in other kinds of female-led organisations, which enhanced women's opportunities to participate in social and political life.

CHARTING OTHER SITES OF WOMEN'S AGENCY AND RESISTANCE

Undoubtedly trade unions played an important part in mobilising a segment of women workers, but other female-led organisations such as the Irish Countrywomen's Association (ICA) and the Irish House-wives' Association (IHA) also played a role in addressing the needs and interests of many home-based women. Terms such as 'maternal feminism', 'social feminism' and 'indigenous feminism' have been used to capture the overall thrust of the organised activity of women in these decades, which was directly concerned with improving their domestic lives in very practical ways.[46] However, these organ-isations mobilised around issues of much wider public concern than the immediate interests of women in the home and their leadership was very politically active on behalf of women. This was reflected in what Alice Ryan (a future president of the ICA) said in 1939, when she urged ICA members to challenge the saying that 'a woman's place is in the home' to 'a woman's place is where she can best help her home'.[47]

Some women we interviewed helped establish guilds of the Irish Countrywomen's Association (ICA) in their areas.[48] They identified the significant contribution this association made to the empower-ment of rural women, who through its nurturance, gained the confidence and skills to move forward and to raise their concerns in public life and to alleviate some of the drudgery associated with their domestic lives. Noreen acknowledged the significance of the

groundwork undertaken by the ICA, which benefited this generation of Irish women:

> ... friends of mine were in [the ICA] and it kind of rose them up and brought them out of the farms and the houses. And they met in a hall ... people were able to talk, air their grievances and things like that ... to be more self-confident and to be able to cook and talk and dress....

Some of the women we interviewed praised the ICA for providing a valuable social outlet for women to enhance their domestic skills. For example, Madge associated the ICA with giving women the 'first break ... to get out of the home' and to demonstrate their intelligence and their skills by getting the guilds started and by taking up roles such as president, secretary and treasurer. Clare also commented that, 'groups like the ICA, which I joined later [in life] are wonderful and give confidence to women to be more positive in their lives and to live more fulfilled lives. I couldn't say enough in praise of the ICA'. Apart from being a significant social outlet in the 1950s, the organisation also provided the focal point for campaigns for the key commodities of piped water and electricity for rural households. According to Madge, the ICA filled an important role in the community through such activities as fundraising for needy families, catering for Irish Farming Organisation (IFA) events and organising family friendly field days and evenings. Through her involvement in the ICA and a local ladies club, Bridie appreciated the opportunities afforded to her in later life to make new friends and to learn new skills. She was active in the organising committees and she took up roles such as club secretary and public relations officer. Some of the women interviewed, who lived in cities, viewed the ICA as having little relevance for them. Indeed Chris recalled that she could only become an assistant member of the ICA because she was a city dweller. She cycled with her friend to Ballincollig outside of Cork city to attend ICA meetings in the 1940s. She was positive about the very informative lectures she attended as a member.

Muriel was a member of the Irish Housewives' Association[49] and she recalled participating in a demonstration in Cork in the 1950s, which was organised by the association to protest against increases in the cost of living: 'and I remember we got a bit militant at one stage and we walked along Patrick Street carrying placards, and they'd ... to do with prices and you know the rise in the cost of

living and that kind of thing'. She also acknowledged that there were difficulties involved in getting women to politically mobilise around issues that concerned them, even when they were supportive of the issues in question. Mary O'D. managed a guest house in her own family home from the 1950s onwards. She helped set up the Town and Country Homes Association, to better represent and promote the guest house/bed and breakfast sector. Eileen D. was a longstanding member of the Fine Gael party and she also became a Commissioner of Oaths. Mary T., widowed at a relatively young age and mother to very young children, was very conscious of the low status, limited rights and poor conditions confronting women who were widowed. She became one of the founding members of the National Association of Irish Widows, when it was established in 1967. She was modest about its impact but she did acknowledge that it was and still is a very good organisation 'that did a lot for widows, you know ... we didn't do a lot there to change the world, no, but we made a contribution'.[50]

Through her involvement in the National Association of Irish Widows in the 1970s, Mary encountered the Dublin Women's Political Association and she attended their meetings for some time until the cost involved travelling to Dublin became too prohibitive.[51] She had a clear recollection of one particular meeting of the association:

> A young woman in the platform heels ... walked up and told us that we were middle aged, middle class and going nowhere. And we invited her up to the platform ... to talk about it. That was a very interesting day. It was a learning experience to be involved in that women's political association and I would have loved to have continued but it was very expensive at that particular time going to Dublin.

Mary T.'s experience at the meeting reflected the coming together of different ideas about change needed for the betterment of women's lives. It provides some insight into connections forged between what tend to be called 'traditional' and newer women's organisations which emerged during the second wave of the women's movement in the 1970s. Organisations that represented women's interests up until the emergence of women's liberation in the early 1970s have tended to be stereotypically viewed as rural, conservative and apolitical by comparison. However, a number of historical and sociological commentators have identified a vital

thread of continuity in women's activism over time, and the significant work undertaken by these organisations in particular, in paving the way for the explosion of feminist activity that emerged from the early 1970s onwards.[52]

Women's domestic concerns provided the main impetus for the organisations which flourished at the time covered by this study. They provided an important lifeline for women who sought to stretch their roles beyond the private sphere and to enhance their earning potential as well as their independence through home-based activity. Beaumont has credited women's organisations in Britain and Ireland at that time for merging the gulf between women's private and public roles in ways which accentuated their rights to citizenship.[53] They may not have been embracing a feminist cause and challenging narrow gender roles but they were actively endorsing an active citizenship for women and particularly for women in the home.[54] As others have noted, despite the idealisation and strong cultural prescription of a woman's role as wife and mother, there were few tangible supports provided to women actively engaged in this role.[55] The organisations which were active at the time sought to facilitate women's opportunities to pursue recreational and educational opportunities. They enabled women to access the skills which might improve their families' living standards. They also sought to enhance women's own sense of themselves as persons who had a contribution to make to the public issues which concerned them and to seek the changes which could make their own domestic roles less arduous.

CONCLUSION

The women we interviewed generally tended to emphasise their compliance as workers, viewing themselves as fashioned by the culture of the time. They tended to interpret their thoughts and actions in this context as techniques designed for the purpose of survival rather than for rebellion. They were not at the vanguard of any major progressive movement of change; few were active trade unionists and many viewed the trade union as the insurance policy needed should they, as individuals, be confronted with serious workplace problems such as the prospect of dismissal.

What was evident in the narratives were the major stumbling blocks to women's labour activism, most notably: fear of parents and

their feelings of familial obligation; their paternalistic relations with employers; their fears of jeopardising their reputations as workers or indeed being dismissed from their employment at times of scarce opportunity. The kinds of work environments in which some women worked were not always conducive to union organisation. A significant number of the women interviewed were ordinary members of trade unions but few were actively involved in union organisation or management. Women living through these decades rarely thought of their work in the paid labour market as life-long careers and this meant that many viewed labour activism as a lesser priority in lives, which they expected to be built around their homes and their children after marriage. Furthermore, the women working through these decades were conscious of the fact that there existed a less than vigorous labour movement, which gave few signs to women in many sectors of employment that they were interested in really involving them as members or representing their particular issues or concerns. There were many indicators in the narratives that women felt they had little sense of entitlement at a time when they were afforded little protection as workers and when employers reigned supreme. Parents encouraged their children to be compliant employees to keep their jobs and in this context, the significant financial contribution they made towards the upkeep of their families of origin cannot be overlooked.

A discourse of activism associated with workers' rights was not considered respectable for certain categories of women workers, particularly for those in female-dominated jobs such as nursing and office work. These fields in particular were characterised by strong traditional authoritarian or paternalistic relations, very conventional views as to how women should behave at work and in the case of nursing, a strong emphasis on vocation. Indeed, a few of the women interviewed acknowledged that they held the view that union organisation and activity was entirely unwholesome in sectors of the labour market concerned with caring.

Women's workplace resistance did find expression in many different ways in the narratives. Dissatisfaction with their conditions of work gave rise to thoughts and feelings which they revealed in their narratives and which they had suppressed in their workplaces. Some women actively relegated their paid work to a less significant place in their lives; seeing it as repetitive, monotonous and unrewarding, or merely a means to an end. Refusing to bow to the pressure

induced by piece work, taking unauthorised breaks, dancing and having fun were some of the ways in which women stretched the rules and succeeded in challenging some of the work-related restrictions in their lives. Women pursued both individual and collective solutions as well as informal and formal means to change their working culture or conditions. Resigning from the job was the low-key non-confrontational individual strategy utilised by those women who were not content to put up with difficult bosses or poor conditions, or who wished to better themselves.

Spontaneous and daring acts of resistance featured in the women's stories, as, for example, in Joan N.'s challenge to one of her employers, which she knew could have resulted in her dismissal. However, these actions were less frequent than the carefully planned collective or formal actions which carried less risk of individual recrimination. The issue of equal pay – which had virtually no public support and had not even been prioritised as a trade union issue – was viewed by a small number of women as significant and they contributed to the process of having it put on union agendas in spite of opposition. There were instances of women going on strike alongside their co-workers, though according to many of them, this was a comparatively rare form of labour protest and they often could not remember what the strike was all about. Women were generally negative about their status in mixed unions but this did not result in any momentum to set up female-only unions that might have better taken on board their particular concerns. In fact most of the growth in union membership during these decades was in the general unions rather than in the Irish Women Workers' Union. While gendered experiences of work and trade unions were recalled by women interviewed, an entirely common and unique female experience of work was not evident and specifically women's employment issues only rarely accounted for women's mobilisation in work and union contexts.

The existence of women-only organisations such as the Irish Countrywomen's Association and the Irish Housewives' Association casts little doubt on women's ability to organise. However, it seems that when they did organise they were more strongly motivated to improve their lives as housewives and mothers rather than as workers. Such organisations undoubtedly provided women with greater opportunity to interact in the public sphere. They also sought to represent women's interests in the political arena during decades

when there existed clear institutional constraints limiting women's opportunities for political expression. However, what is also important about the selection of material presented in this chapter is that it demonstrates how women in this era capitalised on an array of formal and informal opportunities and tactics to improve or change their working environments. They rarely viewed themselves as entirely powerless to act in a climate which was undoubtedly hostile to the notion of the paid woman worker as a significant breadwinner in her own right.

Conclusion

The limited study of women's experiences of waged work in Ireland during the 1930s, 1940s and 1950s, and the representation of women's role in the period as one dominated by life within the home, provided the starting point for the questions raised in this book. By placing women's paid work at the centre of our inquiry, we sought to explore the detail of the material structures that shaped their entry into paid employment and their experiences of it. At the same time, we endeavoured to tease out their perceptions of and engagement with the cultural discourses which prescribed appropriate female behaviour. Furthermore, we attempted to elicit the meaning of paid work in women's lives and indeed the role it played in influencing their sense of who they were as women at different stages of their lives.

The research for this book produced a body of oral evidence on women's work, which has been examined in relation to other historical sources on women's lives in the period. While it cannot be claimed that the women we interviewed were representative of all working women of this generation, the general conditions and the circumstances they experienced have many typical features of the time. Their stories constitute 'micro-histories', which excel at revealing the interplay of gender, class, status, family, community and culture in the shaping of women's working lives. They also highlight the uniqueness of women's individual experiences and in forming our conclusions we have sought not to overlook this aspect. Indeed the diversity and complexity of experiences we encountered in a small regional sample of women caution us against the production of any over-arching narrative of expedience in this field of inquiry. In this context, our conclusions are partial and indeed open to further interpretation, but nonetheless they are a useful resource for advancing the understanding and theorisation of women's work. This study, informed as it is by feminist materialist and post-structuralist currents, provides insight into the diversity of meanings women

ascribed to paid work but also to the other aspects of their lives. In this concluding chapter, we consider not only our findings regarding women and the workplace but we also address issues related to the interconnections between women's working lives and the familial, community and cultural dimensions.

<div align="center">PRODUCING GENDERED WORKERS</div>

The highly gendered division of labour which characterises the stories in this research is an expected finding. What is of interest, are the insights provided into the perpetuation of the sexual division of labour and the implications for women's identities and experiences as workers. The accounts of childhood and schooling provided multiple examples of the material and cultural practices, which produced young women prepared for and accepting of a limited range of work options. Parental practices, which produced gendered divisions of labour within the home and different expectations about the contributions to be made by daughters and sons, were clearly evidenced. Young women were assigned domestic jobs and given responsibility for the care of younger siblings and they worked alongside their mothers, observing and learning the feminine role. Outside the home, gendered educational curricula and in most cases segregated schooling combined with cultural discourses of marriage and motherhood to produce young women who were socially prepared for short-term participation in a limited number of feminised occupations. In their narratives, women indicated an awareness of the material practices and socio-cultural expectations which maintained gendered divisions of labour. Their accounts revealed that, as young women, they did not for the most part perceive these practices as discriminatory, but rather took them for granted; that is, part of the natural order of everyday life.

The other key discourse, which was clearly discernible in the women's stories of childhood and young adulthood, was that of familial obligation. A narrative of self-sacrifice and obedience to the interests of family frequently emerged in accounts provided. This imperative to accommodate family needs was reflected in parental decisions, which frequently determined women's choices relating to completion of education, employment destination and use of their earnings. It was also evident in the manner in which some young women were expected to temporarily suspend their education or

employment, to take on unpaid caring and home-making roles in their families of origin. Though these demands generated some resentment among a small number of women, they were for the most part accepted. In some instances, women drew satisfaction from being dutiful and from their capacity to provide care and support to family members. Furthermore, acceptance of care and domestic roles within the family provided women with opportunities to demonstrate their respectability, complying as they were with prescribed female care roles and expectations of filial obedience and respect. Indeed, the narratives of many women indicated how their sense of who they were was closely bound up in the care and affective relationships they had with others, a point to which we shall return later.

A final theme that emerged in the women's accounts, and is significant in understanding their subjectivities as workers, is that of deference to authority. While a minority of women recounted their contestation of parental decisions, the majority emphasised their acceptance of parental control and indeed the widespread deference to educational and religious figures. The socialisation of women to accept a sexual division of labour, an obligation to support their families and the guidance of parents and other authority figures cut across all class groups. The key difference social class made in the socialisation of women for work related to the educational and employment ambitions held by young women and their parents. Women's ambitions relating to work were constructed in relation to their class and family position and to what they had learned about what would be financially possible and gender appropriate. The women we interviewed rarely expressed an employment aspiration that challenged the gender or class expectations appropriate to their position. Employment ambitions were highly class segregated but within their own sphere, both working-class and middle-class women experienced the same divisions of labour and ideological expectations regarding the abilities and roles of women. However, class differences between women were keenly felt and school and leisure pursuits were key settings in which class differences and hostilities were played out. It was primarily working-class women who highlighted class divisions and their experiences of feeling belittled at school or in other social settings. In a few instances, when women's work brought them into close contact with women of a different class background, they reported experiencing a profound sense of displacement. This was evidenced by Helen's discomfort in

an office setting and Pauline's distaste for the conduct and attitudes of her co-workers in an English factory, which hastened her entry into an office job.

THE GENDERED WORKPLACE

The paid labour market of the 1930s, 1940s and 1950s, as revealed in the women's accounts, was not an attractive place for the majority of women. Notwithstanding the opportunities experienced by a minority of women in professional roles, the majority of the women we interviewed were located in a narrow range of employment settings, had virtually no prospects of promotion and described performing duties which they and others did not hold in any great esteem.

Their concentration in a small range of occupations resulted in keen competition for jobs which were poorly paid, and denied them access to avenues of advancement commensurate with male workers. Furthermore, it reduced the likelihood of women developing a strong consciousness of workplace gender inequalities as they worked with other women, who were for the most part their equals and with whom they shared parity of earnings and conditions. Some women felt they were well remunerated for what they were doing, relative to their peers and other categories of female workers, and a minority felt their jobs enhanced their status in society. Some women commented that while other workers might have benefited or needed the support of a broader labour movement, they did not think that such a movement had any relevance for them in their particular places of employment. Furthermore, while women recognised that they occupied different places in the workplace, earned different wages and were perceived differently, they did not conceptualise this difference as discriminatory. The unfairness of women's employment situations relative to male workers did not appear to be part of popular consciousness at the time. In the main, the women were accepting of workplace gender segregation and some welcomed it for sheltering them from more physical, dirtier and less feminine work. Most claimed that they had no real gripe about gender discrimination in their workplaces and the two women who were most critical of their treatment were widows who returned to the workplace in the 1950s as sole breadwinners for their families. It was very difficult for them at the time to assert their right

to equal pay on the grounds of their equal gender status. In understanding and conveying the nature of her discrimination, Catherine W. mainly drew on the prevailing conceptual framework of the male breadwinner earning the family wage, arguing that as the only breadwinner for her family, she too should be entitled to the same wage as the married man engaged in the same work.

What the interview data also revealed is the absence of any familial or cultural support for women to attempt to change the gendered order of the workplace. Sustaining employment until they married was often the priority for women and their families. There were also practical difficulties and clear disincentives to the collective organisation of women workers. Strong disciplinary regimes applied in many workplaces and the very real fear of dismissal or the loss of reputation, which might render a person unemployable, created a disincentive to worker organisation. The women's stories also demonstrated how worker consent was actively manufactured in workplaces through paternalistic and infantilising workplace practices. Indeed, work welfarism was a significant feature of management practice in the Sunbeam factory in Cork, which provided on-site dental and medical care as well as a range of other benefits designed to encourage a healthy and contented workforce and hence to maximise profit. Workplaces, which were perceived locally as 'a good place of employment' generated a keen sense of duty and loyalty on the part of some women interviewed and further quelled the prospect of worker unrest. There was little to suggest in the stories told that trade unions were helping women workers to develop a collective critical consciousness of their position as gendered workers and overall, the women had very modest involvement in trade union activities. They mainly perceived trade unions as a buffer against the arbitrary decisions employers or managers might make in what they often characterised as an employer's market and as a means of ensuring they received the agreed pay increases.

Women exerted some influence on the cultures of their workplaces and their narratives revealed the ways in which their personal and working lives were intertwined. Furthermore, their gendered interests seeped onto workplaces, humanising and to some extent feminising aspects of their culture and practices. Single women discussed and planned their social lives while at work, devised savings schemes to help them acquire the latest fashions and hairstyles, and developed traditions for the celebration of engagements

and marriages. The workplace was the source of many friendships, which spilled over to leisure pursuits and in some cases continued long after women had resigned from work. Married women's home-making responsibilities also exercised an impact on their interactions at work. For example, married women swapped shifts with others to accommodate their family needs, thus serving their interests more effectively when undertaking dual roles.

A final factor that has to be considered in answering the question as to why the women we interviewed were largely accepting of their working conditions is their prevailing expectation that lifelong waged work would not be a defining feature of their lives. They all identified how strongly this thinking impacted on their sense of themselves as workers and the narratives reveal that as women veered towards marriage, many reported that their worker identities were already assuming less meaning in their lives. The disadvan-taged position of women in the labour market and the degree of parental control many of them experienced even when working made marriage an attractive option. The majority of women inter-viewed reported that they did not mind resigning from work to marry, build a home and start a family. Many perceived married life as an opportunity to escape the drudgery of paid work and to gain social standing as a wife and mother. This, combined with the largely positive accounts they provided of marriage and motherhood are significant in helping us to understand how women rated the relative importance of employment, care work and relationships in their lives.

MARRIAGE, MOTHERHOOD AND EMPLOYMENT

While most women reported being very aware that they were expected to marry and become full-time home-makers, not all slotted smoothly into these roles. Four women remained single throughout their lives, one became a nun, another deferred marriage on the grounds that it would mean an end to her teaching career, while another professional woman recalled that prior to her marriage she took stock of what she was set to lose. Women whose lives were centred in the home commonly constructed their home-making roles as a source of fulfilment and satisfaction. Many viewed their presence in the home as imperative for the creation of a domestic environment conducive to their children's upbringing.

Indeed, a recurring theme in the narratives was the centrality of the mother to child-rearing and there was near unanimous agreement that mothers should avoid employment outside the home when children were very young, unless it was absolutely necessary for family survival. Pride in surviving hardship, in being good and resourceful household managers and in making a little go a long way, were very common themes in the narratives and were means by which women asserted their respectability, capability and suitability for domesticity. While some women highlighted the constraints of home-making and the associated work, which was frequently time-consuming and demanding, they did not devalue what they did in the home and considered good home-making as a prerequisite for good mothering. This idealisation of the importance of a mother within the home did not mean that women were totally uncritical of their positions. Accounts of domestic bliss were provided but there were also many correctives to the idealised version of married life and motherhood. Happy stories about Sundays spent baking, listening to the radio and eating a nice dinner in the company of husbands and children were juxtaposed with accounts from other women, which told of the diminishing sense of self some women experienced in marriage and motherhood. At times these positive and negative aspects of marriage and motherhood were combined in the same narrative. Kathleen F.'s comment that 'all life stopped when I got married', revealed how the demands of marriage and motherhood could constrain women's public selves for a period of their lives. Yet Kathleen, like a significant number of the other women interviewed, firmly believed that only a woman possessed the special qualities suited to domestic life and the rearing of children.

It was clear from the oral histories that a gendered division of labour prevailed in households during the 1930s, 1940s and 1950s and the women acknowledged that husbands were generally accepted as having the ultimate authority in households. Overall, the narratives reveal marital relations which were strongly patriarchal in character. However, some women described their own marriages as more companionate than others, on the grounds that their husbands surrendered their entire wage packet for the family upkeep and took on some household tasks. As the interviews showed, it was not unusual for men to retain some of their wages for their own personal consumption and a few exercised considerable say over how the money in the household should be spent. The principle of the male

breadwinner was widely accepted by women, though many recounted that a small pay packet or a husband's failure to make all or most of it available to the family, did provide the impetus for women's engagement in paid work. When income was short, women appeared to perceive the burden of making do or generating additional income as predominantly their responsibility.

Indeed the majority of the married women in the study engaged in some paid work during their married lives, though for most, it was motivated by economic necessity. Early widowhood, a husband's ill health and other issues obliged some women to emerge from the seclusion of their domestic lives to take on breadwinning roles in a labour market which was largely hostile to them. What emerged in these particular accounts were the enormities of the double burden for these women, who were propelled into the labour market unwillingly and at a stage when their children were very young. Of the other women who worked outside the home, most did so when it was clear that one wage was simply not enough for the family economy. Only three women told us that they experienced domestic life as overwhelmingly stultifying and limiting, and two of these secured part-time employment when their children were of school age, not so much for financial reasons but as a means of enriching their lives.

Notwithstanding the fact that most of the married women who returned to work did so to supplement an inadequate family income and viewed their paid work as an extension of their maternal duty to care for their families, it is worth considering the inherent challenge of their earning a wage. A few women were cognisant of the potential for an independent income, however small, to impact positively on the balance of power in a marital relationship. Indeed the circumstances arising from women's work outside the home heralded a relatively less stereotyped gender division of labour for four women who worked part-time and described a division of household tasks, which although not anywhere near equal, was significant to them. Two women stood up to husbands who opposed their decision to return to work on the grounds that they felt undermined as breadwinners. However, all of the married women who had jobs, including those who were the only providers for the family, constructed their employment as an addendum to, or indeed extension of, their primary role of rearing their children and maintaining a good home. Most women undoubtedly indicated that it

was in their roles as home-makers and mothers that they had made their greatest contribution, gained the most satisfaction and grounded their sense of who they were.

This complicates assumptions often made that it is through employment that women's power, status and their sense of themselves are most enhanced. It is also interesting to note that in telling their stories to us, many of the women who engaged in paid employment after marriage gave precedence to their identities as wives and mothers and downplayed their involvement in work and the economic contribution they made. Furthermore, many married women recalled never entertaining the prospect of paid work outside the home because there was nobody to mind their children or indeed nobody, who in their estimation, could look after their children like a mother. In consequence, most of those who did work outside the home put up with part-time, insecure and poorly paid jobs, precisely because they could more easily integrate such jobs with their domestic responsibilities.

After a period working in the home, the majority of married women who returned to work took up any job that came available to them, to gain a foothold in the labour market once again. Most lacked an identity with a particular occupation and their work careers reflected their practice of being flexible and adaptable to meet labour market requirements. As women's labour was viewed as transitory; women's jobs were often meandering and fractured; women workers were easily replenished and all these features depreciated the value put on women's work. Furthermore, there was little evidence that women who remained single and had continuous employment records experienced paid work any differently. They also experienced work trajectories which were meandering and they were hampered by gender discrimination, narrow opportunities and the prospect that they could marry someday.

WORKER IDENTITIES AND THE MEANING OF WORK

The stories collected in our research provide compelling insights into the ways in which class and gender identities were produced on a day-to-day basis and in a myriad of personal and intimate ways. Class and gender awareness was highlighted in the stories women told us about their sense of their own social positions. It was at times poignantly and at times angrily revealed in their descriptions of how

their occupations informed their social categorisation in relation to status, respectability, femininity and class. Many examples were provided of the everyday gendered and classed practices, which created and perpetuated status differentials between men and women and between women themselves. However, the narratives indicate that this awareness rarely led to collective action around gender or class interests. Yet many women were quick to point out that they had minds of their own and provided examples of their capacity to stand up for themselves as individuals, in both the private and public spheres of their lives. The oral history interview provides a safe place for such revelation of the 'hidden transcript'; that critique of power spoken behind the back of the dominant. The data produced in this oral history highlights discrepancies between women's willingness and capacity to assert agency on an individual level but their reluctance to do so in a more public, political way. It also draws attention to the complicated workings of power, subordination and resistance in the workplace and in wider society.

Overall it would appear that paid work did not provide a primary narrative identity for the women we interviewed and the significance of employment in the women's lives varied throughout the life course. For single women, work played a more central role in shaping their sense of their place and status in society. For most married women, their homes and their relationships with children provided their primary source of identification and even when they were involved in work, they defined themselves first and foremost as mothers. At times during life, work played a crucial part in forming women's sense of their own capabilities, as in the case of daughters contributing to the family economy. Work did take on greater meaning at times and some women spoke of their dedication to particular jobs, but a more common narrative experience was the instrumental approach women had towards paid work. Only in a few of the women's narratives did work emerge as a significant source of pride, satisfaction and enjoyment.

RESEARCHING WOMEN'S WORKING LIVES

After conducting this study, we are very conscious of the many gaps that remain in our knowledge about women's work in this period. The data gathered suggests that when researching women's work it is important to interpret work in its broadest sense and to explore

part-time work and income-generating work undertaken by women within their homes. It also points to the need for greater attention to be given to the relationship between the private and public in the historical study of women's working lives as most of the married women we interviewed integrated both paid and unpaid work and inhabited both the private and public spheres. Life course variations in women's employment trajectories also merit consideration as many married women in our study returned to work after an initial period of child-rearing.

This research has also alerted us to the importance of giving due attention to the topic of care and affective relationships when considering women's work trajectories, their attitudes towards work and their identities as workers. In terms of future research, specific inquiry into the working lives of single women could provide a fruitful vein of inquiry. In particular it could facilitate exploration of perceived changes in workplace conditions and culture over a lifetime of work, and support investigation of the role which work played in the self identity of single women at various stages of their lives. It could also extend and deepen our analysis of the single women's perceptions of and engagements with the prevailing discourses of the 1930s, 1940s and 1950s, which clearly identified marriage and motherhood as a woman's destiny.

While the narratives we collected do speak to the assumptions and debates generated about the generation of women studied, what emerged were accounts that unsettle any narrow or singular representation of women who lived through these decades. As older women recounting their pasts, the participants in this study drew on many interpretations, historical and contemporary. When reading the transcripts, it was very obvious that they were constantly negotiating the old and new; revisiting, retelling and reconstructing the past from the present. As such, the knowledge of the past provided here is not a definitive empirical account but rather a partial and mediated one, which engaged the women in the active construction and reconstruction of their identities. In this study our emphasis was not on producing the authentic story of women's work in the period. We focused instead on elucidating women's subjectivities, by asking them about their working lives. We found that women laid claim to subjectivities that have been denied to them by assumptions that they had unfulfilled lives of enforced domesticity and subservience.

The development of more localised qualitative studies like this have considerable potential to enrich what is in the Irish context, a narrowly based labour history predominantly concentrated on key organisations and personalities. The interplay of material and ideological influences, the tensions between agency and structure and the interchange between empirical and narrative sources have shaped this study. We think this kind of integrated approach is beneficial and may provide a useful framework for further study of women's work, in all its complexity.

Notes

INTRODUCTION

1. By concentrating on documenting the stories of 'ordinary' rather than 'extraordinary' people, oral history has challenged the traditional conceptualisation of what is historically important and has allowed traditionally voiceless groups to reconstruct their own pasts. See B.L. Berg, *Qualitative Research Methods for the Social Sciences* (Boston, MA: Allyn and Bacon, 1995); S. Gluck, 'What's So Special About Women? Women's Oral History' in D. Dunaway and W.K. Baum (eds), *Oral History: An Interdisciplinary Anthology* (Walnut Creek, CA: Altamira Press, 1996), pp.215–30; P. Thompson, *The Voice of the Past, Oral History* (Oxford: Oxford University Press, 1988).
2. See M. MacCurtain and M. O'Dowd (eds), *Women in Early Modern Ireland* (Dublin: Wolfhound Press, 1991), p.2.
3. See M. Luddy, *Women in Ireland 1800–1918: A Documentary History* (Cork: Cork University Press, 1995), pp.xxvi/xxvii; see MacCurtain and O'Dowd, *Women in Early Modern Ireland*, p.13.
4. C. Clear, *Women of the House, Women's Household Work in Ireland 1922–1961* (Dublin: Irish Academic Press, 2000); T. Conroy – Baker, 'Oral History In Ballyconneely', *Women's Studies Review*, 7 (2000), pp.35–9; M. Elders, E. Kiely, M. Leane and C. O'Driscoll '"A Union in Those Days was Husband and Wife": Women's Narratives on Trade Unions in Munster 1936–1960', *Saothar*, 27 (2002), pp.121–30; B. Gray, 'Unmasking Irishness: Irish Women, The Irish Nation and the Irish Diaspora', in J.J. MacLaughlin (ed.), *Location and Dislocation in Contemporary Irish Society: Emigration and Irish Identities* (Cork: Cork University Press, 1997), pp.209–36; B. Gray, *Women and the Irish Diaspora* (London: Routledge, 2004); E. Kiely and M. Leane, 'Money Matters in the Lives of Working Women in Ireland in the 1940s and 1950s', in F. Devine, F. Lane and N. Puirséil (eds), *Essays in Irish Labour History, A Festschrift for Elizabeth and John W. Boyle* (Dublin: Irish Academic Press, 2008), pp.219–37; E. Kiely and M. Leane, 'What Would I Be Doing At Home All Day? Oral Narratives of Irish Married Women's Working Lives, 1936–1960', *Women's History Review*, 13, 3 (2004), pp.427–46; M. Kierse, 'We Taught and Went Home: Women Teachers in Clare 1922–1958', *Women's Studies Review*, 7 (2000), pp.41–52; Y. McKenna, *Made Holy: Irish Women Religious at Home and Abroad* (Dublin: Irish Academic Press, 2006); M. Muldowney, *The Second World War and Irish Women, An Oral History* (Dublin: Irish Academic Press, 2007); L. Ryan, 'I'm Going To England; Women's Narratives of Leaving Ireland in the 1930s', *Oral History*, XXX, 1 (2002), pp.44–53.
5. See M. MacCurtain and M. O'Dowd, 'Introduction', in M. MacCurtain and M. O'Dowd (eds), *Women in Early Modern Ireland* (Dublin: Wolfhound Press, 1991), p.2.
6. J. Bourke, *Husbandry to Housewifery: Women, Economic Change and Housework in Ireland 1890–1914* (Oxford: Clarendon, 1993); Clear, *Women of the House*; M.E. Daly, *Women and Work in Ireland* (Dublin: Economic and Social History Society of Ireland, 1997); M. Hearn, *Below Stairs: Domestic Service Remembered in Dublin and Beyond 1880–1922* (Dublin: Lilliput Press, 1993); M. Jones, *These Obstreperous Lassies: A History of the Irish Women Workers' Union* (Dublin: Gill & Macmillan, 1988); Muldowney, *The Second World War and Irish Women*; B. Whelan, *Women and Paid Work in Ireland 1500–1930* (Dublin: Four Courts Press, 2000).
7. For example, Caitriona Clear has argued that measures which limited women's rights as citizens and workers were not overarching and tended to be unevenly experienced by women; see Clear, *Women of the House*, pp.7–8. Mary E. Daly, Tony Fahey and Maria Luddy have highlighted the problems involved in relying on key Irish statistical data in interpreting women's economic activity. M.E. Daly 'Women in the Irish Workforce from Pre-Industrial to Modern Times', *Saothar*, 7 (1981) pp.74–82; T. Fahey 'Measuring the

Female Labour Supply: Conceptual and Procedural Problems in Irish Official Statistics', *The Economic and Social Review*, 21, 2 (1990) pp.163–191; M. Luddy, 'Working Women, Trade Unionism and Politics in Ireland, 1830–1945' in F. Lane and D. O'Drisceoil (eds), *Politics and the Irish Working Class, 1830–1945* (Houndmills: Palgrave / Macmillan, 2005), p.45. Mary E. Daly, referring to Irish scholarship in women's history, pointed out that there is a danger that 'the freedom and status accorded to Irish women in the early years of the twentieth century may have been exaggerated and that in turn the repressive nature of the new Irish state may also have been overstated'. She proceeds to argue that 'the primacy given to political change and to the culture and ideology of the independent Irish state tends to detract attention from the influence of economic factors on the lives of Irish women'. For example, she argues that 'the clauses in the 1937 Constitution which has tended to be read as circumscribing and stereotyping the place of women in Irish society' should perhaps be seen instead 'as reflecting the lives of most women in Irish society in the 1930s'; see M.E. Daly, 'Women in the Irish Free State 1922-1939: The Interaction between Economics and Ideology', *Journal of Women's History*, 6, 4 and 7, 1 (1995), pp.100–111.

8. D.L. Armstrong, 'Social and Economic Conditions in the Belfast Linen Industry 1850–1900', *Irish Historical Studies*, vii, 28 (September 1951), pp.235–69; Hearn, *Below Stairs*; C. Hynes, 'A Polite Struggle: The Dublin Seamstresses Campaign 1869–1872', *Saothar*, xviii (1993), pp.35–9; Jones, *Those Obstreperous Lassies*; M.A. Kelly, 'The Development of Midwifery at the Rotunda 1745–1995', in A. Brown (ed.) *Masters, Midwives and Ladies in Waiting* (Dublin: Farmar, 1995), pp.77–117.

9. The lack of a regional dimension in women's history in Ireland has been acknowledged; see M. McAuliffe, 'Irish Histories: Gender, Women and Sexualities', in M. McAuliffe, K. O'Donnell and Leeann Lane (eds), *Palgrave Advances in Irish History* (England: Palgrave Macmillan, 2009), p.214.

10. The main female occupations and areas of work according to the 1936, 1946 and 1961 censuses were agriculture, domestic and personal service (domestic service, hotel work) shop work, industrial work, typing, secretarial/administrative work, and home duties. For more discussion of census data on women's paid work covering this period, see Clear, *Women of the House*, p.13–20.

11. S. Reinharz, *Feminist Methods in Social Research* (New York: Oxford University Press, 1992).

12. It was usual for the interviewees to comment that maybe what they were about to tell us was not what we might want. They castigated themselves when they experienced difficulty remembering or they suggested that they were not the best subjects, pointing out how their lives and experiences were humdrum or unimportant. For example, one woman interviewed, Joan G., remarked towards the end of her interview, 'but that's it like, that's my life, nothing extraordinary'.

13. Many interviewees expressed concerns relating to their presentation of self when they received the verbatim transcripts because oral accounts do not make for well-written text. However, once assured that the transcript was only the verbatim record of the interview and not a finished product, most requested only minor changes to syntax. As this book is based on an oral history study, the quoted material in the book is presented with very few edits.

14. S. Gluck, 'What's So Special About Women?', p.218; J. Sangster, *Earning Respect: The Lives of Working Women in Small-Town Ontario*, 1920–1960 (Toronto: University of Toronto Press, 1994), p.6.

15. Thompson, *The Voice of the Past*; Sangster, *Earning Respect*; J. Bornat and J. Diamond, 'Women's History and Oral History: Developments and Debates', *Women's History Review*, 16, 1 (2007), pp.19–39. As expressed so eloquently by Leydesdorff, et al., 'We always need to keep in mind that the reverse side to remembering is forgetting and to speaking is silence'; see S. Leydesdorff, L., Passerini and P. Thompson (eds), *Gender and Memory. International Yearbook of Oral History and Lifestories, Vol. 4* (Oxford: Oxford University Press, 1996), p.13.

16. A. Portelli, *The Battle of Valle Giulia* (Madison: University of Wisconsin Press, 1997); A. Green 'Individual Remembering and Collective Memory: Theoretical Presuppositions and Contemporary Debates', *Oral History*, 32, 2 (2004), pp.35–44; Sangster, *Earning Respect*.

17. Anna Green underlines the need to consider which discourses narrators draw on and why in the act of analysis; see A. Green 'Individual Remembering and Collective Memory', p.42. Hollway has alerted us to the tendency for persons to rely on the 'stock of ready narratives'

when talking about themselves unless invited to divulge the more reflective multi-dimensional accounts of their selves, W. Hollway, *Subjectivity and Method in Psychology* (London: Sage, 1989), p.39. Penny Summerfield has identified the importance of 'discomposing' the oral history subject in the interview context; see P. Summerfield, 'Dis/composing the subject: intersubjectivities in oral history' in T. Cosslet, C. Lury and P. Summerfield (eds), *Feminism and Autobiography, Texts, Theories, Methods* (London and New York: Routledge, 2000), p.91. The value of asking questions to produce more than a story rendered safe for the public domain has also been acknowledged; see Anderson & Jack, 'Learning to Listen', pp.11–26.

18. Poststructuralism is a complex skein of thought encompassing a number of diverse intellectual currents; see M. Peters, *Naming the Multiple, Poststructuralism and Education* (Westport, CT: Bergin and Garvey, 1998). A poststructuralist approach destabilises unitary conceptions of identity/self and unsettles claims to truth, opening up alternative meanings and readings. For more detailed information on poststructuralism, see M. Sarup, *An Introductory Guide to Post-Structuralism and Postmodernism* (New York: Simon and Schuster, 1988). We are impressed by Margaret Sangster's use of poststructuralist insights in her study of women's work. For her discussion of these issues, see Sangster, *Earning Respect*, pp.8–13.

19. G. Beiner, 'Remembrance of Things Past: On the Compatibility of History and Memory' in M.S. O' Neill, C. Cullen and C.A. Dennehy (eds), *History Matters, Selected Papers from the School of History Postgraduate Conferences, 2001–2003* (Dublin: School of History, University College Dublin, 2004); T. Hareven, 'The Search for Generational Memory' in D. K. Dunaway and W. K. Baum (eds), *Oral History, An Interdisciplinary Anthology* (Walnut Creek CA: Altamira Press, 1996), pp.241–56; Leydesdorff, et al., *Gender and Memory*.

20. A. Byrne 'Researching One An-other' in A. Byrne and R. Lentin, (eds) *(Re)searching Women, Feminist Research Methodologies in the Social Sciences in Ireland* (Dublin: Institute of Public Administration, 2000), p.151.

21. T. Hareven, 'The Search for Generational Memory', pp.241–56.

22. Yvonne McKenna provided a detailed discussion of the dynamics involved in the oral history interview encounter with reference to her own experiences of interviewing Irish nuns; see Y. McKenna, 'Sisterhood? Exploring Power Relations in the Collection of Oral History', *Oral History*, 31, 1 (2003), pp.65–72.

23. Sangster, *Earning Respect*.

24. A. Turnbull, 'Collaboration and censorship in the oral history interview', *International Journal of Social Research Methodology*, 3, 1 (2000), p.24.

CHAPTER ONE

1. In 1926 an Act was passed which enforced school attendance up until the age of fourteen and this minimum school-leaving age was not raised again until 1972 when it was increased to fifteen; see R. Cullen Owens, *A Social History of Women in Ireland 1870–1970* (Dublin: Gill & Macmillan, 2005), p.41. For a discussion of debates about the need to raise the school-leaving age, see T. Garvin, *News From A New Republic, Ireland in the 1950s* (Dublin: Gill & Macmillan, 2010), pp.155–97.

2. See Cullen Owens, *A Social History of Women in Ireland*, p.40.

3. Writing about Ireland in the 1950s, Tom Garvin noted that 'up to 80 per cent of young people left school [between] the ages of twelve [and] fourteen with very primitive levels of education and unfitted for any work beyond low-level manual labour'; see Garvin, *News From A New Republic*, pp.122–3, 170.

4. In 1924 the Intermediate and the Leaving Certificate Examinations were introduced. The former was completed after three or four years of secondary education and the latter after two further years. See Cullen Owens, *A Social History of Women in Ireland*, p.41. Females represented only 25-30 per cent of candidates taking Intermediate Board examinations before 1922, while figures for the early 1950s indicated practically equal numbers of males and females candidates. See F. Kennedy, *Cottage to Creche: Family Change in Ireland* (Dublin: Institute of Public Administration, 2001), p.130.

5. See Kennedy, *Cottage to Crèche*, p.45. and D. Ferriter, *The Transformation of Ireland 1900–2000* (London: Profile Books, 2005), p.532.

6. The significance of family in socialising young working-class women for the workplace has been recognised. See, for example, J. Sangster, *Earning Respect*, pp.25-49. However, Avdela argued that the family as a research focus for interrogating gendered workplace identities

has not yet received sufficient attention; see E. Avdela, 'Work, Gender & History in the 1990s and Beyond', *Gender & History*, 11, 3 (1999) pp.528–41.

7. See J.J. Lee, quoted in Ferriter, *The Transformation of Ireland*, p.4.

8. This point is well made by Ferriter in response to Lee's assertions; see D. Ferriter, *The Transformation of Ireland*, p.4.

9. Preparatory Training Colleges were established in 1926 to provide secondary education for prospective primary school teachers. See Cullen Owens, *A Social History of Women in Ireland*, p.41.

10. See A.J. Humphreys, *New Dubliners: Urbanization and the Irish Family* (London: Routledge & Kegan Paul, 1966), p.150 and T. Farmar, *Ordinary Lives: Three Generations of Irish Middle Class Experience 1907, 1932, 1963* (Dublin: Gill & Macmillan, 1991), p.168, for discussion of differential treatment of boys and girls.

11. See K.R. Allen and R.S. Pickett, 'Forgotten Streams in the Family Life Course: Utilization of Qualitative Retrospective Interviews in the Analysis of Lifelong Single Women's Family Careers', *Journal of Marriage and the Family*, 49, 3 (August 1987), p.524.

12. Cullen Owens made the point that poor school attendance was inextricably linked to child labour, particularly on small farms. She cited Akenson, who claimed that average Irish daily school attendance rates in the school year 1950–51 stood at 82.3 per cent; see Cullen Owens, *A Social History of Women in Ireland*, p.41.

13. The practice of young females doing unpaid work on family farms was widespread and Clear's analysis of census returns for 1926 and 1936, indicated that female relatives (a category which excludes farm wives) assisting on farms constituted the largest occupational category for gainfully occupied women, with the majority of such women being in the age category 20–24. However, the 1961 census revealed that less than a fifth of women working in agriculture were farmer's daughters, which suggests a decline in the practice. See C. Clear, *Women of the House*, pp.15–16.

14. Roberts's oral history of British working-class women, 1940–1970 also found that girls' understandings of what their employment futures would entail were influenced most profoundly by the expectations of their family, with school having a less significant role in their socialisation; see E. Roberts, *Women and Families: An Oral History, 1940–1970* (Oxford: Blackwell, 1995), p.53. See Sangster, *Earning Respect*, p.28, for a discussion of the role of family in the socialisation of working-class girls in Ontario between 1920 and 1960.

15. Tom Garvin, in a discussion of efforts to develop industry in Ireland in the late 1950s, noted that Jack Lynch, the then Minister for Education, commented that Irish people 'were far too prone to see no connection between education and the capacity to work and earn a living' and identified farmers as 'particularly likely to have a disregard for education and training'. See Garvin, *News From A New Republic*, p.112.

16. For a discussion of the focus on domestic education, see Cullen Owens, *A Social History of Women in Ireland*, p.42. Ferriter noted that trade-unionist Louie Bennett publicly decried this narrow focus in the education of girls, and Garvin highlights that in 1961 a female vocational teacher in Dublin critiqued the fact that the new Vocational Guidance Service was confined to boys' schools, suggesting that girls were not expected to have careers in craft or technical areas; see Ferriter, *The Transformation of Ireland*, p.464–5 and Garvin, *News From A New Republic*, p.191. A focus on domestic vocational education for girls was not unique to Ireland with vocational schooling for girls in Canada during the inter-war years following a similar orientation. See Sangster, *Earning Respect*, p.40.

17. Class differences in parental attitudes to education for girls have been noted in a number of Irish studies from the period 1930 to 1960, however a common finding of all of the studies was the belief across all classes, that ultimately home, as distinct from the workplace, was the appropriate place for women. For a discussion of this issue, see Cullen Owens, *A Social History of Women in Ireland*, pp.45–7.

18. See Humphreys, *New Dubliners*, p.150, quoted in Cullen Owens, *A Social History of Women*, p.45 and P. McNabb, *The Limerick Rural Survey 1958–64* (Tipperary: Munitir Na Tire 1964), pp.215–16. When thinking about female education participation rates it is worth remembering that the situation in Ireland was not uncommon. Indeed Daly made the point that in 1911, participation rates in second-level education for young women in Ireland were better than those in many other European countries. See M.E. Daly, 'Women in the Irish Free State, 1922–39: The Interaction Between Economics and Ideology', *Journal of Women's History*, 6, 4 and 7, 1 (1995), p.106–7.

19. Garvin noted that university attendance in 1952 stood at 7,600 and was dominated by the middle classes. Farmar's analysis of university attendance in the following decade reveals little change in terms of the class backgrounds of those entering third level. He observed that, in 1963, one in four of the lower professional/managerial/executive class attended university, as compared to one in two hundred children from semi-skilled, unskilled and agricultural labourers. Even among the middle classes, women were less likely to be encouraged to attend university, as the continued existence of the marriage bar in Ireland and the expectation that most women would marry made a university education for daughters seem like a poor investment to parents. Analysis of attendance rates at third-level education between 1930 and 1959 revealed that the proportion of women to men fluctuated between 25 and 34 per cent. For a discussion of these points, see Cullen Owens, *A Social History of Women in Ireland*, pp.45–6, 55.
20. Garvin highlighted that some newspapers were critical of the low number of County Council Scholarships being made available for university entry and asserts that of the few educational scholarships available, most were in the areas of agriculture and farming; see Garvin, *News From A New Republic*, pp.85, 171, 188.
21. Ferriter observed that nearly all memoirs of Irish childhood between 1945 and 1960 emphasise experiences of class distinction; see Ferriter, *The Transformation of Ireland*, p.505. Furthermore, the poor physical conditions in Irish National Schools at the time, and the large class sizes – many classes contained fifty to sixty children – can only have contributed to poor educational experiences. See Garvin, *News From A New Republic*, p.175–6.
22. Unemployment ranged from an estimated 80,000 in December 1923 to a peak of 100,000 in the 1950s. See Ferriter, *The Transformation of Ireland*, pp.313 and 491. In the period between 1947 and 1951, women under the age of twenty-four accounted for 72 per cent of female applicants for travel documents while 412,000 Irish people emigrated between 1951 and 1961. See Ferriter, *The Transformation of Ireland*, p.465.
23. A similar pattern of working-class women aspiring to occupations which were just outside their reach was noted by Sangster in her study of working-class Canadian women in the inter-war years. See Sangster, *Earning Respect*, p.47.
24. Entry into an apprenticeship involved a fee and the training of apprentices was regulated by the Apprenticeship Act (1931). See Garvin, *News From A New Republic*, p.124. In 1949 hairdressing apprenticeships in Dublin and in the Borough of Cork were four-year apprenticeships and applicants had to be over 16 years of age and in possession of a Leaving Certificate. Earnings ranged from 10/- in the first year to £2 in the final year. Outside of these urban centres a Leaving Certificate was not required and applicants had to pay an indoor apprenticeship fee for six months or a year, which ranged from £25 to £50. Earnings consisted of a small weekly sum equivalent to pocket money. After the apprenticeship period, 'improvers' earned a wage of 17/6 per week until they became qualified hairdressing assistants. See 'Any Jobs Going? (No.3)- How Can You Become a Hairdresser?' *Irish Press*, October 19, 1949, p.2.
25. An article in the *Irish Independent* in 1950 claimed that if one were to ask children in national schools what employment ambitions they had, the girls would indicate a preference for teaching, nursing or possibly becoming a nun, but domestic service or being a housewife would never be mentioned. See Garvin, *News From A New Republic*, p.162.
26. See Daly, 'Women in the Irish Free State', p.109.
27. Benninghaus in her study of the narratives of young working-class women in 1920s Germany, noted that in their consideration of their working lives, the young working-class women did not compare themselves with young women from the middle class or with working-class males but took other working-class women as their comparator. Satisfaction with their jobs was determined in relation to the pay and work conditions experienced by young working-class women in other occupational categories; see C. Benninghaus, 'Mothers' Toil and Daughters' Leisure: Working-class Girls and Time in 1920s Germany', *History Workshop Journal*, 50 (2000), pp.49–50.
28. This attribution of low status to the role of domestic worker was not only an Irish phenomenon. Benninghaus's research on young, German, working-class women in the 1920s, also revealed that the housemaid was 'a negative foil against which all other occupations appeared almost luxurious in their conditions'; see Benninghaus, 'Mothers' Toil and Daughters' Leisure', p.50.
29. Garvin argued that Ireland in the 1950s was characterised by 'a weakening of collective

patriotism and the justifying of selfish, anti-civic and "familial" styles of material and cultural defence'. This mentality, he suggested, contributed to many 'closed shop' employment practices where competitive entry into jobs, skilled trades and professions was hampered by familial preference; see Garvin, *News From A New Republic*, pp.114–15, 119. Reliance on 'connections' to secure employment exacerbated class, status, gender and religious differentials and meant that the greater the social capital which accrued to a family the better their chances of employment. For a more comprehensive discussion of the concept of social capital, see P. Bourdieu, 'The Forms of Capital', in J. Richardson (ed.), *Handbook of Theory and Research for the Sociology of Education* (New York: Greenwood, 1986), pp.241–258.

30. Mary T.'s canvassing of local representatives can be understood in the following context. Dating from 1931, the County Committees of Agriculture, which appointed poultry instructresses, were comprised either entirely or partly of county councillors. See Seanad Eireann Volume 57, 01 July 1964, Agriculture (Amendment) Bill 1964 Second and Subsequent Stages, available at: www.oireachtas-debates.gov.ie/S/0057/S.0057196407010007.html (accessed 14 February 2012).

31. Other researchers have noted that migration is rarely an isolated individual decision but rather is a 'collective action' influenced by familial and other communal contacts. See L. Ryan, 'Family Matters: (e)migration, familial networks and Irish women in Britain', *The Sociological Review*, 52, 3 (2004), p.355.

32. Other research on young women's working lives has highlighted the contradictory position of the young working woman and the tensions inherent in reconciling childhood and worker identities. See Sangster, *Earning Respect*, pp.48–9 and Ryan, 'Family Matters', p.355.

33. E. Connolly, 'Durability and change in state gender systems: Ireland in the 1950s', *European Journal of Women's Studies*, 10, 1 (2003), p.80. However, Connolly's assertion of 'a clear division between the public sphere and the private/domestic sphere' is open to question, given that there are many situations in which the private sphere was invaded by the public. The regulation of sexuality is one obvious example.

34. Louise Ryan highlights that even after emigrating to England young female workers continued to experience a tension between family loyalty and obligation and individual autonomy and agency; see Ryan, 'Family Matters', p.352.

35. Roberts in her study has observed that when times were hard economically, individualism was less important than the collective solidarity of the family; see Roberts, *Women and Families*, p.14.

36. For a discussion of the role of families in socialising young workers, see M. Doolittle, 'Close Relations? Bringing Together Gender and Family in English History', *Gender and History*, 11, 3 (1999), p.557.

37. For a discussion of this issues, see Doolittle, 'Close Relations? Bringing Together Gender and Family in English History', p.547–8.

CHAPTER TWO

1. A study of first occupations of girls who completed their education at primary standard in County Limerick during 1959 revealed that most entered domestic or hotel work, some worked at home on the family farm, a small number took up factory jobs while the remainder became shop assistants. See P. McNabb, 'The Farm Worker and the Social Structure', in Rev. Jeremiah Newman (ed.), *The Limerick Rural Survey 1958–1964* (Tipperary: Muintir Na Tire, 1964), p.212.

2. See R. Cullen Owens, *A Social History of Women in Ireland 1870–1970* (Dublin: Gill & Macmillan, 2005), pp.240–1, 244.

3. This is consistent with Nyhan's finding that a family or personal link aided persons in securing a job in the Ford Car Plant in the Marina in Cork; see M. Nyhan, 'Narration and Memory: The Experiences of the Workforce of a Ford Plant', *Irish Economic and Social History*, XXXIII (2006), pp.18–34.

4. Dunlop's rubber factory was established in 1935 and it provided much needed employment until 1983. See Workers and Manufacturing in Cork City and County Archives at www.corkcity.ie/merchantcity/workers/index.shtml (accessed 10 March 2012).

5. The Sunbeam Textile factory was established in 1928 by William Dwyer, who defected from the Dwyer family business and sold his house to set up this factory. See M. Leland, *Dwyers of Cork: A Family Business and a Business Family* (Cork: Ted Dwyer, 2008). It was located near

Shandon until 1933. When it amalgamated with the British firm Wolsey it moved to a site in Millfield in Blackpool where almost 2,000 men and women were employed. A number of subsidiary factories were subsequently developed for the purpose of supplying the main manufacturing facility with production materials such as yarn and silk and eliminating dependency on imported products. These included the Cork Spinning Company (established in 1938), Wool Combers (Ireland) (established in 1940) and the Munster Laundry. The Sunbeam Factory was to become closely associated with life in Blackpool and according to Mary Leland Sunbeam girls in their blue overalls were a daily feature of the domestic industrial landscape'; see Leland, *Dwyers of Cork*, p.61. In Cork 'with Fords and Dunlops it had a kind of local provenance reminiscent, almost of the mines in the Welsh valleys'; see Leland, *Dwyers of Cork*, p.61. At its peak, Sunbeam enterprises employed 4,500 people in Ireland. The single largest employer in Cork in 1986, it closed down in 1990; see Cork City and County Archives, Workers and Manufacturing www.corkcity.ie/merchantcity/workers/index.shtml (accessed 5 March 2012).

6. In the Lee boot factory established by Walter Dwyer, materials such as willow, kid, box calf, patent, fancy calf, crocodile, lizard, chromes, Paul's beva and snake were transformed into the recognisable trademarked boots and shoes under the labels of Lee Footwear and Blackrock Castle. In the 1930s the factory had an annual output of 300,000 pairs of boots and employed 350 workers, one third of them women. See Leland, *Dwyers of Cork*, p.30.

7. Established by Walter Dwyer in 1925, the Hanover Company's shoe factory, located at the Hive Iron Works behind Hanover Street, produced light, fashionable shoes for women and girls. By 1932, the weekly output was 3,000 pairs and it was providing employment for more than 150 men and women. The factory was noted for introducing new designs and new patterns with increasing skill in cutting different types of leather and by offering half as well as full foot sizes, it was improving on the style and range of imported footwear. See Leland, *Dwyers of Cork*, p.31.

8. Sir Peter Tait's clothing factory in Limerick, also known as Prospect Hill Clothing Factory or Limerick Clothing Factory, was engaged in the production of army clothing during the eighteenth and nineteenth centuries. The factory experienced a number of closures and re-openings under different management throughout its history until it finally closed its doors in the 1970s. In 1963 there were approximately 300 factory workers employed in Tait's. For further information, see J. Kemmy, 'The Taits in Limerick and Melbourne', *The Old Limerick Journal*, 23 (Spring 1988), pp.82–7 and K. Hannan, 'Sir Peter Tait', *The Old Limerick Journal*, 31 (1994), pp.26–30.

9. William Dwyer the founder and joint managing director of Sunbeam Wolsey was a devout Catholic, who embraced Catholic social teaching on the duty of employers to workers, as enunciated in the Papal encyclical Quadragesimo Anno. Quadragesimo Anno advised of the need to cultivate greater solidarity between capitalist employers and workers. This was considered necessary to improve work conditions and reduce the danger of workers turning to communism as a solution to their situation. See Pius XI, Quadragesimo Anno, 15/05/1931, available at: www.vatican.va/.../encyclicals/documents/hf_p-xi_enc_19310515_quadragesimo- anno_en.html (accessed 10 March 2012).

10. See Cork City and County Archives, Sunbeam Promotional Booklet in B 506 Sunbeam: Ref: Social Society, Box 9.

11. Ibid.

12. Nyhan highlighted examples of the compassion and generosity of management in the Ford Plant in Cork, which were frequently recounted in the interviews she conducted with employees; see Nyhan, 'Narration and Memory', p.29.

13. See C. Clear, *Women of the House*, p.14.

14. Ibid.

15. Patrick McNabb noted the dramatic decrease in the number of male and female full-time farm labourers in the Limerick Rural Survey 1958–1964. See P. McNabb, 'The Farm Worker and the Social Structure', p.202.

16. See C. Clear, '"Too Fond of Going": Female Emigration and Change for Women in Ireland, 1946–1961' in D. Keogh, F. O'Shea and C. Quinlan (eds), *The Lost Decade: Ireland in the 1950s* (Cork: Mercier Press, 2004), p.137.

17. The relative youth of many female domestic servants is significant in terms of understanding their work experiences. In 1946 one third of all girls in employment under the age of twenty worked as domestics. See D. Ferriter, *The Transformation of Ireland*, p.473.

18. For example, Feeley noted in his essay on domestic servants in Co. Limerick that farmers were known to break up and discourage courtships among the servants and that they also took it upon themselves to see that their employees received the sacraments regularly and attended Mass on Sunday. However, the vulnerability of female live-in domestic servants to sexual abuse by employers is acknowledged by Feeley, when he refers to the popular saying in the Co. Limerick area: 'She came home at Christmas with eleven pounds and a bun in the oven'; see P. Feeley, 'Servant Boys and Girls of County Limerick', *The Old Limerick Journal*, 1 (1979), p.34. The issue of abuse was mentioned by one of the interviewees [off the record] in our study, who recalled the local saying, 'She came home at Christmas with £30, a goose and a baby'. However, none of the interviewees involved in domestic or farm work raised this particular issue in their own accounts. Feeley also claimed that the seduction of female domestic workers was more commonly perpetrated by the gentry than by farmers; see Feeley, 'Servant Boys and Girls in Co. Limerick', p.34. Based on his archival research for *Occasions of Sin*, Ferriter has also documented that domestic servants, young girls out working in fields, those sent out on errands or to work at a young age due to their family's economic circumstances were all very vulnerable to sexual abuse, often perpetrated by employers, neighbours and others known to them; see D. Ferriter, *Occasions of Sin, Sex and Society in Modern Ireland*, (London: Profile Books, 2009) pp.81–6, 174, 245. Mary Clancy drew attention to the evidence from the late nineteenth century of the vulnerability to sexual assault of domestic service workers, who resided in the households of their employers, which led to the promotion of hostels as a better option for such workers. She also referred to Deputy Helena Colcannon's speech in the Dáil about changing lifestyle practices in Ireland in the 1930s. In the course of this speech she recommended hostel accommodation for young working-class country girls, who moved to cities to work as domestic servants with middle-class families in order to save them from the dangers that could await them in certain types of lodging; see M. Clancy, 'Sources, Working Lives, Women's Lives: Some Research Sources and Possibilities', *Saothar*, 32 (2007), pp.65–8. Clancy also acknowledged that, 'Questions of safety, sexual assault, punishment of assaulted women workers through dismissal, personal ruin, incarceration in Magdelan asylums and forced emigration are neglected and difficult themes awaiting integration into Irish history'. See Clancy, 'Sources, Working Lives, Women's Lives', p.66.

19. For discussion of women's involvement in family business, see Daly, 'Women in the Irish Free State, 1922–39: The Interaction Between Economics and Ideology', pp.105–6 and Cullen Owens, *A Social History of Women in Ireland*, p.227.

20. For discussion of the under-recording of married women's work in the census and other statistical sources, see Daly, 'Women in the Irish Free State', p.102 and J. Blackwell, 'Gender and Statistics', in C. Curtin, P. Jackson and B. O'Connor (eds), *Gender in Irish Society* (Galway: Galway University Press, 1987), pp.270–82.

21. Apart from the physical work in the fields, most other jobs on the farm were considered appropriate for women. Patrick McNabb, referring to domestic service, wrote that 'Such jobs have a low status e.g. the term "servant girl" is still used; the work involves milking and feeding animals; hours are long and wages very small'; see McNabb, 'The Farm Worker and the Social Structure', p.173. Describing the layout of farm houses in Limerick, McNabb noted there would be 'two tables, one near the fire for the family and a plain deal table near the door for the serving boy or girl or the hired workers. It is rare for people from this area to eat with their employees. Some kitchens have a screen down the centre to cut off the family from the workers'; see McNabb, 'The Farm Worker and the Social Structure', p.195. Molly's recollections of her own days in service also revealed the amount of indoor and outdoor work involved: 'you had to be up at six o' clock, milk cows from eight to ten, feed the hens and the calves first, feed the pigs, wash the buckets, wash the ware after all the breakfast, scrub down a great big table, start a great big washing ... a great big tub of washing ... wash five or six churns ... go in and bake a couple of brown cakes ... so you washed up after the supper, from six to six ... and you were glad to wash your face, get up on your bicycle and get out from 'em' . See M. Byrne, 'The Life of a Servant Girl', *The Old Limerick Journal*, 14 (1983), p.29–30.

22. Ben Dunne (1908–1983) started his clothing shop in a vacant building on St. Patrick Street, Cork in 1944. Early advertisements for the store emphasised its 'Better Value' slogan, also emblazoned on the side of the shop building. The promise of quality clothing at pre-war prices brought swarms of shoppers eager to snap up bargains on the day the shop opened,

31 March 1944. www.dunnesstores.ie (accessed 10 March 2012). Dowdens Drapery, sited on St. Patrick's Street in Cork, was established in 1844 and was there for well over a century. It was considered a high-class drapery shop and the Dowden family were active in Cork City social and academic life and in Church circles. Cork City Archives, Cork: Merchant City, Retail Heritage at www.corkarchives.ie/merchantcity/.../ johnwdowdenletterhead1942/- (accessed 10 February 2012).

23. Barbara Walsh's history of Woolworths draws attention to the better pay, conditions and promotional prospects afforded to female employees relative to their counterparts employed in other retailers and drapery houses in Ireland. She wrote that one ex-counter assistant employed by Woolworths in Cork remembered her first week's wage packet in the 1940s as being 27/-d. Her account also reveals that the strongly unionised Cork branch made regular requests for pay increases in the 1940s and that some of these requests were granted. She also noted that promotional opportunities on the shop floor, stockroom or office were taken up by some female employees and by the late 1950s some Woolworth outlets in Ireland were being managed by women. See B. Walsh, *When The Shopping Was Good: Woolworths and the Irish Main Street* (Dublin: Irish Academic Press, 2011), p.121.

24. Cullen Owens notes that shop work was considered more respectable than domestic service, however Keogh's work indicates the difficult circumstances some shop workers endured. See Cullen Owens, *A Social History of Women in Ireland 1870–1970*, p.41. See also D. Keogh, 'Michael O'Lehane and the Organisation of Linen Drapers Assistants', in *Saothar*, 3 (1977), p.35.

25. The Cork Butter Market in Shandon in Cork City, housed O'Gorman's hat factory from 1940 until it was destroyed by fire in 1976; see Cork City Council, Maps and Images: Cork Butter Market available at www.corkpastandpresent.ie (accessed 10 March 2012).

26. Apprenticeships generated some comment in the Irish Press newspaper in the 1950s for being exploitative of labour and for not providing enough opportunities for skill development and learning. Small employers came in for particular criticism in relation to exploiting apprentices because it was argued they tended not to be inspected. See T. Garvin, *News From A New Republic, Ireland in the 1950s* (Dublin: Gill & Macmillan, 2010), p.124.

CHAPTER THREE

1. For details of white-collar/secretarial employment trends, see C. Clear, 'Too Fond of Going: Female Emigration and Change for Women in Ireland, 1946–1961' in D. Keogh, F. O'Shea and C. Quinlan (eds), *The Lost Decade: Ireland in the 1950s* (Cork: Mercier Press, 2004), pp.137–8.

2. P. McNabb, 'Chapter IV, The Class Structure and the Farmer', in J. Newman, *The Limerick Rural Survey 1958–1964* (Tipperary: Muintir na Tire, 1964), p.211.

3. See M.E. Daly, 'Women in the Irish Free State, 1922–1939: The Interaction Between Economics and Ideology', *Journal of Women's History*, 6, 4 and 7, 1 (1995), p.107.

4. Ibid.

5. The Unemployment Assistance Act, 1933, provided limited and rigorously means-tested financial assistance for unemployed people not in receipt of unemployment insurance. It represented a transfer of responsibility for the determination of payment rates from local Boards of Assistance to national level and involved the development of a new bureaucratic system for the administration of welfare. For a detailed discussion of the act, see F. Powell, *The Politics of Irish Social Policy 1600–1990* (New York: Edwin Mellin Press, 1992), pp.197–208.

6. From 1935 onwards, unemployment benefit was withdrawn from men in rural areas during summer months. See Powell, *The Politics of Irish Social Policy*, p.202.

7. The 1925 Civil Service Act restricted certain jobs for men and a marriage bar, introduced in the Civil Service in 1933 and strengthened in 1956, operated until 1958 for primary school teachers and until 1973 for all other categories of female public employees.

8. Dr. Thekla Beere was appointed Secretary for the Department of Transport, Marine, Tourism and Power in 1959. See Cullen Owens, *A Social History of Women in Ireland 1870–1970*, p. 311–12.

9. See J. Treacy and N. O'Connell, 'Labour Market', in A. Redmond (ed.). *That was Then and This is Now, Change in Ireland 1949–1999* (Dublin: The Stationery Office, 2000), p.109 and C. Clear, *Women of the House*, p.15.

10. See D. Ferriter, *The Transformation of Ireland*, p.496 and Clear, *Women of the House*, p.15.

11. See Ferriter, *The Transformation of Ireland*, p.496. See E. O'Leary, 'The Irish National Teachers' Organisation and The Marriage Bar For Women National Teachers, 1933–1958', *Saothar*, 12 (1987), p.47.
12. By 1967, the number of female religious in Ireland reached its peak. At this time there were almost over 19,000 nuns in Ireland, which does not take account of the significant number of women who entered non-Irish and missionary congregations outside Ireland. See J. Beale, *Women in Ireland: Voices of Change* (Dublin: Gill & Macmillan, 1986), p.173 and Y. McKenna, *Made Holy: Irish Women Religious At Home and Abroad* (Dublin: Irish Academic Press, 2006), p.28.
13. See McKenna, *Made Holy*, p.199.
14. Cunningham was drawing on figures taken from P. Duffy, *The Lay Teacher: A Study of the Position of the Lay Teacher in an Irish Catholic Environment* (Dublin: Fallons, 1967); see J. Cunningham, *Unlikely Radicals, Irish Post-Primary Teachers and the ASTI 1909–2009* (Cork: Cork University Press, 2009), p.112.
15. See T. Garvin, *News From A New Republic, Ireland in the 1950s* (Dublin: Gill & Macmillan, 2010), p.191.
16. The OECD/Department of Education report *Investment in Education* (1965) revealed that while science subjects were studied by a majority of Leaving Certificate boys, few senior girls took science subjects other than physiology and hygiene or domestic science. *Department of Education Investment in Education, Report of the Survey Team Appointed by the Minister for Education*, October 1962, (Dublin: The Stationery Office, 1965).
17. McNabb, 'Chapter IV, The Class Structure and the Farmer', p.215.
18. See M, Ó hÓgartaigh 'Flower Power and "Mental Grooviness": Nurses and Midwives in Ireland in the Early Twentieth Century', in B. Whelan (ed.), *Women and Paid Work in Ireland 1500–1930* (Dublin: Four Courts Press, 2000), p.140.
19. See J. Robins, *Nursing and Midwifery in Ireland in the Twentieth Century* (Dublin: An Bord Altranais, 2000), p.79.
20. See Ó hÓgartaigh, 'Flower Power and "Mental Grooviness"' p.140. Nicola Yeates has written that by 1951, England, Scotland and Wales had become the place of training for 95 per cent of Irish registered nurses. She also noted that in the period from 1929 until 1951, anywhere between 8 and 14 per cent of Irish registered nurses were working abroad. See N. Yeates, 'Migration and Nursing in Ireland: An Internationalist History', *Translocations: Migration and Social Change* 5, 1 (2009), p.8 and p.9, www.translocations.ie/docs/v05i01/ Vol_5_Issue_1 _d.pdf (accessed 10 March 2012).
21. See Robins, *Nursing and Midwifery in Ireland*, p.77.
22. In a lecture organised by the Irish Nurses Organisation in 1949, Rev. Meehan noted that prospective students required 'interest in other people and a highly developed mothering instinct'. See Robins, *Nursing and Midwifery in Ireland*, p.79.
23. In 1949, the Minister for Health, Dr. Noel Browne, highlighted his commitment to improving the work and pay conditions of nurses and in 1965 Donogh O'Malley, a subsequent Minister for Health, campaigned for improvement in the conditions of student nurses. See Robins, *Nursing and Midwifery in Ireland*, pp.82, 86.
24. Ibid., p.18.
25. Ibid., pp.23, 87.
26. Preparatory Training Colleges were established in 1926 to provide secondary education for prospective primary school teachers and there were six such colleges by 1939. See Cullen Owens, *A Social History of Women in Ireland*, p.41.
27. See E. O'Leary, 'The Irish National Teachers' Organisation and The Marriage Bar For Women National Teachers, 1933–1958', *Saothar*,12 (1987), p.49.
28. From 1926 onwards a language and cultural revival programme was pursued by the Department of Education. Passing an oral Irish examination became compulsory and teachers who taught through Irish received bonus payments. See Cullen Owens, *A Social History of Women in Ireland*, p.43
29. In 1924 the Department Education identified the Higher Diploma in Education as the minimum educational qualification for secondary teachers. See Cullen Owens, *A Social History of Women in Ireland*, p.41.
30. See O'Leary, 'The Irish National Teachers' Organisation and The Marriage Bar', p.49.
31. The 'appalling overcrowding' in national schools, where classes of fifty and sixty students were commonplace, was mentioned in the *Irish Times* in 1955, as documented by Garvin, *News From A New Republic*, p.175.

32. Cunningham's 2009 study of post-primary teachers and the ASTI, indicated that the religious presence in secondary schools was extensive right up until the 1960s and lay teachers were often marginalised within the schools and had poor opportunities for promotion; see Cunningham, *Unlikely Radicals*, p.112. Kierse identified in her oral history study of primary school teachers in Clare that the nuns' control of female education was a source of great bitterness amongst the teachers she interviewed. See M. Kierse, 'We Taught and Went Home: Women Teachers in Clare, 1922–1958', *Women's Studies Review*, 7 (2000), p.43.

33. Cunningham noted that many schools followed a policy of employing unqualified teachers in the secondary school system in order to save money and that religious orders running schools filled teaching posts with their own increasing members in the decades following the establishment of the Free State; see Cunningham, *Unlikely Radicals*, pp.83-4.

34. 'Secondary tops', a discrete group of unregistered teachers, both qualified and unqualified, who were offering the secondary school curriculum but were attached to national schools, also grew in number. According to Garvin, the 'secondary tops', though little spoken about, generated concern in the ASTI and were discussed in an *Irish Times* article in 1959. The article suggested that they could represent an attempt by Church and State to stymie the emergence of proper second-level education, controlled by lay people rather than clerics. See Garvin, *News From A New Republic*, p.189.

35. Cunningham cited one ASTI document which revealed that only 10 per cent of male lay teachers were unqualified, for male religious, the unqualified represented 37 per cent of the total; the corresponding figures for female lay teachers were 39 per cent and for female religious, 43 per cent; see Cunningham, *Unlikely Radicals*, p.83.

36. See O'Leary, 'The Irish National Teachers' Organisation and The Marriage Bar', p.50. The marriage bar reflected prevailing societal expectations that women should cease employment upon marriage and motherhood. It also reflected the public disquiet about married women taking employment during a time of economic depression and the notion that teachers having babies caused disruption for schools and pupils. The marriage bar did not apply to second-level teachers, as secondary schools were privately owned. However, Ferriter notes a Department of Education memorandum from 1953 which acknowledged that few second-level schools employed married teachers. See Ferriter, *The Transformation of Ireland*, p.497 and Cullen Owens, *A Social History of Women in Ireland*, p.246. The Department of Education resisted removing the marriage bar in 1953 because it was considered that the presence of a heavily pregnant teacher in a school was likely to generate 'comment and a degree of unhealthy curiosity in mixed schools of boys and girls and even in schools of girls only'; see D. Ferriter, *Occasions of Sin, Sex and Society in Modern Ireland*, p.240. As late as 1960 it was reported in the *Irish Independent* that some vocational teachers sought to maintain the marriage bar because they maintained that women wanted it that way; see Garvin, *News From A New Republic*, p.190.

37. See O'Leary, 'The Irish National Teachers' Organisation and The Marriage Bar', p.50.

38. For more discussion of this, see E. Connolly, 'Durability and Change in State Gender Systems', *European Journal of Women's Studies*, 10, 1 (2003), pp.79–80.

39. Ibid.

40. Joanna Bourke has noted that by 1911 all counties were employing poultry instructresses and that in 1912 there were thirty-six instructresses employed; see J. Bourke, 'Women and Poultry in Ireland 1891–1914', *Irish Historical Studies*, 25, 99 (1987), p.299. Brendan J. Senior writing in 1953 stated that there were eighty poultry instructresses employed by County Committees of Agriculture. See B.J. Senior, 'Agricultural Education and Research', *Journal of the Statistical and Social Inquiry Society of Ireland*, XXXI, 1 (1952/1953), pp23–41.

41. Senior, in his discussion of agricultural education in the early 1950s indicated that each year about 300 students took residential courses at domestic economy schools. See Senior, 'Agricultural Education and Research 1953'.

42. See Clear, *Women of the House*, pp.27–34 and pp.46–51 for a review of commentaries relating to Irish women's domestic skills. An article written by Emer O'Kelly, the Farm Home Editor of the *Irish Farmer's Journal* in 1965, identified a year spent in a domestic economy college as something that was potentially very beneficial for any young woman, regardless of her career plans. O'Kelly wrote 'whatever her outside interests and her before marriage career, the modern mother still has to face up to the day of reckoning, when her first task is preparing her family's meals and furnishing their home in comfort and good taste'. E. O'Kelly, 'These Girls – The Perfect Housewives of the Future', *Irish Farmers Journal* (20 February 1965), p.27.

43. Sangster noted a similar emphasis on vocational training for girls in the Ontario school system in the interwar years. See S. Sangster, *Earning Respect*, p.40.
44. Cullen Owens, *A Social History of Women in Ireland 1870–1970*, p.42.
45. Since 1900 the Munster Institute was the training centre for young women wishing to pursue training in poultry-keeping and butter-making. Entry was at matriculation standard and the course provided was both specialised and applied according to Senior, who was writing in 1953. He wrote that fourteen students qualified from the Munster Institute on a yearly basis; see Senior, 'Agricultural Education and Research 1953'. This is in keeping with Mary T.'s recollection that only about fourteen students, two from each of the seven domestic economy schools, would secure training places in the Institute and that 'half a dozen' would be expelled and approximately another half a dozen qualify every six months.
46. See E. O'Kelly, 'These Girls – The Perfect Housewives of the Future', p.27.
47. For definition of various categories of qualification/positions, see S.I. No.276/1952, *Employment Regulation Order (Creameries Joint Labour Committee)*, www.irishstatutebook.ie/1952/statutorya.html (accessed 10 March 2012).
48. The statutory minimum remuneration for creamery workers as decreed by the Employment *Regulation Order (Creameries Joint Labour Committee) 1952* was 103/6d per week for male butter-makers and cheese-makers and 101/6d for females, with rates of 98/6d and 96/6d respectively for assistant butter and cheese-makers. The butter-makers and cheese-makers were no more qualified than the assistants but they had responsibility for their respective departments. See S.I. No.276/1952, *Employment Regulation Order (Creameries Joint Labour Committee)* www.irishstatutebook.ie/1952/statutorya.html (accessed 10 March 2012).
49. Joanna Bourke described the work of the itinerant poultry instructress as 'lecturing on poultry-keeping, visiting poultry runs, giving advice and conducting classes on fattening, killing, plucking, trussing and preparing fowl for the market and on grading, testing and packing eggs'. See Bourke 'Women and Poultry in Ireland', p.299. Margaret Humphreys stated that the professional poultry instructresses provided valuable advice on various aspects of fowl husbandry and that they also recommended specific breeds, which could increase productivity. See M. Humphreys, 'The Hens' Excursion', in *The Archive, Journal of the North-side Folklore Project*, 13 (2009), p.11.
50. The prestige bestowed on car owners is understandable given that there were only 7,845 licensed private cars in Ireland in 1945. See Ferriter, *The Transformation of Ireland*, p.499.
51. Between 1940 and 1965 more than two hundred hospitals were built and many more were reconstructed. Between 1943 and 1953 there was a 50 per cent increase in hospital beds. This work was overseen by the Hospitals Commission and funded in large part through the Irish Hospital Sweepstakes. See J. Deeny, *To Cure & to Care: Memoirs of a Chief Medical Officer* (Dublin: Glendale Press, 1989), pp.137–43; and Powell, *The Politics of Irish Social Policy*, pp.253–4.
52. Providing accurate data on pay rates proved very difficult in this study, as women could not always remember what they earned doing different jobs and in different periods. Conversions from old to new and new to old money further complicated matters. Making comparisons was also challenging because some women reported their weekly earnings while others reported their monthly or yearly pay, in some cases at job entry level and in others, at the time of resignation. In some newspaper advertisements for positions vacant, the rate of pay was specified, e.g. 'Positions Vacant – Civil Engineers', *Irish Press*, (October 7 1936), p.8. The 'Any Jobs Going?' series published in the *Irish Press* (between October 1949 and March 1950) provided fairly comprehensive information on the range and types of employment available in post-war Ireland. The kinds of income expected after qualification was specified for many of the 117 jobs covered and provided a useful source of information for us. See, for example, 'Any Jobs Going? Nurse', *Irish Press* (24 October 1949), p.2; 'Any Jobs Going? National Teacher', *Irish Press* (8 November 1949), p.2; 'Any Jobs Going? Poultry Instructress', *Irish Press* (16 December 1949), p.2 and 'Any Jobs Going? Secondary Teacher,' *Irish Press* (14 February 1950), p.2. For a summary of the entire series, see 'Any Jobs Going? Summary of Series', *Irish Press* (4 March 1950), p.2. For information on teachers' salaries, see Cunningham, *Unlikely Radicals*, p.127. For information on nurses' pay, see Robins, *Nursing and Midwifery in Ireland*, pp.18, 23, 86, 87. Mary Muldowney's book is also a useful source of information on male and female wage differentials in 1940s Ireland; see Muldowney, *The Second World War and Irish Women, An Oral History* (Dublin Irish Academic Press, 2007), pp.50–52.

CHAPTER FOUR

1. The need to disaggregate the roles played by individuals within the household unit and to explore the gendered power struggles between household members has been identified. See M. Doolittle, 'Close Relations? Bringing Together Gender and Family in English History', in *Gender & History*, 11, 3 (1999), pp.542–54.

2. For a discussion of these factors, see L. O'Dowd, 'Church, State and Women: the Aftermath of Partition', in C. Curtin, P. Jackson and B. O'Connor (eds), *Gender in Irish Society* (Galway: Galway University Press, 1987), pp.3–36; M.G. Valiulis, 'Gender and Identity in the Irish Free State', in J. Hoff and M. Coulter (eds), *Journal of Women's History*, 6, 4 (1995) & 7, 1 (1995), pp.117–36. Recent work considering the influence of the Second World War on the experiences of Irish women suggests that the war had little or no impact in terms of changing women's expectations or indeed aspirations regarding marriage and mother-hood. See M. Muldowney, *The Second World War and Irish Women* (Dublin: Irish Academic Press, 2007), p.9 and C. O'Kane, '"To Make Good Butter and Look After Poultry": The Impact of the Second World War on the Lives of Rural Women in Northern Ireland', in G. McIntosh and D. Urquhart (eds), *Irish Women at War* (Dublin: Irish Academic Press, 2010), pp.87–102.

3. C. Clear, *Women of the House*, pp.1–8 and M.E. Daly, 'Women in the Irish Free State, 1922–1939: The Interaction Between Economics and Ideology', *Journal of Women's History*, 6, 4 & 7, 1 (1995), p.99–116.

4. See Clear, *Women of the House*, pp.5–8.

5. The 1924 Civil Service Regulation Act restricted certain jobs for men and a marriage bar, introduced in the Civil Service in 1933 and strengthened in 1956, operated until 1958 for primary school teachers and until 1973 for all other categories of female public employees. A similar bar applied in many semi-state and private organisations, like Aer Lingus and the Banks, until 1974. The 1936 Conditions of Employment Act, which introduced a 48-hour maximum working week and a right to one week of paid holidays, also provided a mech-anism for the Minister for Industry and Commerce to prohibit and control the employment of women in certain industries. For discussion of these measures, see Cullen Owens, *A Social History of Women in Ireland*, pp.251–79 and E. O'Leary, 'The Irish National Teachers' Organisation and the Marriage Bar for Women National Teachers, 1933–1958', *Saothar*, 12 (1987), pp.47–52. The 1929 Censorship of Publications Act made it illegal to publish any material which promoted contraception while the 1935 Criminal Law Amendment Act prohibited the importation and sale of contraceptive devices. For a discussion of the intro-duction and implications of these laws, see C. Hug, *The Politics of Sexual Morality in Ireland* (Hampshire: Macmillan Press, 1999), pp.76–96.

6. Article 41.2:1 acknowledged that, 'By their life within the home, women give to the State a support without which the common good cannot be achieved.' While article 41.2:2 indi-cated the State's active support of this role for women asserting that, 'The State, shall, there-fore, endeavour to ensure that mothers shall not be obliged by economic necessity to engage in labour to the neglect of their duties in the home.' For examples of international discourses relating to the suitability of women for marriage and motherhood, see P. Summerfield, *Reconstructing Women's Wartime Lives* (Manchester: Manchester University Press, 1998), pp.199–204 and J. Sangster, *Earning Respect*, pp.83–8. Concerns about population decline in the aftermath of the First World War have also been identified as significant in in-forming discourses about women's suitability for motherhood. See M.E. Daly, 'Women in the Irish Free State, 1922–39: The Interaction between Economics and Ideology', *Journal of Women's History*, 6, 4 and 7, 1 (1995), p.109. It must be acknowledged that Ireland was not unusual in the regulation of employment opportunities for married women. Marriage bars were commonplace in Europe and the United States in the inter-war years. See E. Connolly, 'Durability and Change in State Gender Systems', *European Journal of Women's Studies*, 10, 1 (2003), pp.75–6 and O'Leary, 'The Irish National Teachers' Organisation and the Marriage Bar', p.48. For a discussion of attitudes to female workers in the 1920s and '30s see Daly, 'Women in the Irish Free State, 1922–39: The Interaction Between Economics and Ideology', pp.99–116 and O'Leary, 'The Irish National Teachers' Organisation and The Marriage Bar', p.48. For similar discussion relating to the 1950s, see Connolly, 'Durability and Change in State Gender Systems', pp.65–86.

7. Commentators have however noted the deficiencies of such statistical data in interpreting women's economic activity and it is generally accepted that women's labour activities have been underestimated in Irish labour statistics. The Principle Economic Status (PES) approach to labour supply measurement categorises each adult according to his or her principal occupation. Where the measurement of married women's labour activity is concerned, a number of drawbacks of this particular approach have been highlighted. For example, married women's dual roles would have posed problems for classification. For discussion of this, see Clear, *Women of the House*, pp.18–20; T. Fahey, 'Measuring the Female Labour Supply: Conceptual and Procedural Problems in Irish Official Statistics', *The Economic and Social Review* 21, 2 (1990), pp.163–91; M.E. Daly, 'Women in the Irish Work-force from Pre-Industrial to Modern Times', *Saothar*, 7 (1981), pp.74–82.

8. See Daly, 'Women in the Irish Free State, 1922–1939', p.102.

9. See Clear, *Women of the House*, pp.7–8.

10. In 1922, Reverend J. S. Sheehy decried the poor mothering practices of contemporary mothers and highlighted their culpability for social ills such as consumption and insanity while in 1940 Reverend Cassidy lauded large families as 'God's recognition of the exceptional virtue of the mothers of our country'; see A. Guilbride, 'Mad or Bad? Women Committing Infanticide in Ireland from 1925 to 1957' in R. Lentin (ed.), *In From the Shadows: The UL Women's Studies Collection* (Limerick: Women's Studies, Department Government & Society, University of Limerick, 1996), pp.88–9. Very limited attention was paid in the publications to the issue of employment for married women or to political issues, however, philanthropic and charitable endeavours were encouraged. See C. Conway, *Recipes for Success in a Woman's World*, www.ucd.ie/pages/97/conway.html (accessed 10 March 2012).

11. Second children became eligible for the allowance in 1952 and it was extended to all children in 1963. See Clear, *Women of the House*, pp.51–6 for a discussion of the debate over which parent should receive the payment.

12. Joan's perception in this regard was not unfounded. Arensberg and Kimball's study of rural life in Co. Clare in the early 1930s comments on the 'country divorce', which referred to the practice of infertile wives being returned or sent back to their own families. They did note, however, that at the time of their research the practice was in rapid decline. See C. Arensberg and S. Kimball, *Family and Community in Ireland* (Cambridge Massachusetts: Harvard University Press, 1968), p.132.

13. National school teachers, who had a minimum of seven-years' service, were entitled to either one-month's salary per year of service or a year's salary, whichever was the least amount; see O'Leary, 'The Irish National Teachers' Organisation and The Marriage Bar For Women National Teachers, 1933–1958', p.51. The implications of the marriage bar have been significant. For example, it was reported in the *Irish Times* (2 July 2010) that *Older and Bolder*, an alliance of eight different NGOs in the ageing sector, were actively campaigning for a restoration of pension entitlements for the estimated 47,000 women who were forced to give up their Civil Service posts before the removal of the marriage bar in 1973; see www.irishtimes.com/newspaper/ireland/2010/0702/1224273803925.html (accessed 10 March 2012).

14. See Summerfield, *Reconstructing Women's War Time Lives*, p.279.

15. See E. Roberts, *Women and Families: An Oral History, 1940–1970* (Oxford: Blackwell, 1995), p.20.

16. This view dominated professional discourses of childcare in the 1950s. See Roberts, Women and Families, pp.141–54. Evidence from studies of popular literature available to Irish women in the period from the 1920s to the 1960s suggests that the childcare advice being provided followed international norms. Conway, following a review of a range of women's magazines available in Ireland in the 1930s, indicated that most magazines assumed that women were in the main housewives and mothers, and that the key advice to mothers was that apart from providing basic care and education, they also had to be altruistic and nurturing and sensitive to the emotional needs of their children; see C. Conway, *Recipes for Success in a Woman's World*, p.5. Clear's review of women's pages in newspapers and women's magazines from the 1920s to the 1960s indicates that childcare advice was limited and that which did appear was quite general and did not take into account the particularities of childrearing in the Irish context; see Clear, *Women of the House*, p.94.

17. Similar accounts of the supportive role that neighbours played in working-class urban communities are provided in other Irish oral history studies. See Clear, *Women of the House*, pp.178–83 for a discussion of these.

18. Conditions in Irish households during the 1940s and 1950s were generally poor. In 1946, 90 per cent of urban dwellers had access to piped water and most had electricity. In contrast, over 90 per cent of rural homes were without piped water, and only 20 per cent had a toilet of any kind. In 1956, ten years after the introduction of the rural electrification scheme, 50 per cent of rural houses were still without power, while in 1971 fewer than half of all rural homes had access to running water. Overcrowding was widespread, with 80,000 people still living in one-room dwellings in 1948. See Y. McKenna, *Made Holy: Irish Women Religious at Home and Abroad*, (Dublin: Irish Academic Press, 2006), p.26.

19. There is evidence to suggest that some Irish women were still engaged in manual labour in farms well into the 1950s. See Cullen Owens, *A Social History of Women in Ireland*, p.218.

20. Other oral history work has generated similar accounts of the various enterprises married women engaged in to generate an income for their families; see M. Cronin, 'Class and status in twentieth-century Ireland: the evidence of oral history', *Saothar*, 32 (2007), pp.33–43.

21. The presumption that families were headed by male financial providers and adherence to the principle of subsidiarity resulted in very limited support for families headed by women. Widows received non-contributory pensions due to legislation introduced in 1935, but no statutory provision was made for either unmarried mothers or deserted wives until the 1970s. For more discussion of this, see N. Yeates, 'Gender and the Development of the Irish Social Welfare System', in A. Byrne and M. Leonard (eds), *Women and Irish Society, A Sociological Reader* (Belfast: Beyond the Pale Publications, 1997), pp.145–66.

22. See M.E. Daly, *Women and Work in Ireland* (Dublin: Economic and Social History Society, 1997), p.49.

23. This term 'meandering', which refers to a movement through numerous unconnected jobs with no apparent progression, has been used by others. See D. Vincent, 'Mobility, bureaucracy and careers in twentieth-century Britain', in A. Miles and D. Vincent (eds), *Building European Society. Occupational Change and Social Mobility in Europe, 1840 and 1940* (Manchester: Manchester University Press, 1993), pp.225–6 and P. Summerfield, 'They Didn't Want Women Back in That Job!: The Second World War and the Construction of Gendered Work Histories', *Labour History Review*, 63, 1 (1988), p.329.

24. The notion of singleness as 'a deficit identity' has been acknowledged by others, who argue that it tends to position single women who are telling their stories against a cultural background which is negative for women on their own. Some women, however, when accounting for their single status, position themselves as positive women in control of their lives, who make choices and who do not feel they miss out on a lot by not marrying. For a discussion of this, see J. Reynolds, M. Wetherell and S. Taylor, 'Choice and Chance: Negotiating Agency in Narratives of Singleness', *The Sociological Review*, 55, 2 (2007), pp.331–51.

25. Mary O'D.'s identification of a tendency for single women to be perceived as persons to be pitied finds resonance in other published work. Yvonne McKenna noted that being single was an identity that was viewed as marginal and miserable and that spinsters held a very low position in Irish society between the 1930s and 1960s; see Y. McKenna, 'Entering Religious Life, Claiming Subjectivity: Irish Nuns 1930s–1960s', *Women's History Review*, 15, 2 (2006), p.193. Anne Byrne's research on contemporary single women's identities in Irish society identified the 'othering' of women who were on their own; see A. Byrne, 'Researching One An-Other', in A. Byrne and R. Lentin (eds), *(Re)searching Women, Feminist Research Methodologies in the Social Sciences in Ireland* (Dublin: Institute of Public Administration, 2000), pp.140–66. The derision and negativity exhibited toward single women in employment has also been highlighted. See, for example, J. Blount, 'Spinsters, Bachelors and other Gender Transgressors in School Employment 1850–1990', *Review of Educational Research*, 70 (2000), pp.83–101 and K. Whitehead and S. Thorpe, 'The Function of Age and the History of Women's Work: The Career of An Australian Teacher 1907–1947', *Gender & History*, 16, 1 (2004), pp.172–97.

26. See Clear for a more detailed discussion of the reasons put forward for the low marriage rates in Ireland. She concluded, 'looking at the 1940s and 1950s, however, it seems that the low marriage rates and high rates of permanent celibacy were almost entirely because of women's choices'. C. Clear, 'Too Fond of Going: Female Emigration and Change for Women In Ireland, 1946–1961', in D. Keogh, F. O'Shea and C. Quinlan (eds), *Ireland in the Lost Decade in the 1950s* (Cork: Mercier Press, 2004), p.141. Mary Kierse's oral history work with female primary school teachers indicated that many of the interviewees were cynical about marriage and they recalled that absolute caution was required when choosing a partner. One

woman, who was married, considered that unscrupulous men would see an earning woman teacher as an asset to their lifestyle, if not a meal ticket. Furthermore, she found that the high number of single men and women in Ireland during these decades, which was often viewed as a social tragedy, was not interpreted in these negative terms by the interviewees; see M. Kierse, 'We Taught and Went Home: Women Teachers in Clare 1922–1958', *Women's Studies Review*, 7 (2000), pp.41–52.

CHAPTER FIVE

1. The concept of identity or subjectivity has been widely interrogated by post-structuralist feminists, who challenge assumptions that any generic feminine identity can be identified. Furthermore, post-structuralist critiques have highlighted the role which cultural constructions, as manifest in discourse and practice, play in shaping individual identities. For a discussion of these issues, see P. Summerfield, *Reconstructing Women's Wartime Lives* (Manchester: Manchester University Press, 1998), pp.11–16 and J. Sangster, *Earning Respect*, pp.8–10, 83–5.
2. For a discussion of the ideas that inform our theoretical position and understanding of memory and of narrative, see the introduction to this book.
3. Similar evidence of the pervasiveness of parental and religious control in the lives of British young women in the period under study has also been documented. See E. Roberts, *A Woman's Place: An Oral History of Working-Class Women, 1890–1940* (Oxford: Blackwell, 1984). However, Roberts' subsequent oral history study of working class families, which considers the period between 1940 to 1970, found evidence of increasing independence among young workers from the 1960s onwards; see E. Roberts, *Women and Families: An Oral History, 1940–1970* (Oxford: Blackwell, 1995), pp.45–9. Penny Summerfield also notes that Tinkler's analysis of English girls' magazines between 1920 and 1950 suggests that popular literature upheld parental authority and in particular emphasised the supreme authority of the father within the family. For a discussion of Tinkler's work, see Summerfield, *Reconstructing Women's Wartime Lives*, p.47.
4. For further discussion of family decision making regarding the employment of members, see S. D'Cruze, 'Imperfect Workers, Imperfect Answers: Recent Publications on the History of Women and Work', *Urban History*, 26, 2 (1999), pp.260–62.
5. In this regard, our oral histories suggest a different set of practices than those reported in the Limerick Rural Survey. In the survey it was revealed that it was mothers who made all the decisions about the training and education of children in farming families, as fathers rarely thought of their role as extending beyond that of provider; see P. McNabb 'Chapter VIII, Family Roles', in J. Newman (ed.) *The Limerick Rural Survey, 1958–1964* (Tipperary: Muintir na Tire, 1964), pp.228–29.
6. Theories of subjectivity and composure draw attention to the version of 'self', which people construct or compose in interviews and to the fact that there are many discourses which can be drawn upon in constructing this account. In this example, Mary struggles to provide a coherent version of self as she is torn between the discourses of dutiful daughter and passionate teacher. For an in-depth discussion of memory and composure, see Summerfield, *Reconstructing Women's Wartime Lives*, pp.16–32.
7. Status is very usefully explained by Maura Cronin as 'the multiple shapes and shades of individuals' and families' places in the social tapestry'. See M. Cronin, 'Class and status in twentieth-century Ireland: the evidence of oral history', *Saothar*, 32 (2007), p.34.
8. Mothers have been identified in a range of studies as being the parents who assumed responsibility for maintenance of respectability among family members. See Cronin, 'Class and status in twentieth-century Ireland: the evidence of oral history', p.37.
9. Skeggs has argued that the working class and in particular working-class women have always been classified in relation to an ideal of respectability and that working-class people themselves have also engaged in this process of self-classification. See B. Skeggs, *Formations of Class and Gender: Becoming Respectable* (London: Sage, 1997), pp.1–8.
10. Discourses of female working-class respectability, which highlight quietness and deference to elders, appear to have had widespread cultural currency. C. Benninghaus, 'Mothers' Toil and Daughters' Leisure: Working-class Girls and Time in 1920s Germany', *History WorkShop Journal*, 50 (2000),pp.59–63; Roberts, *Women and Families*, pp.158–9, and Sangster, *Earning Respect*, p.35. Hart's discussion of perceptions of respectability among women workers in

the pottery industry in Britain in the early 1980s suggests that being quiet, respectful and deferential to older women was still seen as a sign of respectability; see E. Hart, 'Anthropology, class and the "big heads": an ethnography of distinctions between "rough" and "posh" amongst women workers in the UK pottery industry', *The Sociological Review*, 53, 4 (2005), pp.719, 721.

11. For a discussion of the regulatory controls introduced in relation to travel between Ireland and Britain during the period of the Second World War, see M. Muldowney, *The Second World War and Irish Women* (Dublin: Irish Academic Press, 2007), pp.70–7.

12. Summerfield has highlighted how English discourses of female employment in the 1950s identified teaching as the occupation most suitable for women who wanted to combine employment and motherhood. See P. Summerfield, 'They Didn't Want Women Back in That Job!', in F. Montgomery and C. Collette (eds), *European Women's History Reader* (London: Routledge, 2002) p.335.

13. Making ends meet on a limited salary was not an experience restricted to young female workers. Dowling Almeida's discussion of the reasons why young people emigrated in the 1950s refers to a young man who, despite having a State job in the Post Office in Galway, was not earning enough to pay for his digs and living expenses and was being supplemented by his parents who could ill afford the cost; see L. Dowling Almeida. 'A Great Time to Be in America: The Irish in Post-Second World War New York City', in D. Keogh, F. O'Shea and C. Quinlan (eds) *Ireland in the 1950s: The Lost Decade* (Cork: Mercier Press, 2004), p.208.

14. In the years following independence in 1921, women were actively constructed as symbols of the unique culture and identity, which differentiated Ireland from its former coloniser. The dress, deportment, manners and in particular sexual morality of women were subjected to increased surveillance and legislative regulation. For a discussion of this, see B. Gray, and L. Ryan, '(Dis)locating "Woman" and Women in Representations of Irish National Identity', in A. Byrne and M. Leonard (eds), *Women and Irish Society: A Sociological Reader* (Belfast: Beyond the Pale Publications, 1997), pp.517–34.

15. Sangster's work has revealed similar differentials in the degree of surveillance of young men and women and also found that parental control of leisure continued after women became wage earners. See Sangster, *Earning Respect*, p.35–6.

16. Roberts' work indicates that the dance hall was also the key place for working-class English young people to meet members of the opposite sex in the 1940s and 1950s. See Roberts, *Women and Families*, p.62.

17. The late 1950s saw the emergence of the showbands with their iconic performers such as Clipper Carlton and Dickie Rock, who were identified as the stars of the 1960s. See F. O'Keefe, *Goodnight, God Bless and Safe Home – The Golden Showband Era* (Dublin: The O'Brien Press, 2002) and V. Power, *Send 'em Home Sweatin': The Showband Story* (Cork: Mercier Press, 2000).

18. Maura Cronin has argued that the move away from parish dances facilitated by the greater availability of cars also led to a greater mixing of social classes; see Cronin, 'Class and status in twentieth-century Ireland: the evidence of oral history', p.41.

19. Roberts' work indicates that women in England rarely frequented public bars in the 1940s and 1950s. See Roberts, *Women and Families*, p.62.

20. The existence of an inter-war cultural discourse which emphasised female attractiveness and heterosexual relationships is identified by a number of commentators. See: Sangster, *Earning Respect*, p.44; Clear, *Women of the House*, p.94; C. Conway, 'Recipes for Success in a Woman's World: Irish Women's Magazines in the 1930s', p.5, see www.ucd.ie/pages/97/conway.html (accessed 10 March 2012).

21. John W. Dowden & Co. Limited was a high-class drapery establishment at 113–115 Patrick Street, Cork. Established in 1844, it continued for well over a century and in 1942 advertised as 'Linen Drapers: Manufacturers of Ladies Gowns, Coats, Costumes, Blouses and Underclothing'. See Cork City & County Archives – CCCA B500/11 J.W. Dowden & Company.

22. Flann O'Brien, commenting on dancing in Dublin in 1941, made a distinction between dances for the wealthy and those attended by the general masses. See Ferriter, *The Transformation of Ireland*, p.409.

23. The Legion of Mary was a religious organisation founded by a lay Irish Catholic, Frank Duff in 1921. Marian devotion peaked in Ireland during the 1940s and 1950s and religious organisations and activities devoted to the worship of Mary were frequently mentioned in the narratives we collected. For a discussion of Duff and the Legion, see F. Kennedy, *Frank*

Duff: A Life Story (London and New York: Burns and Oates, 2011).
24. The Oireachtas na Gaeilge is an annual festival promoting Irish arts and culture. The first festival was held in 1897.
25. Pius XII declared 1950 to be a Holy Year of Pilgrimage to Rome and Catholics who visited Rome in that year earned plenary indulgences. Thousands of Irish Catholics made the pilgrimage, including a great number of government members. Pius XII hoped that the pilgrimage would assert the power of Catholic workers and Catholic principles in the face of the feared spread of communism in Europe. For a discussion of Ireland and the Holy Year, see Chapter 7 of D. Keogh, *Ireland and The Vatican: The Politics and Diplomacy of Church-State Relations 1922–1960* (Cork: Cork University Press, 1995). The Sunbeam Social Service Society administered the finances of the holiday savings club. For details, see Cork City and County Archives, Minute Books of the Sunbeam Social Service Society, B 506 Sunbeam: Ref: Social Society, Box 9.
26. Rural electrification began in 1946. See Ferriter, *The Transformation of Ireland*, pp.499–500.
27. These customs and the intertwining of social and working life they represented, have been described by Sangster as humanising of the work place. Sangster's work revealed similar practices among the former female factory workers she interviewed in Ontario. See Sangster, *Earning Respect*, p.267.

CHAPTER SIX

1. Agency and resistance, significant themes in this book, are complicated concepts. They have given rise to different schools of thought on what exactly they are, how they can be identified or analysed and what they can achieve, see R. Raby, 'What is Resistance?', *Journal of Youth Studies*, 8, 2 (2005), pp.151–71. In some theoretical and historical writings everyday forms of agency or resistance which tend to elude documentation because they are small-scale, informal and local, are championed as significant political practices, which need to be interpreted as such; see J. C. Scott, *Weapons of the Weak: Everyday Forms of Peasant Resistance* (New Haven: Yale University Press, 1985); see R.D.G. Kelley, 'We Are Not What We Seem: Rethinking Black Working Class Opposition in the Jim Crow South', *The Journal of American History*, 80, 1 (1993), pp.75–112; See R.D.G. Kelley, *Race Rebels: Culture, Politics and the Black Working Class* (New York: Free Press, 1994); see A. Prasad and P. Prasad, 'Everyday Struggles at the Workplace: The Nature and Implications of Routine Resistance in Contemporary Organizations', *Research in the Sociology of Organizations*, 16, (1998), pp.225–257; see R. Thomas and A. Davies, 'What Have Feminists Done for Us: Feminist Theory and Organizational Resistance', *Organization*, 12, 5 (2005), pp.711–40; see J. Hockey, A. Meah and V. Robinson, 'A Heterosexual Life: Older Women and Agency Within Marriage and the Family', *Journal of Gender Studies*, 13, 3 (2007), pp.227–38. In contrast, Adolph Reed, has interpreted everyday localised acts of resistance as expressions of discontent with the potential to provide the raw material for major popular movements of change to emerge, see A. Reed, *Class Notes: Posing as Politics and Other Thoughts on the American Scene* (New York: New York Press, 2005). However, in this source it is also argued that by their very occurrence, they draw attention to the absence of major political change projects or indeed where such projects do exist, their failure to significantly connect with the lives of the populace, see Reed, *Class Notes*. In Reed's analysis, everyday, ubiquitous, spontaneous activities in localised workplaces designed to re-assert personal dignity, to re-negotiate terms or conditions, to make work more fun or to give it less meaning in one's life, are considered politically bereft. They are not part of a visible, broad-based, collective and conscious project seeking to utterly transform society and its oppressive relations; see Reed, *Class Notes*. Brown also questioned the theoretical value of 'the discovery of resistance everywhere'; see M. F. Brown, 'On Resisting Resistance', *American Anthropologist*, 98, 4 (1996), p.733. Contu differentiated between what she calls 'decaf resistance' from the real act of resistance, which alters the constellation of power relations and which has a cost not accounted for in advance; see A. Contu, 'Decaf Resistance: On Misbehaviour, Cynicism and Desire in Liberal Workplaces', *Management Communication Quarterly*, 21, 3 (2008), pp.364–79. In terms of thinking about and interpreting agency, we have been influenced by Nancy Fraser's call for 'a coherent, integrated, balanced conception of agency, a conception that can accommodate both the power of social constraints and the capacity to act situatedly against them', see N. Fraser, 'Introduction' in N. Fraser and S. Bartky (eds), *Revaluing French*

Feminisms: Critical Essays on Difference, Agency and Culture (Bloomington: Indiana University Press, 1992), p.17. We have also acknowledged the agency involved when women adhered to norms or practices, which constrained their choices. In this chapter, women's agency is conceptualised at the macro, meso and micro levels, taking into account expressions of agency which were personal, collective, local, and national.

2. Meanings, feelings, wishes and fantasies are present in abundance in oral narratives and provide a rich source of data for analysis in their own right.

3. Paul Thompson and Miriam Nyhan have for instance drawn attention to the importance of factory sociability in providing an escape from work but also in making the work more fully human. P. Thompson, 'Playing at being Skilled Men: Factory Culture and Pride in Work Skills among Coventry Car Workers', *Social History*, XIII (1988), p.66 and M. Nyhan, 'Narration and Memory: The Experiences of the Workforce of a Ford Plant', *Irish Economic and Social History*, Vol.XXXIII (2006), p.26.

4. With reference to women specifically, Saba Mahmood suggested that 'we think of agency not as a synonym for resistance to relations of domination, but as a capacity for action that historically specific relations of subordination enable and create'; see S. Mahmood, 'Feminist Theory, Embodiment and the Docile Agent; Some Reflections on the Egyptian Islamic Revival', *Cultural Anthropology*, 6, 2 (2001), p.203. Rather than an 'all or nothing' understanding of resistance, we have opted for one which seeks to appreciate resistance as socially produced and practiced in ways which have contingent, local and temporal features.

5. For more discussion, see C. Clear, *Women of the House*, p.1–12 and L. Connolly, *The Irish Women's Movement, From Revolution to Devolution* (Dublin: Lilliput Press, 2003), p.24–5.

6. Diarmaid Ferriter has written that 'despite legislative discrimination and the confinement of women to a limited sphere, the successful attempts to organise women collectively to further their comfort and status have been overlooked'; see D. Ferriter, *The Transformation of Ireland*, p.361.

7. Diarmaid Ferriter noted Grainne O'Flynn's recollections in 1987 of the socialisation strategies of a Catholic education in the 1940s that did not encourage women to engage with social or political life. As she recalled, 'the female form was a source of evil' and 'the best ways to rid ourselves of its encumbrances were to pray, be modest, adopt low vocal tones and become non-argumentative'. See D. Ferriter, *Occasions of Sin, Sex and Society in Modern Ireland*, p.320. Yvonne McKenna also highlighted how the women religious, in her oral history study covering the same period, spoke about Catholicism as something which surrounded them but which they also experienced as intrinsic to them. See Y. McKenna, 'Entering Religious Life, Claiming Subjectivity: Irish Nuns, 1930s–1960s', *Women's History Review*, 15, 2 (2006), p.191.

8. James Scott usefully distinguishes between the public transcript, which is skewed in the direction of the dominant discourse, and the hidden transcript, which contradicts the public transcript. The hidden transcript can remain hidden and be revealed in a safe context or can on occasion be openly declared in the face of power. See J. Scott, *Domination and the Arts of Resistance* (New Haven: Yale University Press, 1990), pp.1–16.

9. Churching was a kind of purification ritual, which involved a type of blessing after childbirth. (It supposedly cleansed the woman of the sin acquired by committing the act necessary to conceive a child.)

10. M.E. Daly, 'Women and Trade Unions' in D. Nevin (ed.) *Trade Union Century* (Cork: Mercier Press, 1994), p.111.

11. M. Muldowney, *The Second World War and Irish Women, An Oral History* (Dublin: Irish Academic Press, 2007), p.52–3.

12. J. Cunningham, *Unlikely Radicals: Irish Post-Primary Teachers and the ASTI, 1909–2009* (Cork: Cork University Press, 2009), p.232.

13. Ibid.

14. Ibid., pp.85–6.

15. In terms of highlighting divisions between women workers, the potential for the re-entrance of married women into paid employment to generate resentment among single women workers has been documented. See M. Jones, *Those Obstreperous Lassies, A History of the Irish Women Workers' Union* (Dublin: Gill & Macmillan, 1988), p.105–6.

16. Miriam Nyhan remarked on the tight knit working relationships characteristic of the Ford Plant in Cork, which possibly made industrial conflict less fierce and dramatic than in larger car plants elsewhere. She also noted the paternalistic attributes of the firm; the standard charitable donations and acts of kindness and generosity toward employees which were frequently

mentioned by those interviewed; see M. Nyhan, 'Narration and Memory', p.25 and p.29.

17. Leland wrote that William Dwyer was 'so strongly identified with the plant at Millfield (i.e., Sunbeam's factory) that there are still stories circulating about his personality, the parties held at the garden of his house there, where he bridged over the pool so that the Cork Symphony Orchestra could play on this improvised stage'. She described 'his Renaissance-like appetite for the arts' as evident in his sustained patronage of Seamus Murphy, the Cork sculptor and stone carver, whom he commissioned to do tablets for his factories and to supervise much of the design of the Church of the Annunciation at Blackpool. She also wrote that he was the only one of the infamous Dwyer family who 'actively engaged in and tried to influence the economic politics of war-time Ireland'. See M. Leland, *Dwyers of Cork: A Family Business and a Business Family* (Cork: Ted Dwyer, 2008), pp.62, 75.

18. P. Feeley, 'Servant Boys and Girls in Co. Limerick', *The Old Limerick Journal*, 1, (1979), p.34.

19. Ibid., p.35.

20. P. McNabb, 'Chapter 2, Status', in J. Newman (ed.), *The Limerick Rural Survey 1958–64* (Tipperary: Muintir na Tire, 1964), p.197.

21. M.E. Daly, 'Women and Trade Unions', p.112.

22. Ibid., p.113.

23. McNabb noted that farm workers in the Limerick region were not unionised, nor was there any organisation specifically devoted to their interests. Identifying Muintir na Tire, Macra na Feirme and the Irish Countrywomen's Association as organisations which admitted farm workers, he pointed out that such workers were not allowed representation on the committees of Macra and that many workers would not join these organisations because they felt other members would look down on them. See P. McNabb, 'Chapter 3, The Farm Worker and the Social Structure', p.208. Feeley wrote that servant boys and girls could have had support from the trades unions but with the exception of 'the Federated Workers' Union, which was confined to a small number of Leinster counties, the unions ignored them'; see P. Feeley, 'Servant Boys and Girls in Co. Limerick', p.35.

24. In her book on the Cork Ford plant, Miriam Nyhan noted that agreement with the Irish Transport and General Workers' Union was only enshrined in 1950, when in fact trade unions were established in the British plants in the previous decade. She also took account of a Cork Examiner editorial which castigated the striking workers who greeted Henry Ford II on his arrival to the city in 1953, because Mr. Ford personified 'an organisation which has contributed more than any other single factor to the prosperity of Cork and the high standards of living enjoyed by Cork workers'. M. Nyhan, *Are You Still Below? The Ford Marina Plant, Cork, 1917–1984* (Cork: The Collins Press, 2007), p.110.

25. When the Irish Nurses' Union was established in 1919 under the aegis of the Irish Women's Workers Union it was the first of its kind in Europe. According to Cullen Owens, the horror at this development was evident in the Irish Times newspaper, which implored nurses 'not to dethrone and degrade the profession by dallying with the promises of Trade Unionism'; see R. Cullen Owens, *A Social History of Women in Ireland 1870–1970* (Dublin: Gill & Macmillan, 2005), p.200. According to Mary Daly, nurses in psychiatric hospitals gained superior conditions to their counterparts in general nursing because the latter refused to become involved in full-scale trade union activity; see M.E. Daly, 'Women in the Irish Workforce from Pre-Industrial to Modern Times', *Saothar*, 7 (1981), p.79.

26. The ASTI had small membership and a low level of activity especially in the 1940s when it disaffected from several organisations, including the Congress of Trade Unions; see S. Ward-Perkins, *Select Guide to Trade Union Records in Dublin: With Details of Unions Operating in Ireland to 1970* (Dublin: Irish Manuscripts Commission, 1996), p.14. However, despite its problems the ASTI's members' salaries were higher than those of their colleagues in primary and vocational teaching in the 1950s, as noted by John Cunningham. See Cunningham, *Unlikely Radicals*, p.126.

27. At the first annual conference of the Irish Congress of Trade Unions in 1959, there were seventeen women delegates from a total of 316 delegates (5 per cent of the total) and six of the delegates spoke. Only eight were elected to the National Executive of the Irish Trade Union Congress over the period 1894 to 1959 and five of the eight were from the Irish Women's Workers Union. See D. Nevin, 'Women and the Trade Union Movement', in D. Nevin (ed.), *Trade Union Century* (Dublin: ICTU, RTE and Mercier Press, 1994), p.361–2. When the Commission on the Status of Women reported in 1972, there was only seven full-

time female trade union officials out of a total of 230 and there were very few female shop stewards relative to the female membership which constituted a quarter of all trade union membership. The majority of women unionised in this study were in the ITGWU and it was only in 1955 that the first woman was elected on to the national executive and she remained the only female member of the executive up until the 1970s; see Daly, 'Women and Trade Unions', p.109.

28. Mary E. Daly also pointed out that though the INTO opposed these measures and succeeded in getting some concessions for teachers already in employment, the union never argued against them on the principle of a woman's right to equal treatment in the workforce. See Daly, 'Women in the Irish Workforce from Pre-Industrial to Modern Times', p.79.

29. E. Connolly, 'Durability and Change in State Gender Systems, Ireland in the 1950s', *The European Journal of Women's Studies*, 10, 1 (2003), p.76.

30. Daly, 'Women and Trade Unions', p.110 and Connolly, 'Durability and Change in State Gender Systems', p.68.

31. C. Beaumont, 'Women, Citizenship and Catholicism in the Irish Free State 1922–1948', *Women's History Review*, 6, 4 (1997), p.573.

32. Ibid.

33. F. Kennedy, *Cottage to Crèche, Family Change in Ireland* (Dublin: Institute of Public Administration, 2001), p.96.

34. Ibid., p.83.

35. Daly, 'Women and Trade Unions', p.9.

36. Ibid., p.114.

37. Hilda Tweedy, one of the founding members of the Irish Housewives Association (IHA), wrote that after returning from an International Alliance of Women Congress held in Amsterdam in 1949, the IHA decided to press for equal pay. The association made representations to government and the trade unions but the only support came from the Women Workers Union and the association also found that many married women were unsupportive on the grounds that they were fearful of how equal pay might threaten their husbands' livelihoods. See H. Tweedy, *A Link in the Chain, The Story of the Irish Housewives Association 1942–1992* (Dublin: Attic Press, 1992), p.28.

38. Connolly, 'Durability and Change in State Gender Systems, Ireland in the 1950s', p.73.

39. Junior Assistant Mistresses or JAMs were women who possessed a Leaving Certificate qualification but had not undertaken the formal two-year national school teaching qualification offered by teacher training colleges. As a result they were restricted to teaching the junior classes in the smaller two teacher schools. Their grievance related to their demand for equal pay and the same status and conditions as other primary school teachers who possessed the teaching qualification. Ó hÓgartaigh wrote that T.J. O'Connell (the INTO General Secretary, 1916–1948) sought the elimination of JAMs and the Teachers' unions generally were strongly opposed to the employment of unqualified teachers in the education sector. See M. Ó hÓgartaigh, 'Female Teachers and Professional Trade Unions in Early 20th Century Ireland', *Saothar*, 29 (2004), p.34.

40. Ferriter, *The Transformation of Ireland*, p.493.

41. C. McCarthy, *Trade Unions in Ireland 1894–1960* (Dublin: Institute of Public Administration, 1977), p.359.

42. Ferriter, *The Transformation of Ireland*, p.493.

43. Nevin, 'Industrial Disputes 1922–1993', p.397.

44. Miriam Nyhan also found that Trade Union records reveal frequent unofficial work stoppages in the Ford Plant in Cork, yet much of the industrial conflict was perceived by workers interviewed, as symptomatic of boredom and the routinised nature of factory work. See Nyhan, 'Narration and Memory: The Experiences of the Workforce of a Ford Plant', p.25.

45. A significant number of protracted industrial disputes and major strikes took place in Ireland in the 1960s, which involved bus and building workers, workers in electricity generating stations, workers in the bogs, bank officials, bank managers, school teachers and school managers and maintenance fitters. See C. McCarthy, *The Decade of Upheaval, Irish Trade Unions in the Nineteen Sixties* (Dublin: Institute of Public Administration, 1973), pp.1–2.

46. Women in this study, who were active in organisations in the 1940s and 1950s, were mainly involved in the ICA. However, for a more extensive discussion of the different women's

organisations active in this period, see Connolly, *The Irish Women's Movement, From Revolution to Devolution*. Ferriter has used the words 'maternalist' or 'social' feminism to refer to what he defines as feminist activity during this period; see Ferriter, *The Transformation of Ireland*, p.420. Ethel Crowley used the term 'indigenous feminism' to describe feminist activity attractive to ordinary women in this time period; see E. Crowley, 'An Irish Matrilineal Story, A Century of Change', in E. Sizoo (ed.), *Women's Lifeworlds, Women's Narratives of Shaping Their Realities* (London: Routledge, 1997), p.169.

47. D. Ferriter, *Mothers, Maidens and Myths, A History of the ICA* (Dublin: FÁS and the Irish Countrywomen's Association 1995), p.17.

48. The ICA was originally founded in 1910 as the United Irishwomen and in 1935, it became known as the ICA. Originally supported by the Protestant Ascendancy, it became increasingly a middle-class Catholic organisation in the 1930s. By 1953, every county in Ireland had an ICA guild. See A. Heverin, ICA, *The Irish Countrywomen's Association, A History 1910–2000* (Dublin; Wolfhound Press, 2000). Heverin pointed out that as women's lives were very much centred on the home, it was in this context that the ICA sought to improve standards of living and health, modernise domestic living through campaigning for piped water and electricity, provide social and cultural outlets and to educate and inform rural women through demonstrations and training courses. See Heverin, *ICA, The Irish Countrywomen's Association*, p.105. Describing the ICA in rural County Limerick, Patrick McNabb wrote that its programme was 'relatively unambitious'. He stated that its social significance was not so much 'its educational value', rather 'for the first time women have the opportunity to assume an institutionalised role outside the home'. Noting that the organisation was growing in East Limerick, he commented that 'with wider membership, women in this region will have a greater influence in community affairs', McNabb, 'Chapter X, Conclusion', p.246.

49. The Irish Housewives Association was formed in 1942 to campaign for fair prices for consumer and producer and equitable distribution of all goods including food. The Irish Women's Citizens Association was incorporated into the membership of the IHA and in 1966, the IHA initiated the Consumers Association of Ireland. See Heverin, *ICA, The Irish Countrywomen's Association*, p.91. Apart from demanding women's rights as consumers, the IHA sought to have its say in many different areas of community planning and it provided support for female candidates running for election to the Irish parliament. See Ferriter, *The Transformation of Ireland 1900–2000*, p.425. It worked with other women's organisations to campaign for the introduction of women police, for equal pay, for jury service for women on the same grounds as men, for legislation to raise the marriage age and for the establishment of a National Commission on the Status of Women. See Tweedy, *A Link in the Chain, The Story of the Irish Housewives Association 1942–1992* for more information on IHA activities. The Cork branch was formed in November 1951 and it operated until 1959. It was reformed in 1965 and it was active until 1978. A Limerick branch formed in May 1966 was active until 1981. In addition to fair price campaigns the Cork and Limerick branches worked on many local issues relating to planning and service provision. Caitriona Clear has also highlighted some of the less attractive aspects and the limitations of the IHA's agenda for change; see C. Clear, *Women of the House*, pp.61–6.

50. Cullen Owens has written that 'a notable development from the 1960s onwards was the politicisation of widows in Ireland'. As Cullen Owens noted, 'these women were described by June Levine as being ahead of their time in their recognition of the relationship between the personal and the political realms of life'. Formed as a support group, Cullen Owens has acknowledged how this organisation grew throughout Ireland and became more militant in the 1970s as evidenced by their street protests and mass meetings. This association achieved increased social welfare allowances for widows with dependent children, and increased support for widows with dependents up to 21 years attending third-level education; see Cullen Owens, *A Social History of Women in Ireland 1870–1970*, p.307.

51. The inaugural meeting of what was initially called the Women's Progressive Association was in Dublin in 1971. Subsequently called The Women's Political Association, it was a political pressure group which encouraged women to become involved in politics. It provided a training ground for women who had a taste for politics. Some of these went on to establish political careers and to put women's issues on the political agendas of different political parties. For more information, see the *Office of the Minister of State for Women's Affairs, Irish Women in Focus* (Dublin: Department of the Taoiseach, 1987), p.22.

52. See C. Clear, *Women of the House*; see L. Connolly, *The Irish Women's Movement*; see Ferriter, *The Transformation of Ireland*; see Heverin, *The Irish Countrywomen's Association*. Tweedy, who viewed the Irish Housewives Association as 'a link in the chain' of the women's movement, wrote: 'So many people believe that the women's movement was born on some mystical date in 1970, like Aphrodite rising from the waves. It has been a long continuous battle in which many women have struggled to gain equality, each generation adding something to the achievements of the past'. See Tweedy, *A Link in the Chain*, p.111.
53. See Beaumont, 'Women, Citizenship and Catholicism in the Irish Free State 1922–1948' and 'Citizens not Feminists: The Boundary Negotiated Between Citizenship and Feminism by Mainstream Women's Organisations in England, 1928–1939', *Women's History Review*, 9, 2 (2000) pp.411–29.
54. Beaumont, 'Citizens not Feminists', p.411–29.
55. McKenna, *Made Holy: Irish Women Religious at Home and Abroad*, p.26.

Select Bibliography

Secondary sources are cited in full in end notes to individual chapters. The following is a selection of those secondary sources most directly related to the subject area, which we used and which may be of interest to readers.

Clear, C., *Women of the House, Women's Household Work in Ireland 1922–1961* (Dublin: Irish Academic Press, 2000).

Cullen Owens, R., *A Social History of Women in Ireland 1870–1970* (Dublin: Gill & Macmillan, 2005).

Daly, M.E., *Women and Work in Ireland* (Dublin: Economic and Social History Society of Ireland, 1997).

Elders, M., Kiely, E., Leane, M., and O' Driscoll, C., 'A Union in Those Days Was Husband and Wife: Women's Narratives on Trade Unions in Munster 1936–1960', Saothar, 27 (2002), pp.121–9.

Ferriter, D., *The Transformation of Ireland 1900–2000* (London: Profile Books, 2004).

Garvin, T., *News From A New Republic, Ireland in the 1950s* (Dublin: Gill & Macmillan, 2010).

Gluck, S.B. and Patai, D. (eds), *Women's Words, the Feminist Practice of Oral History* (London: Routledge, 1991).

Hill, M., *Women in Ireland. A Century of Change* (Belfast: The Blackstaff Press, 2003).

Kiely, E. and Leane, M., '"But You Know, Times Were Not Too Great for Women Then": Oral Narratives of Irish Married Women's Working Lives, 1936–1960' Women's History Review, 13, 3 (2004), pp.427–45.

Kiely, E. and Leane, M., 'Money Matters in the Lives of Working Women in Ireland in the 1940s and 1950s' in F. Devine, F. Lane and N. Puirséil (eds), *Essays in Irish Labour History* (Dublin: Irish Academic Press, 2008), pp.427–46.

Luddy, M. and Murphy, C. (eds), *Women Surviving: Studies in Irish Women's History in the 19th and 20th Centuries* (Dublin: Poolbeg, 1990).

Muldowney, M., *The Second World War and Irish Women, An Oral History* (Dublin: Irish Academic Press, 2007).

Roberts, E., *A Woman's Place. An Oral History of Working-Class Women 1890–1940* (Oxford: Blackwell, 1984).

Roberts, E., *Women and Families. An Oral History 1940–1970* (London: Blackwell, 1995).

Sangster, J., *Earning Respect: The Lives of Working Women in Small-Town Ontario, 1920–1960* (Toronto: University of Toronto Press, 1995).

Sangster, J. 'Telling Our Stories: Feminist Debates and the Use of Oral History', Women's History Review, 3, 1 (1994), pp.5–28.

Summerfield, P., *Women Workers in the Second World War: Production and Patriarchy in Conflict* (London: Croom Helm, 1984).

Summerfield, P., 'Women and War in the Twentieth Century' in J. Purvis (ed.), *Women's History. Britain, 1850–1945* (London: University College London Press, 1995), pp.307–32.

Summerfield, P., *Reconstructing Women's Wartime Lives. Discourse and Subjectivity in Oral Histories of the Second World War* (Manchester: Manchester University Press, 1998).
Wakewich, P. and Smith, H., 'The Politics of "Selective" Memory: Re-visioning Canadian Women's Wartime Work in the Public Record', *Oral History*, 34, 2 (2006), pp.56–68.
Whelan, B. (ed.), *Women and Paid Work in Ireland 1500–1930* (Dublin: Four Courts Press, 2000).

Index

Locators in bold refer to tables.